THE
ARTISTS DIRECTORY

HEATHER WADDELL
AND RICHARD LAYZELL

Published by
ART GUIDE PUBLICATIONS
89 Notting Hill Gate
London W11 3JZ
Tel: 01-229 4669

ACKNOWLEDGEMENTS

We would like to thank the following contributing editors: Adrian Barr-Smith, Robert Coward, Alister Warman, Jeni Walwin, Liz Colin and Muriel Wilson.

We would also like to acknowledge all the galleries, art centres, art colleges, studios, artists' groups, overseas art organisations, regional arts associations, the British Council Fine Art department and countless others who gave up time to help us with all the necessary information, especially all the artists who wrote to us with specific addresses of the suppliers that they use throughout the UK.

Thanks also to Sarah Greengrass, Sally Layzell, Greta Curson, Jackie Fortey, Noel Sheridan, Nick Waterlow, Michael Hobbs, Ian Hunter, Debby Gardner, Graham Nickson, Jill Scott, Sue Jones, Richard Padwick, Ian McMillan, Bob McGillivray, Danielle Fox, Ann Symington, Jennifer Williams, the Waddell family, Gordon Cook, CAIRN (Paris), QEII Arts Council of New Zealand, Visual Arts Board (Australia), Scottish Arts Council, Welsh Arts Council, the Arts Council of Northern Ireland and the Regional Arts Associations.

Text Copyright © Heather Waddell and Richard Layzell
Cover photograph: Artist's studio copyright Heather Waddell

British Library Cataloguing Publication Data
Layzell, Richard, The Artists Directory I.A/Great Britain
I.T2. Waddell, Heather
709.41 N6768

ISBN 0 9507160 5 7
First edition 1982
Printed in Great Britain by Archway Press Ltd, Poole, Dorset

CONTENTS

PHOTOGRAPHS

Unless otherwise stated we would like to thank all the galleries that provided us with photographs for *The Artists' Directory*.

FOREWORD

We hope that this Artist's Handbook will provide a comprehensive art directory for British and overseas artists, gallery directors, art organisations and the general public interested in buying and seeing original artwork. It is an almost impossible task to cover the whole of Britain adequately for all sections and we apologise if your particular area is not adequately represented. Please do write with additional information over the next two years so that we can bear this in mind for updating purposes. We have specifically avoided a London bias as much as possible so that the whole of Britain is included.

The idea of an artist's handbook arose when we realised, through our daily involvement with artists and the art world, that there was no comprehensive British artists' handbook available and that we both often carried lists of useful information around which could be distributed and made use of by other artists. The two publications that we had been involved in separately, the *Covent Garden Arts Map* (compiled by Richard Layzell and Sarah Greengrass) and the *London Art and Artists Guide* (compiled by Heather Waddell), had proved very useful and popular and we knew that a larger comprehensive UK art directory for artists was the next step.

We hope that artists will find the handbook an essential directory for use both within Britain and before travelling overseas. We would also like to think that we have perhaps helped members of the public to consider buying original artwork for the first time or at least widen their knowledge about the practical world of art.

HEATHER WADDELL AND RICHARD LAYZELL

Chapter 1
THE ART WORLD

APPLYING FOR AN EXHIBITION

Try to find out which galleries might be interested in your work, what kind of work they normally exhibit and their particular procedure for applications. The gallery guide that follows does not include comprehensive details for every gallery, but is as thorough as we were able to make it.

Documentation: This is more important than many artists realise because it's very often the only work that is seen, and studio visits or a personal meeting are frequently based on it. It's advisable to present your documentation, whether it's in the form of slides, photographs, a book or written proposal, as clearly, concisely and thoroughly as you can. It might help to think of the person viewing your slides as an outsider who does not know you or your work and try to present the information so that he or she can gain a clear idea of your previous work and what you would like to exhibit. Interesting *presentation,* in whatever form, can make a considerable contribution to how your work communicates itself in the form of documentation. What may seem obvious to you may not be so to somebody else. It is also essential to enclose a curriculum vitae or some sort of biography about yourself.

PREPARATION BEFORE AN EXHIBITION

This is really to help artists who are not in the fortunate position to be holding an exhibition at a gallery that is going to do all the printing of invitations, posters and general press contact. Since many artists show work at alternative venues such as art schools, rented galleries etc. we hope that the following information will be of some help to them.

Private view invitation: If you are holding a private view for friends and buyers, press and other contacts then a card should be sent out *at least two weeks before the opening date* and should clearly state *the time, date, place and name of the artist and the exhibition.* A photograph is desirable, but not essential, and clarity of information is the most important factor. Printing costs vary according to the printer, from £40–£1000 (if you use colour) for 500 to 1000 invitations. If you do the artwork yourself it saves money but if you hate lettering then a more professional end product is desirable.

Press lunch: For small exhibitions this is unnecessary but, if you can afford it and can guarantee members of the press turning up, go ahead with drink and provide simple eats. Remember that the press can't resist a drink or two now and again! Invitations to a press lunch can be either on a separate card or the same one as the private view invitation and should be sent out, once more, *at least two weeks before the show opens.*

Wine for the opening: Unless you are feeling very flush see if a local wine dealer will give you wine on a sale or return basis or ask if they will consider a reduction. For example, if your show has any connections with a country that produces wine, then approach a wine shipper from that country direct. Glasses should be clean and are usually borrowed from the wine trader on the basis that you pay for any breakages.

Poster: Desirable for publicity but not essential. Black and white posters can be done cheaply if you find the right printer. They should be clear and simple with the *time of opening for gallery visitors, place, address, dates of the show and any additional information, name of the artist and exhibition* and a clear photograph if possible. These should be *posted two weeks before the opening* to galleries, museums and any other outlets that might entice the public to the exhibition, for example shops, notice boards at art schools and so on.

Press release: If possible a press release should be sent to the various art critics and journalists on newspapers, magazines, radio, TV and local papers stating exactly *what the show is about* with *dates, time of openings and the name of the artist* and *the exhibition.* Don't make the press release too long as journalists get bored reading too much irrelevant information. If possible also send a 10" x 8" *black and white photograph* to newspapers that you think might consider printing a photograph if they review it or list the exhibition. Remember that, even if you don't get a review, most art magazines, photographic magazines and some newspapers list exhibitions. For example, in London, listings for visual arts would go to *Time Out, What's On, Where to Go, Event, City Limits Arts Review, Art Monthly, British Journal of Photography* (for photo exhibitions), *The Guardian* (on Saturday) and *The Standard.* Out of London visual arts listings are found in local newspapers and *The Guardian, Arts Review, BJ, The Artist* and some women's magazines. If you want to cover the whole of the UK and you can obtain a good colour transparency which is unusual enough send it to the colour supplements *(The Sunday Times, The Observer* and *The Sunday Telegraph)* six weeks before the show opens and include a press release. Don't forget a *contact address* and *phone number for further information* at the end.

Exhibition card: Sometimes a separate card is sent with no private view invitation, to the press and to people that one does not want to add to the private view list due to shortage of space. This should have *clear information and a photograph* on it. Alternatively a card can be stamped with the private view details to save money and included or not as you wish.

Catalogue: For those who can afford the cost, it is well worth producing a small catalogue. This can be sold at the Arts Council shop, the ICA or other art bookshops after the show is over. Most catalogues are sent to art critics and select mailing-list people. The price of producing one is therefore extremely high. Colour is the main expense so using black and white instead can be a good alternative. Always avoid a very cheap catalogue — it's probably better to do without and save for the next exhibition when you can afford one. Check with several printers for prices as they vary enormously. Make sure they are reliable as well to save upset and delays. Ask local galleries for names of good printers locally and then visit them in person to see if they will do small jobs.

Private view night: When the press arrive it is advisable to have black and white photographs ready if they intend to write a review or mention the show. Artists often forget about this. Journalists like to have work made easy for them and the editor might ask for a photo but not have a spare photographer to send along that evening.

Whatever happens do not get depressed if the press do not come to the opening. They may prefer to come along during the week when they can see the work without hordes of artists clamouring for a mention. If, after following all this advice, nothing is mentioned, then it certainly isn't for want of trying or planning. It's probably just that there are too many exhibitions on at the same time or perhaps your particular exhibition was not different or unusual enough. Remember that the press thrives on new and varied news items. It bears no reflection on your work, only on the level of readership of the local paper.

Remember that *listings* should always be put first in case reviews are not forthcoming, and information should be sent *separately* if you also intend to mail the art critic or journalist as listings will invariably be dealt with by a different person.

Local radio is also a useful source of publicity. Contact the arts section to see if they will mention the exhibition on an arts programme for that week.

Below is a list of newspapers and art magazines that cover art exhibitions and art events. See the section on art magazines for other specialist publications. It's worthwhile phoning them to see if they'd be interested in coming along. Wherever you live in the UK find the name of the art critic on your local paper and inform him or her, as mentioned above, at least two weeks before the show opens.

ART REVIEWS

Most national and local newspapers, as well as art magazines, publish reviews of current exhibitions weekly. Some of these papers are listed below together with the art critics who write for them on a regular basis.

Art Monthly, 37 Museum Street, London WC1. (Peter Fuller, Andrew Brighton, Lucy Havelock Allen).
Artscribe, 5 Dryden Street, London WC2. (James Faure Walker, Adrian Searle, Matthew Colling).
Aspects, 3 Roseworth Terrace, Gosforth, Newcastle upon Tyne (Colin Painter).
Daily Express, 121/128 Fleet Street, London EC4P 4JT. Tel. 01-353 8000. (John Rydon).
Daily Mail, Carmelite House, Carmelite Street, London EC4. Tel. 01-353 6000 (Dick Lay).
Daily Mirror, 33 Holborn Circus, London EC1P 1DQ. Tel. 01-353 0246. (Richard Stott).
The Daily Telegraph, 135 Fleet Street, London EC4P 4BL. Tel. 01-343 4242. (Terence Mullaly).

Financial Times, Bracken House, Cannon Street, London EC4P 4BY. Tel. 01-248 8000. (William Packer).

Glasgow Herald, 195 Albion Street, Glasgow G1 1QP. Tel. 041-552 6255. (Clare Henry).

The Guardian, 119 Faringdon Road, London EC1. Tel. 01-278 2332. (Waldemar Januszcak).

Harpers & Queen, National Magazine House, 72 Broadwick Street, London W1V 2BP. Tel. 01-439 7144. (Bryan Robertson).

International Herald Tribune, 103 Kingsway, London WC1. Tel. 01-242 5173. (Max Wykes-Joyce).

The Illustrated London News, 4 Bloomsbury Square, London WC1A 2RL. Tel. 01-404 4300. (Edward Lucie-Smith).

The Standard, 118 Fleet Street, London EC4. Tel. 01-353 8000 (Richard Cork).

New Statesman Magazine, 10 Great Turnstile Street, London WC1V 7HJ. Tel. 01-405 8471. (John Spurling).

The Observer, 8 St. Andrews Hill, London EC4V 5JA. Tel. 01-236 0202. (William Feaver).

The Observer Colour Magazine, 8 St. Andrews Hill, London EC4V 5JA. Tel. 01-236 0202 (Caryl Faraldi).

Performance Magazine, PO Box 421, London NW1.

The Scotsman, 24 North Bridge, Edinburgh EH1 1QG. Tel. 031-225 2468. (Edward Gage).

The Spectator, 56 Doughty Street, London WC1N 2LL. Tel. 01-405 1706. (John McEwen).

Sunday Telegraph, 135 Fleet Street, London EC4P 4BL. Tel. 01-353 4242. (Michael Shepherd).

The Sunday Times, 200 Grays Inn Road, London WC1. Tel. 01-837 1234. (Marina Vaizey).

The Sunday Times Magazine, 200 Grays Inn Road, London WC1X 8EZ. Tel. 01-837 1234 (Clive Crook).

Time Out, Tower House, Southampton Street, London WC2. Tel. 01-836 4411. (Sarah Kent).

The Times, P O Box 7, Grays Inn Road, London WC1X 8EZ. Tel. 01-837 1234. (John Rusell Taylor).

The Times Educational Supplement, New Printing House Square, Grays Inn Road, London WC1X 8EZ. Tel. 01-837 1234. (Michael Church).

Vogue, Vogue House, Hanover Square, London W1R 0AD. Tel. 01-499 9080. (William Feaver).

Event, 99 Kensington High Street, London W8. Tel. 01-937 8923. (Roger Bevan).

City Limits, (Guy Brett).

See also under Art Magazines.

ART MAGAZINES

Apollo, 22 Davies Street, London W1Y 1LH. Tel. 01-629 3061. Editor: Denys Sutton, Glossy monthly publication with articles about art and antiques for collectors. £2 or annual subscription: £30.

Art Monthly, 37 Museum Street, London WC1. Tel. 01-405 7577. Editors: Peter Townsend and Jack Wendler. 10 issues p.a. Magazine with news, reviews, criticism, interviews, monthly artlaw articles and correspondence from artists, dealers, gallery directors and historians, 60p. Annual subscription: £6.00 UK £7.50 Europe and $25.00 USA or equivalent elsewhere outside Europe.

Artscribe, 5 Dryden Street, London WC2. Tel. 01-240 2430. Editor: James Faure Walker. Art magazine with lengthy interviews and reviews of contemporary painting, performance, sculpture and other art events, 70p. Annual subscription: £6.50.

Artists' Newsletter, 17 Shakespeare Terrace, Sunderland, Tyne and Wear. Tel. 0783 73589. Compilers: Richard Padwick and Sue Jones. Published by Artic Producers with the aid of a grant from the Arts Association, Northern Arts, North West Arts and Yorkshire Arts Association. Useful magazine listing suppliers, awards available and other generally useful information for artists. £4.50 p.a.

Arts North, Northern Arts, 10 Osborne Terrace, Newcastle upon Tyne. Tel. 0632 816334. Editor: Tim Brassell. Guide to art events in the north of England with interviews, articles etc. Free.

Arts Review, 16 St. James Gardens, London W11. Tel. 01-603 7530 or 8533. Editor: Graham Hughes. Fortnightly art magazine with listings of London art exhibitions, art reviews and news, 70p. Annual subscription: £17.50. $40.00 USA and Canada. Overseas £21.00.

Arts Review Yearbook £8.00.

Art Services Newsletter, 6/8 Rosebery Avenue, London EC1. Tel. 01-278 7795/7751. Editor: Danielle Fox. Covers information for artists about awards, studios, jobs, competitions and exhibitions. Annual subscription: £4.00. Run from SPACE studios and AIR gallery offices.

Artlog, The School of Art, Park Avenue, Winchester. Editor: Tony Godfrey. Two artists per issue.

Audio Arts, 6 Briarwood Road, London SW4. Tel. 01-720 9129. Editor: William Furlong. Quarterly publication on audio cassettes with slides. Covers performances, events and documentation of work by known UK artists, £4.00. Annual subscription £16.00.

Aspects, 3 Roseworth Terrace, Gosforth, Newcastle upon Tyne. Tel. 0632 854914. Editor: Colin Painter. Art magazine by artists for artists. Interviews with artists in the UK. 55p.

The Artist, 102 High Street, Tenterden, Kent. Tel. 05806 3673. 70p monthly. Annual subscription: £9.50. Art magazine for amateur artists.

British Journal of Photography, 28 Great James Street, London WC1. Tel. 01-404 4202. Editor: Geoffrey Crawley. Established weekly photographic magazine with photo news, reviews and articles and fortnightly photographic exhibition listings. 25p weekly.

Arts Alert, Greater London Arts Association, 25 Tavistock Place, London WC1. Tel. 01-388 3211. Editor: Barry Jackson. Free art magazine to cover London art news.

Arts Council Bulletin, 105 Piccadilly, London W1. Tel. 01-629 9495. General ACGB information on arts courses, conferences, awards, news from regional arts associations. Free.

Black Phoenix, 120 Greencroft Gardens, London NW6. Tel. 01-624 7185. Editor: Rasheed Aereen. Arts magazine for artists from minority groups.

Burlington Magazine, 4 Bloomsbury Square, London WC1. Tel. 01-404 4300. Editor: Terence Hodgkinson. Monthly art journal for art historical studies in English. £2.80. Annual subscription: £48.

Camera, Bretton Court, Peterborough. Tel. 0733 264666. Editor: Richard Hopkins. Articles on equipment and portfolios in colour and black and white of work by British photographers. 95p. Annual subscription: £11.50. **Practical Photography** also at this address.

Camerawork, Half Moon, 119 Roman Road, London E1. Tel. 01-980 8798. Photographic paper/magazine with emphasis on photography as a medium for social change and documentation of social problems. Also useful articles for photographers. 60p ($2.00).

Creative Camera, 19 Doughty Street, London WC1. Tel. 01-405 7562. Portfolios of photographs by known and not so well-known photographers. £2.50 each issue. Annual subscription: £11.50 ($30 USA).

Ten, 81 Grove Lane, Handsworth, Birmingham. Photographic paper/magazine with portfolios and useful articles. 75p per issue. Annual subscription: £3.00 UK. £6.50 overseas (air).

The Connoisseur, National Magazine House, 72 Broadwick Street, London W1. Tel. 01-437 7144. Editor: William Allan. Monthly glossy art magazine covering art for collectors. £2.50. Annual subscription: £25.00.

Crafts, 12 Waterloo Place, London SW1. Tel. 01-839 6306. Editor: Martina Margetts. Published every two months with reviews, books, news, articles, 90p. Annual subscription: £6.00.

Design, 28 Haymarket, London SW1. Tel. 01-839 8000. Editor: James Woudhuysen. Monthly publication for design students to design managers. Covers graphic, textile, interior and product design. £1.50. Annual subscription: £16.00.

Block, Middlesex Polytechnic Art History Department, Cat Hill, Cockfosters, East Barnet. Tel. 01-440 7431. Articles on performance, exhibitions, art historical research. £3.50. Annual subscription: £4.00 (overseas).

Performance Magazine, PO Box 421, London NW1. Art magazine covering performance and other related events in the UK. Subscription: £4.00 (individuals), £7.00 (institutions). 60p each copy.

Flash Art, UK distribution: Art Guide Publications, 89 Notting Hill Gate, London W11. Tel. 01-229 4669. £2 per issue. Covers revues in the USA, Europe, Britain and Australia. Glossy, colour photos.

Ramp, 32 Royal Crescent Mews, London W11. Tel. 01-603 3528. Reviews, poems, drawings, short stories and prose pieces by artists and arts people. 50p. Four issues £1.60.

PS—Primary Sources, 146 Dawes Road, London SW6. £4.40 p.a. UK, £8 Europe, £10 overseas.

The Art Magazine, Federation of British Artists, 17 Carlton House Terrace, London SW1. Tel. 01-930 6844. Editor: Bruce Wilson. Articles, reviews, photographs of openings. Four issues £3.50.

Viz, 24 Harcourt Terrace, London SW10. Tel. 01-370 6547. *Avant-garde* magazine that covers photography, fashion, visual arts and artglossy news.

Zoom, 2 Rue du Fbg. Poissonière, 10 ème, Paris, France. Tel. 523.3981. A glossy magazine that covers photography and the visual arts. Previously published in London.

Photo Technique, 15-23 Porteus Road, London W2. Tel. 01-262 1184.

Scottish Arts Review, Glasgow Art Gallery and Museum, Kelvingrove, Glasgow. Tel. 041 334 1134. Editor: Patricia Bascom. Published twice yearly with articles on art history and art. £1 or free to members of the Gallery and Museums Association in Glasgow.

Insight, 58 Palmerston Place, Edinburgh. Tel. 031 225 3562. Editor: Robert Sanders. News, reviews and events on the Scottish art scene and listings of exhibitions. Free.

ZG magazine, Gallery House Press, 23 Montrell Road, London SW2. Art magazine/paper that covers *avant-garde* art events and exhibitions. 50p per copy. Six issues £5, Europe £7, outside Europe £11.00.

Quarter Magazine, 105 Blackheath Hill, Greenwich, London SE10. Tel. 01-692 5137. South East London quarterly arts review magazine. Essential if you live in South London. 60p per copy.

Control, 5 London Mews, London W2. Tel. 01-262 3032. £3 per copy. Annual subscription: £13.20. Art magazine with emphasis on conceptual art documentation.

Studio International, 25 Denmark Street, London WC2. Tel. 01-836 0767. UK's glossy art magazine. £2.50 per copy. Appears sporadically.

ART BOOKSHOPS

London

The Art Book Company, 91 Great Russell Street, London WC1B 3PS. Tel. 01-637 0421. Books on art history, modern art and architecture, new and rare books.
The Art Book Company, 18 Endell Street, London WC2. Tel. 01-836 7907. Books on design history, graphics, advertising, cinema history and photography.
Arts Council Shop, 8 Long Acre, London WC2. Tel. 01-836 1359. Open Mon-Sat 10 a.m. –7.45 p.m. Good selection of art books, art magazines, photography books, general books, art postcards, artists' books and much more.
Arts Bibliographic, 37 Great Russell Street, London WC1B 3PP. Tel. 01-636 5320. Good selection of art books; also mail order service.
Compendium Books, 234 Camden High Street, London NW1. Tel. 01-485 8944 or 01-267 1525.
Idea Editions, 31 Oval Road, London NW1. Tel. 01-722 6663. Distributor of art books.
Ian Shipley (Books) Ltd., 34 Floral Street, London WC2. Tel. 01-836 4872. Specialist art booksellers.
St Georges Gallery Bookshop, 8 Duke Street, St James, London SW1. Tel. 01-930 0935. Good selection of art books, especially historical.
London Art Bookshop, 7-8 Holland Street, London W8. Tel. 01-937 6996. Good selection of most art books.
Design Centre Bookshop, 28 Haymarket, London SW1. Tel. 01-839 8000.
Peter Stockham Ltd., 16 Cecil Court, London WC2. Tel. 01-836 8661. Secondhand art books.
Creative Camera, 19 Doughty Street, London WC1. Tel. 01-405 7562. Art bookshop and large mail order business for photographers and artists.
Triangle Bookshop, 36 Bedford Square, London WC1. Tel. 01-631 1381. Art and architectural books. Open 10 a.m. – 6 p.m.
Nigel Greenwood Inc. Ltd. Books, 41 Sloane Gardens, London SW1. Tel. 01-730 8824. Publishes a list of books for sale. Good selection of art and artists' books.
Creative Book Service, 100 St. Martins Lane, London WC2. Mail order service for rare and out-of-print books.
Dillons, 1 Malet Street, London WC1. Tel. 01-636 1577. Excellent art section.
ICA Bookshop, ICA, The Mall, London SW1. Selection of books, catalogues, magazines for visual arts, performance, photography, video and general literature books. Bookshop within an arts centre context.
Hayward Gallery Bookshop, Hayward Gallery, London SE1. Art bookshop selling magazines, catalogues and books at the entrance to the Hayward galleries.
W. & G. Foyle Ltd., (Art Department), 119 Charing Cross Road, London WC2. Tel. 01-437 5660. Large selection of art books and art related subjects.
A. Zwemmer Ltd., 76-80 Charing Cross Road, London WC2. Tel. 01-836 1749/4710. Art bookshop with large selection of books on art, architecture and art related subjects.
Many small galleries sell art magazines and small art books and artists' postcards. Royal Academy AIR, ICA, Photographers gallery. Camden Arts Centre and the Serpentine fall into this category, as do Whitechapel, Riverside Studios and Edward Totah gallery.
Royal Academy Bookshop, Royal Academy, Burlington House, London W1. Art books, art materials, postcards etc.
Tate Gallery Bookshop, Tate Gallery, Millbank, London SW1. Large bookshop with postcards, calendars, art books and art slides. Open: gallery hours. Reductions for Friends of the Tate.
Photographers Gallery, 8 Great Newport Street, London WC2. Larger bookshop now that the gallery has expanded. Good selection of photographic magazines, photography books and other art related books.

Elsewhere in the UK

Many arts centres, galleries and other centres for artists sell art magazines and small art books. A very incomplete list of art bookshops is given below. Most major bookshops in British cities have an art section.
Third Eye Bookshop, Third Eye Centre, 350 Sauchiehall Street, Glasgow. Tel. 041 332 7521. Good selection of art magazines and art books.
City Art Centre, 14 Market Street, Edinburgh. Catalogues and art books.

The Public House Bookshop, 21 Little Preston Street, Brighton. Tel. 0273 28357. Bookshop; also performance and poetry events.

Oriel Bookshop, 53 Charles Street, Cardiff, Wales. Tel. Cardiff 395548.

Newlyn Orion Art Gallery Bookshop, Penzance, Cornwall. Tel. 0736 3715.

Ceolfrith Bookshop, Sunderland Arts Centre, 27 Stockton Road, Sunderland. Tel. 0783 41214.

Arnolfini Bookshop, Narrow Quay, Bristol. Tel. 0272 299191.

South Hill Park Arts Centre, Bracknell, Berkshire. Art books, postcards and craftwork.

Art Books, 27 Middleway, Chinnor, Oxford. Tel. 0844 53326. Also publishes a catalogue annually listing art books as well as supplying libraries, museums and art departments throughout Britain and overseas.

South West Arts, 23 Southernhay, Exeter, Devon. Tel. 0392 38924. Bookshop for art, poetry, fiction and art catalogues.

Chapter 2
THE GALLERIES

INTRODUCTION BY JENI WALWIN
Exhibitions in a Regional Art Centre
South Hill Park, Bracknell

The shape of an exhibition programme in a regional arts centre may in many ways be determined by existing provision for the visual arts within the town or surrounding area. For example, if the town already has a municipal museum and art gallery, a small commercial print gallery, and a craft shop, then the centre's exhibitions might perhaps concentrate on the contemporary fine arts and photography.

There are no other galleries in Bracknell, although there is a municipal art gallery in Reading (only eleven miles away) and a number of smaller commercial galleries and craft shops in the area, often showing the work of local artists and craftsmen. As a result, the gallery spaces at South Hill Park have adopted a commitment to a wide range of contemporary art.

The programme of visual art and craft exhibitions may, in the case of an art centre such as South Hill Park, represent only one small part of the centre's activity, but it is nevertheless interesting to consider what its particular function is, and how far an exhibition programme may respond to the particular needs of the centre as a whole; the local community which the art centre serves, and the much broader considerations of the contemporary art world.

As with each area of activity in an art centre these three considerations are significant factors in determining the shape and content of the programme. It must allow a certain flexibility in order to accommodate the varying requirements from other disciplines, the demands from the local community and the concerns of professional working artists. Each of these factors plays a part in determining the nature and balance of an exhibition programme at South Hill Park.

In order to show the idea that much artistic activity crosses barriers between the various disciplines, several inter-departmental projects have been co-ordinated. These may involve film, theatre, music, workshops and exhibitions in one joint project illustrating a common theme (for example the African festival), or it might be on a smaller scale involving only one or two areas, for example, a video festival organised by the film department, but combined with a video installation in the gallery.

Other aspects of the centre's work to which the exhibition programme responds are the residencies. Artists and craftspeople come to the centre for one or two year fellowships and can usually expect to take part in a one-person or group show during the course of their residency.

The second concern of the exhibition programme is to discover ways in which work by professional artists can be brought to the region. It is of particular importance when there are few other galleries in the surrounding area wholly devoted to the showing of contemporary art. This can be achieved in a number of ways: either by taking touring exhibitions from The Arts Council and other galleries, or by generating funds within the centre to originate group and one-person shows which might be available for hire to other galleries. This brings up the question of sponsorship which is of such importance when working on small budgets. For touring exhibitions in particular, it may be possible to attract sponsorship from local and national companies who would like to be associated with a specific exhibition and who would receive in turn recognition on all the publicity. The showing of work from artists both resident locally and from further afield may illustrate more established nationally known areas of activity, yet there is also room for more experimental work by younger lesser-known artists and in this respect South Hill Park has given some young artists an opportunity of showing their work for the first time.

The third area for consideration is largely based on the demands and involvement of the local community. This is often a two-way process – on the one hand involving them in the exhibition programme, with shows of work by local artists, school children and community organisations, and on the other hand, organising a number of projects for participation by local people, for example, talks, demonstrations, and films to coincide with the exhibition, as well as projects for artists in local schools during the period of their exhibition.

Apart from these more general considerations, each exhibition may be the result of a variety of different approaches made either by the artist or by South Hill Park. In all initial enquiries for exhibitions, slides and perhaps written proposals are sent in, and if there is a possibility of a show, this will be followed by a studio visit. On the other hand, South Hill Park will often approach individuals with the idea of a particular show or theme in mind. Some special areas of interest may begin to emerge, and the recently established fund for a permanent outdoor collection has meant that sculpture, especially during the summer months, has become a regular feature of the programme. As far as touring exhibitions are concerned, there are few galleries in the country which make craft shows available to other venues, and as a result, South Hill Park is beginning to put together mixed exhibitions of craft work which can then be hired by other galleries.

No one exhibition programme can meet the variety of responsibilities and demands expected of it, and each programme will in the end be to some extent dependent upon the funds available, the requirements of those who make the funds available, and of course the availability and commitment of the artists themselves.

JENI WALWIN

LONDON

London Art and Artists Guide (editor Heather Waddell), also published by Art Guide Publications, has more detailed information on some 500 galleries. Price £2.95.

ABERBACH FINE ART, 17 Savile Row, London W1X 1AG. Tel. 01-439 6686. Opening: Mon-Fri 10-6.30. Contact: Paul Hope. Exhibitions: 20th century paintings, drawings, graphics and sculpture. Large stock of graphics by English and continental artists.

AI MEI GALLERY, 205 Royal College Street, London NW1. Tel. 01-267 4597. Opening: Tues-Fri and Sun 3-6. Contact: Nancy Kuo, Guy Davis. Applications: They specialise in Oriental Art but other arts and crafts are also considered. Exhibition: The gallery is an art centre, its activities include; lectures/demonstration on Chinese calligraphy, painting, paper-cut, puppets, flower arrangement, cookery, also art classes, poetry reading etc. Artists showing regularly are Nancy Kuo and some leading artists of China. Space: Front gallery 15m, rear gallery 10m.

AIR GALLERY, 6 & 8 Rosebery Avenue, London EC1. Tel. 01-278 7751. Opening: Mon-Fri 10.30-6, late evenings Tues and Thurs till 8. Contact: Robert McPherson. Applications: It is advisable for artists to acquaint themselves with the work handled by the gallery and the spaces available, before making an application. Application forms sent on request. Proposals should be specifically designed for the Air Gallery. Exhibitions: Artists who do not exhibit on a regular basis elsewhere and who have not had a recent major exhibition in London. Painting, sculpture and allied activities – music, dance, poetry, film, performance and video. Regional artists are encouraged to apply, as well as London-based. Space: 2000 sq ft, on 2 floors, with approx. 200 linear feet of wall space, spotlighting and natural light. Basement has been converted into a performance space. There are usually two one-person shows running at the same time. Air Gallery is a service provided by AIR and SPACE (Arts

Services Grants Ltd) a registered charity which provides various services to visual artists, including a slide collection and studio space.

ALWIN, 9-10 Grafton Street, London W1X 4DA. Tel. 01-499 0314. Opening: Mon-Fri 10-6, Sat 10-1. Exhibitions: 12 one-person shows per year, mainly sculpture.

AMALGAM ART LTD., 3 Barnes High Street, London SW13. Tel. 01-878 1279. Opening: Tues-Sat 10-1, 2.15-6. Contact: T A M Boon, A F Boon. Applications: Professional artists can apply but avoid Nov/Dec. Exhibitions: Specialises in contemporary ceramics, prints and studio glass. Shows English art and crafts. Space: one floor 15ft x 30ft.

AMWELL GALLERY, 31 Amwell Street, London EC1R 1VN. Tel. 01-837 7756. Opening: Varies with each exhibition. Contact: Elizabeth Dunbar/Jane Blackstock. Applications: Professional artists can apply at any time. Exhibitions: One-man exhibitions, specialise in young, local painters, print makers, jewellers. Informal gallery that takes a very small commission on sales. Artists staff their own exhibitions. Space: one floor.

ANDERSON O'DAY, 5 St Quintin Avenue, London W10. Tel. 01-969 8085. Opening: 10-5. Contact: Don Anderson and Prue O'Day. Applications: Considered at any time of the year. Exhibitions: They publish and deal in prints only. Their exhibition programme is related to the artists whom they publish regularly, including Ackroyd, Neiland, Wilkinson, Tinsley, Smallman, Orr, Fassolas. Space: one floor.

THE ANNEXE GALLERY, On the corner of the Common, 45 Wimbledon High Street, London SW19. Tel. 01-946 0706. Opening:

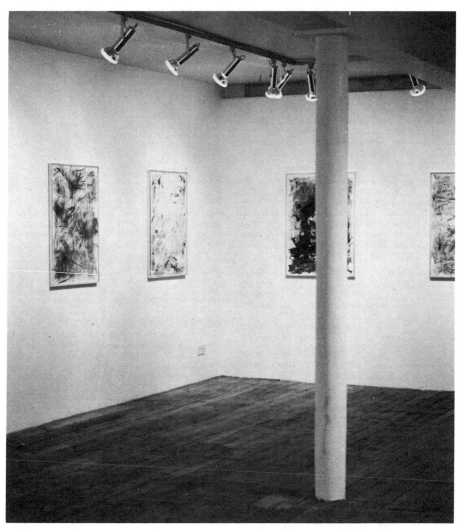

AIR Gallery London EC1.

Mon-Sat 10-6 (closed Thurs) Sun 11-4. Contact: Christopher Hull. Applications: Open to professional artists but in the mornings only. Exhibitions: Modern, 20th century British artists.

JUDA-ROWAN GALLERY, 11 Tottenham Mews (off Tottenham Street), London W1. Tel. 01-637 5517/8. Opening: Mon-Fri 10-6 Sat 10-1 or by appointment. Contact: Mrs Annely Juda and David Juda. Applications: Professional artists can apply but at present they are fully committed for the next 3 years. Exhibitions: 20th century art including: Alan Green, Nigel Hall, Peter Kalkhof, Michael Kenny, Edwina Leapman, Michaeledes, Alan Reynolds, Christo, Alheld, and Russian Constructivism and Suprematism. Space: 3 rooms on 2 floors. Each room – 13ft x 15ft approx.

ARCHITECTURAL ASSOCIATION, 34 Bedford Square, London WC1. Tel. 01-636 0974. Opening: Mon-Fri 10-7 Sat 10-1.30. Occasional art and architectural exhibitions. Also Triangle Bookshop for art and architectural books.

15

ARGENTA GALLERY, 82 Fulham Road, London SW3. Tel. 01-584 3119. Opening: Mon-Sat 9.30-5.30. Exhibitions: Jewellery by about 30 younger designer/craftsmen.

ARTISTS REGISTER, 110 Kingsgate Road, London NW6. Tel. 01-328 7878. Opening: 10-5 Weekdays. Contact: P. Sims, C. Cook, M. Rieser, A. Forbes. Applications: Open to applications any time of the year. Exhibitions: Shows contemporary work including: Bennett, Butler, Cook, Forbes, Margrave, Mcgowan, Rieser, Sims. Space: Gallery walls measuring 20ft x 8ft, ceiling 60ft x 10ft. Mezzanine adjoins ground floor.

ART FOR OFFICES, Riverside Gallery, O&N Block, Metropolitan Wharf, Wapping Wall, London E1. Tel. 01-481 1337. Contact: Andrew Hutchinson and Peter Harris. Artists can submit 35mm slides of work and if suitable these will be shown to architects, designers and business clients. Gallery by appointment only. Prints, painting, sculpture, photography.

ATMOSPHERE, 148 Regents Park Road, London NW1. Tel. 01-722 6058. Opening: Mon-Fri 10-6. Contact: Ian Freedman. Applications: By invitation only. Exhibitions: Major British craftsmen — jewellers, glass-blowers, potters, print-makers, weavers etc. Space: 2 floors 44ft x 27ft and 19ft x 27ft. Contemporary work only.

BANKSIDE GALLERY, 48 Hopton Street, Blackfriars, London SE1 9JH. Tel. 01-928 7521. Opening: 10-5 daily some Sundays 1-6. Contact: Malcolm Fry. The gallery houses The Royal Society of Painters in Watercolours, Royal Society of Painter-Etchers and Engravers, the R.W.S. Art Club and the Society of Minia-turists. Mostly members only. Space: one floor 60ft x 30ft.

BEN URI ART GALLERY, 21 Dean Street, London W1. Tel. 01-437 2852. Opening: Mon-Thurs 10-5. Contact: A. Katz. Applica-tions: Artists can apply for exhibitions. Exhibitions: Specialises in Jewish artists or Jewish themes by artists of any denomination. Space: one floor, 50ft x 32ft approx. (walls).

ANNE BERTHOUD GALLERY, 1 Langley Court, London WC2E 9JY. Tel. 01-836 7357. Contact: Anne Berthoud. Opening: Mon-Fri 11-6 Sat 11-2 and by appointment. Exhibi-tions: Contemporary art; gallery artists include: John Elliot, Robert Mason, Victor Newsome and Michael Upton. Previously the Hester van Royen Gallery.

BLACKHEATH GALLERY, 34 Tranquil Vale, London SE3. Tel. 01-852 1802. Opening: Mon, Tues, Wed, Fri, Sat 10-6. Contact: J.V. Corless. Exhibitions: Contemporary paintings, prints and sculptures.

BLOND FINE ART LTD., 33 Sackville Street, London W1. Tel. 01-437 1230. Opening: Mon-Fri 10-6 Sat 10-1. Exhibitions: 20th century British paintings, drawings, sculpture and graphics, including Ardizzone, Blond, Bomberg, Gill, Gross and Nash.

BOOKSHOP GALLERY, 4 Perrins Lane, Hampstead, London NW3 1QY. Tel. 01-794 2775. Opening: Tues-Sat 10-6 Sun 12-6. Contact: Leigh Middleton, Gail Goodwin. Exhibitions: Contemporary art, graphics, painting, sculpture, ceramics, frequent one-person shows.

BRITISH CRAFTS CENTRE, 43 Earlham Street, London WC2H 9LD. Tel. 01-836 6993. Opening: Mon-Fri 10-5 Sat 10-4. Director: Karen Elder. Exhibitions: Contemporary crafts, mostly British, sometimes international exhibi-tions e.g. Finnish glass. A major venue for crafts in a bright, spacious gallery.

BROWSE & DARBY LTD., 19 Cork Street, London W1. Tel. 01-734 7984. Opening: Mon-Fri 10-5.30. Exhibitions: 20th century and contemporary painting and sculpture.

BUSINESS ART GALLERIES (The Upstairs Gallery), Royal Academy of Arts, Burlington House, Piccadilly, London W1V 0DS. Tel. 01-437 5875. Opening: Mon-Fri 10-6. Contact: Stephen Reiss. Applications: Artists need not make an appointment to show their work to the Director, but they must remove their work on the same day, after it has been viewed. Exhibitions: Contemporary British painters and printmakers recruited from the Royal Academy, Curwen and other sources. Set up in 1978 by the Royal Academy mainly to offer a compre-hensive art service to businesses, but members of the public are welcome also.

CALE ART, 17 Cale Street, London SW3. Tel. 01-352 0764.

CAMDEN ARTS CENTRE, Arkwright Road, London NW3 6DG. Tel. 01-435 2643/5224. Opening: Mon-Thurs, Sat 11-6; Fri 11-8; Sun 2-6. Contact: Zuleika Dobson. Exhibitions: Contemporary art, photography and crafts, some historical shows. Space: Two large galleries, a foyer and a coffee bar used for small photographic shows. Garden space used for sculpture shows in the summer. Part of an educational centre offering courses in art and crafts.

CANADA HOUSE GALLERY, Canada House, Trafalgar Square, London SW1. Tel. 01-629 9492 ext 246. Opening: Mon-Fri 9.30-5. Contact: Griselda Bear. Exhibitions: Monthly shows of Canadian art, mostly contemporary.

16

CENTAUR GALLERY, 82 Highgate High Street, London N6. Tel. 01-340 0087. Opening: Mon-Sat 11-6. Contact: Jan and Dinah Wieliczko. Exhibitions: Contemporary painting and sculpture.

CENTRE 181, 181 King Street, London W6. Tel. 01-741 3696. Opening: Mon-Fri 10.30-5.30 Sat 11-2. Contact: Liz Taunt. Applications: Open to London artists to apply at any time. Exhibitions: One-man shows by young, London based, professional artists, monthly. Space: One floor, 30ft x 10ft.

CHENIL GALLERY, 183 Kings Road, Chelsea, London SW3. Tel. 01-352 9093. Opening: Mon-Sat 10-6. Applications: Would like to hear from young professional artists interested in exhibiting, send S.A.E. for details. Exhibitions: Paintings, prints, photography, crafts, sculpture. Four open exhibitions are held annually.

CHRISTIE'S CONTEMPORARY ART, 8 Dover Street, London W1. Tel. 01-499 6701. Opening: Mon-Fri 9.30-6, Sat 10-1. Exhibitions: Contemporary etchings, lithographs and sculpture, publishes the work of over 90 artists.

COCKPIT GALLERY HOLBORN, Cockpit Arts Workshop Annexe, Drama and Tape Centre, Princeton Street, London WC1. Tel. 01-405 5334. Opening: Mon-Fri 10-8. Contact: Alan Tomkins, Exhibitions Organiser. Applications: Photographers can apply for exhibitions. Exhibitions: They promote and show exhibitions (usually by groups) on contemporary culture e.g. style, youth, race, politics etc. Space: Main gallery 40ft x 20ft. Small gallery 40ft x 10ft. All walls 8ft high.

COMMONWEALTH ART GALLERY, Commonwealth Institute, Kensington High Street, London W8. Tel. 01-602 3253. Opening: Mon-Sat 10-4 Sun 2-5. Exhibitions: Commonwealth painters, sculptors and craftsmen. Applications open to commonwealth artists.

THE CONCOURSE GALLERY, The Polytechnic of Central London, 35 Marylebone Road, London NW1.

THE REGENT STREET GALLERY, Polytechnic of Central London, 309 Regent Street, London W1. Tel. 01-580 2020 ext 335. Opening: Mon-Fri 8-8. Contact: Richard Allen. Applications: Apply to Richard Allen, exhibitions consultant to Polytechnic of Central London, for consideration by exhibition committee. Exhibitions: No regular artists, mainly group shows, artists and/or photographers, documentary shows etc. and overseas shows. Space: Concourse Gallery approx 70 metres (screens and walls), Regent Street Gallery approx 27 metres (screens).

CORACLE PRESS, 233 Camberwell New Road, London SE5. Tel. 01-701 5762. Opening: Tues-Sat 11-6 and by appointment. Exhibitions: Mostly small works — paintings, drawings, prints, artists' books, contemporary only. Also a publishing project next door. Produces a monthly Gallery Guide — 'New Exhibitions of Contemporary Art'. This covers alternative exhibition spaces as well as galleries. Inclusion costs £20 per 2-monthly Guide. Contact 235 Camberwell New Road, London SE5. Tel. 01-703 5201. Kay Roberts.

CRAFTS COUNCIL GALLERY, 12 Waterloo Place, London SW1. Tel. 01-930 4811. Opening: Tues-Sun 10-5. Contact: Ralph Turner. Exhibitions: Contemporary British crafts and some from overseas. Slide register of work by British craftsmen and women — the public can use this to look at work or buy an illustrated catalogue.

CRAFTSMEN POTTERS ASSOCIATION, William Blake House, Marshall Street, London W1 1FD. Tel. 01-437 7605. Opening: Mon-Fri 10-5.30 Sat 10.30-5.00. Contact: David Canter and Stephen Brayne. Applications: Selection committee meets 4 times a year. Exhibitions: About 6 major exhibitions a year and there is always a large selection of both functional and decorative, contemporary ceramics. They specialise in artists from the United Kingdom. There are 165 full members of CPA who show regularly. Space: 1 floor.

CRANE ARTS LTD., 321 King's Road, London SW3. Tel. 01-352 5857. Opening: Mon-Sat 10-6. Contact: A. Kalman. Applications: They are always interested in seeing new work. Exhibitions: Specialise in unusual paintings by talented and witty new artists. They also have a selection of nineteenth century naive paintings. Space: Two floors. Also the CRANE GALLERY, 171A Sloane Street, London SW1. Tel. 01-235 2464. Open Mon-Fri 10-6 Sat 10-4.

CRANE KALMAN GALLERY, 178 Brompton Road, London SW3. Tel. 01-583 7566. Opening: Mon-Fri 10-6 Sat 10-4. Contact: Andras Kalman. Exhibitions: 20th century established British and French artists.

CURWEN GALLERY, 1 Colville Place, off Whitfield Street, London W1. Tel. 01-636 1459. Opening: Mon-Fri 9.30-5.30 Sat by appointment only. Contact: Jane Hindley. Exhibitions: All kinds of contemporary printmaking. Publishes a large selection of lithographs by well-known artists.

CREATIVE CAMERA GALLERY AND BOOK-SHOP, 19 Doughty Street, London WC1. Tel. 01-405 7562. Contact: Judy Goldhill. Applications: Photographers can apply for shows throughout the year, no fee. Exhibitions: Photography shows only, non-commercial gallery, space for showing experimental work. Good bookshop and mail order business for photographic and art books. Coo Press Ltd. Space: One floor, 2 x 10ft walls-1 x 4ft.

DAVID DAWSON LTD., Second Floor, B-2 Metropolitan Wharf, Wapping Wall, London E1. Tel. 01-488 9815. Opening: Tues-Fri 10.30-5 Sat 10-1. Exhibitions: Mainly contemporary photography.

7 DIALS GALLERY, 52 Earlham Street, London WC2. Enquiries to: Goods & Chattels Ltd., 44 Earlham Street, London WC2. Tel. 01-240 5470. Contact: Carol Watkinson. Gallery space is available for rent by any individual or group of artists, details available from the above. Space: Approx 280 linear feet of wall space, spotlights, some pillars.

DOCKLANDS GALLERY, O & N Warehouse, Metropolitan Wharf, Wapping Wall, London E1. Opening: Weekdays 12-8. Applications: Open to artists to organise and present their own exhibitions, contact the gallery for further information. Space: 3,000 sq ft.

ANTHONY D'OFFAY, 9 Dering Street, New Bond Street, London W1. Tel. 01-629 1578. 23 Dering Street, London W1. Tel. 01-499 4695. Opening: Mon-Fri 10-5.30, Sat 10-1. Contact: Anthony d'Offay. Exhibitions: 20th century British art, including Bell, Burra, Epstein, Wyndham Lewis, John Nash, Roberts, Spencer and Wadsworth. Also contemporary British, European and American experimental art, including Gilbert and George, Joseph Beuys, Lawrence Weiner and Boyd Webb.

DRIAN GALLERIES, 7 Porchester Place, London W2 2BT. Tel. 01-723 9473. Opening: Mon-Fri 10-5 Sat 10-1. Contact: Halima Nalecz. Applications: Professional artists can apply. Exhibitions: Contemporary painting, mostly with figurative references – Alkazzi, Lacasse, Portway, Spears, Tate, Zack etc.

EBURY GALLERY, 89 Ebury Street, London SW1. Tel. 01-730 3341/7806. Contemporary artwork by young British artists.

EDITIONS ALECTO, 27 Kelso Place, London W8. Tel. 01-937 6611. Opening: Mon-Fri 10-5.30. Sat by appointment. Exhibitions: Contemporary prints. Studios and workshops attached providing etching, screenprinting and lithography facilities.

5 DRYDEN STREET GALLERY, 5 Dryden Street, Covent Garden, London WC2E 9NW. Tel. 01-240 2430. Opening: Mon-Sat 9-6. Applications: Application forms can be obtained from the gallery, these should be sent back with slides of work to the selection panel. Exhibitions: Gallery run on a non-profit making basis, 10% commission on sales. Exhibitions organised on a self-help basis, gallery was set up to show a wide variety of work. They want to provide opportunities for lesser-known artists to show their work. Exhibitions held every fortnight. Mostly smaller works. Space: One floor and staircase area, spotlights, some screens, providing, in total about 110 linear feet of wall space.

12 DUKE STREET GALLERY, St James's, London SW1. Tel. 01-930 5247.

S. EAST GALLERY, 229 Camberwell New Road, London SE5. Tel. 01-701 9152. Opening: Thurs-Sun 2-7. Contact: Sally East, Michael Guy. Applications: Professional artists can apply at any time. Exhibitions: Shows contemporary work especially young artists, from all over Europe. Space: 2 floors.

ELECTRUM GALLERY, 21 South Molton Street, London W1. Tel. 01-629 6325. Opening: Mon-Fri 10-6, Sat 10-1. Contact: Barbara Cartlidge. Applications: Not open to artists to apply. Exhibitions: Contemporary jewellery only. Artists showing regularly include; Wendy Ramshaw, David Watkins, Gerda Flockinger, Martin Page, Roger Morris, Babetto, Paul Preston, Nelé, Lisa Kodré. Space: 2 floors.

ANTHONY ENGLAND, 5 Artillery Row, London SW1. Tel. 01-222 2855. Opening: Mon-Fri 10-5. Contact: A. England. Exhibitions: Mainly representational art, limited editions mostly, including Russell Flint, David Shepherd, Piper, Hockney, Moore and Frink, some original watercolours. Small showings of individual artists' work throughout the year.

ROGER EVANS, 5 Alenmore Road, Belsize Park, London NW3 4DA. Tel. 01-586 5267. Opening: By appointment only. Contact: Roger Evans. Applications: Printmakers resident in the UK only. Exhibitions arranged through galleries in the UK and abroad. Exhibitions: Artists who exhibit include: Ana Maria Pacheco, Vinicio Horta, Maung Tin Aye, Richard Blaney, Kent Jones, Marcus Rees Roberts, Terry Wilson, David Hockney, Edward Paolozzi, RB Kitaj and Wunderlich. They deal in twentieth century art and also act as agents to artists. Special emphasis on the work of professional younger artists, mainly printmakers. An investment service is provided for collectors.

18

GIMPEL FILS, 30 Davies Street, London W1Y 1LG. Tel. 01-493 2483. Opening: Mon-Fri 9.30-5.30, Sat 10-1. Contact: R. & P. Gimpel. Applications: Not open to artists to apply. Exhibitions: Contemporary work including; Davie, Adams, Hepworth, Scott, Jenkins. They also exhibit South Arabian antiquities and Eskimo art. Space: 2 floors.

FISCHER FINE ART, 30 King Street, St James's, London SW1. Tel. 01-839 3942. Opening: Mon-Fri 10-5.30, Sat 10-12.30. Contact: W. F. Fischer. Exhibitions: German Expressionism, Russian Constructivism and Suprematism, Vienna School, Bauhaus and various 20th century and contemporary British artists.

MARGARET FISHER, 2 Lambolle Road, London NW3. Tel. 01-794 4247. Opening: Mon-Fri 2-6, Sat 11-3. Applications: Professional artists can apply, but they should phone for an appointment. Contact: Margaret Fisher. Exhibitions: Modern English artists but they specialise in Austrian art and have shown the work of Hundertwasser and Kokoschka. Space: 1 floor.

FOTOGALERIE, 48 Hill Rise, Richmond, Surrey. Tel. 01-940 9143. Exhibitions; photography.

FRENCH INSTITUTE, 17 Queensberry Place, London SW7. Tel. 01-589 6211. Opening: 8-6.30. Exhibitions: The work of French artists. Space: 70 metres of wall space on one floor.

ANGELA FLOWERS GALLERY, 11/12 Tottenham Mews, off Tottenham Street, London W1P 9PJ. Tel. 01-637 3089. Opening: Mon-Fri 10.30-5.30, Sat 10.30-12.30. Contact: Angela Flowers. Exhibitions: Gallery artists are Boyd and Evans, Ian Breakwell, David Hepher, Carole Hodgson, Derek Hirst, Patrick Hughes, Dave King, John Loker and Michael Pennie.

THE GAL, 1st Floor, 98 Waterford Road (Kings Road), London SW6. Tel. 01-731 6954. Young contemporary British artists. Interested in helping promote young women artists; also shows work by male artists.

THE GALLERY, 52 Acre Lane, London SW2. Tel. 01-274 0577. Opening: Depends on exhibitors. Exhibitions: Any kind of contemporary work. The gallery is part of a studio block and exhibitors have to organise their exhibitions, publicity etc., for themselves. Can be hired by any professional artist, contact the Acme Housing Association (Tel. 01-981 6811) for details.

GALLERY 10, 10 Grosvenor Street, London W1. Tel. 01-491 8103. Opening: Mon-Fri 10-5.30, Sat 10-11. Applications: Professional artists can apply for shows. Exhibitions: Contemporary British artists including; Peter Coker RA, D Hamilton Fraser ARA, Tom Nash, R. T. Cowern RA, R. Buhler RA, Roger De Grey RA, Jean Creedy, Jo Milton, etc. Space: One floor.

GALLERY 273, Queen Mary College, Physics Building, Mile End Road, London E1 4NS. Tel. 01-980 4811 Ext 373. Opening: Mon-Fri 10-5. Contact: Keith Nickels, John Charap. Applications: Professional artists can apply at any time. Exhibitions: About 6 exhibitions a year in term time. The gallery shows work by young artists, usually small paintings or graphics. No charge is made to artists nor is any commission taken on sales, the intention is to encourage less well known artists. Space: One floor.

GALLERY 44, 309a New King's Road, London SW6. Tel. 01-736 6887. Opening: Mon-Fri 10-4, Sat 10-2. Contact: Matthew Wallis. Exhibitions: Wide range of contemporary art, from traditional watercolours to abstracts. Aims to promote younger, less well-known artists.

ST GEORGES GALLERY, 11 Church Street, Twickenham. Tel. 01-891 2611. Opening: Tues-Sat 10-6. Contact: T. Osborne, P. A. Osborne. Application: Open to professional artists. Exhibitions: Special interest in local artists and artists of the Wapping group. Locally produced ceramics, pottery and jewellery are also exhibited. Space: One floor 30ft long x 20ft wide.

GILBERT-PARR GALLERY, 285 King's Road, Chelsea, London SW3. Tel. 01-352 0768. Opening: Tues-Sat 9.30-1 and 2-5.30. Contact: David and Inga Gilbert. Applications: Considered. Exhibitions: They show the work of contemporary artists including; Peter Eugene Ball, David Evans, John Hitchens, Patrick Hall, Will Maclean, Margaret Neve, Michael Gillespie, Douglas Portway.

GOETHE INSTITUTE, 50 Princes Gate, London SW7. Tel. 01-581 3344. Opening: Mon-Fri 12-8, Sat 10-7. Exhibitions: Work connected with Germany, contemporary and historical. Space: 50 metres of hanging space.

GRAFFITI, 44 Great Marlborough Street, (3rd floor), London W1. Tel. 01-437 6848.

Contact: Nancy Patterson, Peter Leigh. Exhibitions: Mostly original prints, some painting and sculpture. Artists shown include – Peter Daglish, Anthony Benjamin, Martin Leman, Julia Atkinson, Noreen Grant, Bob Chaplin, Val Ewens, Roslyn Kean.

GREENWICH PRINTMAKERS ASSOCIATION, 7 Turnpin Lane, Greenwich, London SE10. Tel. 01-858 2290. Opening: 11-5 daily except for Mon & Thur. Contact: Run by 30 artist-printmakers mainly living in Greenwich. Applications: Show work of the co-operative. Exhibitions: Run on co-operative lines by the print-makers whose aims are to show their work together in Greenwich, to arrange travelling group exhibitions, to buy printmaking materials cheaper in bulk, and generally to promote an interest in printmaking in the area. The association is run by a committee of 7 members, elected annually. Selection of 2 new members takes place twice a year. Show mainly etchings, lithographs with some watercolours and drawings. Space: Gallery and local restaurant used as an overflow gallery.

GREENWICH THEATRE ART GALLERY, Greenwich Theatre, Crooms Hill, Greenwich, London SE10. Tel. 01-858 4447/8. Opening: Mon-Sat. 10.30-10.15. Contact: Geoffrey Beaghen. Applications: Professional artists can apply. Exhibitions: Contemporary work. Space: 3 floors.

NIGEL GREENWOOD INC LTD, 41 Sloane Gardens, London SW1. Tel. 01-730 8824. Contact: Nigel Greenwood. Opening: Mon-Fri 10-6, Sats-Please ring. Applications: Artists are free to send in slides. Exhibitions: Gallery artists showing regularly include; Adams, Becher, Bill Beckley, Jane Berthot, Chaimowicz, Rita Donagh, Ger Van Elk, Joel Fisher, Alan Johnston, Chris Lebrun, Ian McKeever, J Stezaker, D. Tremlett, Tuttle, J Walker, and other contemporary artists. Space: One floor.

HALF MOON GALLERY, 119/121 Roman Road, London E2. Tel. 01-980 8798. Part of the Half Moon Photographic Workshop, the gallery has recently opened and shows the work of young photographers involved with social documentary.

HAMILTONS GALLERY, 13 Carlos Place, London W1. Tel. 01-499 9493. Exhibitions by known names, also historical exhibitions.

HAYWARD GALLERY, Belvedere Road (The South Bank), London SE1 8XZ. Tel. 01-928 3144. Opening: Mon-Thurs 10-8, Fri and Sat 10-6, Sun 12-6. Exhibitions: The Arts Council's major British venue for exhibitions. The shows are mainly contemporary or 20th century, covering all media. Many prestigious international shows have been mounted here or originated by the gallery itself. Retrospective, two-person, mixed thematic and group shows. Applications: By invitation only. Space: A purpose-built new building, with spacious galleries on three levels, no natural light. Two exterior courtyards for sculpture. Part of the South Bank complex, between the Royal Festival Hall and the National Film Theatre. There is a bookstall selling Arts Council catalogues, books and postcards, also a schools mailing list.

HEALS ART GALLERY, Heal & Son Ltd, 196 Tottenham Court Road, London W1. Tel. 01-636 1666 Ext 44. Opening Mon-Sat 9-5.30, Thurs 9.45-5.30. Contact: Linda Hart (Buyer). Applications: Artists can apply at any time but phone first for an appointment. Exhibitions: Contemporary landscape studies, original prints and limited amount of figurative sculpture. Artists showing regularly include Phyllis del Vecchio, Enid Bloom, Simon Palmer. Mixed shows. Space: One floor.

HOUSE, 62 Regent's Park Road, London NW1. Tel. 01-722 1056. Opening: Tues-Sun 12-7. Exhibitions: Contemporary painting and sculpture.

HOLFORD GALLERY, 34 Tavistock Square, London WC2. Tel. 01-836 5511. Opening: Tues-Sat 10-8. Contemporary art and good selection of prints on sale. Often young UK, European and American artists. Magazines and books on sale.

ILLUSTRATORS ART, 16A D'Arblay Street, London W1. Tel. 01-437 2840. Opening: Mon-Sat 10-6. Contact: Robin Johnson. Applications: Professional artists can apply at any time. Exhibitions: Specialise in contemporary illustrators particularly of children's books, including; Nicola Bayley, Quentin Blake, Martin Leman, Edward Ardizzone, Ralph Steadman. Space: 2 floors 30ft x 12ft.

IAN BIRKSTED GALLERY, 37 Great Russell Street, London WC1. Tel. 01-637 8846. Contemporary British and European painting, photography and sculpture. Also galleries in New York and Brussels.

THE INSTITUTE OF CONTEMPORARY ARTS, Nash House, The Mall, London SW1. Tel. 01-930 3647. Opening: Tues-Sun 12-8. Contact: Sandy Nairn. Applications: All 3 galleries in the Institute of Contemporary Arts have a scheduled programme of exhibitions. The ICA is not a submissions gallery, but at the same time they are interested to see applications for exhibitions in the form of slides, photographs, or documentation. Exhibitions: Contemporary, including performance and video. Also houses a cinema and theatre besides

the 3 galleries and new cinematheque for 8mm and 16mm films and video. Specialist bookshop, bar and restaurant. Space: 3 gallery spaces, so there are usually at least three exhibitions running concurrently. £8 full membership, £5 associate, 40p day membership.

IRAQUI CULTURAL CENTRE, 177 Tottenham Court Road, London W1. Tel. 01-637 5831. Opening: Mon-Sat 10-6. Exhibitions: Contemporary and historical shows of Iraqui art, architecture and ceramics.

NICOLA JACOBS GALLERY, 9 Cork Street, London W1. Tel. 01-437 3868. Opening Mon-Fri 10-5.30, Sat 10-1. Contact: Nicola Jacobs. Applications: Not open to applications. Exhibitions: Six one-man shows and six group shows per year. Artists showing include John Gibbons, Jeff Lowe, John Carter, Shelagh Cluett, Jennifer Durrant, Jean Gibson, Jon Groom, Patrick Jones, Ken Kiff, Kim Lim, John McLean, Mali Morris, H-Dieter Pietsch, Peter Rippon, Paul Rosenbloom, Adrian Searle, Colin Smith, Derek Southall, Anthony Whishaw, Gary Wragg. Specializes in British art but plans to have occasional exhibitions from the USA. Space: One floor.

BERNARD JACOBSON LTD, 2a Cork Street, London W1. Tel. 01-439 8355. Opening: Mon-Fri 10-6. Contact: Bernard Jacobson. Exhibitions: Contemporary work, including Ivor Abrahams, Stephen Buckley, Robyn Denny, Michael Heindorff, Howard Hodgkin, Richard Smith, William Tillyer. Space: One floor. They also have galleries in New York and Los Angeles.

JORDAN GALLERY, Camden Lock, Commercial Place, Chalk Farm Road, London NW1. Tel. 01-267 2437. Contact: William Jordan. Opening: Tues-Sun 11-6. Exhibitions: One-person shows of well-known and new artists. Gallery artists include Bill Laing, Dos Santos, Tom Phillips, Norman Ackroyd.

J.P.L. FINE ARTS, 24 Davies Street, London W1. Tel. 01-493 2630. Opening: Mon-Fri 10-6 and by appointment. Contact: Christian Neffe. Exhibitions: 20th century masters.

JUDA-ROWAN GALLERY, 11 Tottenham Mews, London W1. Tel. 01-637 5517. Opening: Mon-Fri 10-6, Sat 10-1. Amalgamation of Annely Juda and the Rowan Gallery. Established British and USA artists such as Christo, Sean Scully, Bridget Riley, Keith Milow, Michael Craig-Martin.

KALEIDOSCOPE, 98 Willesden Lane, London NW6. Tel. 01-624 1343/01-328 5833. Opening: Mon-Sat 9.30-6. Contact: Karl Barrie. Exhibitions: 18th-20th century paintings and prints + contemporary artists. Occasional open shows. New artists are invited to apply.

KASMIN KNOEDLER, 22 Cork Street, London, W1. Tel. 01-439 1096. Opening: Mon-Fri 10-6. Contact: J. Kasmin. Exhibitions: Contemporary paintings from Britain and USA, also 20th century masters.

FRANCIS KYLE GALLERY, 9 Maddox Street, London W1. Tel. 01-489 6870. Opening: Mon-Fri 10-6, Sat 11-5. Contact: Francis Kyle. Exhibitions: Paintings, watercolours, drawings and limited edition prints by younger British artists. Some leading artists from Europe.

LISSON GALLERY, Bell Street, London NW1. Tel. 01-262 1539. Opening: Tues-Fri 12-6, Sat 10-1. Contact: Fiona and Nicholas Logsdail. Exhibitions: Conceptual, minimal and other recent developments in visual art, from Britain and abroad, including Roger Ackling, Jo Baer, Alan Charlton, Stephen Cox, Dan Graham, John Hilliard, Richard Long, On Kawara, etc.

LEINSTER FINE ART, 9 Hereford Road, London W2. Tel. 01-229 9983. Contemporary European artists.

MOIRA KELLY FINE ART, 97 Essex Road, Islington, London N1 2SJ. Tel. 01-359 6429. Opening: Tues-Sat 11-6. Contact: M. Kelly and R. A. Ripper. Applications: Professional artists can apply all year round but they must send clearly labelled slides or photographs. Exhibitions: Small group of regular artists plus some others. All artists represented are relatively new – usually one or two person shows. A number of works always in stock. Artists who have shown include; Fred Watson and Harry Snook. Only shows contemporary work. Space: 3 floors, 167 running feet of wall space.

KODAK PHOTOGRAPHIC GALLERY, 190 High Holborn, London WC1. Tel. 01-405 7841. Opening: Mon-Fri 9-5. Photographic exhibitions, mainly contemporary work.

LANGTON GALLERY, 3 Langton Street, London SW10. Tel. 01-352 9150. Opening: Mon-Sat 10-6. Contact: Robert Stuart, Marina Henderson. Applications: Open to professional artists. Exhibitions: Specialise in British 19th and 20th century illustrators and humorous drawings. Space: One floor 40ft x 20ft approx.

LOCUS GALLERY, 116 Heath Street, London NW3 1DR. Tel. 01-435 4005. Opening: Mon-Fri 10.30-5.30, Sat 11-5. Other times by appointment. Contact: Gudrun Fazzina. Applications: Considered. Exhibitions: Artists showing regularly include Aldo D'adamo, Rintaro Yagi, Claudia Amari, Enzo Plazzotta. Works exhibited in bronze, marble terracotta. Also artisan marble sculptures, copies of classic works. Specialise in Italian art. Space: 2 floors 5m x 13m approx.

SUSAN LOPPERT LTD, 22 Lady Somerset Road, London NW5 1UP. Tel. 01-267 1921. Opening: By appointment only. Works permanently in stock by Rib Bloomfield, Elizabeth Butterworth, Nick Cudworth, Judith Downie, Achilles Droungas, Brian Lewis etc.

MARLBOROUGH FINE ART (LONDON) LTD, 6 Albemarle Street, London W1. Tel. 01-629 5161. Opening: Mon-Fri 10-5.30, Sat 10-12.30. Exhibitions: 20th century paintings, drawings and sculpture – Auerbach, Bacon Jacklin, Davies, Kitaj, Kokoschka, Moore, Nolan, Pasmore, Piper, Sutherland etc.

MATT'S GALLERY, 10 Martello Street, London Fields, London E8. Tel. 01-249 3799, 01-263 7548. Opening: 2-8, Closed Fri and Mon. Contact: Robin Klassnik. Applications: Ring for an appointment. Exhibitions: Artists showing regularly include; David Troostwyk, Joel Fisher, Jaroslaw Kozlowski, Robin Klassnik, Susan Hiller, Jeff Instone, Mike Porter, Tony Bevan, Tom Claril. Space: One floor, 21' x 16'4" and 14' x 10' and 35' x 16'.

THE MAYOR GALLERY, 22A Cork Street, London W1X 1HB. Tel. 01-734 3558. Opening: Mon-Fri 10-5.30, Sat 10-1. Contact: James Mayor, Andrew Murray, Anne Vribe-Mosquera. Applications: Not open applications. Exhibitions: Modern, 20th century, American, British and European paintings, drawings and sculpture. Space: One floor.

MINSKY'S GALLERY, 81 Regent's Park Road, London NW1. Tel. 01-586 3533. Opening: Thurs and Fri 11-6, Sat 11-3. Contact: M. & S. Mintz. Exhibitions: Limited edition original prints and works on paper – John Keane, Richard Beer, Peter Daglish, Dick Hart, Richard Walker and others.

MIRANDY, 10 Glentworth Street, London NW1. Tel. 01-262 5893. Opening: Mon-Fri 10-6. Contact: Andrew and Mireille Archer. Exhibitions: Naive and super-realist paintings, divided on two floors.

MONTPELIER STUDIO, 4 Montpelier Street, London SW1. Tel. 01-584 0667. Opening: Mon-Fri 10-5, Sat 10-1. Contact: Bernice Sandelson and Victor Sandelson. Exhibitions: Artists showing regularly include J. Emanuel, G. Yeomans, B. Dorf, D. Hazlewood, plus works in stock by Joseph Herman, Meninski, Duncan Grant, Sir Jacob Epstein, Sir Stanley Spencer, John Piper. Specialise in 20th century British art. Space: Ground floor and basement 8ft high, varying lengths.

MORLEY GALLERY, 61 Westminster Bridge Road, London SE1. Tel. 01-928 8501 ext 30. Opening: 10am-9pm during college term, 10am-6pm otherwise. Contact: Adrian Bartlett.

Exhibitions: All forms of art and craft are considered. Space: Approx. 150 linear feet on one floor. No exhibiting fees, but artists or societies pay own costs – publicity, private views etc.

MUSEUM OF LONDON, London Wall, London EC2. Tel. 01-600 3699. Opening: Tues-Sat 10-6, Sun 2-6, Closed Mondays. Exhibitions connected with London, often photographic.

NATIONAL THEATRE, South Bank, London SE7. Tel. 01-928 2033 ext 381. Opening: Mon-Sat 10-11pm, Closed Sundays. Regular exhibitions of contemporary art. Open to professional artists to apply.

THE NEAL STREET GALLERY, 56 Neal Street, Covent Garden, London WC2. Tel. 01-379 7232. Opening: Mon-Fri 10-6, Sat 11-6. Contact: John Painter, Ashley Lloyd-Jennings. Applications: Professional illustrators, photographers, artists, designers can apply for shows. Commercial artists only. Exhibitions: They show the work of the above. They are also setting up THE CREATIVE BANK. The purpose of this is to provide a much needed service to and for the communications industry (media) by showing and having available on transparency, print, film and video, the latest examples of all the best British (and some foreign) creative people's work. Contact gallery for more info. Space: 2 floors.

NEW ART CENTRE, 41 Sloane Street, London SW1 9LU. Tel. 01-235 5844. Opening: Mon-Fri 10-6, Sat 10-1. Contact: Madeleine Ponsonby, Michael Servaes. Applications: Artists can apply but heavy future commitments make chances of success slim. Exhibitions: Young and established living British artists. Monthly exhibitions, one-man and mixed stock of both gallery artists and modern British masters. Space: 2 floors. Slim galleries 40ft deep.

THE NEW GALLERY, Hornsey Library, Haringey Park Road, London N8. Applications: Open to applications from contemporary artists. Space: Self-contained gallery adjacent to the library.

NEW SOUTH WALES HOUSE, 66 The Strand, London WC2. Tel. 01-839 6651. Opening: Mon-Fri 9-4. Exhibitions: Work by Australian artists, mostly contemporary, including photography, painting and sculpture. Contact: Wilf Beaver.

NEW ZEALAND HOUSE, Mezzanine Gallery, Haymarket, London W1. Tel. 01-930 8422. Exhibitions: The work of artists from New Zealand. Contact: Jane Cominik.

NEW GRAFTON GALLERY, 42 Old Bond Street, London W1. Tel. 01-499 1800. Opening:

10-6. Contact: David and Geraldine Wolfers. Applications: Professional artists can apply at any time of the year. Exhibitions: Contemporary figurative work including; Carel Weight, Ken Howard, Peter Greenham, Christyen Hall, Dick Lee, Joan O'Connerm, Mary Fedden, Clotilde Peploe. Also a portrait centre with examples of portraits by 16 painters and 6 sculptors. Space: One floor.

NIGHT GALLERY, 52-4 Kenway Road, London SW5. Tel. 01-373 4227. Exhibitions: Photography. Photography training courses also.

N.P.C. GALLERY, The Poetry Society, 21 Earls Court Square, London SW5. Tel. 01-373 7861. Opening: Mon-Fri 10-5. Contact: John Stathatos. Exhibitions: One-person shows of photography, prints, drawings, graphics and sculpture.

OBELISK GALLERY, 15 Crawford Street, London W1H 1PF. Tel. 01-486 9821. Opening: Mon-Fri 10-6, Sat 10-5. Exhibitions: Contemporary paintings, sculpture and drawings by surrealists.

THE OCTOBER GALLERY, 24 Old Gloucester Street, London WC1. Tel. 01-242 7367. Opening: Tues-Sat 12.30-4.30. Contact: Zara Kriegstein, Flash Allen. Applications: Considered. Exhibitions: 12 shows per year, artists from around the world, only contemporary work. Space: One floor. 40ft x 20ft.

OLYMPUS CAMERA CENTRE, 4 The Ritz Colonnade, Piccadilly, London W1. Tel. 01-351 1109. Exhibitions: Commercial photography.

PARKIN GALLERY, 11 Motcomb Street, London SW1. Tel. 01-235 8144.

PENNYBANK GALLERY, 33-35 St Johns Square, London EC1. Contemporary British artists.

PENTONVILLE GALLERY, 46 Amwell Street, London EC1. Tel. 01-837 9826. Contact: Geoffrey Evans. Opening: Mon-Fri 11-6, Sat 11-2. Applications: Are welcome bearing in mind content (see exhibitions). Exhibitions: Different one-person shows every 3-4 weeks. Prefer work that has a social and/or political content. The purpose of the gallery is not to show purely decorative or aesthetically 'pure' work. Space: One floor.

PERRINS ART GALLERY, 16 Perrins Court, (off Hampstead High Street), London NW3. Opening: Mon-Sat 11-6. Contact: M. Sarkozi and I. Sarkozi. Exhibitions: Artists showing work regularly include Wright, Brychta, Skinner, Trevelan. Space: Very small gallery.

PETERSBURG PRESS, 59a Portobello Road, London W11. Tel. 01-229 0105. Opening: By appointment only, from 10-5. Exhibitions: Publishers of prints by well-known British and international artists. Hockney, Kitaj, Stella.

PHOTOGRAPHER'S GALLERY LTD, 5 & 8 Great Newport Street, London WC2. Tel. 01-240 5511/2. Opening: Tues-Sat 11-7, Sun 12-6, closed Mondays. Contact: Sue Davies. Applications: Photographers can apply at any time but decisions are made at meetings in early March and early October. Exhibitions: All types of photographic work exhibited, from reportage and advertising to the purely creative. Space: The new space at 5 Great Newport Street includes 2 gallery areas. The old gallery has been re-arranged to make one big space and an enlarged bookshop. The gallery has 3 ground floor spaces and the walls measure 35ft x 30ft, 50ft x 20ft, 40ft one wall only. New facilities include a good-sized, quiet print room; a reference library containing over 3000 books; slide library containing over 5000 slides of prints; enlarged bookshop stocking over 1200 titles and over 400 postcards and international selection of posters, magazines and catalogues. Telephone information centre giving details of exhibitions, photographers, agents etc.

PICCADILLY GALLERY, 16 Cork Street, London W1X 1PF. Tel. 01-629 2875/01-499 4632. Contact: Godfrey Pilkington, Eve Pilkington and Christabel Briggs. Applications: Make an appointment to show work. Exhibitions: Specialise in contemporary British figurative painting, including Eric Holt, Rosie Lee, Graham Ovenden, Jack Simcock, David Tindle, Peter Unsworth. Space: One floor, 500 sq.ft.

PICTURE GALLERY, 4 Abercrombie Street, Battersea Park Road, London SW11. Tel. 01-228 6370. Opening: Mon-Sat 11-10, Tues and Thurs 11-6. Contact: Tony and Anne Isseyegh. Applications: Professional artists can apply for an exhibition at any time. Exhibitions: The gallery mainly shows the work of young and contemporary artists in mixed exhibitions with a two-man show every three months. The exhibitions change every month. They show the work of British artists, including: Peter Smith and Libby Raynham. Space: One floor, 2 walls 8ft 6in x 10ft 6in; 8 strips 3ft 4in x 10ft 6in; 3 strips 4ft 6in x 10ft 6in.

PORTAL GALLERY LTD, 16A Grafton Street, Bond Street, London W1. Tel. 01-629 3506/ 01-493 0706. Opening: Mon-Fri 10-5.45, Sat 10-1.00. Contact: E. Lister, L. Levy, J. Wilder. Applications: Professional artists can apply for shows at any time. Exhibitions: Approximately 40 painters regularly exhibit and they specialise in self-taught (naive) art and figurative fantasy painting. Mainly 20th century British painters. Space: 2 floors.

PORTHILL INTERNATIONAL GALLERY, 12 New Quebec Street, London W1. Tel. 01-262 4419. Opening: Mon-Fri 11-6, Sat 11-3. Contact: Radomir Putnikovic. Applications: Open to professional artists, they should apply from August to December. Exhibitions: The gallery specialises in wildlife paintings and sculptures and animal character paintings, oil on glass paintings by Yugoslav naive artists. English, Dutch, Swedish and Yugoslav artists exhibited, including Sylvia Emmons, David Binns, Ralf Williams, Lindorm Liljefors, Martin Kopricanec, Ana Bocak, Matt Bruce, Sarah Grice and Brian Gallagher. Space: One floor space for approx. 35 medium-sized paintings.

THE REDFERN GALLERY, 20 Cork Street, London W1. Tel. 01-734 1732. Opening Mon-Fri 10-5.30, Sat 10-12.30. Contact: Harry Tatlock-Miller, John Synge, Gordon Samuel, Margaret Thornton. Applications: Preferably in the first six months of the year and appointments should be made first. Exhibitions: The gallery changes its exhibitions every month, showing about 7 artists each year. There is usually a print show during Dec/Jan, with a mixed show of gallery artists and others during the summer. Artists showing regularly include Proktor, Oxtoby, Stevens, Wunderlich, Preece, Kneale. Space: Ground floor, painting and sculpture; basement, graphics.

RIVERSIDE STUDIOS, Crisp Road, London W6 9RL. Tel. 01-741 2251. Contact: Jenny Stein. Opening: Mon 11-6, Tues-Sat 11-11, Sun 12 noon-10.30. Exhibitions: Very wide-ranging, from contemporary painting and sculpture to historical shows, i.e. Munch and pre-Raphaelites. Space: A very recently opened new gallery, converted from workshops and dressing rooms. 150-160 linear feet of wall space, brick and plaster walls, natural and soft artificial lighting no spotlighting, dark-grey concrete floor. The original gallery space in the foyer will still be used for exhibitions (40ft x 12ft high). Performance art has been shown in the theatre space at Riverside, including Dan Graham and Bruce McLean, as well as theatre, music and dance. There is a specialist bookshop on the premises.

ROUND HOUSE GALLERY, Round House, Chalk Farm Road, London NW1. Tel. 01-267 2541. Opening: Mon-Sat 12-5.30 and evenings for theatre-goers only. Contact: Jim Latter. Applications: Anyone can apply for a show at any time, to Jim Latter. Exhibitions: Always different. Contemporary art, including new media. Artists shown include Roger Kite, Alan Green, Keith Milow, Liliane Lijn, Nigel Hall and Simon Read. Space: Very unusual, 120ft x 25ft in a gentle curve, being a section of the Roundhouse Spotlighting.

ROYAL COLLEGE OF ART GALLERY, Kensington Gore, London SW7 2EU. Tel. 01-584 5020 ext 355. Opening: Mon-Fri 10-6. Contact: Exhibition Organiser. Exhibitions: Small exhibitions by schools and departments as well as individual students, occasionally sponsored exhibitions are held. Degree shows are held in the summer term.

SAINT BENET'S GALLERY, Queen Mary College, Mile End Road, London E1. Tel. 01-980 1204. Opening: 9-6 during term. Contact: St Benet's House. Applications: To the Chaplain at the above address. Exhibitions: Paintings and sculpture. Space: A small gallery.

FELICITY SAMUEL, 20 Beaufort Gardens, London SW3. Tel. 01-581 2009. Opening: Mon-Fri 10-6. Contact: Felicity Samuel, Antoinette Godkin. Exhibitions: Contemporary experimental art – Mark Boyle, Nigel Hall, Carl Plackman, Carolyne Kardia, Nicholas Monro, Mark Dunhill etc.

SANDFORD GALLERY, 1 Mercer Street, off Long Acre, London WC2H 9Q1. Tel. 01-379 6905. Opening: Mon-Sat 11-6. Contact: Betty Middleton-Sandford. Applications: Strictly by invitation only. Exhibitions: Only contemporary, known UK artists. Mostly mixed shows. Space. One floor, 1000 sq.ft. (Mercer Street).

PATRICK SEALE GALLERY, 2 Motcomb Street, Belgravia, London SW1. Tel. 01-235 0934. Opening: Mon-Fri 10-6. Contact: Patrick Seale. Applications: Considered. Exhibitions: 2 galleries, one showing late 19th and early 20th century paintings, the other showing contemporary paintings and original prints, i.e. Chris Orr, Mark Rooney, Andrew Logan.

SEEN, 39 Paddington Street, London W1M 3RN. Tel. 01-486 4292/3282. Opening: Mon-Fri 10-6.30, Sat 10-5. Contact: Jeffrey Sion. Applications: Open application at any time. Exhibitions: Specialise in figurative and representational paintings, drawings and prints. Also print publishers. They deal in contemporary work. Space: 2 floors.

SERPENTINE GALLERY (Arts Council of Great Britain), Kensington Gardens, London W2 3XA. Tel. 01-402 6075. Opening: April-Sept 10-7 daily, other months 10-dusk. Contact: Sue Grayson (Gallery Organiser). Applications: Annual open submissions in autumn for the following summer shows, application forms from gallery. Exhibitions: Only contemporary work from Britain and abroad, including painting, sculpture, prints, drawings and mixed media. Space: 450 linear hanging feet, divided amongst four large rooms, with plaster walls and high ceilings. Adjacent outdoor facilities for sculpture and performance. The annual summer shows are a significant venue for many

new artists, there are usually 3 or 4 of these each year. Admission free.

SLOANE STREET GALLERY, 158 Sloane Street, London SW1X 9BT. Tel. 01-730 5835. Opening: Mon-Fri 10-5.30, Sat 10-2. Contact: Gordon and Danielle Allen. Exhibitions: Contemporary paintings, drawings, ceramics and sculpture by new and relatively unknown artists.

SOUTH LONDON ART GALLERY, Peckham Road, London SE5. Tel. 01-703 6120. Opening: Mon-Sat 10-6, Sun 3-6. Contact: K. A. Doughty. Exhibitions: Contemporary art, historical and retrospective shows and local societies. Permanent collection of British paintings and drawings from 1700 onwards.

THE TALENT STORE GALLERY, 11 Eccleston Street, London SW1. Tel. 01-730 8117. Opening: Mon-Fri 9.30-5.30. Contact: Anne Phelps, Berth J. Pinnell. Exhibitions: Shows unknown artists in as many fields as possible, perhaps for the first time.

THACKERAY GALLERY, 18 Thackeray Street, Kensington Square, London W8 5ET. Tel. 01-937 5883. Opening: Tues, Thurs and Fri 10-6, Wed 10-7, Sat 10-5. Closed Sun and Mon. Contact: Mrs Priscilla Anderson. Applications: Open to applications but the gallery is very booked up and is closed in January and August. Exhibitions: Mainly British artists and solely contemporary work including; Nicholas Barnham, Donald Blake, Charles Duranty, James Gunnell, Susan Hawker, Ben Levene, Donald McIntyre, James Morrison, Alberto Morrocco, Neil Murison, Kyffin Williams, Andy Wood, Brian Yale, Roderick Barrett. Space: Ground floor and basement.

THUMB GALLERY LTD, 20/21 D'Arblay Street, London W1. Tel. 01-434 2931. Opening: Mon-Fri 10-6, Sat 11-4. Contact: Clare Beck (Gallery Director) (Directors – Peter Nutter and Andrew Wakelin). Applications: Prefer to see slides before making an appointment to see the work. Exhibitions: The gallery specialises in works on paper by young British artists, prints, drawings and watercolours. Artists showing regularly include: Trevor Allen, Chloe Cheese, Sue Coe, Sue Dunkley, Jeffery Edwards, Andrew Holmes, Anthony Moore, Chris Orr, Richard Walker. Space: One floor 30ft x 8ft, 22ft x 8ft, 40ft x 8ft (wall measurements).

EDWARD TOTAH GALLERY, 39 Floral Street, London WC2. Tel. 01-379 6241. Opening: Tues-Sat 11-6. Contact: Edward Totah. Exhibitions: Mostly contemporary painting, prints and sculpture. Application: Artists should contact the director first to arrange for an appointment to show slides and

work. Space: One average sized room and small adjoining room.

NICHOLAS TREADWELL GALLERY, 36 Chiltern Street, London W1M 1PH. Tel. 01-486 1414/01-935 6739. Opening: Mon-Fri 10-6, Sat 10-1. Contact: Nicholas Treadwell. Applications: Open to professional artists to apply. Exhibitions: Contemporary work including Dean, Francis, Gladwell, Gorman, Knight, Poynter, Scott, and 20 other English and European based contemporary figurative artists. Space: Five small adjoining rooms and connecting corridors on 2 floors. Max. size of rooms 6ft x 6ft (approx. 100 sq ft).

TRYON GALLERY LTD, 41 Dover Street, London W1. Tel. 01-493 5161. Opening: Mon-Fri 9.30-5.30. Contact: A. D. Tryon, D. E. H. Bigham, B. D. Booth, C. De P. Berry. Applications: Considered at any time. Exhibitions: All artists paint sporting and natural history subjects and include David Shepherd, Susan Crawford, Rodger McPhail. Space: One floor.

WADDINGTON GALLERIES LTD, 2 & 4 Cork Street, London W1X 1PA. Also at: 34 Cork Street (Waddington Galleries II), 31 Cork Street (Waddington Graphics). Tel. 01-439 1866. Opening: Mon-Fri 10-5.30, Sat 10-1. Contact: L. Waddington, A. Bernstein, V. A. Bernstein, A. C. Cristea, E. S. Waddington, D. Cornwall-Jones, A. G. Sprackling. Applications: Do not accept applications. Exhibitions: Contemporary well known artists including Peter Blake, Patrick Caulfield, Bernard Cohen, Robyn Denny, Barry Flanagan, Elisabeth Frink, Hamish Fulton, Ivon Hitchens, John Hoyland, David Inshaw, Allen Jones, Kenneth Martin, Michael Moon, Ben Nicholson, Kenneth Noland. Works in stock by: Dubuffet, Matisse, Calder, Picasso, Avery, Dine Dufy, Hayden, Kitaj, Louis, Moore, Morris and many others. Space: One floor in each gallery.

THEO WADDINGTON, 25 Cork Street, London W1. Tel. 01-734 3534. Opening: Mon-Fri 10-5.30, Sat 10-1. Contact: Robert Stoppenbach. Exhibitions: Derain, Matisse, Hilton, Herman, Lhote. About ten exhibitions annually, they are also a Canadian company so show some contemporary Canadian and American artists. Space: Two floors 10ft wide x 25ft long, approx. 7ft high. Specialise in 20th century British and French painting. Applications: Difficult as they have gallery artists and are also committed to some Canadian artists. Also galleries in New York and Canada.

THE WARWICK ARTS TRUST, 33 Warwick Square, St George's Drive, London SW1. Tel. 01-834 7856. Opening: Mon-Fri 10-5.30, Sat 10-1. Large gallery space.

25

WATERLOO GALLERY, 23-61 Gray Street, off Webber Street (behind Old Vic), Waterloo, London SE1. Opening: Usually 12-6. Applications: Only from artists who wish to exhibit together and are prepared to accept the full responsibility of organising their show on an entirely self-help basis. Exhibitions: A co-operative, particularly interested in artists who have had little or no previous exposure in London galleries. The directors are all artists resident at the Waterloo studios. The space is provided free of charge but all other expenses (electricity, publicity, etc) incurred by the show will be paid by the artists. Space: Approx 5,000 sq ft and suitable for exhibitions of up to 6 artists.

WHITECHAPEL GALLERY, Whitechapel High Street, London E1. Tel. 01-377 0107. Opening: Sun-Fri 11-6, Closed Sat. Contact: Nicholas Serota. Applications: Details for applications to Whitechapel Open Exhibition, available from gallery. Exhibitions: Contemporary art from this country and abroad. Work by artists living and working in the locality and historical exhibitions which are of particular contemporary or local interest. Duration of shows usually 6-8 weeks. Space: Main gallery – 315 linear feet, concrete floor, natural and spot-lighting. Upper gallery – 250 linear feet, wooden floor, natural and spot-lighting. The Whitechapel Gallery shows a mixture of prestigious British and International one-person shows i.e. Max Beckmann, Carl Andre, Joel Shapiro, Richard Long. Shows with local, East End, relevance and some mixed shows.

WOODLANDS ART GALLERY, 90 Mycenae Road, Blackheath, London SE3 7SE. Tel. 01-858 4631. Opening: Weekdays 10-7.30, Sat 10-6, Sun 2-6. Closed Wed. Contact: H. Davis, Borough Librarian, J. Bunston, Keeper. Applications: Professional artists can apply for shows at any time throughout the year. Exhibitions: Mainly local artists. A continuous series of temporary contemporary art exhibitions each lasting for about a month.

Space: Four galleries on the ground floor. 200ft of wall space.

THE WORKSHOP, 83 Lamb's Conduit, London WC1. Tel. 01-242 5335. Opening: Mon-Fri 10.30-5.30, Sat 11.30-1.30. Contact: Mel Calman. Applications: Open to professional artists to apply at any time, the work is seen by Mel Calman. Exhibitions: Shows leading cartoonists, along with Calman. Original artwork of cartoons published in national newspapers and magazines together with Searle lithographs and etchings and illustrations by other well known living artists. Mainly work by British artists, sometimes American and other nationalities. Space: One floor.

WRAXALL GALLERY, 25 Cheval Place, London SW1. Tel. 01-584 3637. Run by Sarah Long and Laura Gerahty. 1500 sq ft of wall space. Gallery opened in mid-1981. Contemporary work by British artists.

X FACTOR WOMEN'S GALLERY, Women's Arts Alliance, 10 Cambridge Terrace Mews (off Chester Gate), London NW1. Tel. 01-935 1841. Opening: Tues-Thurs 5-9, Sat 2-6. Contact: Gallery run by a collective of women. Applications: Women artists can apply at any time. Exhibitions: The gallery is a space for women to show their work to other women, about women. Space: One room measuring, 7 metres x 6 metres x 3 metres high.

ZEBRA ONE GALLERY, Perrins Court, Hampstead, London NW3. Tel. 01-794 1281. Opening: Tues-Sat 10-6. Contact: Lee Brews. Application: Professional artists can apply at any time. Exhibitions: Contemporary work, including Samuel Koskh, Oliveiro Masi, Gill Lawson, Massingham, Le Yaouanc, Hastaire. Space: 2 floors, 24ft x 18ft approx.

ZELLA 9, 2 Park Walk, London SW10. Tel. 01-351 0588. Opening: Mon-Sat 10-9. Exhibitions: Prints of all kinds by British and European printmakers. Work of a professional nature can be submitted for sale, contact gallery for details.

NORTHERN ENGLAND
These galleries are listed alphabetically by town not by name.

ASHINGTON
WOODHORN CHURCH MUSEUM, Woodhorn Village, Ashington, Northumberland. Tel. Ashington 814444. Opening: Tues-Sat 10-noon, 1-4. Contact: A. G. White, Chief Leisure and Publicity Officer. Applications: A. G. White, Wansbeck District Council, Wansbeck, Ashington. Exhibitions: Mostly local artists or travelling shows. Space: 60ft x 45ft, ceiling spots. The church was one of the oldest in Northumberland.

BEVERLEY
BEVERLEY ART GALLERY, Champney Road, Beverley, N. Humberside. Tel. Beverley

882255. Opening: Mon, Tues, Wed, Fri 9.30-5.30 (closed 12.30-2), Thurs 9.30-12 noon, Sat 9.30-4. Contact: Chief Administrative Officer, Beverley Borough Council, the Hall, Lairgate, Beverley. Applications: To Chief Administrative Officer. Exhibitions: Permanent collection and local artists' work only. Some one-person and two-person shows.

BILLINGHAM
BILLINGHAM ART GALLERY, Queens Way, Billingham, Cleveland. Tel. 0642 555443. Opening: Mon-Sat 10-5.30. Contact: J. P. Warbrook, Curator. Opening submission write

to Curator, 76 Norton Road, Stockton-on-Tees, Cleveland. Exhibitions: Group and one-person. Painting, prints, photographs, sculpture and ceramics. Space: Mixture of hanging space and glass show-cases. Approx. 200ft of linear hanging space. Spotlights. Equipment: Slide projectors, limited supply of aluminium frames. Aims to show work of national or international significance, with occasional shows by better-known local artists or art groups. Funded by local authority.

BIRKENHEAD
WILLIAMSON ART GALLERY & MUSEUM, Slatey Road, Birkenhead, Merseyside. Tel. 051 6524177. Opening: Mon-Sat 10-5, Sun 2-5. Contact: Mr. C. E. Thornton, Curator. Applications: In writing. Exhibitions: Contemporary, retrospective and historical. Space: Temporary exhibitions in two rooms: hessian covered walls, daylight and artificial light. Permanent collection of 18th-20th century English watercolours. Temporary exhibitions are geared to local artists and societies as well as nationally known individuals/groups ideally with Merseyside connections.

BLACKBURN
EXHIBITION GALLERY, BLACKBURN MUSEUM AND ART GALLERY, Library Street, Blackburn. Tel. 0254 667130. Opening: Mon-Sat 9.30-6. Contact: Mr. A. Lewis, Assistant Director (Arts), Borough of Blackburn, Recreation Department. Applications: In person or in writing (with photographs of work) to Blackburn Museum and Art Gallery – letter to be addressed to Director of Recreation, Royal Chambers, Richmond Terrace, Blackburn, or telephone Museum 670211. Exhibitions: Work of local interest, i.e. (1) local landscapes and townscapes, (2) work by local artists, occasional exhibitions of contemporary art. Space: Ground floor, approx. 10 x 17 metres, fluorescent lighting. Equipment: Metal frames can be borrowed by artists but they must supply their own mounts. The average size of these is 15in x 20in. Slide projector and tape recorder could also be made available. The aim of the gallery (as far as artists' shows are concerned) is to interest the local public in the work of artists working in the area and also in the best of contemporary art.

EXHIBITION GALLERY, LEWIS TEXTILE MUSEUM, Exchange Street, Blackburn. Tel. 0254 667130. Opening: Mon-Sat 9.30-6. Contact: Adrian Lewis (Assistant Director, Arts, Borough of Blackburn, Recreation Department). Applications: In person or in writing (with photographs of work), addressed to Director of Recreation, Royal Chambers, Richmond Terrace, Blackburn, or phone Museum 667130. Exhibitions: Work of local interest i.e. (1) local landscapes, townscapes, (2) work by local artists, exhibitions of contemporary work. Space: First floor gallery,

with windows at one end, approx. 70 x 28ft carpeted floor, pin board walls, spot lighting. Equipment: Metal frames can be borrowed by artists, but they must supply their own mounts. Average size of these is 15in x 20in. Slide projector and tape recorder could also be made available. The aim of the gallery (as far as artists' shows are concerned) is to interest the local public in the work of artists working in the area and also in the best of contemporary art. Also, being housed in the Lewis Textile Museum, the gallery does have a special interest in exhibiting textile work.

BLACKPOOL
GRUNDY ART GALLERY, Queen Street, Blackpool. Tel. 0253 23977. Opening: Mon-Sat 10-5. Contact: James Burkitt, Curator. Applications: Are welcomed, particularly from artists living in the north west. Send letter with slides. Exhibitions: Professional work of suitable quality and that of local amateurs. Space: 3 main galleries giving about 100 linear feet of wall space each. Hessian wall surfaces, overhead track lighting, polished wood floor. Equipment: Slide projector. The Grundy is the major public funded gallery in the Fylde areas of Blackpool, Fylde and Wyre. It attempts to give space to (1) Its own permanent collection of 19th and 20th century paintings. (2) One-person shows throughout the year. (3) Fylde Arts Ass. promoted exhibitions and travelling exhibitions. (4) Local amateur societies. Most of the one-person shows are by artists based in the N.W.

BOSTON
BLACKFRIARS ARTS CENTRE, Spain Lane, Boston, Lincs. Tel. 63108. Opening: 9-10. Contact: Barry Cawtheray. Applications: Send slides with a written application, or arrange appointment. Exhibitions: Paintings, photography, drawings, prints and crafts. Space: Walls and white double screens, spotlights. Equipment: Slide projector, video equipment (colour camera, two edit decks and monitors). Shows the work of local, amateur and professional artists, also touring exhibitions, interested in participating in exchange exhibitions with other galleries.

BOLTON
BOLTON MUSEUM AND ART GALLERY, Le Mans Crescent, Bolton, Lancs BL1 1SA. Tel. (0204) 22311 ext 380/379. Opening: Mon-Fri 9.30-5.30, Sat 10-5, Closed Sun. Contact: Elizabeth Hancock, Senior Keeper of Art. Applications: In writing, with biography, slides and photos. Exhibitions: About 20 temporary exhibitions per year, touring shows, historical, contemporary fine and decorative arts, local societies. Space: 2 large galleries – 160 and 140 running feet, painted woodchip walls, parquet floors, spot and fluorescent lighting, no daylight. Equipment: Slide projectors, tape recorder, display cases, some

27

frames. Permanent collection of 17th-20th century fine and applied art.

GREAT HOUSE GALLERY, Rivington, Nr. Bolton, Lancashire. Tel. Horwich 66327 or Horwich 691427. Opening: Daily 2-5 except Mons and Fris. Contact: Mrs. Dorothy Almond. Applications: Write or telephone. Space: It is a 400 year old Tudor building. Gallery size 54ft x 18ft, spot and strip lighting. Promotes the work of modern painters, some sculpture and ceramics.

BRADFORD

ART LIBRARY GALLERY, BRADFORD CENTRAL LIBRARY, Prince's Way, Bradford, West Yorkshire, BD1 1NN. Tel. (0424) 33081. Opening: Mon-Fri 9-8, Sat 9-5. Contact: Subject Adviser – Arts : Responsible to Mr. W. Davies, F.L.A., City Librarian. Applications: Preferably in person, unless professionally known. Exhibitions: Paintings, murals, textiles, graphics, photography and crafts. Space: Approx. 50ft x 26ft, glass walls, fluorescent overhead lighting, screens, green composition floor. 4 display cases. Equipment: Tape recorders, slide projectors. Local artists residing in Yorkshire and art groups associated with West Yorkshire are encouraged to exhibit.

BRADFORD ART GALLERIES AND MUSEUMS, Cartwright Hall, Lister Park, Bradford, West Yorkshire. Tel. 0274 493313. Opening: Open daily 10-5 (closed Mondays). Contact: Howard M. Smith. Applications: In writing, sending slides or photographs. Exhibitions: Exhibits work in any media and attempts to create an exhibition programme which in total reflects the diversity of current artistic practice at all levels, places contemporary art in an historic context by exhibiting art from the past. Space: (1) The Cartwright Hall is an Edwardian art gallery; the largest gallery is 85 x 27ft, there are smaller spaces approx 60 x 27ft and 30 x 27ft. All galleries have track tungsten lighting, daylight control and humidity control. (2) The Manor House is a late 16th century yeoman's house now used as an art gallery and museum. There are two galleries on the first floor, each approx 18 x 25ft. The building retains its original atmosphere with oak beams, rough hewn stone walls etc. (3) Information on the other museums, which are not used so frequently for art exhibitions, is available on request. Equipment: Projectors and tape recorders.

BRAMPTON

LYC MUSEUM AND ART GALLERY, Banks, Brampton, Cumbria, CA8 2JH. Tel. Brampton 2328. Opening: 9-7 every day of the year. Contact: Li Yuan-Chia. Applications: Usually by letter, on receipt of which an LYC application form is sent to the artist. Exhibitions: Contemporary art, some by well known artists (Winifred Nicholson, Paul Neagu, David Nash and Shelagh Wakeley have all shown recently),

but the gallery has a policy of showing young artists of promise for a large proportion of the time. There is space for up to 5 shows at one time, which are usually one-person. Space: 8 rooms with the following dimensions – 13ft x 10ft, 21ft x 13ft, 28ft x 14ft, 15ft x 8ft, 15ft x 7ft, 20ft x 20ft, 20ft x 13ft, 20ft x 10ft. Walls are stone rendered with plaster, galleries are well-lit with screened fluorescent lights. Sculpture and performance can be shown outside. Equipment: Slide projector, some frames, darkroom facilities. This is very much the conception of one man, and, as such, is quite unique. It represents an attempt to make a place to which all are welcome – there is, for example, a room where people (especially children) can draw and paint and write – no charge is made, either for this or for entry to the museum. There is a free reading room too, stocked with books that have been donated. The kitchen is open for public use. Alongside this generally welcoming policy is one which hopes to uphold the highest standards of contemporary arts and crafts and promote young, promising artists in all fields, making contemporary work readily available for the viewing public of the area and of Carlisle and North East England. The gallery spaces are available for local use – for childrens' workshops, meetings and rehearsals etc. – it is a centre for people to use recreationally or educationally and to meet friends.

BURY

BURY ART GALLERY AND MUSEUM, Moss Street, Bury, Lancs. Tel. 061 761 4021. Opening: Mon-Fri 10-6, Sat 10-5. Contact: C. Billingham, Senior Keeper. Applications: Personal contact or by letter. Exhibitions: 19th/20th century permanent collection, travelling shows, local art societies, one-person shows. Mainly group shows. Space: Approx 250 linear feet of hanging space in two galleries.

CREWE

WEAVER HALL MUSEUM AND ART GALLERY, Cheshire Museum Service, Weaver Hall, 162 London Road, Crewe, Cheshire. Tel. 0606 41331/2. Contact: Moira Stevenson, Display Officer.

CARLISLE

CARLISLE MUSEUM AND ART GALLERY, Castle Street, Carlisle, Cumbria CA3 8TP. Tel. (0228) 34781. Opening: April-Sept Mon-Fri 9-7, Sat 9-5, Sun 2.30-5 (May-Aug incl), Oct-Mar Mon-Sat 9-5. Contact: Neil Hanson, Arts and Exhibition Officer. Applications: In writing initially plus slides of recent work. Exhibitions: Contemporary visual art, photography and craft, exhibitions of work selected from the permanent collection, occasional social history exhibitions, art historical shows from external sources. Space: 3 galleries of approx. 120 linear feet each. Gallery walls recently relined in a high density chipboard.

Lighting by tracked spotlights. Floors polished hardwood. Daylight excluded in Gallery 2. All galleries recently rewired. Ample power-points throughout. Equipment: Carousel projector. Photographic darkroom. Tape recorders. The policy of the museum is to display and interpret the collections and to exhibit the best of contemporary art, photography and craft, particularly when relating to the region.

DARLINGTON
DARLINGTON ARTS CENTRE, Vane Terrace, Darlington DL3 7AX, Co. Durham. Tel. 0325 483271. Opening: Mon-Sat 9-10.30. Contact: Gail Boardman. Applications: In writing or by telephone. Exhibitions: Currently, work produced by local groups, young artists and work relating to courses offered in the centre and to that of the artists/craftsmen based in the building, i.e. photography, painting, crafts etc. Space: Garden Gallery – 27 metres long, blockboard walls, wood floor, floodlights. Glass Gallery – 10.5m long, blockboard walls, tiled floor, floodlights. Equipment: Slide projector, some frames. Extensive rebuilding is being undertaken and is due to be completed in Dec 1981, this would include two new gallery spaces which will be used for showing high quality work from outside the area, as well as local work. The centre also shows music, dance, theatre, film and has various workshops. There is a sculptor in residence.

DARLINGTON ART GALLERY, Crown Street, Darlington, Co. Durham DL1 1ND. Tel. Darlington 62034/69858. Opening: Mon-Fri 10-8, Sat 10-5.30, Closed Sunday. Contact: Mrs. F. M. Layfield, A.L.A., District Librarian. Applications: In writing, followed by personal visit with photographs and samples of work. Professionals only. Exhibitions: Temporary exhibitions from various sources which include painting, photography, prints etc. Also annual exhibitions from local art and photographic societies. Works vary from abstract to traditional and local exhibitions have a tendency to be on landscape, genre, wildlife or railway themes. Selections from the permanent collection are shown from time to time. Space: Walls – hessian covered panels. Floor – thermoplastic tiles. Lighting – indirect ceiling. Dimensions – 70ft x 40ft. Approx. 150ft wall run. Display case. Permanent collection of local paintings of the 19th century. Temporary exhibitions are predominantly by local artists, both figurative and abstract.

DONCASTER
DONCASTER MUSEUM & ART GALLERY, Chequer Road, Doncaster DN1 2AE. Tel. 0302 62095/60814. Opening: Weekdays 10-5, Sun 2-5. Contact: T. G. Manby, Curator. Applications: In writing, giving details of subject and content. Exhibitions: Painting, sculpture, ceramics, glass, textiles, wood and metalwork, as well as historical and scientific subjects. Group and one-person shows. Space: First floor of museum, mobile display screen system of 300ft linear. Floor area 2000sq ft. Adjustable track lighting. Equipment: Slide projectors, tape recorders. Provides a venue for a number of national exhibitions. Permanent collection of fine and applied art.

DUKINFIELD
DUKINFIELD LIBRARY GALLERY, Town Lane, Dukinfield, Cheshire. Tel. 061 330 3257. Opening: Mon, Tues, Wed, Fri 2-8, Sat 9-12 noon and 2-4. Contact: Arts Officer, Tameside Libraries and Arts, Stamford House, Jowett's Walk, Ashton-under-Lyne OL7 0EP. Applications: Send slides of recent work. Local connections preferred. Exhibitions: Includes painting, drawing, sculpture, collage, photography and mural painting. About 14 exhibitions per year, mostly one-person. Space: Floor area 36ft x 18ft carpeted. Hessian covered panelling on walls 6ft x 50ft in total. Lighting fluorescent and spotlights. A small gallery presenting a wide range of exhibitions in an area of Tameside previously lacking such facilities. Equipment: Slide projector and tape recorder.

DURHAM
DLI MUSEUM & ARTS CENTRE, Aykley Heads, Durham DH1 5TU. Tel. Durham 42214. Opening: Tues-Sat 10-5, Sun 2-5, closed Mondays except bank holidays. Contact: Nerys A. Johnson, Keeper-in-Charge. Applications: In writing enclosing slides/photographs. Exhibitions: All aspects of contemporary visual arts in two or three dimensions. Main emphasis on painting, printing, sculpture and photography. Only very limited facilities for any type of performance art. Space: Gallery 1 – 18.29m x 9.14m x 2.67m high. Gallery 2 – 15.24m x 9.14m x 2.67m high. White plaster walls; cork floors; lytespan track in Gallery 2; diffused daylight in Gallery 1. Flexible system of screens and hanging rods. Full security. Equipment: One Steinway Grand Piano. One Kodak Carousel Slide Projector. Two small single frame Hanimex Projectors. One Tanberg two track tape recorder. BASF 9110 tape recorder. Indoor sound system to both galleries and coffee bar. The Arts Centre shares a modern building with the Regimental Museum of the Durham Light Infantry, which means that its exhibitions are seen by a wide range of people, many of whom do not have any specialist knowledge or understanding of art. The broad policy of the Arts Centre therefore, is educational in a very wide sense, with work by living artists included in thematic exhibitions (structure, colour, etc.) or into meaningful groupings. These, together with one-man shows, are often accompanied by seminars, creative workshops, films and talks which involve the artists with the local community.

ECCLES
MONKS HALL MUSEUM, 42 Wellington Road, Eccles, Lancashire M30 0NP. Tel. 061-789 4372. Opening: Mon-Fri 10-6, Sat 10-5. closed Sundays. Contact: Mr. W. M. Weber at Salford Art Gallery. Space: Approx. 75ft of hanging space, max. size of work shown is 6 feet square. Fluorescent lighting. Other details, see Salford Art Gallery.

ELLESMERE
ELLESMERE COLLEGE ARTS CENTRE, Ellesmere, Shropshire. Tel. Ellesmere 2828. Opening: 9-9. Contact: Merriel Halsall Williams. Applications: In writing or visit, with examples of work. Exhibitions: Mostly oils/watercolours, screenprinting, batik, anything 2D. Space: 30 linear feet, red brick walls, no spotlights, grassed areas outside. Equipment: Slide projectors, tape recorders. Local artists are encouraged.

GATESHEAD
SHIPLEY ART GALLERY, Prince Consort Road, Gateshead NE9 4JB, Tyne and Wear. Tel. (0632) 771495. Opening: Mon-Sat 10-6. Sun 2-5. Contact: Mrs. Joan Chowdry (Acting Curator). Applications: By letter. Exhibitions: Cover the following areas – contemporary British craft; work of special interest to Gateshead; work of special relevance to the permanent collection. Space: About 50m of hanging space, track lighting. Equipment: Audio-visual equipment available.

HARTLEPOOL
GRAY ART GALLERY AND MUSEUM, Clarence Road, Hartlepool, Cleveland TS24 8BT. Tel. Hartlepool 66522 extn. 259. Opening: Mon-Sat 10-5.30, Sun 3-5. Contact: Curator: H. S. Middleton, Keeper of Art: Mrs. E. Law. Applications: In writing to the Curator, or in person to the Keeper of Art. Exhibitions: Local artists, one or two-person exhibitions, artists from other areas, Arts Council exhibitions. Space: 2 galleries available for temporary exhibitions – 30ft x 20ft and 40ft x 40ft strip and track lighting. Equipment: Slide projector, frames. Most exhibitions are biased towards 2-dimensional work.

HUDDERSFIELD
HUDDERSFIELD ART GALLERY, Kirklees Libraries and Museum Service, Princess Alexandra Walk, Huddersfield, W. Yorks. Tel. 0484 21356. Contact: Stanley Dibnah. Opening: Mon-Fri 10-7.30, Sat 10-4.

HULL
FERENS ART GALLERY, Queen Victoria Square, Hull. Tel. 0482 222750. Opening: Mon-Sat 10-5, Sun 2.30-4.30. Contact: Lesley Dunn, Senior Keeper. Applications: By letter, with slides. Exhibitions: Old masters, 19th/20th century painting, photography, design, graphics, contemporary art. Space: 2 spaces 28ft x 24ft and 2 x 28ft x 49ft, all interconnecting. Walls lined with hessian, lighting is U.V. screened fluorescent, with additional spotlights. Equipment: Slide projectors. Support is given to local artists by one-person shows, but these are kept at a 'professional' rather than 'amateur' level.

JARROW
BEDE GALLERY, Springwell Park, Jarrow, Tyne and Wear NE32 5QA. Tel. (0632) 891807. Opening: Tues-Fri 10-5, Sat and Sun 2-5, closed all day Monday. Contact: Vincent Rea. Applications: By letter enclosing slides or photographs. All applications go before a management committee for acceptance. Exhibitions: 20th century, contemporary, British and foreign art. Twenty-five one-person shows are held each year. Space: Gallery 1: 70ft x 30ft x 11ft high, floor carpeted, walls wood. Gallery 2: 35ft x 15ft x 11ft high, floor quarry tiled, walls brick. Gallery 3: (Foyer) one wall 15ft x 11ft high, floor quarry tiled, walls brick. Tracked spot lights to all galleries. The gallery is situated in a public park which has been used in the past for performance events. Equipment: Slide projectors, tape recorders and a fully comprehensive art film library on video cassette and monitor. Although beginning, in 1967, in premises used formerly as an underground air-raid shelter, the Bede Gallery now has exhibition resources to equal those of any major regional gallery in the country. In addition to showing the work of young, experimental artists, it is gallery policy to devote space regularly to new work by established British artists and to provide a venue in the north-east for major shows of international standing. It also maintains close links with the local community by showing local artists and having a permanent collection of local history exhibits. The gallery's excellent film library plays a part in involving children and young people in the gallery's activities.

BEDE MONASTERY MUSEUM, Jarrow Hall, Church Bank, Jarrow, Tyne and Wear NE32 3DY. Tel. Jarrow 892106. Opening: April to October – Tues-Sat 10-5.30, Sun 2.30-5.30. November to March – Tues-Sat 11-4.30, Sun 2.30-5.30, closed Mondays except Bank Holidays. Contact: Mr. J. R. Kilburn. Exhibitions: Local history, photographic and artistic exhibitions, but the emphasis is not on contemporary arts. Space: First floor gallery 14ft x 17ft x 10ft. Track Lighting. Equipment: Slide projector, plinths, screens. Jarrow Hall is a site-museum for St. Paul's Church, Jarrow, nationally famous as the home of the Venerable Bede. Temporary exhibition programme serves two purposes: (1) To provide a changing display producing regional interest in the museum generally. (2) Specialist exhibitions of an archaeological or historical nature relating to the monastic site and its cultural significance.

KEELE

UNIVERSITY OF KEELE, Keele, Staffs ST5 5BG. Tel. Newcastle, Staffs 367. Opening: 9-10 every day of the week. Contact: Mr. R. L. Smyth (Economics). Applications: By letter or telephone. Exhibitions: Contemporary paintings and prints. One person and group shows. Space: Two areas – Chancellor's Building, a large entrance hall to lecture rooms, hanging rails, spotlighting and good daytime lighting. Keele Hall is also available, which has dark oak walls. 600 acres of exterior space. Aims to provide the students with good quality, original paintings and prints by local and international artists. Hanging spaces are public, so there are security problems.

KENDAL

ABBOT HALL ART GALLERY, Abbot Hall, Kendal, Cumbria LA9 5AL. Tel. (0539) 22464. Opening: Mon-Fri 10.30-5.30, Sat and Sun 2-5. Contact: Miss M. E. Burkett OBE, BA. Applications: By letter to the Gallery Director, with slides/photos etc. Exhibitions: Modern paintings, sculpture, ceramics, crafts, permanent collections. Space: 4 Galleries about 20ft x 30ft each. Equipment: Slide projectors, tape recorders. Abbot Hall was built in 1759, ground floor has been restored to period decor and contains permanent collection of fine and decorative art of local significance and national importance. Gallery aims to encourage young talent as well as established artists.

MUSEUM OF LAKELAND LIFE AND INDUSTRY, Abbot Hall, Kendal, Cumbria LA9 5AL. Tel. (0539) 22464. Opening: Mon-Fri 10.30-5, Sat and Sun 2-5. Contact: Miss M. E. Burkett OBE, BA. Exhibitions relating to the local community, having a strong social or human interest.

LANCASTER

UNIVERSITY OF LANCASTER LONG GALLERY, Department of Art & Environment, Pendle College, Bailrigg, Lancaster. Tel. 0524 65201.

LEEDS

BREADLINE GALLERY, 138 Town Street, Rodley, Leeds 13, Yorkshire. Tel. Pudsey 566960. Opening: 9.30-6 every day except Friday. Contact: Trevor Whetstone. Applications: Write, phone, or call in. Exhibitions: Any kind of work is shown. Mostly group exhibitions, about 13 per year. Space: Six rooms 15ft square, hessian covered walls, spotlights in most rooms, various floor surfaces – stone, wood, vinyl and floorboards. Equipment: Frames can be hired at 50p each, plinths available and glass cases. A privately funded gallery, which is concerned to give the opportunity to exhibit to serious artists, not amateurs. The gallery's criteria for exhibiting work is based on commitment to art rather than quality and Trevor Whetstone is prepared to show work that he does not personally like, since he believes the gallery should not reflect his personal preferences. The Breadline Gallery is self-sufficient.

LEEDS ART GALLERIES, Temple Newsam House, Leeds LS15 0AE. Tel. (0532) 647321/641358. Opening: May to Sept – Tues-Sun 10.30-6.15, Wed 10.30-8.30 (or dusk in winter). Contact: Robert Rowe. Applications: Normally by invitation. Exhibitions: Modern crafts, paintings, sculpture, photography. Space: Temporary exhibition galleries at Temple Newsam House, limited space also at Lotherton Hall. There is an arena at Temple Newsam for performances. Mainly art historical exhibitions, fine and decorative arts. Some modern painting and sculpture exhibitions each year. Modern one-person craft shows – pottery, textiles, furniture etc. and competitions for designers, craftsmen etc.

LEEDS POLYTECHNIC GALLERY, H Block, Leeds Polytechnic, Calverley Street, Leeds 1. Tel. 41101. Opening: Mon-Fri 10-5. Contact: Benjamin Johnson.

ST PAUL'S GALLERY, 57 St Paul's Street, Leeds LS1 2TE. Tel. (0532) 456421. Opening: Weekdays 10-5, Sat 10-1. Contact: Gerald Deslandes. Applications: In writing or by appointment. Exhibitions: Contemporary painting, sculpture, prints, photography and crafts. Mostly one-person shows. Space: 3 galleries – 27ft x 10ft, 25ft x 15ft and 15ft x 15ft, total linear feet of the three is 176ft. Track lighting + daylight, linoleum floors. Equipment: Small number of frames. About 4 shows a year are devoted to the work of artists living in Yorkshire, about 4 to artists from other parts of Britain and the remaining to work from abroad. Gallery attempts to strike a balance between work in different styles and media and between well-known and less-established exhibitors. Programme of lunch-time events includes artists' talks, recitals, poetry readings and films. Funded by the Yorkshire Arts Assoc.

UNIVERSITY GALLERY, LEEDS, Department of Fine Art, University of Leeds, Leeds LS2 9JT. Tel. Leeds 31751, ext 6227. Opening: Term only 10-5. Contact: Head of Department of Fine Art. Applications: In writing. Exhibitions: Fine, applied art and photography. The University has a department of fine art, to which this gallery is linked.

WHITE ELEPHANT GALLERY, 23 Chapel Lane, Headingley, Leeds 6. Tel. 787826. Contact: Andrew Caffery and Christine Main.

LINCOLN

BISHOP GROSSETESTE COLLEGE GALLERY, Newport, Lincoln LN1 3DY. Tel. (0522) 27347. Opening: 9-9. Contact: Jack Jones, Exhibitions Officer. Applications: To Exhibitions Officer. Exhibitions: Almost any kind of work which is interesting and of a good standard. Mostly one-person shows. Space: Gallery is also the entrance to a college.

About 80 linear feet of hanging space, additional corridor space available for large exhibitions. Tracked spot and flood lights. Exterior spaces available for showing sculpture. Equipment: Audio/visual equipment is freely available. Gallery aims to provide a continuing diverse programme of exhibitions for students and visitors to the college, but is also open to the public. Situated centrally, close to the Cathedral.

USHER GALLERY, Lindum Road, Lincoln LN2 1NN. Tel. (0522) 27980. Opening: Weekdays 10-5.30, Sundays 2.30-5. Contact: Antony Gunstone, BA, FSA, FMA. Applications: Preference given to local artists, send for application form. Exhibitions: Touring exhibitions, work by local artists and students, craft shows etc., about 24 shows per year. Space: 3 temporary exhibition galleries all with controlled spotlighting, neutral wall and floor surfaces, flexible hanging screens. Equipment: Slide projector, plinths, frames, showcases. Permanent collection containing a wide variety of fine and applied art, including Dutch, Flemish and Italian paintings, ceramics, metalwork and sculpture. Active temporary exhibitions programme. Art loan scheme.

LIVERPOOL

BLUECOAT GALLERY, School Lane, Liverpool L1 3BX. Tel. 051 709 5689. Opening: Tues-Fri 10.30-5, Sat 10.30-4. Contact: Bryan Biggs. Applications: Submit slides/photographs of work, together with C.V. Exhibitions: Local artists (touring shows sometimes arranged); one-person shows by nationally recognised artists; thematic touring shows; small exhibitions of craftwork, graphics, photography etc.;

industry-sponsored historical shows. Space: 4 Galleries — 800sq ft, 180sq ft, 300 sq ft and 200sq ft. Natural, strip and spot lighting. Equipment: Carousel projector, some frames. Occasional lectures by exhibiting artists and art films. Dance and music events are promoted in other parts of the building by the Bluecoat Society of Arts.

OPEN EYE GALLERY, 90-92 Whitechapel, Liverpool 1. Tel. 051-709 9460. Opening: Mon-Fri 10-5, Sat 10-4.30. Contact: Peter Hagerty (Gallery Director). Applications: By appointment for viewing of portfolio. Exhibitions: Fundamentally a photographic gallery for photographers/artists using photographic media, although excluding silkscreen and lithographic processes. Usually only one or two per annum are one person shows, the remainder group shows. Space: Gallery 1-40 linear metres of wallspace, ambient daylight with additional fluorescent lighting. Gallery 2-64 linear metres of wallspace, 24m x 10m, ambient daylight, fluorescent and spotlighting. Equipment: Photography: 4 fully equipped darkrooms with facilities from 35mm to 5/4. Colour printing facility. Hard bed mounting press. Dual projection slide-tape. Range of cameras (35mm and 2¼ square). Studio. Video: U-matic editing suite (JVC). U-Matic portable with colour camera. Film: A comprehensive facility for both 16mm and Super 8 which will be fully developed over the next year to finally include, plus various frames. The gallery is part of an audio visual project that has as its aim complete access to equipment (photography, film, video, sound), facilities (studios, darkrooms etc) and technical assistance requested. The gallery

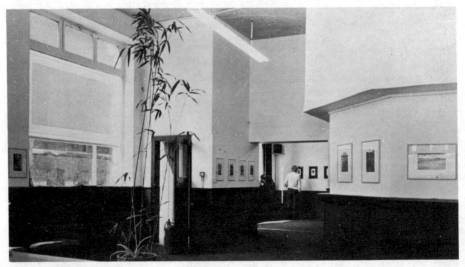

Open Eye Gallery, Liverpool

policy is one of showing the work of contemporary photography from local and international photographers/artists. Also concerned with developing practical and financial assistance to photographers/artists' work in the region for the realisation of particular projects. Performance work has been shown and video installations are planned for the future.

WALKER ART GALLERY, William Brown Street, Liverpool L3 8EL. Tel. 051-227 5234. Opening: Mon-Sat 10-5, Sun 2-5. Contact: Timothy Stevens. Applications: By letter to the Director. Exhibitions: Work in all media, including painting, graphics, sculpture, video and performance. Mostly group shows. Space: 6 galleries – 72ft x 28ft, 71ft x 26ft, 103ft x 35ft and 3 measuring 35ft x 35ft. Wooden floors, strip and spot lighting, also natural top lighting. Equipment: Slide projectors, 16mm projector, cassette recorder, a selection of wooden frames in different sizes. The aim is to make available on Merseyside the best cross-section of current art to enlarge on aspects of the permanent collection which includes Old Masters, contemporary British art and the local school of artists, and to provide a forum for the work of painters, especially in the John Moores Liverpool Exhibitions, as well as for more established artists.

MANCHESTER

CITY ART GALLERY, Mosley Street, Manchester M2 3JL. Tel. 061 236 9422. Opening: Mon-Sat 10-6. Contact: Timothy Clifford. Exhibitions: Wide-ranging, including permanent collection, some temporary shows. The City Art Gallery administers 6 other Branches, including the Gallery of Modern Art, Princess Street, Manchester M1 4HR, which has a permanent collection of 20th century British art and has a succession of temporary exhibitions.

HENRY DONN GALLERY, 138-142 Bury New Road, Whitefield, Manchester. Tel. 061 766 8819. Opening: Mon-Sat 9.30-5.30. Contact: Henry Donn. Applications: By appointment, preceded by a letter. Exhibitions: Specialises in the work of Lowry and Russell-Flint.

GALLERY OF MODERN ART (Athenaeum), Princess Street, Manchester. Tel. 061 236 9422. Opening: Weekdays 10-6.

HEATON HALL, Heaton Park, Prestwich, Manchester. Tel. 061 773 1231. Opening: Weekdays 10-6, Sun 12-6, closed Nov-Feb.

COLIN JELLICOE GALLERY, 82 Portland Street, Manchester 1. Tel. 061 236 2716. Opening: Mon-Fri 10-6, Sat 1-5. Contact: Colin Jellicoe. Applications: Open submission. Send slides or photos, or phone gallery for appointment. Exhibitions: Group and one-person. Figurative, abstract: drawings, graphics and paintings. Space: Small basement, approx. 400sq ft, white walls and spotlights, suited to small works only. Equipment: A framing service. Private gallery in present premises since 1968. Four main themes of work exhibited: Landscapes/townscapes/traditional figure/modern figure. New artists generally shown in mixed exhibitions first. A lively gallery, showing a wide range of work by known and unknown artists.

LANTERN GALLERY, 3 Worsley Road, Worsley, Manchester M28 4NN. Tel. 061 794 8956. Opening: Easter to Christmas (only) Wed/Thur/Fri/Sat 12-5. Contact: Peter Tillotson. Applications: In writing, enclosing photos, catalogues, biography etc. Exhibitions: Paintings, drawings, prints, usually figurative and usually on a small scale, also crafts and sculpture. Space: 2 small galleries, approx 20ft x 12ft and 20ft x 9ft. Overhead track spot lighting. Entrance to the gallery is from a footpath alongside the Bridgewater Canal and the area is semi-rural. Promotes young artists mainly living in the north west.

MEMORIAL ART GALLERY, Central Library, Chorley Road, Swinton, Manchester M27 2AF. Tel. 061 794 7440, 061 794 7449. Opening: Mon, Tues, Wed, Fri 9-7. Contact: Mr W. M. Weber at Salford Art Gallery. Space: Approx 100 feet of hanging space, fluorescent lighting, chain and hook hanging system. Other details: See Salford Art Gallery.

PORTICO LIBRARY GALLERY, 57 Mosley Street, Manchester M2 3HY. Tel. 061-236 6785. Opening: Mon-Fri 9.30-5. Contact: Mrs. Laura Trowski. Applications: Contact Mrs Trowski. Exhibitions: Mostly one-person shows of paintings, drawings, engravings, photographs, small craft items etc. Space: 18.5m of display boards positioned around the central well of a balcony, fluorescent lighting. The gallery is not organised with a formal policy in mind, but its general aim is to encourage exhibitors who might not be able to afford to exhibit elsewhere. It is mainly local artists who exhibit, but every case is decided on its own merits.

QUEEN'S PARK ART GALLERY, Rochdale Road, Harpurhey, Manchester. Tel. 061 205 2121. Opening: Weekdays 10-6, Sun 12-6, closed Nov-Feb.

TIB LANE GALLERY, 14A Tib Lane (off Cross Street), Manchester 2. Tel. 061 834 6928. Opening: Mon-Fri 11-2, 3-5, Sat 10.30-1. Contact: Jan Green or Geoffrey Green. Applications: Phone or call to make an appointment. Exhibitions: Mainly figurative, British paintings, drawings and sculpture of this century. Group and one-person. Space: Very small – one room, semi-basement, wooden walls, carpeted floor, window onto street level, spotlighting on track. Private gallery showing

work by well-established artists and those who are lesser or unknown, whose work the owners are enthusiastic about.

UNDERCROFT GALLERY, Manchester Polytechnic, Faculty of Art and Design, All Saints, Manchester M15 6BR. Contact: John Rabbetts.

WHITWORTH ART GALLERY, University of Manchester, Whitworth Park, Manchester M15 6ER. Tel. 061 273 4865. Opening: Mon-Sat 10-5, Thurs 10-9: Contact: Prof. C. R. Dodwell. Applications: By letter (only a few can be accepted). Exhibitions: Fine and decorative arts of all periods, with special emphasis on English watercolours, European drawings, textiles, prints and 20th Century British art, including contemporary. Apart from biennial Northern Young Contemporaries, shows by living artists tend to be one-person. Space: Approx 600sq metres, divided into two rooms of equal size (interconnecting), plastered walls. Exterior spaces used for biennial outdoor sculpture exhibitions, one or two-person. Equipment: Slide projectors, tape recorders and video equipment can be hired. Extensive permanent collection, well worth visiting.

MARKET WEIGHTON

THE GALLERY, 11 Spring Road, Market Weighton, York YO4 3JJ. Tel. Market Weighton 3754. Opening: 11-7 (during exhibitions). Contact: Heather Bramwell. Applications: By letter, enclosing slides. Exhibitions: Mainly paintings, also sculpture, prints, ceramics and textiles. Mostly group shows. Space: Part of a converted school, it is an integral part of two artists' home/studio. Main gallery: 40ft x 16ft x 16ft high. Upper gallery: 16ft square x 8ft high. Stripped pine floor, plaster walls, spot and fluorescent lighting. Gallery is self-financing and therefore has to pass on expenses (publicity etc) to exhibitors and/or exhibit work that is saleable in the area. Professional and amateur artists considered.

MIDDLESBROUGH

MIDDLESBROUGH ART GALLERY, Linthorpe Road, Middlesbrough, Cleveland. Tel. Middlesbrough 247445.

NEWCASTLE UPON TYNE

THE BASEMENT GROUP, Bells Court, Pilgrim Street, Newcastle upon Tyne. Tel. 0632 614527 or 733686. Contact: Belinda Williams. The Basement Group is a venue for artists working within the area of performance, film, video, installation, sound and related media. It was originally established by artists who found it increasingly difficult to show their own work within the traditional gallery system and consequently created their own venue. It is now run co-operatively by six artists Ken Gill, Jon Bewley, Dick Grayson, Belinda Williams, John Adams and Neil Armstrong. There is one paid member who undertakes to carry out group decisions on the policies of the day-to-day

running of the space and organisation of weekly events. Each member of the group shows work regularly at the basement in order to establish themselves as artists rather than administrators. As far as it is possible, the basement is an open access venue. The only method of selection used is one of programme planning, i.e. group shows, film/video screenings, discussions, seminars etc. This is necessary in order to show a wide spectrum of work. Artists who are felt to be relevant to the space are also invited to help towards making an interesting and varied programme. Careful documentation is made of each show, with the hope that this may be used towards a yearly publication of work. Space: 9.2 metres x 10.4 metres (plans available on request), concrete floor, no daylight. Equipment: Most audio-visual equipment available.

CALOUSTE GULBENKIAN GALLERY, Peoples Theatre Arts Group, Stephenson Road, Newcastle upon Tyne NE6 5QF. Tel. 0632 655020. Opening: 6.30-9 and during Arts group activities – plays, music etc. Contact: Henry D. Davy. Applications: Open to anyone, but priority given to young, local artists. Apply by letter to Chairman, Calouste Gulbenkian Gallery Committee. Exhibitions: Gallery is part of the Arts Centre and audiences to plays will see the exhibitions (about 1500 people per exhibition). About half of the shows are allocated to young artists from local universities and polytechnics given their first one-person show. There is a wide range of media. About 12 one-person exhibitions each year. Space: 63 feet length of continuous hanging space, with additional space from screens if required. A set of small wooden display blocks for sculpture or pottery. Strip lights and a grid of 58 adjustable spotlights. Equipment: A stock of A3 frames. Small hire charge. The Arts Centre with the gallery was opened in 1962 but the history of the link between fine art and the People's Theatre goes back to the 1940's when small art exhibitions were displayed in the Greenroom of the old Rye Hill theatre. The gallery provides a sunken promenade in a modern refreshment area so a tour of the current exhibition is a natural part of an evening at the Arts Centre by play, music and other audiences.

HATTON GALLERY, The University, Newcastle upon Tyne. Tel. 0632 28511. Contact: John Milner. Exhibitions: A wide range of mostly fine art, contemporary and historical. Gallery houses a permanent collection, which includes the only remaining Merzbau by Kurt Schwitters.

LAING ART GALLERY, Higham Place, Newcastle upon Tyne NE1 8AG. Tel. 0632 26989/ 27734. Opening: Mon-Sat 10-6, Sun 2.30-5.30. Contact: John Millard, Acting Curator. Applications: Include C.V., past reviews etc., and at

least 12 slides of recent work. Exhibitions: Historical, educational, fine and applied arts plus a few contemporary shows. Spaces: (For temporary exhibitions) Two galleries 30 x 40ft, hessian walls, carpeted floor, track lighting with spotlights; two galleries 30 x 60ft, painted hessian walls, parquet floor, fluorescent and/or natural light. Equipment: Slide projectors for occasional (not continual) use, wood/perspex frames A3 to A0 sizes. Newcastle's most centrally situated and prestigious gallery, with a large permanent collection of applied, decorative and fine art (mostly British). The policy for temporary exhibitions is to supplement and complement these with touring and self-originated exhibitions of quality and/or local relevance. Contemporary art shows are usually by invitation. Occasional lunch-time concerts, readings, performances etc.

NEWCASTLE CENTRAL LIBRARY, Princess Square, Newcastle upon Tyne. Tel. 0632 610691. Opening: Mon-Thurs 9-9, Fri and Sat 9-5. Contact: Anne Nicholson, Publicity Officer. Applications: In person, by telephone or letter. Exhibitions: Wide range, including one-person shows. Space: 40ft x 20ft, fluorescent lighting. Equipment: Carousel projector. There is a similar exhibition room at Gosforth Library (Tel. 854244) and apart from these there are 12 libraries which can accommodate small exhibitions. They are used not only by artists but by local community groups etc.

POLYTECHNIC ART GALLERY, Library Building, The Polytechnic, Sandyford Road, Newcastle upon Tyne. Tel. 0632 26002 ext 440. Exhibitions: Mostly contemporary British painting.

SIDE GALLERY, 9 Side, Newcastle upon Tyne NE1 3JE. Tel. 0632 22208. Opening: Tues-Sun 10-6. Exhibitions: Entirely photography, monthly shows of contemporary and historical material. Regular shows of new British work as well as a venue in the north-east for major shows of international standing. Space: 2600sq ft on three floors, natural and spotlighting. There is also a bookshop specialising in film and photography and a small cinema showing mainly non-commercial and independent films.

SPECTRO GALLERIES (1 and 2), Spectro Arts Workshop, Bells Court, Pilgrim Street, Newcastle upon Tyne. Tel. 0632 22410. Opening: 11-5.30. Contact: Lucy Krause. Applications: Documentation/photographs/slides of current work is put before a selection committee. Exhibitions: Gallery 1 – Anything considered in any medium/media; the only proviso is that it should be considered relevant to Spectro's activities. Gallery 2 – Mainly photographic shows selected by staff of the

photographic workshop at Spectro. Space: Gallery 1 – an unusual Z-shaped space, giving about 70 linear metres of wall space, limited daylight, concorde track/spot lighting, lino-tiled floor. Gallery 2 – 16 linear metres, track/spot lighting and* daylight. Equipment: 2 Carousel projectors, large amount of sound equipment, frames. Spectro houses high-standard workshops in screenprinting, photography and sound, as well as the galleries. These are open-access for artists and the public. There is also an artist residency scheme which has played a major part in the galleries operating as an integrated part of the centre, the exhibitions not standing in isolation but revealing the artists' working processes and those of Spectro itself. There is a performance studio, which is sound-proofed and is used for concerts and events. The basement, a major venue for performance and video is situated in the basement of Spectro.

NORTHUMBERLAND
WANSBECK SQUARE EXHIBITION GALLERY, Wansbeck District Council, Wansbeck Square, Ashington, Northumberland. Tel. Ashington 814444. Opening: Mon-Thurs 8.30-5, Fri 8.30-4.30. Contact: A. G. White, Chief Leisure and Publicity Officer. Applications: By letter. Exhibitions: Paintings, photographs, sculptures etc., by local artists or of local interest. Space: 15ft x 15ft, wall-space – 15 hessian covered boards 7ft x 4ft, ceiling spots, two display cases.

OLDHAM
OLDHAM ART GALLERY, Union Street, Oldham. Tel. 061 678 4651. Opening: Mon, Wed, Thurs, Fri 10-7, Tues 10-1, Sat 10-4. Contact: J. Carter. Applications: To the Gallery Curator. Exhibitions: Contemporary art, local societies, one-person shows (usually local), thematic shows. Space: 3 galleries – 2 60ft x 24ft, 1 30ft x 16ft, hessian covered walls, artificial and daylight. Equipment: Slide projector, tape recorder and frames.

SADDLEWORTH MUSEUM GALLERY, High Street, Uppermill, Oldham, Lancs. Tel. Saddleworth 2273 and 3884 (eves). Opening: Sat 2-5, Sun 2-5. Contact: Anthony Burke. Exhibitions: Wide range of mostly group shows.

PRESTON
HARRIS MUSEUM & ART GALLERY, Market Square, Preston, Lancs PR1 2PP. Tel. 0772 58248/9. Opening: Mon-Sat 10-5. Contact: Michael Cross. Exhibitions: Some temporary shows. Permanent collection of paintings and sculpture.

VERNON GALLERY, Vernon Street, Moor Lane, Preston, PR1 3PQ. Tel. 0772 59383. Opening: Mon-Fri 9-5.30. Applications: Local artists preferred, work is assessed by the Art Committee of Building Design Partnership. Write including slides or samples of work.

Exhibitions: Work in any medium, including sculpture, preferably by young or new artists. One or two-person shows only. Space: 50sq metres divided by full-height screens. Spot lighting, carpeted floor. Equipment: Slide projectors, tape recorders, but not for full-time use. Established artists could be considered, provided they make their own security arrangements.

ROCHDALE

ROCHDALE ART GALLERY, Esplanade, Rochdale, G.M.C. Tel. 0706 47474 Ext. 764. Opening: Mon-Sat 10-5, Sun 2.30-5. Contact: Arts and Exhibitions Officer, Antonia Roberts. Applications: In writing, with slides or photographs. Exhibitions: Contemporary work in all media, one exhibition of local amateur work per year, work from 18th century to present day. Mainly British. Space: Wall space: 476 linear feet. Floor: Wooden block flooring. Light: Track lighting with dimmer switches. Overhead natural light — glass treated against ultra violet and blinds. Three interconnecting galleries. One separate gallery, at present closed. All galleries completely modernised in 1978. Equipment: Slide projector, back projection unit, 35mm sound projector, display cases. The gallery aims to present a varied programme of exhibitions showing the variety and strength of contemporary British art as well as providing an opportunity to see earlier work from many different schools. By giving talks, working with schools and colleges, providing lectures and information sheets, intention is to make art as a whole more accessible to people. Many exhibitions draw an audience from well outside the immediate locale — some gain national as well as regional publicity.

ROTHBURY

COQUETDALE ART GALLERY, Church House, Rothbury, Northumberland. Secretary's Tel. Rothbury 20534. Opening: Mar-Nov — Tues-Fri 10.30-12.30, 2-4, Sat 10-12.30, 2-5, Sun 2-5. Contact: Mr. Andrew Withers, Chairman of Committee. Applications: To the gallery. Exhibitions: No limits set, but most have been on conventional lines — landscapes, portraits, wildlife, some crafts. Space: 2 average-sized house rooms and one smaller room. Local artists encouraged. The community is small and the gallery depends on summer visitors for interest and support.

ROTHERHAM

ART GALLERY, Brian O'Malley Central Library and Arts Centre, Walker Place, Rotherham S65 1JH. Tel. 0709 2121 ext 3569/3519.

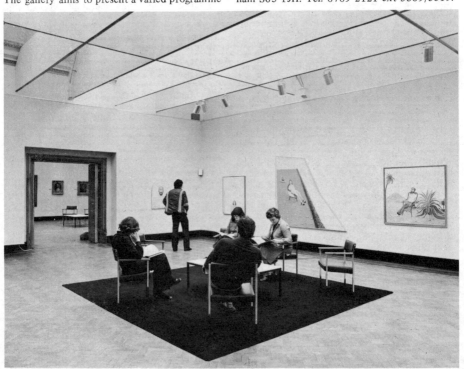

Rochdale Art Gallery

Opening: Tues-Fri 10-6, Sat 10-5. Contact: Michael Densley. Applications: Local or locally related artists only, apply direct. Exhibitions: Modern/traditional. Space: Spotlights, hessian-covered walls, floors carpeted, 3 gallery spaces, about 20ft x 40ft each.

ST. HELENS
ST. HELENS MUSEUM AND ART GALLERY, College Street, St. Helens, Merseyside WA10 1TW. Tel. St. Helens 24061 ext 2572. Opening: Mon-Fri 10-5, Sat 10-1. Contact: Curator — Miss E. Lloyd. Applications: In writing to the curator — gallery is booked up a year in advance. Exhibitions: Touring shows; annual shows by local societies; one-person photographic and art shows. Space: 1172sq ft, 109 linear feet of hanging space.

SALFORD
SALFORD MUSEUM AND ART GALLERY, Peel Park, Salford, Lancashire M5 4WN. Tel. 061 736 2649, 061 737 7692. Opening: Mon-Fri 10-5, Sun 12-5, closed Saturday, Good Friday, 24-27 December, New Year's Day. Contact: Curator — Mr. S. Shaw, F.M.A. Art Exhibitions Officer — Mr. W. M. Leber. Applications: Normally by letter, enclosing slides (4) and a list of previous exhibitions. Exhibitions: A wide range of fine and applied arts. Space: Two galleries, providing a total of 330 feet of hanging space, incandescent lighting. The gallery aims to present contemporary trends in art and encourage the work of artists working in the north. Some of the finest exhibition spaces in the north.

SCUNTHORPE
SCUNTHORPE BOROUGH MUSEUM AND ART GALLERY, Oswald Road, Scunthorpe, South Humberside. Tel. 0724 843533. Opening: Mon-Sat 10-5, Sun 2-5. Contact: Miss D. P. Hillhouse. Applications: In writing, enclosing photographs. Exhibitions: Both amateur and professional — oils, watercolours, pastels, sculpture, photography and craftwork. 20-24 mainly one-person shows each year. Space: 1 large gallery for fine art shows — 61ft x 21ft, diffused ceiling light. Also a smaller gallery — 39ft x 20ft, blacked out with spotlights. Equipment: Screens and projector. Preference given to artists working within the locality, e.g. South Humberside and Lincolnshire.

SHEFFIELD
GRAVES ART GALLERY, Surrey Street, Sheffield S1 1XZ. Tel. 734781. Opening: Mon-Sat 9-8, Sun 2-8. Contact: H. F. Constantine. Exhibitions: Permanent collection of 20th century British paintings etc., temporary exhibitions continuously.

MAPPIN ART GALLERY, Weston Park, Sheffield S10 2TP. Tel. 0742 26281. Opening: Mon-Sat 10-5 (10-8 in June, July and August);

Sun 2-5. Contact: Director — Frank Constantine, Keeper — James Hamilton. Applications: By letter, enclosing photographs/slides and C.V. Exhibitions: 18th, 19th, 20th century and contemporary fine art and photography. This is shown in the permanent collection as well as in a continuing succession of temporary exhibitions. About 20 shows per year. Space: Total floor area: 8794sq ft, polished wooden floors, fluorescent, spot and track lighting. Weston Park is available as an exterior space. There are five galleries. Permanent collection of British art from 1700 to the present. Temporary exhibitions tend to reflect the Sheffield area by showing the work of artists who have links with the district, e.g. John Hoyland, Kate Rose, Nigel Inglis. Dance, music and films are also shown. The Gallery Upstairs, a self-contained space of 570sq ft, is regularly given over to shows of work by artists who have not shown regularly.

SHEFFIELD POLYTECHNIC GALLERY, Faculty of Art and Design, Psalter Lane, Sheffield. Tel. 0742 56101. Opening: Mon-Fri 10-6, Sat 9-12 noon. Contact: Paul D. Walker.

SHEFFIELD UNIVERSITY LIBRARY, The University Library, Western Bank, Sheffield S10 2TN. Tel. 0742 78555 ext 4333. Opening: Mon-Fri 9-9, Sat 9-12 noon. Contact: University Librarian. Applications: To Secretary, University of Sheffield Fine Art Society. Exhibitions: Paintings, prints, drawings, small sculpture, crafts.

SOUTH SHIELDS
METAL ART PRECINCT AND ART CENTRE, Wapping Street, South Shields, Tyne and Wear. Tel. 0632 568536. Opening: Tue-Fri 11-1, 2.30-5, Sun 11-1. Contact: Mrs. Jean Rudkin. Applications: Write, enclosing slides. Priority to artists from the north east. Exhibitions: Metal sculpture (welded or cast), ceramics, jewellery, watercolours, glass. 3 major exhibitions per year, mainly 2 or 3 person shows. Space: There are two galleries on a very picturesque quayside at the mouth of the River Tyne. Sculpture Gallery has a painted concrete floor, fluorescent lighting and double doors leading on to the quay (1100sq ft). The smaller gallery (550sq ft) is carpeted and spotlit. Large gallery is only used in summer to avoid heating cost. Equipment: Slide projectors and tape recorders.

SOUTH SHIELDS MUSEUM AND ART GALLERY (Tyne and Wear County Council Museum), Ocean Road, South Shields, Tyne and Wear. Tel. 568740. Opening: Mon-Sat 10-6, Sun 2-5. Exhibitions: Mostly group shows. Space: 40ft x 30ft, track lighting, no natural light.

SOUTHPORT

ATKINSON ART GALLERY, Lord Street, Southport, Merseyside PR8 1DH. Tel. 0704 33133 ext 129. Opening: Mon, Tues, Wed, Fri 10-5, Thurs and Sat 10-1. Contact: Mrs. Diana de Bussy (Keeper of Fine Art). Applications: In writing to the Keeper. Exhibitions: Arts Council touring shows and work by local artists. Space: 8 galleries, some of which are used for permanent collection. New lighting and wall surfaces are being installed, wood floor. Equipment: Slide/tape unit.

STALYBRIDGE

ASTLEY CHEETHAM ART GALLERY, Trinity Street, Stalybridge, Cheshire. Tel. 061 338 2708. Opening: Tues-Fri 1-8, Sat 9-4. Contact: Mrs. Helen Caffrey. Applications: Send slides of recent work, artists with local connections preferred. Exhibitions: Travelling shows, exhibitions of local interest, drawn from the permanent collection and contemporary shows. Space: Approx. 200 linear feet of wall space. Spotlights and some floodlights from roof. Equipment: Tape recorders and facilities for slide projection. An exhibition programme provides exhibitions in numerous art forms – painting, textiles, ceramics, photographs and so on, changing monthly. Material may be old or new, some exhibitions are hired (for instance from the Arts Council, and formerly from the Victoria and Albert Museum), some borrowed from the Whitworth Art Gallery, and the rest set up by the Museums Officer.

STOCKTON

DOVECOT ARTS CENTRE, Dovecot Street, Stockton, Cleveland. Tel. 611625/611659.

GREEN DRAGON ART GALLERY, Stockton, Cleveland. Tel. 64308.

PRESTON HALL MUSEUM, Yarm Road, Stockton, Cleveland. Tel. 781184. Exhibitions: Wide range, including crafts, fine art and historical, priority given to artists with local connections.

STOCKSFIELD

STOCKSFIELD STUDIO GALLERY, Branch End, Stocksfield, Northumberland NE43 7NA. Tel. 06615 3065. Opening: Mon, Wed, Fri 10-12.30, 2-5.30, closed Bank Holidays. Contact: Bruce Allsopp. Applications: In writing. Exhibitions: Figurative paintings and watercolours, emphasis upon landscapes in northern England. Space: Wallspace for 50-70 small pictures, good daylight. The gallery is operated by Oriel Press Limited, Publishers, a subsidiary company of Routledge and Kegan Paul Limited. Its main aim is to exhibit figurative paintings by nationally famous artist alongside the work of the most talented local artists and to encourage, in particular, the development of a watercolour school in north east England.

STOKE-ON-TRENT

FOYER GALLERY, North Staffordshire Polytechnic, College Road, Stoke-on-Trent, Staffs. Tel. 0782 45531 ext 108. Opening: 10-5. Contact: Robert Bird. Applications: In writing with slides or photographs. Exhibitions: Mostly one-person shows related to the visual arts, although there is also opportunity for showing visual material related to aspects of science and technology. Space: 44ft x 22ft, three walls are made of glass, display surfaces are provided by panels of hessian-covered building board, strip and spot lighting, neutral green carpeted floor. There is an unsupervised grassed area adjacent. Equipment: Slide projectors, tape recorders, frames (aluminium). The aims of the gallery are essentially educational and the work shown is not exclusively fine art. The first concern is that the exhibitions should have relevance to the activities of its known audience – the staff and students of the Polytechnic, where there are degree courses in art and design, science and technology.

SUNDERLAND

CEOLFRITH GALLERY/SUNDERLAND ARTS CENTRE, 17 Grange Terrace, Sunderland, Tyne and Wear. Tel. 0783 43976. Opening: Mon-Sat 10-6 (except Bank Holidays). Contact: Director – Tony Knipe, Exhibition Organiser – Marian Mills. Applications: In writing, with slides/photographs. Exhibitions: Contemporary painting, sculpture, drawing, prints, crafts etc. Space: Two spacious galleries, well-lit and painted. Gallery 1: 130 linear feet, 1000sq ft, floor T & G wood varnished, spot lighting, no daylight. Gallery 2: 125 linear feet, 1000sq ft, floor T & G wood varnished, spot lighting, no daylight. Craft Gallery: 60 linear feet, 300sq ft, daylight optional. Equipment: Wide range, plus print-making facilities and studio space. Ceolfrith Gallery is a public gallery, showing and originating exhibitions. The programme covers significant aspects of contemporary visual arts and crafts. Exhibitions are arranged to tour throughout the region, Great Britain and abroad. They range from large scale research projects shown in national galleries, to exhibitions designed specifically for more limited gallery spaces in arts centres, universities and polytechnics. The gallery also originates touring exhibitions specific to the region, looking at aspects of social development and the environment, for show in community centres, clubs and libraries. The newly refurbished basement of 17 Grange Terrace will be the base for a programme of performing arts. These events will include folk music, jazz, contemporary music, films, drama, poetry and lectures, and aim to interest a wide section of the community. The programme is mainly promoted by Sunderland Arts Centre, although some events will be organised with Sunderland Polytechnic. There is also a print workshop, bookshop and

the Ceolfrith Press (a non-commercial small press established in 1970, concentrating mainly on poetry).

SUNDERLAND MUSEUM AND ART GALLERY (Tyne and Wear County Council Museum), Borough Road, Sunderland. Tel. 77075. Opening: Mon-Fri 9.30-6, Sat 9.30-4, Sun 2-5. Contact: Curator – N. T. Sinclair, M.A., A.M.A. Exhibitions: Work by artists of national or regional importance. Space: 35ft x 63ft natural light excluded, track lighting. Equipment: Projectors and frames.

WAKEFIELD
THE YORKSHIRE SCULPTURE PARK, Bretton Hall College, West Bretton, Wakefield, W. Yorks WF4 4LG. Tel. 092 485 261. Opening: Mon-Fri 10-6, Sat and Sun 10-4. (not open on Bank Holidays). Contact: Peter E. Murray. Applications: In writing to the Secretary. Exhibitions: Group and one-person exhibitions of sculpture suitable for open air and public display. One major and two or three smaller shows are put on each year, plus work on temporary loan. Space: Open air parkland. The Sculpture Park provides the public with a broad view of sculpture, in a

natural setting and is developing as a centre for sculpture by providing a Resources Centre and Fellowship in Sculpture. There is a permanent collection gradually being built up.

WAKEFIELD ART GALLERY, Wentworth Terrace, Wakefield, W. Yorks. Tel. 0924 70211 ext 8031. Opening: Mon-Sat 12.30-5.30, Sun 2.30-5.30. Contact: Mrs Gillian Spencer. Permanent collection of 20th century British art, some temporary exhibitions. Sculpture is displayed in the garden. A new temporary exhibitions gallery is shortly to be opened – Elizabethan Exhibition Gallery, Brook Street, Wakefield.

WARRINGTON
WARRINGTON MUSEUM AND ART GALLERY, Bold Street, Warrington WA1 1JG, Cheshire. Tel. 0925 30550. Opening: Mon-Fri 10-6, Sat 10-5. Contact: Mrs. C. E. Gray (Keeper of Art). Applications: In writing or by appointment with Keeper of Art. Exhibitions: One-person shows of fine and decorative arts; group exhibitions with variety of work; travelling, photographic and items from permanent collection. Space: Hessian covered panelled walls, with hanging rail. Approx. 200 linear

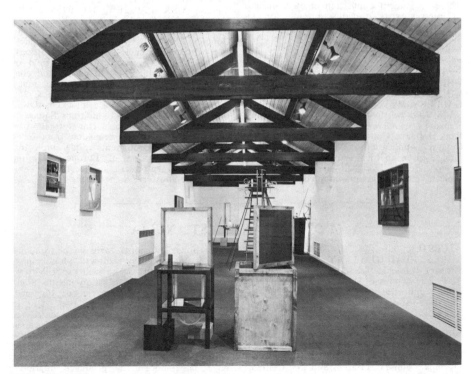

Biddick Farm Arts Centre, Tyne and Wear.

feet of hanging space. Fluorescent lighting and linoleum floor-covering. Equipment: Slide projector and tape recorder. Aims to provide a programme appealing to as many sections of the community as possible. Local artists are encouraged – individually and in groups, also those outside the area. There is an 'open art' competition held each year.

WASHINGTON
BIDDICK FARM ARTS CENTRE GALLERY, Biddick Farm Arts Centre, Biddick Lane, Fatfield, Washington, Tyne and Wear. Tel. 0632 466440. Opening: Tues-Fri 10.30-5, Sat 10.30-4, Sun 2-4. Contact: Director of Centre – John Forster. Visual Arts Officer – Wendy Brown. Applications: Send biography, C.V., plus photographs/slides. Exhibitions: A varied programme, with focus on certain areas – crafts, video (well known for the international video show), 3-D and experimental work. Space: Approx. 67ft x 18ft, with natural wood beams supporting roof. Blockboard walls facing the natural stone shell, carpeted floor, 12 screens (8ft x 4ft). Lighting fluorescent and spots. A number of grassed areas surrounding the centre are available. Equipment: Any equipment required can be hired. Biddick Farm promotes the arts in Washington, a new town where no student population or other nucleus of interest exists, providing a venue for any area of art activity to keep the population abreast of current developments. The Arts Centre has a theatre for dance, drama and music performances; however, where relevant, the gallery might present these areas also.

WHITEHAVEN
WHITEHAVEN MUSEUM AND ART GALLERY, Market Place, Whitehaven, Cumbria CA28 7JG. Tel. 0946 3111 ext 289. Opening: Weekdays inc. Sat 10-5, closed Sundays and Bank Holidays. Contact: Harry Fancy, A.M.A., Curator. Applications: To the Curator, preference given to local artists. Exhibitions: As diverse as possible, half are on arts/crafts subjects, others museum-oriented. Space: No

natural light, spotlights on overhead gantry, textured plaster walls. Equipment: Large quantity of screens, tape/slide facility (carousel projector and tape recorder). 15-20 exhibitions are featured each year, whilst some are travelling shows, most are originated by the museum staff.

WIGAN
WIGAN MUSEUM AND ART GALLERY, Station Road, Wigan. Tel. 0924 41387.

WORKINGTON
CARNEGIE ARTS CENTRE, Finckle Street, Workington, Cumbria. Tel. 2122. Exhibitions: Wide range, including fine art, crafts, photography and shows of local interest.

YORK
HESLINGTON HALL GALLERY, University of York, Heslington, York. Tel. 0904 59861. Opening: Mon-Fri 9-5, Sat/Sun 2-5. Contact: Dr. D. T. Jenkins, Economics Dept.

IMPRESSIONS GALLERY OF PHOTO-GRAPHY, 17 Colliergate, York. Tel. 0904 54724. Contact: Val Williams. Opening: Tues-Sat 10-6. Exhibitions: Photography, mostly contemporary, some touring shows.

YORK CITY ART GALLERY, Exhibition Square, York YO1 2EW. Tel. 0904 23839. Opening: Mon-Sat 10-5, Sun 2.30-5, closed 25 and 26 Dec, 1 Jan and Good Friday. Contact: Richard Green, Curator. Applications: In writing, enclosing slides. Exhibitions: A wide range, covering the whole field of western pictorial art – old master and contemporary, local, national and international. Occasionally applied arts. Space: Approx. 250 linear feet of hanging space, blockboard wall surface, track lighting. Exhibitions Square – a paved pedestrian area in front of gallery – could be used, with permission from York City Council. Equipment: Slide projector. Permanent collection of European painting from 1350 to the present, also local topography and modern pottery. Art reference library.

MIDLANDS AND EAST ANGLIA

ALCESTER
TURKS HEAD GALLERY, 4 High Street, Alcester, Warwicks. Tel. 0789 762676. Opening: 10-1, 2.15-5, closed Thurs. Contact: Mr. T. J. Ford. Applications: By invitation. Exhibitions: Drawings, paintings, textiles, ceramics, furniture. Space: 14ft x 9ft, spotlights.

BIRMINGHAM
BIRMINGHAM ARTS LAB, Holt Street, Birmingham B7 4BA. Tel. 021 359 4192. Opening: Mon-Sat 11.30-8, Sun 2-8. Contact: Gillian Clark. Applications: Letter and slides.

Exhibitions: Regional artists, performance work, some touring shows, photography. Space: 35ft x 40ft, white walls, spot lighting. Also a paved courtyard. Equipment: Some frames. Other equipment can be obtained. The Birmingham Arts Lab was first set up in 1968 and is now one of the major centres for the experimental and contemporary arts in the country. Music, theatre, literature, dance and cinema are presented as well as visual art. Policy emphasis is to promote new work. A 50-page booklet is produced quarterly, listing events at the Arts Lab.

BIRMINGHAM CITY MUSEUM AND ART GALLERY, Chamberlain Square, Birmingham B3 3DH. Tel. 021 235 9944. Opening: Mon-Sat 10-5.30, Sun 2-5.30. Contact: Keeper of Fine Art – Richard Lockett. Applications: By letter enclosing slides/photos. Exhibitions: Painting, sculpture and graphics of all periods. Usually only 1 or 2 exhibitions of contemporary art per year. Space: 21 x 9.5 metres; 55 linear metres hanging space + screens.

BIRMINGHAM POLYTECHNIC GALLERY, Faculty of Art and Design, Gosta Green, Birmingham. Tel. 021 359 6721 ext 223. Contact: Jenny Irvin Thomas.

HOLT STREET GALLERY, University of Aston, Centre for the Arts, Gosta Green, Birmingham B4 7ET. Tel. 021 359 3979. Opening: Noon-8pm, weekdays. Contact: Visual arts organiser. Applications: By letter. Exhibitions: Prefer first showing of work by younger artists who are based in the West Midlands. Space: A pleasant, bright gallery, with courtyard for sculpture. Equipment: 40 standard A2 frames. Gallery is part of a multi-purpose arts centre and is programmed jointly by the Centre for the Arts and the Birmingham Arts Lab, an independent tenant of the university. Interested only in new work and local artists.

IKON GALLERY, 58/72 John Bright Street, Birmingham B1 1BN. Tel. 021 643 0708. Opening: Mon-Sat 10-6, Thurs till 8. Contact: Director Antonia Payne. Applications: Send slides/photos/documentation. Exhibitions: All media, including the "Third Area", emphasis on contemporary, experimental work, but not exclusively so. About 25 shows per year, which vary widely in scale, mostly one-person shows. Space: A former showroom – very open. Two floors, ground and basement approx. 3000sq ft per floor. Ground: natural light form high glass roof + halogen lamps, basement: halogen lamps, floors concrete. Walls are demountable and some are movable in the basement. Equipment: Carousel projector plus pulse-linked cassette player, few frames, other equipment can be borrowed or hired. Not geared necessarily to showing local artists, criteria are national rather than regional. Artists from overseas have produced installations and performances at the gallery.

LONG GALLERY, Faculty of Arts, University of Birmingham, Birmingham B15 2TT. Tel. 021 472 1301 ext 2339. Opening: 8-9. Contact: Dr. M. Butler. Applications: Direct to organiser. Exhibitions: Paintings and graphics only. Space: Long corridor, windows down one side, about 150 linear feet of wall space. Audience/spectators are staff and students of the university.

THE OPPOSITE LOCK, 52 Gas Street, Birmingham. Tel. 021 643 2573. Opening: 10-2.

Contact: Ian Hone. Applications: Write or phone. Exhibitions: Paintings and photography. Two one-person shows per year only. Space: 200sq ft of wall space, spotlights, also a patio 25sq yds. Gallery is within a night club complex. It provides local artists with a guaranteed audience.

TIMAEUS, 2A Salisbury Road, Moseley, Birmingham B13 8JS. Tel. 021 449 7301. Opening: Mon-Sat 10-4 (except Bank Holidays) and by appointment at other times. Contact: Martin Purdy, Anna Hlinka. Applications: Usually by invitation. Exhibitions: Generally, the middle ground of recent art, mostly 2D. Works are mostly grouped, but occasional one-person shows. Space: 3 separate but linked spaces for changing shows, one area for more permanent work (roughly 20ft x 15ft x 25ft x 20ft). White-painted walls, hanging track, tungsten spots and fluorescent lighting. Small brick courtyard which could be used for sculpture. Equipment: A few frames. A venue for professional artists based in the West Midlands and others from outside the area. There is a 'young artists' series in which a space is given over to a promising student. A private gallery, which also holds some non-selling shows.

BLAKESLEY
HELEN DARE GALLERIES, The Old Greyhound, The Green, Blakesley, Nr. Towcester, Northants NN12 8RD. Tel. Blakesley 274. Contact: Helen and Martin Ball. Applications: By writing or visiting. Exhibitions: Pottery, sculpture, prints, jewellery and paintings. Continuous exhibition of about 30 artists. Space: A converted barn of about 1000sq ft. Walls are stone (white and natural), spotlighting throughout. Exterior space available for showing sculpture. A private gallery showing predominantly fine art. Whilst showing work by some nationally known artists, the development of relative newcomers is also encouraged and the gallery works closely with local art colleges.

BURTON-UPON-TRENT
BURTON-UPON-TRENT ART GALLERY AND MUSEUM, Guild Street, Burton-upon-Trent, Staffs. Tel. 0283 63042. Opening: Mon-Fri 11-6, Sat 11-5. Contact: R. H. Lockley, Burton Library, High Street, Burton-upon-Trent. Applications: Informally. Exhibitions: Paintings, prints, small sculptures. Mostly Arts Council touring shows, local artists and organisations.

CAMBRIDGE
FITZWILLIAM MUSEUM, CAMBRIDGE, Trumpington Street, Cambridge CB2 1RB. Tel. 0223 69501. Opening: Tues-Sat 10-5, Sun 2.15-5. Contact: Prof. A. M. Jaffé. Applications: By invitation only. Exhibitions: Ancient and modern, eastern and western decorative and fine arts.

KETTLE'S YARD, Northampton Street, Cambridge CB3 0AQ. Tel. 0223 352124. Opening: Exhibition gallery 12.30-5.30, Sun 2-5.30. Permanent collection 2-4 daily. Contact: Jeremy Lewison. Applications: By letter with photographic documentation. Exhibitions: Contemporary and modern art of any kind. About 10 shows per year, mostly one-person, but some groups. Space: At present: brick floor, plaster walls except one brick, top natural lighting, lightspan tracks and concord lighting, 175 running feet, 1050 square feet, ceiling height 7ft 9in and 8ft 9in. Planned extension will be similar size and materials with ceiling height 11ft. Equipment: 1 cassette player, amplifier and two speakers. 1 carousel projector. Kettle's Yard is owned by the University of Cambridge. Exhibitions are funded by the Arts Council of Great Britain. Ten exhibitions are mounted per year of which normally at least eight are originated by Kettle's Yard. The emphasis is on modern and contemporary art although occasionally exhibitions of craftwork are mounted. Some exhibitions are toured to other venues. Exhibitions are aimed at as wide an audience as possible without compromising standards. For this reason the programme is always varied. A series of talks and lectures is generally organised in connection with exhibitions both at Kettle's Yard and elsewhere. School visits and group visits are encouraged. Kettle's Yard is the only major venue for contemporary art in Cambridge and serves the whole region in this respect. Exhibitions are also of interest to those living outside the region, and in particular to those living in London. It aims to bring the most interesting, and the best in contemporary art to Cambridge without neglecting to consider the value of more historical exhibitions of modern art. Its overall aim is to be a centre for learning, education and recreation.

COLCHESTER

THE MINORIES, 74 High Street, Colchester, Essex CO1 1UE. Tel. 0206 77067. Opening: Tues-Sat 11-5, Sun 2-6, closed Monday. Contact: Jeremy Theophilus. Applications: In writing, with slides, a link with the region preferred. Exhibitions: Contemporary fine art and crafts; historical or theme shows of particular relevance to the area; photography; continually changing small shows of crafts and printmakers. Space: The gallery is composed of two Georgian houses, the one retaining the rooms as they were, the other renovated and reconstructed to give three main areas, the largest able to seat 100 persons for concerts. Most rooms are carpeted, with walls covered in timber cladding suitable for screw fixings: Most lighting is Concord track all of which is dimmer controlled. Approx. 500 linear feet hanging space. Equipment: 1 slide projector, Carousel; 6 16in x 20in wooden frames; 25 20in x 30in wooden frames.

The Minories was established to provide an exhibiting facility for Colchester primarily, but since then increased public funding has given it a greater responsibility to the whole region, and its policy has expanded to include this. It can take very large exhibitions as well as the work of very local artists; it shows regularly the Colchester Art Society, and the work of local, regional and national craftspeople. Whilst it exists as a 'touring house' for ACGB exhibitions, it tries to initiate as many of its own shows as well.

COVENTRY

THE ARTS CENTRE, University of Warwick, Coventry CV4 7AL. Tel. 0203 51240. Opening: Mon-Sat 10-6 (10.30 with evening performances). Contact: Haddon Davies, Theatre Manager. Applications: In writing plus submission of slides/photos. Exhibitions: Photography, painting, sculpture by amateur, semi-professional artists and occasional major touring exhibitions. Space: Main foyer, approx. 30sq ft, fluorescent lighting, paved floor. Screens must be used. Equipment: A wide range of audio-visual equipment. Arts Centre has a wide-ranging programme of theatre, music and film.

HERBERT ART GALLERY, Jordan Well, Coventry, W. Midlands. Tel. 0203 25555 ext 2613. Opening: Mon-Sat 10-6, Sun 2-5. Contact: Mr. P. Day. Applications: Slides plus letter. Exhibitions: Any contemporary art of sufficient quality. Loan exhibitions, one-person shows, local art, permanent collection. Space: 3 galleries available for temporary shows – 70ft x 25ft, 52ft x 32ft, 33ft x 32ft, linoleum floors, louvred daylight with blackout, fluorescent and track spotlighting. Equipment: Lecture theatre facilities. Permanent collection of British art. For temporary exhibitions, preference is given to younger artists who show promise.

LANCHESTER POLYTECHNIC GALLERY, Priory Street, Coventry CV1 5FB. Tel. Coventry 24166 ext 525. Contact: Kenneth Mosedale.

DERBY

GREEN LANE GALLERY, 130 Green Lane, Derby. Tel. 368652. Opening: 10-5 (closed Wed), Wed, Thurs and Fri 8-10 also. Contact: Jeffery Tillett. Applications: By letter, with slides. Exhibitions: Contemporary art. Space: 3 gallery rooms – ground floor of a Georgian town house, one of which is a wine bar. Private gallery, linked closely with local community arts trust. Annual craftwork show in December and local (Derbyshire) shows in summer months, at least one show per year for 'young artists'.

GREAT YARMOUTH

GREAT YARMOUTH MUSEUMS EXHIBITION GALLERIES, Tolhouse Street, Great Yarmouth, Norfolk NR30 2SH. Tel. Great Yarmouth

58900. Opening: Mon-Sat 9.30-5.30. Contact: Damian Eaton. Applications: By letter, with biography, etc. Exhibitions: Various local groups, annual open exhibition, travelling exhibitions. Space: 3 galleries about 10m x 6m each, various lighting. Equipment: Slide projector, tape recorder, adjacent lecture theatre for films and slides, screens, plinths and display cases.

HEREFORD
HEREFORD CITY MUSEUMS, Broad Street, Hereford HR4 9AU. Tel. Hereford 68121 exts 207 and 334. Opening: City Museum – Mon, Tues, Wed, Fri 10-6, Thurs 10-5, Sat 10-5. Churchill Gardens – Hatton Gallery 2-5 daily. Contact: A. E. Sandford, Curator, B.A., A.M.A. Applications: By letter. Exhibitions: Local art groups including schools. Art college student shows. Arts Council travelling exhibitions. Single or joint exhibitions. Midlands area service exhibitions. Craft exhibitions. Permanent collection. Craft Council. Space: Maximum wall space of 49 metres, display cases. Equipment: Can be borrowed. Aims above all to serve the local community.

IPSWICH
WOLSEY ART GALLERY, Christchurch Mansion, Ipswich Museums, c/o Dept Recreation and Amenities, Civic Centre, Civic Drive, Ipswich, Suffolk. Tel. Ipswich 53246. Opening: Mon-Sat 10-5, Sun 2.30-4.30. Contact: Miss C. Bennett. Applications: Only one one-person show by a local artist per year. Apply in writing to J.G.R. Bevan, Director of Recreation and Amenities. Exhibitions: Permanent collection, community projects, one major national or regional exhibition, one theme show. Space: 24m x 8m, parque floor, skylight and floodlights. Local artists are involved as much as possible.

KIDDERMINSTER
KIDDERMINSTER ART GALLERY, Market Street, Kidderminster, County of Hereford and Worcester. Tel. 0562 66610. Opening: Daily 11-4, closed Wed, Sun and Bank Holidays. Contact: Michael Dwight, assistant curator. Applications: Open submission. Send slides, photos or examples of work, or phone for appointment. Exhibitions: 2 or 3 group exhibitions per year of contemporary art. Space: 40m of linear hanging space, on brown, hessian-covered screens. Fluorescent lighting and daylight from glass roof. Public gallery aiming to serve the local community. Exhibitions often of a local nature, also Arts Council and museum touring shows. The contemporary art shown should be of an easily accessible kind. Permanent collection of Frank Brangwyn etchings.

KING'S LYNN
FERMOY ART GALLERY, Fermoy Centre, King Street, King's Lynn, Norfolk PE30 1HA. Tel. 0553 4725. Opening: Mon-Sat 10-5. Contact: John Brazier. Applications: In writing with examples of work. Exhibitions: All periods, loan, touring, commissioned. Space: 105ft of linear wall space. Walls are fabric-lined, ceiling spotlights, screens and plinths available. Ample unloading space. Equipment: Slide projector, 16mm projector.

LEAMINGTON SPA
WARWICK DISTRICT COUNCIL ART GALLERY AND MUSEUM, Avenue Road, Leamington Spa, Warwickshire CV31 3PP. Tel. 0926 26559. Opening: Mon, Tues, Fri and Sat 10.45-12.45 and 2.30-5, Wed 10.45-12.45 only, Thurs 10.45-12.45, 2.30-5 and 6-8, closed Sundays. Contact: Curator: Mrs. Margaret A. Slater. Applications: By letter. Exhibitions: Oils, watercolours and craftwork. Space: Four areas, the largest is 29ft x 21ft. Fluorescent and spot lighting. Composition block floor, plaster walls. Permanent collection of 20th century paintings, with a few Dutch and Flemish works. Bi-annual exhibition for young people.

LEDBURY
COLLECTION, 13 The Southend, Ledbury, Herefordshire. Tel. 0531 3581. Opening: Mon-Fri 9-1 and 1.45-5.30, Sat 10-5.30. Contact: Stuart Houghton. Applications: Are accepted, but shows are usually by invitation. Exhibitions: British crafts, both decorative and functional, by established and new craftsmen. Space: 20ft x 30ft, track lighting, floor solid oak block. Equipment: Slide projector, display boxes. Private gallery having 3 or 4 major shows per year.

LEEK
ENGLAND'S GALLERY, 56-58 St Edward Street, Leek, Staffs ST13 5DL. Tel. 0538 373451. Opening: Daily 11-6, Thurs 11-1, closed Sunday. Contact: Frederick J. England. Applications: In writing or telephone for appointment. Exhibitions: Extremely wide range, including work from abroad and first one-person shows, as well as historical shows. Space: About 100 linear feet of wall space, spotlights, track hanging system. Private gallery with a permanent stock of art from the 16th century to the present day. Selection of early works is shown in small gallery and monthly exhibitions in main gallery.

LEEK ART GALLERY, Nicholson Institute, Leek, Staffs. Tel. 0538 2615.

LEICESTER
THE LEICESTERSHIRE MUSEUM AND ART GALLERY, New Walk, Leicester LE1 6TD. Tel. 0533 554100. Opening: Weekdays 10-5.30, Sun 2-5.30. Contact: Assistant Director Arts – Norman Pegden. Keeper – Robin Paisey. Applications: By letter. Exhibitions: Contemporary art from this country and abroad, from major retrospectives to simple one person or group shows. Space: Approx. 1000sq metres of divisable space, fully air-conditioned, controlled lighting u/v filtered, daylight and spotlighting, carpeted timber floors. Belgrave Hall

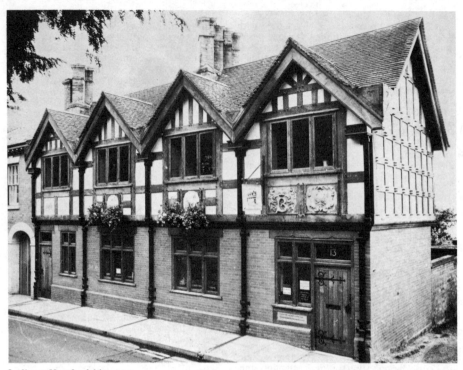

Ledbury Herefordshire

Gardens can be used for displaying sculpture outside. Equipment: Usual audo-visual equipment available. Permanent collection of British Art (17th-20th century), French Impressionists and German Expressionists.

LICHFIELD
LICHFIELD DISTRICT ART GALLERY, Bird Street, Lichfield, Staffs. Tel. Lichfield 24972. Contact: Dr. Graham Nicholls. Applications: To Samuel Johnson, Birthplace Museum, Breadmarket Street, Lichfield, Staffs WS13 6LG. Exhibitions: Any work which it is possible to hang. Some small cases available for three-dimensional work. Space: Large, open room with screens around the walls, skylight.

LOUGHBOROUGH
COTES MILL, Nottingham Road, Loughborough, Leics LE12 5TL. Tel. 0509 31786. Contact: Marie Leahy. Exhibitions: A new gallery, part of a converted watermill. Shows a good deal of performance and installation work, also sculpture and some painting. Interested in the work of younger artists.

NORWICH
CASTLE MUSEUM, Norwich NR1 3JU. Tel. 0603 22233 ext 630/637. Opening: Mon-Sat 10-5, Sun 2-5. Contact: Mr. Francis Cheetham.

Applications: By invitation only. Exhibitions: From permanent collection; local societies; travelling shows. Space: 67ft x 28ft, fluorescent and spot lighting, wood block floor.

LIBRARY CONCOURSE, University of East Anglia, Norwich NR4 7TJ. Tel. 0603 56161. Opening: Term – Mon-Fri 9-10, Sat 9-5, Sun 2-7. Vacation – Mon-Fri 9-6. Contact: The Librarian, Mr. W. L. Guttsman. Applications: Directly to Mr. Guttsman. Exhibitions: Mainly modern art. Space: 250sq metres, 93m wall and screen, tube and track lighting. 12 showcases.

NORWICH SCHOOL OF ART GALLERY, St. George Street, Norwich NR3 1BB. Tel. 0603 610561/5 ext 62. Opening: Mon-Fri 10-7, Sat 10-5, closed during the school holidays. Contact: Lynda Morris. Applications: Send slides/photographs. Exhibitions: Concentrate on aspects of the subjects taught at the school – painting, sculpture, graphic design, printmaking and photography. Space: Rectangular 38 x 26ft, with plate glass window facing onto the street, polished wood floor and moveable screens, track lighting. Equipment: Frames, display cases and other equipment can be borrowed from school. One of the principles

of the gallery is to encourage students to participate in the origination and organisation of exhibitions, and students are able to work on gallery projects in their second year. Theme exhibitions are organised which are open to contributions from all members of the school, and there are occasional exhibitions of staff work and departmental work. This is, in addition to exhibitions organised by the curator and other members of staff, exhibitions of individual and groups of artists and designers and hired exhibitions. We are also interested to show groups of student work for other schools and colleges.

PREMISES, NORWICH ARTS CENTRE, Reeves Yard, St. Benedicts Street, Norwich. Tel. 0603 60352. Opening: 10.30-6. Contact: Ms. Nicky Whitworth, Administrator. Applications: In writing or person with documentation or examples of work. Exhibitions: Any work that is of artistic or documentary interest to the local community. Space: The Arts Centre is undergoing extensive conversion work, a new gallery will be created by summer 1982. At present, exhibitions will be held in the hall and the church. There are lawns which are used for exhibiting sculpture and performance, an aspect which they are keen to develop. Equipment: 20 frames (wooden) 3ft 6in x 2ft 6in, slide projector, hessian screens. The arts centre has a full programme of theatre, dance, mime, jazz and contemporary and early music; also various projects in the community. The gallery shows a mixture of community oriented exhibitions and major contemporary art shows. Lectures and informal talks by artists.

SAINSBURY CENTRE FOR VISUAL ARTS, University of East Anglia, Norwich, Norfolk NR4 7TJ. Tel. 0603 56161. Opening: Tues-Sun inclusive 12-5, closed for Easter and Christmas. Contact: Keeper – Dr. Alan Borg. Applications: By letter, with C.V. and slides or photographs; there is generally a two year waiting list. Exhibitions: A balance between historical and contemporary exhibitions. About 8, mostly group shows, per year. Space: 400sq metres, screen system hanging, combination of natural and overhead spot lighting. Gallery is surrounded by grassed areas. Equipment: Video equipment and slide projectors. A very large, extraordinary new building, housing a permanent collection of ethnic art and contemporary painting and sculpture, the space for temporary exhibitions is relatively small.

NOTTINGHAM
CASTLE MUSEUM AND ART GALLERY, Nottingham NG1 6EL. Tel. 0602 411881. Opening: Apr-Sept 10-6.45 daily, Oct-Mar 10-4.45 daily. Contact: Brian Loughborough. Permanent collection of ceramics, silver, glass, alabaster carvings etc. Two temporary exhibition galleries.

FOCUS GALLERY, 108 Derby Road, Nottingham. Tel. 417913. Opening: Mon-Sat 9.30-5.30. Contact: Norman Rowland. Applications: By phone or letter. Exhibitions: Oils, watercolours, prints, sculpture etc. Only 2-3 group shows each year. Space: Two basement rooms containing about 200 linear feet of wall space. Carpeted, spotlights and fluorescent lighting. A private gallery aiming to show the best of British 2- and 3-dimensional art.

MIDLAND GROUP GALLERY, 24-32 Carlton Street (Warser Gate entrance), Nottingham NG1 1NN. Tel. 0602 582636. Contact: Exhibitions Organiser. Opening: Mon-Sat 10.30-5. Applications: By letter with slides/photographs. Exhibitions: Mainly contemporary fine art, including performance, also photography, jewellery, ceramics and an interesting film programme.

NOTTINGHAM UNIVERSITY ART GALLERY, Portland Building, University Park, Nottingham NG7 2RD. Tel. 0602 56101. Opening: Mon-Fri 10-7, Sat 11-5. Contact: Mr. John Wilton-Ely. Exhibitions: Range from old masters to latest developments in contemporary art.

NUNEATON
NUNEATON MUSEUM AND ART GALLERY, Riversley Park, Nuneaton, Warwicks. Tel. 0682 338263.

PETERBOROUGH
PETERBOROUGH CITY MUSEUM AND ART GALLERY, Prestgate, Peterborough. Tel. 0733 43329. Opening: Tues-Sat 12-5, Nov to May. Tues-Sat 10-5, June to Oct. Contact: Dr. Peter Crowther (Asst. Curator). Applications: To the above, preference given to local artists. Exhibitions: 2 and 3 dimensional work, no restrictions. Space: 2 galleries available for temporary exhibitions, one 50ft x 24ft, the other 24ft square. Good top natural lighting, so fluorescent lighting is not used during the day, polished wood floors. The primary aim is to promote local and regional artists.

RUGBY
RUGBY LIBRARY GALLERY (Authority: Warwickshire County Council), Rugby Library, St. Matthew's Street, Rugby, Warwickshire CV21 3BZ. Tel. Rugby 2687/71813. Opening: Mon, Tues, Thurs, Fri 9.30-8, close 5pm Wed, close 4pm Sat. Contact: The Librarian. Applications: From art societies only, not individual artists. Exhibitions: Local interest; travelling shows; privately hired exhibitions. Space: 40ft x 25ft.

STAFFORD
STAFFORD MUSEUM AND ART GALLERY, The Green, Stafford. Tel. 0785 57303. Opening: Tues-Sat 10-5. Contact: John Rhodes. Applications: In writing. Exhibitions: Contemporary, fine art, photography and craft. Space: Two rectangular spaces each 40ft x 20ft. Floor t.p.

tiles, walls hessian painted white. Lighting – fluorescent – some track spotlight. Equipment: Carousel projector slides synchronised tape recorder. Selection of about 75 aluminium section frames. The gallery shows a wide range of contemporary work from the visual arts. Work of any visual artist is considered although for practical and economical reasons, those living or working in the West Midlands region are given preference.

STOKE-ON-TRENT
STOKE-ON-TRENT CITY MUSEUM AND ART GALLERY, Bethesda Street, Hanley, Stoke-on-Trent, North Staffs. Tel. 29611. Opening: Mon-Sat 10.30-5 (Wed 10.30-8). Contact: Mr. A. R. Mountford. Applications: Write enclosing slides/photos, or make an appointment. Exhibitions: Anything considered; falling into following categories – (a) from permanent collection (b) Major touring shows (c) Shows of regional importance (d) Mixed and one-person shows by contemporary artists, including emphasis on the best local artists. Space: Up to 214 metres of linear hanging space, in two galleries, dimmable lighting on track network, screens available. Equipment: Slide projector, frames, plinths. Traditional and more adventurous shows are often shown together. Galleries were completed only a year ago and are some of the most flexible and up-to-date in the Midlands region, perhaps best compared to the Ikon Gallery in Birmingham.

WALSALL
WALSALL MUSEUM AND ART GALLERY, Lichfield Street, Walsall, West Midlands WS1 1TR. Tel. 916 21244. Contact: Valerie Wynn.

WOOD GALLERIES, 1 Day Street, Walsall, West Midlands. Tel. Walsall 33437. Opening: Wed, Fri and Sat 10-5. Contact: Mike Wood. Applications: Personally, with work. Exhibitions: All fields – no restrictions other than size. Space: Three galleries on first floor of building – one room 24ft x 13ft, two rooms 10ft x 9ft. Track lighting system in large gallery, fluorescent lighting in others. A privately funded gallery, which is the only one of its kind holding regular exhibitions of living artists' work in the area. Although not specialising in local artists' work, they do get a fair showing and the aim is to expand the involvement and appreciation of all art forms.

WOLVERHAMPTON
THE TETTENHALL GALLERY, 1B Upper Green, Tettenhall, Wolverhampton, West Midlands. Tel. Wolverhampton 756958. Opening: Tues, Thur, Fri, Sat 10-6. Contact: Cynthia Jenkins, Thomas Jenkins. Applications: By letter, phone or personal contact. Exhibitions: Amateur and professional work, also students. All aspects of contemporary art. Group or two-person shows. Space: Two

ground floor rooms, the largest is 16ft x 12ft, one first floor room 16ft x 9ft. White walls, strip lighting, carpet throughout. Equipment: Frames available. A new private gallery providing a service that is badly needed in Wolverhampton for both the artist and the art viewing public.

WOLVERHAMPTON ART GALLERY, Lichfield Street, Wolverhampton WV1 1DU. Tel. 0902 24549. Opening: Mon-Sat 10-6. Contact: David Rodgers. Exhibitions: Fine and applied arts, photography, local and social history. Space: Three galleries – 2 at roughly 140sq yds, 1 at 60sq yds. Fluorescent and spotlights, air-conditioned, no natural light. Equipment: Anything within reason can be obtained. Normally artists are invited to exhibit, but applications accompanied by slides are sympathetically considered. Programme is usually finalised 12 months ahead.

WOLVERHAMPTON POLYTECHNIC GALLERY, Faculty of Art and Design, North Street, Wolverhampton WV1 1DT. Tel. Wolverhampton 29911. Contact: Bill Kimpton.

WORCESTER
CITY ART GALLERY, Foregate Street, Worcester WR1 1DT. Tel. 0905 25371. Opening: Mon, Tues, Wed, Fri 9.30-6, Sat 9.30-6, closed Thurs and Sun. Contact: Principal Curator. Applications: In writing, or personal visit, priority given to local artists. Exhibitions: All aspects of contemporary art and crafts, also shows drawn from permanent collection. Space: Artists are welcome to use all or any combination of three galleries. Two are 25ft x 18ft, third is 46ft x 22ft. Wall surface – hessian over matchboard, fluorescent lighting with dimmers and spotlighting. Equipment: Slide projector, tape recorder.

FRAMED, 46 Friar Street, Worcester. Tel. 28836. Opening: Tues-Sat inc. 10.30-4.30. Contact: David Birtwhistle, Michael Westby. Applications: Submit portfolio or six framed works. Exhibitions: Contemporary paintings and original prints. Space: Mediaeval timber framed buildings on three floors, hanging track suspension, carpeted floors, 200-300 paintings all displayed, none held in stock. Tungsten track spotlighting. A private gallery, close to the cathedral, showing a wide range of contemporary work.

WORKSOP
NOTTINGHAMSHIRE COUNTY LIBRARY, Memorial Avenue, Worksop, Notts. Tel. Worksop 472408. Opening: Mon, Tues, Wed and Fri 9.30-7.30, Thurs and Sat 9.30-1. Applications: To the above address. Exhibitions: Local and national. Space: Cork covered walls, picture rails, about 200 linear feet of hanging space, fluorescent and spotlighting.

SOUTHERN ENGLAND

BAMPTON
BAMPTON ARTS CENTRE, Town Hall, Bampton, Oxon. Tel. 0993 850137. Opening: Tues, Thurs, Fri, Sat 10.30-1 and 12.30-5, Sun 2.30-4.30. Contact: A. Baynes. Space: 30ft x 15ft plus screens.

BARNSTAPLE
NEW THEATRE GALLERY, North Devon College, Old Sticklepath Hill, Barnstaple, North Devon. Tel. 0271 5291 ext 67. Opening: Weekdays during the academic year 9-5.30. Contact: Robin Wiggins, Head of Creative Arts. Applications: By letter or interview. Exhibitions: Mainly 2D. Space: Unusual – 46ft x 56ft at its widest points. Spotlighting. Equipment: Slide projectors, tape recorders. Gallery is part of a creative arts block that includes a public theatre. Encourages young artists particularly. Best exhibiting space in North Devon. Artist meets most of the exhibition costs.

BASILDON
TOWNGATE GALLERY, Towngate Theatre, Towngate, Basildon, Essex. Tel. 0268 23953. Opening: 10.30-10. Contact: Eileen Townsend Jones. Applications: Phone to make an appointment, or send in slides/photos. Exhibitions: Cross section of work – wall mounted exhibits and large freestanding sculptures only – by professional, semi-pro and occasionally amateur artists or groups. Space: Unsupervised gallery at ground floor level, squarish room with windows at ceiling level, hanging space of 63ft, carpeted floor, track spotlighting. Public courtyard for large sculptures. Gallery is within an arts centre with 460 seat theatre. Most work shown is by artists resident in S E Essex. Cost of publicity is borne by the artist.

BASINGSTOKE
CENTRAL STUDIO, Queen Mary's College, Cliddesden Road, Basingstoke, Hants. Tel. Basingstoke 20861. Opening: 9-4 and 7.30-10.30. Contact: Sarah Pew. Space: 60 linear metres.

WILLIS MUSEUM AND ART GALLERY, New Street, Basingstoke, Hants. Tel. Basingstoke 65902. Opening: Mon 1-5, Tues-Sat 10-5, closed Sun. Contact: Ex. Officer – J. D. Stewart. Applications: Supply evidence of work to the Director. Exhibitions: From permanent collection, industry and Southern Arts, also from other museums. Space: 28 linear metres of wall space, two track concorde lighting, carpet. Yard at back can be used for sculpture.

BATH
FESTIVAL GALLERY, 1 Pierrepont Place, Bath. Tel. Bath 60394. Opening: Tues-Sat 11-5. Contact: Mrs. V. Stevens. Applications: Submit slides or photographs or actual work. preferably with West Country bias. Exhibition: Paintings, sculpture, ceramics, prints, jewellery, in variety of styles. Mostly one-person shows.

Space: Two rooms, 26ft x 11ft and 17ft x 15ft, carpets, spotlighting on tracks. Also exterior spaces.

MELTONE GALLERY, 32 Barton Street, Queen Square, Bath. Tel. 0225 26020. Contact: M. E. & J. Litherland.

PACKHORSE GALLERIES, 5 George Street, Bath BA1 2EJ. Tel. 0225 66755. Contact: R. M. A. Wood.

RPS NATIONAL CENTRE OF PHOTO-GRAPHY, The Octagon, Milsom Street, Bath BA1 1DN. Tel. 0225 62841. Opening: Mon-Sat 10-6 (Easter to October), Mon-Sat 10-5 (November to Easter 1982), Sun 10-5. Contact: Mrs. Julie P. Davis – Manager. Applications: In writing, initially, from 1981. Exhibitions: Contemporary and historical photography. Space: (1) Octagonal room with 120ft of wall space and free standing screens. (2) Upper Hall with 100ft of wall space. Mostly artificial light. Equipment: Slide projectors.

VICTORIA ART GALLERY, Bridge Street, Bath. (Correspondence to: Bath Museums Service, 4 Circus, Bath). Tel. 0225 61111 ext 418. Opening: Mon-Fri 10-6, Sat and Bank Holidays 10-5. Contact: Miss Marjorie Pringle. Applications: In writing to Exhibitions Officer. Exhibitions: Contemporary work and items form permanent collection. Space: Approx. 350 feet of hanging space. Natural and artificial light. Equipment: Slide projector. Municipal Gallery with permanent collection of Old Master and 18th-20th century paintings and prints. There is a lively programme of travelling and special exhibitions.

BIDEFORD
BURTON ART GALLERY, Kingsley Road, Bideford, North Devon. Tel. Bideford 6711 ext 275. Opening: Weekdays 10-1, 2-5, Sat 9.45-12.45, closed all day Sun. Contact: Curator – J. Butler. Applications: By obtaining an applications form from T.D.C. (Secretariat Dept.), Bridge Buildings, Bideford, North Devon. Exhibitions: Varied, but largely of a local flavour. Space: 60ft x 40ft, screens over permanent exhibits, diffused lighting. A public gallery, with a permanent collection of paintings, ceramics and furniture.

OLD FORD GALLERY, New Road, Bideford, North Devon EX39 5JG. Tel. Bideford 3434. Opening: 10-6 Easter to Christmas daily except Sun and Mon. July and August daily except Sun. From Christmas to Easter by appointment. Contact: Desmond E. Simpson. Applications: West Country artists only, unless well-known. Exhibitions: Permanent moving exhibition of fine arts and crafts of the West Country. One-person and group shows of living painters' and sculptors' work. Space:

(1) Mediaeval Hall 25ft x 30ft. (2) Barn Gallery 22ft x 26ft. (3) Georgian Room 18ft x 15ft. Oldest house in Bideford, built of local stone, with high ceilings, wooden beams etc. Spotlights and striplights, various floor coverings and wall surfaces.

BLANDFORD

THE HAMBLEDON GALLERY, 42-44 Salisbury Street, Blandford, Dorset. Tel. Blandford 52880. Opening: Mon-Sat 9-5. Contact: Mrs Kitty West, Mrs Wendy Suffield. Applications: By showing work to the gallery. Exhibitions: Mostly well known British artists – Moore, Frink, Piper, Sutton etc., some local artists; 8-9 shows per year. Space: Roughly 25sq ft above shop, with shelf space for pottery and small sculpture. Thirty three and one third per cent commission on sales.

BLETCHINGLEY

CENTRE GALLERY, Bletchingley Adult Education Centre, Stychens Lane, Bletchingley, Surrey. Tel. Godstone 842115. Opening: Weekdays 9.30-5 General Public, Weekdays 7.30-9.30 Student Members, Weekends by appointment. Contact: Gus. H. Hyatt. Applications: By phone or letter to Gus H. Hyatt, Head of Art Dept., Tandridge A. E. Institute, Caterham Valley Adult Education Centre, Beechwood Road, Caterham, Surrey. Tel. Caterham 45398. Exhibitions: Paintings, drawings, prints, craftwork, small sculpture, local history, community education. Group and one-person. Space: Approx. 60 linear feet of hanging space, only suitable for fairly small works, spotlights and natural light. Equipment: Slide projectors, overhead projector, 16mm projector, video recorder plus monitor, tape recorders.

BRACKNELL

SOUTH HILL PARK ARTS CENTRE, Bracknell, Berkshire. Tel. 0344 27272. Opening: 9-1, 2-5, 7-10.30, Sat/Sun 12-5, 7-10.30. Contact: Jennifer Walwin. Applications: Initially by letter, enclosing colour slides. Exhibitions: Contemporary work in all fields – fine art, craft, photography and performance. Permanent collection of outdoor sculpture. Between 20 and 25 exhibitions, one-person and group, per year. Space: Main Gallery – 30ft square, wooden floor, many windows, track lighting, 75ft of linear wall space. Long Gallery – 30ft long, windows on one side, carpeted floor, track lighting, 50ft of linear wall space. Staircase Area – Extension of main entrance, deep walls, mostly suitable for large paintings

South Hill Park Arts Centre, Bracknell, Berkshire

and woven/printed textiles. Smaller wall areas adjacent, suitable for drawings/photographs. About 90 linear feet of wall space. The centre is surrounded by 15 acres of unfenced parkland and is highly suitable for showing sculpture and outdoor performances. Equipment: Most of the Art Centre's facilities can be made available to exhibiting artists. Touring exhibitions of craftwork are organised each year; in August there are outdoor projects related to the permanent collection. Remainder of the programme is divided between more popular shows (e.g. cartoons and kites), work from the local community (e.g. murals from local primary schools), group shows by local younger artists and one-person shows of a more experimental nature by established artists.

BRIDGWATER

BRIDGWATER ARTS CENTRE, 11 Castle Street, Bridgwater, Somerset TA6 3DD. Tel. Bridgwater 422700. Opening: Tue-Fri 10.30-7 (later when meetings and performances take place), Sat 10.30-1. Contact: John Ridley. Applications: By letter. Exhibitions: Paintings, pottery, sculpture, prints, mostly one-person shows, from 20 to 24 per year. Space: Exhibitions are held in theatre foyer and rooms and some corridor space is available. Foyer: 4.27m x 6.10m; 2.60m high. Exhibition room: 4.57m x 3.96m; 3.05m high. Walls are very light grey, hessian in corridor. Hanging system – picture rail, not possible to screw to walls. Daylight is from North in exhibition room and foyer, skylight in corridor. Lighting: Rotaflex track with 20 x 100W lamps. Equipment: 16mm sound projector, Sony stereo tape recorder, turntable, amps and speakers. Full stage lighting. Selection of rostra. 20% commission on sales.

BRIGHTON

AXIS GALLERY, 12 Market Street, The Lanes, Brighton, Sussex. Tel. Brighton 203193. Opening: Mon-Sat 10-6, Sun 12-6. Contact: Ron Cservenka. Exhibitions: Exclusively contemporary art – the work of more established artists exhibited alongside that of lesser-known and new artists. Comprehensive stock of contemporary graphics. Regular one-person and group shows. Space: Modern, well-lit, on three floors. A private gallery, formerly 'Gallery of Portland St.'

BRIGHTON ART GALLERY AND MUSEUMS, (Royal Pavilion), Church Street, Brighton. Tel. 0273 63005. Opening: Tues-Fri 10-6, Sat 10-5, Sun 2-5. Contact: Duncan Simpson. Exhibitions: Regular commitments include the Brighton Festival and an annual open exhibition to which any local artist or photographer may submit work. At other times, exhibitions are wide ranging in subject matter. Space: 3 galleries (for temporary exhibitions) totalling 3000sq ft. Permanent displays of ethnography, archaeology, paintings, etc.

BRIGHTON POLYTECHNIC GALLERY, Faculty of Art and Design, Brighton Polytechnic, Grand Parade, Brighton. Opening: Mon-Fri 9-8. Contact: Julian Freeman. Applications: By letter, enclosing slides/photos and as much information as possible. Exhibitions: Fine and applied art, some crafts, occasionally sculpture and mixed media work, mostly contemporary work. Space: 77ft x 19ft, three large pillars and one wall is windows, looking out on to the street, screens available, concrete floor, spotlighting and daylight. Equipment: Frames, slide projectors and back projection, cassette recorders and video equipment can be obtained from Polytechnic.

THE BURSTOW GALLERY, Brighton College, Eastern Road, Brighton BN2 2AL. Tel. 0273 606033. Contact: Maurice De'Ath. Exhibitions: Paintings, drawings and prints, or visual material of an educational nature. Space: 900sq ft divided into two areas. Gallery is situated in the college and adjoins the main hall which has seating for 300/400. Exhibitions can be arranged to coincide with concerts, seminars etc.

GALLERY 20, 20 Bristol Road, Kemptown, Brighton, East Sussex. Tel. 0273 604566. Opening: Mon-Sat 10-6, closed Wednesdays. Contact: Peter Nichols. Applications: Always pleased to hear from professional artists with a view to exhibiting their work or perhaps suggesting alternative venues for exhibit or promotion. Slides or photos should be sent with return postage giving sizes and prices of work along with details about the artist. Work usually shown is painting but occasionally graphics and or other work by artists. Photographs are also sometimes considered. Eight exhibitions a year usually one man shows. Framing service also available at the gallery. Privately funded.

GARDNER CENTRE GALLERY, University of Sussex, Falmer, Brighton, East Sussex BN1 9RA. Tel. 0273 685447. Opening: 10-6, closed Sundays. Contact: Hilary Lane (Visual Arts Organiser). Applications: By letter in the first instance, with supporting material. Exhibitions: One-person shows form a small part of the programme, only 2 or 3 per year; these are small exhibitions by one person (4 or 5 per year), the rest are group shows. A wide range of work is shown, mostly contemporary, painting, sculpture, mixed media, prints etc. Space: Gallery – White painted plaster walls and an interesting screen system, giving approx. 230 linear feet of wall space, quarry tiled floor, spotlighting and natural light. Foyer – Brick staircase and plaster landing area giving 64 linear feet, rod system for hanging. Sculpture can be shown outside, but work cannot be insured and may be at risk. Equipment: Some standard frames available – 20 @ 30in x 40in,

10 @ 30in x 20in, 50 @ 15in x 12in. Projectors, sound equipment etc. can usually be borrowed. The Gallery forms part of an arts centre where ballet, dance, classical and contemporary music and theatre are shown. The gallery space itself is an interesting, curved shape with dramatic, high windows looking out onto water and grass.

BRISTOL
ARNOLFINI GALLERY, 16 Narrow Quay, Bristol BS1 4QA. Tel. 0272 299191. Opening: Tues-Sat 11-8. Contact: Lewis Biggs. Applications: Send documentation by post. Exhibitions: Contemporary developments in visual art. A balance of 2-dimensional, 3-dimensional and time-based work. Ten 'major' and ten smaller shows are held each year, most of these are one-person exhibitions. Space: Two large galleries, each with 170 linear feet of hanging space and an area of about 1700sq ft. Floors are polished wood blocks, no daylight, spots only. There is also an open air 'sculpture park' 50ft square and an auditorium seating 150 which can be used to show films, music or dance events. Equipment: Most things can be arranged, finance permitting. The largest venue for contemporary work in the south west, the Arnolfini aims to stage exhibitions of a sufficiently high quality to attract the attention of the national and international art world. A programme of discussions, films and lectures is organised, to provide a context for the work. There is also a print loan scheme, Artists in schools placement scheme (for the south west) and the gallery acts as artists' agent in finding commissions. There is also a full-time public cinema, a music and jewellery programme, restaurant, bar and specialist art bookshop.

BRISTOL ARTS CENTRE, 4/5 King Square, Bristol 2. Tel. 45008. Opening: Mon-Sat 9-11. Contact: Visual Arts Organiser – Deborah Ely. Applications: In writing enclosing slides or by completing an application form. Exhibitions: Primarily photography – no facilities for three dimensional work. Some painting – usually group shows of work by pre-formed groups (Artspace, Artists Union etc). Educational and historical exhibitions. Some installation and performance work. Space: Gallery space: 18ft x 20ft with Georgian windows, spotlighting, carpeted floors. Situated on the first floor. Concourse area – 55 running feet with spotlighting, carpeting and chipboard walls. Bar area 15ft x 30ft walls broken by Georgian panelling and windows. Spotlighting. Grassed square in front of the building suitable for performance – slight slope unsuitable for sculpture. Equipment: Tape recorder/record player/access to projectors and limited access to framing. The Arts Centre houses cinema, dance, theatre and informal music – for both performance and workshop activity. The original policy – to provide a much needed

venue for local artists, has been expanded to link the visual arts with other areas of activity within the Arts Centre and to show work which has some relationship to current social, political and aesthetic debates.

BRISTOL CITY ART GALLERY, Queen's Road, Clifton, Bristol BS8 1RL. Tel. 0272 45008. Opening: Mon-Sat 10-5. Contact: Arnold Wilson. Permanent collection and temporary exhibition programme.

35 KING STREET GALLERY, 35 King Street, Bristol 1. Tel. Bristol 20926. Opening: Mon-Fri 10-7.30, Sat 12-7.30. Contact: Carole Innocent. Applications: By letter, enclosing slides or photos. Exhibitions: The gallery holds three fine art shows a year (normally one or two-person exhibitions); two mixed 'selling' shows, which include painters, printers and craftsmen; one architectural exhibition and two or three 'design' shows, or ones with particular reference to the West Country. Space: Ground floor of a Victorian warehouse, area is roughly 40sq ft, with rough stone walls, a flagstone floor and 6 cast iron columns supporting a timber beamed ceiling. Central track lights and additional lighting near the walls. Equipment: Frames. The gallery was the conception of a group of architects working in the south west, who felt there was a need for a gallery that would be concerned with a broad spectrum of exhibitions, ranging from fine art and design through to architecture and technology. In the fine art area, mainly figurative work is shown.

NAILSEA GALLERY, 71 High Street, Nailsea, Bristol. Tel. Nailsea 6763. Contact: John Griffiths.

PARK STREET GALLERY, 52 Park Street, Bristol. Tel. 0272 26602. Opening: Mon-Sat 9-5.30. Contact: Andrew Gilman. Exhibitions: Monthly shows of contemporary painting, sculpture and graphics. West Country artists preferred, mainly one-person shows. Artists from outside the region may apply. Gallery is part of a specialist fine art bookshop.

PATRICIA WELLS GALLERY, Morton House, Thornbury, Bristol BS12 1RA. Tel. Thornbury 412288. Opening: Daily 11-5, during exhibitions, otherwise by appointment. Contact: Patricia Wells. Exhibitions: Living artists, one-person and mixed shows.

PHOTOGRAPHERS ABOVE THE RAINBOW, 10 Waterloo Street, Clifton, Bristol 8. Contact: Adrian Loveless.

ROYAL WEST OF ENGLAND ACADEMY, Queen's Road, Clifton, Bristol BS8 1PX. Tel. 0272 35129. Opening: 10-5.30 during exhibitions; staff available 9-5 at other times. Contact: Jean McKinney, Organising Secretary. Applications: Write to the Organising Secretary giving full details, and sending slides if possible.

The request will be passed on to the exhibitions committee for consideration. Two years notice is normally required. Exhibitions: Drawings, paintings, water colours, sculpture (if not too heavy). Space: All five galleries are extremely well proportioned and all have natural lighting. Walls are hessian covered tongue and groove cladding, painted silver-grey. Floors are highly polished wood strip. Sizes of galleries may be obtained on application to the Organising Secretary. The general policy of the RWA's Council is to keep a steady flow of exhibitions including national travelling exhibitions on occasion e.g. Peter Lanyon, Terry Frost, the National Children's Art Exhibition. The RWA is a society of artists and the first consideration is given to its own members and to artists whose work is either known to members of the council or whose work has been accepted for an annual exhibition.

CANTERBURY

GULBENKIAN THEATRE GALLERY, University of Kent, Canterbury, Kent. Tel. 0227 66822. Opening: Weekday afternoons 2-6 and theatre opening times (most evenings). Contact: Stephen Bayley. Exhibitions: Transferred from other galleries and some mounted independently. Space: Foyer area of theatre.

JOHN NEVILL GALLERY, 43 St. Peter's Street, Canterbury, Kent. Tel. 0227 65291. Opening: Mon-Sat 10-1, 2.30-5.30. Half-day Thurs. Contact: John Nevill. Exhibitions: Modern paintings, drawings and lithographs. 33% commission on sales, artist pays for printing and postage.

THE ROYAL MUSEUM, High Street, Canterbury, Kent. Tel. 0227 52747. Opening: Mon-Sat 10-5. Contact: Ken Reedie. Exhibitions: Wide range – crafts, painting and photography from local and national sources. Space: Main gallery 50ft x 25ft, hanging rail and rods, flexible track lighting. Smaller gallery 20ft x 12ft with screens.

CHAGFORD

CHAGFORD GALLERIES, 20 The Square, Chagford, Devon. Tel. Chagford 3287. Opening: 10-1, 2.30-5, closed Sun and Wed. Part-time winter opening advisable to phone. Contact: Mrs. June Ashburner. Applications: Telephone or write to the owner. Exhibitions: Paintings, prints, crafts. Space: About 80 linear feet of wall space, natural and spotlighting, carpet.

CHELTENHAM

HERITAGE GALLERY, 29 Suffolk Parade, Cheltenham, Glos. Tel. Cheltenham 24724. Opening: 10-6. Contact: Mrs. S. E. Forge. Applications: Only work that has a chance of selling. Apply by phone or letter. Exhibitions: Fine and applied art, including sculpture, jewellery, painting and engraved glass. Space:

Two areas, 24 x 14ft and 12ft square, natural and spotlights. Equipment: Tape recorder. A private gallery providing a show-room for artists and craftsmen, locally and further afield, established in 1974.

CHICHESTER

CHICHESTER CENTRE OF ARTS LTD., St. Andrew's Court, East Street, Chichester, W. Sussex. Opening: Evening events – times to suit. Exhibitions – mainly 10.30-4.30. Contact: Mrs Doris A. Wilson. Applications: Give fullest possible information. Exhibitions: Mainly group shows, covering painting, sculpture, collage and crafts. Space: Size 66ft x 21ft, hanging rails, plaster walls. The building is converted 13th century church, with good natural lighting, with the addition of fluorescent lighting. Gallery is part of an arts centre whose activities include music, poetry reading and practical workshops.

PALLANT HOUSE GALLERY, 9 North Pallant, Chichester, West Sussex. Contact: Neil Colyer. Space: A new gallery housing temporary exhibitions in a space 33ft x 27ft, giving 120ft linear space, plus 100 on screens.

CHIPPENHAM

FOX TALBOT MUSEUM, Lacock, Near Chippenham, Wilts. Tel. Lacock 459. Opening: 11-6. Contact: Robert Lassam. Exhibitions: Early and some contemporary photography.

CHRISTCHURCH

THE RED HOUSE MUSEUM AND ART GALLERY, Quay Road, Christchurch, Dorset. Tel. Christchurch 482860. Opening: Tues-Sat 10-5, Sun 2-5. Contact: Kenneth Barton, Hampshire County Museum Service, Chilcomb House, Chilcomb Lane, Bar End, Winchester. Applications: Local artists preferred. Exhibitions: All types of two and three dimensional art especially by local artists. Group and one-person shows. Space: 130ft of linear wall space, spotlights and natural light.

CIRENCESTER

THE DELAHAYE GALLERY, 24 Castle Street, Cirencester, Glos GL7 1QH. Tel. 0285 4674. Opening: Daily 9-5.30 except Thurs afternoons and Sundays (closed). Contact: Jane and Patricia Sampson. Applications: Submit selection of work and/or photographs plus biography. Exhibitions: Figurative, abstract contemporary art, sometimes craft. Interested in promoting the work of young artists of promise. Space: Main gallery – 15ft x 15ft, Entrance hall and stairs – 300sq ft, Tungsten and fluorescent lighting. A private gallery, providing a wide and varied programme of contemporary art.

ERNEST COOK GALLERY, Cirencester Workshops, Cricklade Street, Cirencester, Glos. Tel. Cirencester 61566. Opening: 10-5.30. Contact: Jessica Taplin. Applications: Local artists/craftsmen only. Exhibitions: Mostly

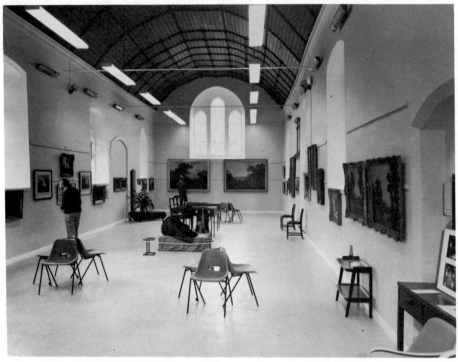

Chichester Arts Centre

group shows of painting, pottery, textiles, photography, ceramics etc. Space: 42ft x 20ft – good lighting, matted floor, white walls. Also a paved courtyard outside. The gallery is part of Cirencester Workshops, which provides studio space for eleven working craftsmen. The centre was created, and is now managed, by a charitable trust which is non-profitmaking and has as its objective the education of the public in the appreciation of the arts and crafts.

COLYTON
THE MARKET PLACE GALLERY, The Market Place, Colyton, Devon. Tel. Colyton 52918. Opening: 10-1, 2.15-5, closed Wed afternoons and Sun. Contact: Miss P. Rattray. Applications: In writing, enclosing slides, or by personal visit. Exhibitions: Contemporary art. Mixture of group and one-person shows. Space: Natural light and spotlights.

COOKHAM
STANLEY SPENCER GALLERY, Kings Hall, High Street, Cookham, Berkshire. Opening: Easter to October daily 10.30-6. Nov to Easter, Sat, Sun, Bank Holidays 11-5. Shows the works of Stanley Spencer in the village where he was born and worked.

CRAWLEY
IFIELD BARN, Rectory Lane, Ifield, Crawley, W. Sussex. Tel. Crawley 513355. Contact: Mrs Honor Edwards.

CROWBOROUGH
GILLRIDGE GALLERY, Gillridge Farm Oast, Crowborough, E. Sussex. Tel. 089 26 2494. Opening: Friday (all day), Sat mornings and by appointment. Exhibitions: Emphasis on contemporary art, engravings, aquatints etc. Space: 28ft x 15ft.

DORCHESTER
DORSET COUNTY MUSEUM, High West Street, Dorchester, Dorset DT1 1XA. Tel. Dorchester 2735. Opening: Mon-Sat 10-5. Contact: R. N. R. Peers. Applications: To the curator at the beginning of March and beginning of September. Exhibitions: Paintings, photographs, engravings, sculpture and pottery, by contemporary and artists of the past. Mostly mixed exhibitions. Space: About 140 linear feet of wall space, wall 10ft high. Small courtyard for sculpture. Equipment: Display cases and stands for sculpture.

DAVID AND SUE POTTER, The Studio, King's Arms Yard, Dorchester, Dorset DT2 9QZ and 5 Abbotsbury Road, Weymouth, Dorset. Tel. 0305 66828 and 03057 79726. Opening: Dorchester — Tues-Sat 10-5, Thur 10-1, Weymouth — Mon-Sat 10-5, Wed 10-1. Contact: David Potter. Applications: By invitation. Exhibitions: 19th and 20th century paintings, drawings and prints. A bias towards wood-engraving, some sculpture and pottery. Spaces: Dorchester — 25sq ft one time malthouse, track lighting. Weymouth — 18ft x 15ft, double fronted shop. Equipment: Tape recorder, framing service.

EASTBOURNE

TOWNER ART GALLERY, Manor Gardens, Borough Lane, Old Town, Eastbourne, E. Sussex. Tel. 0323 21635 or 25112. Opening: Mon-Sat 10-6, Sun 2-6. Contact: David Galer. Exhibitions: Frequent temporary shows from this country and abroad. At least one sponsored, selling exhibition, in addition to annual shows of local professionals and amateur societies. Space: 18th century manor house providing 10 galleries and housing a permanent collection of 19th and 20th century British art.

EXETER

EXE GALLERY, Gandy Street, Exeter, Devon. Contact: Peter Pay/C Fishwick, Exeter College of Art and Design, Earl Richards Road North, Exeter.

ROYAL ALBERT MEMORIAL MUSEUM, Queen Street, Exeter EX4 3RX. Tel. Exeter 56724. Opening: Tues-Sat 10-5.15. Contact: Curator of Fine Art — Miss C J Baker. Applications: Write, sending slides or photographs, or arrange appointment. Usually artists from south west region only are considered. Exhibitions: Local artists, crafts, touring V & A and Arts Council exhibitions. There is a permanent collection. Space: Hessian covered walls, carpeted floors, track and overhead lighting. Main gallery has about 170 linear feet of wall space. The permanent collection includes archaeology, natural history and ethnography, as well as fine and applied art. They try to include one or two local one-person shows each year in the area of contemporary art.

SPACEX GALLERY, 45 Preston Street, Exeter, Devon. Tel. 0392 31786. Opening: Tues-Sat 11-5. Contact: Caroline Fox/Diane Howse. Applications: Send colour slides of recent work (approx 12), curriculum vitae and written statement (not more than 500 words) about the work. Exhibitions: Selected by the gallery committee with a view to presenting a balanced programme of exhibitions throughout the year reflecting the variety of work now being done by contemporary artists, ranging through painting, sculpture, printmaking, film, video, photography, performance, etc. A mixture of group and one-person shows. Space: Gallery occupies the ground floor of a converted warehouse, two floors above are artists studios. Walls are white painted brickwork. Even lighting throughout by fluorescent and spotlights. Large arched windows and archways. Large doors make access easy. Local artists and groups are supported, also artists who do not exhibit regularly elsewhere. There are also other activities such as music, poetry, film, drama, dance etc., and talks and discussions.

FALMOUTH

FALMOUTH ARTS CENTRE, Church Street, Falmouth, Cornwall. Tel. Devoran 863343. Contact: Mrs M Spargo, Nancemellyn, Perranwell Station, Truro, Cornwall.

FALMOUTH ART GALLERY, The Moor, Falmouth, Cornwall 7R11 2RT. Tel. 0326 313863. Opening: Varying — Summer — Tues-Sat 10.30-4.30, Winter — Mon-Fri 10.30-4.30. Contact: Shaun Kavanagh. Applications: In writing or in person, include slides or photos. Exhibitions: Open to any reasonable suggestions. Mostly one-person shows. Space: Two rooms, hinged wall panels, display plinths and free standing panels, strip lighting and track spots. 40-60m of wall space. Gallery is intended primarily to house permanent collection of late 19th and early 20th century paintings and prints, but also puts on a wide variety of changing shows. It is a new venture and is open to new possibilities.

FARNHAM

NEW ASHGATE GALLERY, Wagon Yard, Farnham, Surrey GU9 7JR. Tel. 0252 713208. Opening: 10-1, 2.30-5, closed Wed and Sun. Contact: Elfriede Windsor. Applications: Write or call to arrange an interview with director, professional artists only. Exhibitions: Painting, sculpture, prints, ceramics, textiles, jewellery and glass by living artists. Mostly 3-4 artists are shown each month, two mixed exhibitions (summer and winter). Space: 2 large rooms, 3 small rooms, white walls, carpet throughout, daylight and spotlights, showcases and plinths. The New Ashgate Gallery is administered by a board of trustees, as a charitable trust. The local authority owns the building and supports the gallery to the extent that a non-commercial rent is charged. The artistic policy is solely decided by the director, Elfriede Windsor, who selects the artists to exhibit. The artists may come from anywhere in the country. Each monthly exhibition comprises the work of two or three painters, a potter, a jeweller and perhaps some other craftsman or woman. The trust buys work from time to time, which is lent to local institutions — hospitals, schools, libraries etc. on indefinite loan. "Friends of the Gallery" pay a subscription, and a programme of visits, (Paris and Venice for example) and lectures are open to those who join.

REDGRAVE THEATRE "CLUB ROOM", The Redgrave Theatre, Brightwells, Farnham, Surrey GU9 7SB. Tel. Farnham 722790. Opening: 10-10.30pm except Sun/Mon. Sun 12-2, Mon 10-6. Contact: Peter Bentley-Stephens (Theatre Manager). Applications: Write or telephone Peter Bentley-Stephens. Exhibitions: Tend to be small, due to limited space, all kinds of work have been exhibited. Mostly one-person shows. Space: Plaster walls with spotlights (no floor space available). The gallery aims to provide exhibition space for 'up and coming' artists, whilst providing an interesting diversion for the theatre-going public.

WEST SURREY COLLEGE OF ART AND DESIGN, Falkner Road, The Hart, Farnham, Surrey. Tel. 025 13 22441. Opening: During college hours. Contact: Brenda Underwood. Applications: Write, enclosing slides/photographs. Exhibitions: Wide range of exhibitions of a high standard — major retrospective and survey exhibitions, also smaller, more frequent displays of contemporary work. Viewed as a teaching aid to students and as an accessible resource for other colleges and the public. Space: Main Exhibition Hall — 5000sq ft. Window Gallery (545sq ft) for wide variety of student work and outsiders — information and application forms on request. Equipment: Cinema, lecture theatre, seminar rooms and library with audio-visual material, video recording and play-back, slides, records and tapes.

FOLKESTONE

NEW METROPOLE ARTS CENTRE, The Leas, Folkestone, Kent. Tel. 0303 55070. Contact: John Eveleigh. Space: 252sq ft of hanging space. There is also a studio for the practice of art and crafts, painting, photography, print-making etc.

FROME

WHITTOX GALLERY, 59 Catherine Street, Frome BA11 1DA, Somerset. Tel. Frome 65873. Opening: Mon-Sat 11-4, or by appointment. Early closing Thurs. Contact: Mrs Philippa Sleigh. Applications: Write or call at gallery with examples of work plus slides when available. Exhibitions: A variety of professional work. Abstract and figurative fine art, occasionally craft. Space: One main gallery roughly 20ft square x 8ft 4in high, with two window display areas 8ft x 3ft. Wood floor, two walls covered in natural canvas, one in painted pine. Spot and flood units. Most exhibitions spill over into a room behind the gallery, where work can be displayed in a domestic setting. Equipment: Slide projector, tape recorder, frames, mounts, print box, tables, plinths, easels, locking display cabinet, shelf and window display areas. Aims to present a continuous sequence of art and craft exhibitions, which the local community and visitors from other parts of the country and abroad will find stimulating. It is intended to encourage young artists by offering them a first or early opportunity to exhibit commercially, and also to give priority to local artists.

GLOUCESTER

CITY MUSEUM AND ART GALLERY, Brunswick Road, Gloucester GL1 1HP. Tel. 0452 24131. Opening: 10-5 daily, closed Sun and public holidays. Contact: J F Rhodes (Curator). Exhibitions: As varied as possible to give visitors a wide range of interest. Sciences represented as well as arts. Applications: Submit ideas with back-up information, (photos or slides if possible). Space: Approx. 150 feet of linear hanging space. The gallery mounts a wide range of exhibitions, including support for local art societies, touring exhibitions and shows of local interest. There are modest facilities (i.e. foyer exhibition space) for young local talent, who couldn't otherwise afford to put on a show.

GODALMING

BRIDGE STREET GALLERY, 18 Bridge Street, Godalming, Surrey. Tel. Godalming 22686. Opening: Mon-Sat 10-5, except Wed. Contact: Mrs J M Oakley. Applications: Verbally, usually. Exhibitions: Local artists. Space: 18ft x 12ft, carpeted floor, daylight and neon.

GUILDFORD

GUILDFORD HOUSE, 155 High Street, Guildford, Surrey. Tel. 0483 32133. Opening: Mon-Sat 10.30-5. Contact: Miss I C Rhodes. Exhibitions: Change monthly, wide ranging programme, group and one-person shows. A charge of £25 per week for one-person shows.

THE REID GALLERY LTD., Milkhouse Gate, High Street, Guildford, Surrey GU1 3HJ. Tel. Guildford 68912. Opening: Tues-Fri 9.30-5.30, Sat 9.30-1, closed during August, and after Christmas for 3 weeks. Contact: Graham and Pamela Reid. Applications: Will always look at any artist's work, and if appropriate, arrange to show it. Exhibitions: 19th and early 20th century watercolours. A "stable" of contemporary artists (both oils and watercolours) mostly landscapes, some flowers and still lives. Space: One long room downstairs, stairs, landing, and smaller, divided by partitions, room upstairs. Off-white painted walls, red carpet, spotlighting. Dimensions approx. 50ft x 15ft — only about a third of that upstairs for display purposes. Small enclosed paved courtyard in which are shown a couple of pieces of sculpture.

UNIVERSITY OF SURREY GALLERY, Guildford, Surrey. Tel. 71281. Opening: Mon-Fri 10-6. Contact: John Freyne, Dept of General Studies. Exhibitions: About 9 exhibi-

tions per year of modern works by significant contemporary artists, some touring shows. Talks, lectures, films etc. are featured with the exhibitions.

HARLOW
THE PLAYHOUSE GALLERY, The High, Harlow, Essex. Tel. 0279 33351. Contact: Douglas Addey.

HASSOCKS
CHICHESTER HOUSE GALLERY, High Street, Ditchling, Hassocks, West Sussex BN6 8SY. Tel. 07918 4167. Opening: Tues-Sat 11-1 and 2.30-5, or by appointment. Contact: Mr and Mrs Hunter. Applications: By letter or telephone in the first instance. Exhibitions: Original paintings, crafts, drawings. Space: Wallspace to hang 150-200 small works, spotlights throughout. Privately funded.

HASTINGS
MUSEUM AND ART GALLERY, John's Place, Cambridge Road, Hastings, E. Sussex. Tel. 0424 435952. Opening: Weekdays 10-1 and 2-5, Sun 3-5. Contact: Miss Victoria Williams. Exhibitions: Balance of local artists/societies and loan exhibitions of general interest. Space: One top-lit gallery with total wall area of 122sq ft.

HAVANT
HAVANT ARTS CENTRE, East Street, Havant, Hants. Tel. 0705 472700. Opening: Tues-Fri 10-12 and 2-5, Sat 10-12. Contact: Sandra Craddock. Space: 20ft x 40ft, soft board panels on walls plus screens.

HAVANT MUSEUM AND ART GALLERY, East Street, Havant, Hants. Tel. 0705 451155. Opening: Tues-Sat 10-12, 1-5 (maybe extended). Contact: Curator – Nicholas Hall. Applications: To Nicholas Hall, or to John Stewart, Hampshire County Museum Service (0962 66242). Local connections might help. Exhibitions: Local art shows, historical exhibitions, photographic work and local industries, past and present, and touring painting or graphic exhibitions. Sculpture and craft could be shown. Space: Originally a large Victorian room in a private house, it provides about 70 linear feet of wall space. Suspended track lighting, very flexible. Walls panelled up to 7ft in height. Adjoining Havant Arts Centre, the Gallery and Museum has a permanent collection. Temporary exhibitions cover some of local origin.

HEMEL HEMPSTEAD
OLD TOWN HALL GALLERY, Old Town Hall Arts Centre, High Street, Hemel Hempstead, Herts. Tel. 0442 42827. Opening: Mon-Fri 10-5, Sat 9-noon. Contact: Robert Adams. Applications: By letter or appointment. Exhibitions: Small shows of paintings or photographs by local or national artists, some touring shows. About 20 one-person shows per year. Space: 385sq ft, hessian-covered chipboard, strip and spotlighting. A paved area under arches (cloisters) 25ft x 55ft.

HENLEY-ON-THAMES
BOHUN GALLERY, Station Road, Henley on Thames, Oxon. Tel. 6228. Opening: Mon-Sat 10-5.30, closed Wed, Sun 2.30-5. Contact: Patricia Speirs. Applications: In writing with slides or photos, or in person with examples of work. Exhibitions: Original work by contemporary artists – paintings, prints, sculpture, ceramics etc. Space: 28ft x 13ft, windows and spotlights. A private gallery established in 1973, has shown the work of: Elizabeth Frink, John Piper, Ivon Hitchens, Patrick Proctor, Peter Blake, but is also interested to show the work of younger artists.

HENLEY EXHIBITION CENTRE, Market Place, Henley-on-Thames, Oxon. Contact: Cherry Birkett. Small gallery for hire at all times, opening hours as required by hirer.

HITCHIN
HITCHIN MUSEUM AND ART GALLERY, Paynes Park, Hitchin, Herts SG5 1EQ. Tel. 0462 4476. Opening: Mon-Sat inclusive 10-5, closed Sun and Bank Holidays. Contact: A L Fleck. Applications: Only from artists working in Hertfordshire or its immediate surroundings. Apply by letter to the Curator. Exhibitions: Paintings, sculpture, ceramics, textiles etc. Mostly one-person shows, some group. Space: Three rooms, white painted walls, spotlights and daylight. Equipment: Slide projectors. A public gallery aiming to encourage and promote art and artists in Hertfordshire. A wide range of exhibitions, giving a balance between the various media. A permanent collection, including 19th century topographical paintings and early 20th century etchings.

HOVE
HOVE MUSEUM OF ART, 19 New Church Road, Hove, Sussex. Tel. Brighton 779410. Opening: Mon-Fri 11-1, 2-4.30, Sat 11-1, 2-5. Contact: J Boyden. Applications: Local artists only. Exhibitions: Mainly of local interest. Permanent collection of 18th to 20th century fine and applied arts.

ILMINSTER
BUTLIN GALLERY, Dillington House College and Arts Centre, Ilminster, Somerset TA19 9DT. Tel. Ilminster 2427. Opening: 2-5. Contact: Mr Peter Epps. Applications: To the gallery steward. Exhibitions: Paintings, sculpture, photography, crafts, childrens' work. Space: 12 year old, purpose designed gallery, 100 linear feet of wall space, lighting is recessed behind diffusing panels. Exterior spaces for sculpture etc. Equipment: Most things available. Possible to use the gallery as a working studio for agreed periods. Other arts activities can be shown i.e. dance, poetry, music and mixed media. The gallery is part of a college which runs resident and day courses in all aspects of the arts.

LEATHERHEAD

THORNDIKE GALLERY, Thorndike Theatre, Church Street, Leatherhead, Surrey. Tel. Leatherhead 76211. Opening: 10am to end of performance (10pm-ish–. Contact: Owen Hale. Applications: By agreeing to the conditions and terms of exhibition, whereupon the artist's name is put on file and asked to submit two works. Exhibitions: All kinds of work shown. Mostly one-person shows. Space: The wall is 40 ft long by about 8ft deep (usable, lighted area). It faces a bar about the same length, so the floor space available is limited to about 4 feet. The wall is white brick and is lit by small spots and floodlights. It is the leading gallery in the area and the policy is to give first chance to local artists.

LETCHWORTH

LETCHWORTH MUSEUM AND ART GALLERY, Broadway, Letchworth, Herts SG6 3PD. Tel. 5647. Opening: 10-5 every day except Sunday. Contact: Peter R Field, B.A., A.M.A. Applications: In writing, with photographs and C.V. Exhibitions: Work by local and non-local artists, photographic exhibitions, travelling exhibitions, work by local schools. Space: 13 mtrs x 6mtrs, parquet floor, central lighting track. Equipment: Slide projector, screens, plinths, some frames.

LEWES

COOTES GALLERY, 28 School Hill, The High Street, Lewes, E. Sussex. Tel. Lewes 71085. Opening: Mon-Sat 10-5.30. Contact: E A Long and E Pelling-Fullford. Exhibitions: Group and one-person. Travelling exhibitions arranged, some retrospective. Space: Ground floor area of approx 650sq ft plus first floor space of 25ft x 15ft.

THE SOUTHOVER GALLERY, 7 Southover Street, Lewes, E. Sussex. Tel. 079 16 2640. Opening: Tues-Sat 11-1, 2.30-5.30. Contact: Mrs Deidre Bland. Exhibitions: 6 per year of contemporary art, figurative only. Pottery and occasional sculpture.

LUTON

LUTON MUSEUM AND ART GALLERY, Wardown Park, Luton, Beds LU2 7HA. Tel. 0582 36941. Opening: Summer 10-6 weekdays, Sun 2-6; winter 10-5 weekdays, Sun 2-5. Contact: Doreen Fudge. Applications: By letter. Exhibitions: Painting, drawing, prints, photographs etc., mainly figurative. Two open exhibitions each year for artists in Beds, Bucks and Herts. Space: 30ft x 15ft plus 1st floor landing, fluorescent lighting, hessian covered walls. Open air facilities adjacent. Equipment: Slide projector.

MAIDSTONE

MUSEUM AND ART GALLERY, St Faith's Street, Maidstone, Kent. Tel. 54497. Opening: Mon-Sat 10-6 (summer), 10-5 (winter). Exhibitions: Temporary shows, supported by permanent collection, in rotation with loan exhibitions.

MILTON KEYNES

THE CITY GALLERY, The Chapel Studio, Little Brickhill, Milton Keynes MK17 9NP. Tel. 052 526 617. Opening: By appointment. Contact: Edna Read. Applications: Professional artists only. Write, enclosing slides or photos. Exhibitions: All kinds of contemporary work, including sculptures, tapestries and work relating to public spaces. Space: City Gallery has no premises open to the public, but runs about 10-15 exhibition sites located in new buildings in Milton Keynes and has occasional special events and functions to promote an artist or a group. Equipment: Frames available. City Gallery was started in 1973 with the following objectives:- To bring the work of contemporary artists to people where they live and work; to offices, factories, hospitals, educational institutions and private homes. To introduce a new audience to the work of living artists and to create for the latter, a new patronage. To provide in the Milton Keynes area many different visual experiences, to create a more open-minded and aware climate for art in the new city.

OXFORD

ASHMOLEAN MUSEUM, Beaumont Street, Oxford. Tel. 57522. Opening: Weekdays 10-4, Sun 2-4. Contact: Keeper of Western Art. Exhibitions: No set policy, programmes vary between the work of contemporary artists and subjects of an academic nature. Space: The McAlpine Gallery, designed by Brian Henderson. Marble floor, plain hessian covered walls, spotlighting. Policy is dictated by the needs of the department of Western Art within the framework of the University of Oxford and the permanent collection.

MUSEUM OF MODERN ART, 30 Pembroke Street, Oxford OX1 1BP. Tel. 0865 722733. Opening: Tues-Sat 10-5, Sun 2-5. Contact: David Elliott. Applications: In writing, enclosing slides etc. Exhibitions: 20th century visual arts, generally. The accent is on showing contemporary work in the context of historical developments. Some international work is shown. Mostly one-person shows. Some performance and mixed-media work. Space: When building work is completed in early 1981, there will be 6 separate exhibition areas, which vary in size considerably, from the walls of the coffee bar to the principal gallery (with 60 running metres length and walls over 12 feet high). Walls are mainly brick, painted white. Lighting is tungsten spots, tungsten-halogen floods or larger arc lights. Museum is housed in an old brewery and the industrial architecture is still evident in the feel of the exhibition areas. Equipment: Slide projector, 16mm projector, video monitor and cameras (no playback facilities), frames. The museum has tried to fill a gap in the British gallery system

by organising large one-person shows, the like of which might not normally be seen in the U.K. i.e. Rodchenko, Pollock, Siskind etc. It organises many of its own exhibitions and these have travelled to other galleries in the U.K., on the Continent and in the U.S.A. It was one of the first organisations of its kind to appoint a full-time educational officer and links have been established with local schools and colleges all over the country and Oxford University.

OLD FIRE STATION ARTS CENTRE, 40 George Street, Oxford OX1 2AZ. Tel. 722648. Opening: 10-10. Contact: Nigel Robson. Space: Room 20ft x 20ft used occasionally for exhibitions, difficult to provide full security.

OXFORD PLAYHOUSE EXHIBITION ROOM, Beaumont Street, Oxford OX1 2LW. Tel. 47134. Opening: Mon-Fri 10-6, Sat 10-1. Contact: Mrs Mary Hine.

PENZANCE

NEWLYN ORION GALLERIES, Passmore Edwards Art Gallery, New Road, Newlyn, Penzance, Cornwall. Tel. 0736 3715. Opening: 10-5 (10-6 July-August). Contact: John Halkes, Director. Applications: Write/phone for appointment to Director. Exhibitions: Eclectic range of contemporary visual art, painting, printing, photography, sculpture, film (not much performance or video). Space: Two level gallery. Upper floor access from the street. Arts information in entrance hall. Reception area and good little gallery shop leading to main gallery. 80ft x 40ft. White hessian wall to 9ft. Lofty space augmented daylight Central staircase descends to lower gallery 40ft x 15ft. Passageway through to two small exhibition areas – 20ft x 12ft and 12ft x 11ft. Garden space leading to wide public green and the shore of Mounts Bay. Equipment: Metal frames for hire; 16mm projector, small offset litho printing machine (A4). Newlyn Orion provides a service to the public and artists. The aim is to stimulate public awareness of contemporary visual art. And to encourage artists whether or not they are well established. Newlyn Orion is an educational charity which receives 75% of its funds from the Arts Council of Great Britain. The small professional staff work actively with artists and members of the public to create a warm and active environment. The staff maintain close links with the regional arts association. The Arts Council, the local art schools and Exeter University extra mural department. Regular poetry readings, occasional music and some lectures.

PLYMOUTH

PLYMOUTH ARTS CENTRE, 38 Looe Street, Plymouth. Tel. Plymouth 60060. Opening: Mon-Fri 10-6, Sat 10-1. Contact: Bernard Samuels. Applications: Contact the Director. Exhibitions: Mainly painting and photography,

occasionally weaving and textile work, local artists (the south west) preferred. Space: An attractive room, with daylight from the west, recently sanded floor, track lighting. Equipment: 80 aluminium frames (20in x 24in and 20in x 16in) for photography. There is a cinema in the arts centre, which could provide audio/visual equipment.

POOLE

POOLE ARTS CENTRE, Kingland Road, Poole BH15 1UG. Tel. 02013 70521. Opening: 10-10.30 p.m. Contact: Sharon Davis, Exhibition Organiser. Applications: Telephone, call in, or in writing. Exhibitions: 2D and 3D visual art; crafts; photography; most other forms of art. Spaces: There are three main gallery spaces, each serving a slightly different function:- Seldown Gallery and Studio: 44ft x 27ft, 12 screens 8ft x 4ft. Used as a multi-purpose studio for dance, music lectures etc., as well as for exhibitions. It is used mainly for touring, international, national or professional exhibitions. This can be for an individual artist, group of artists, or school or college. Longfleet Gallery: Foyer gallery, very long, narrow space, about 115 linear feet of wallspace in total, divided into fairly short stretches, track lighting. Used mainly to promote individual artists, groups or societies, nominal hire fee. Whitecliff Gallery: Open floor, foyer area. Artists need to provide their own screens or cases, exhibitions need to be self-contained. Equipment: Slide projectors. There is also a picture bank for which all artists are invited to submit 1-3 pieces of work for selection. If selected, the works are then kept for 3 months and exhibited for at least 2 weeks. This system offers the public a permanent, but constantly changing exhibition.

PORTSMOUTH

PORTSMOUTH CITY MUSEUM AND ART GALLERY, Museum Road, Old Portsmouth, Hants PO1 2LJ. Tel. Portsmouth 811527. Opening: 10.30-5.30. Contact: Mrs J C Chamberlain. Keeper of Art – Miss R Hardiman. Applications: Submit slides, with written biography etc. Space: Two ground floor galleries – 104 linear feet and 192 linear feet of wall space. One with natural light, one without, track lighting in both, carpeted. Grassed areas at front and rear are used for outside displays of sculpture. Equipment: Slide projectors and tape recorders, other equipment can be loaned from Polytechnic. The Museum and Art Gallery's own collections consist of British decorative art from the 17th century to 20th century and contemporary crafts and British 20th century prints, drawings, sculpture, paintings from the 30's and by artists with local connections. The exhibition programme attempts to give a varied diet of mainly fine art of work of a national or international importance together with historical shows and other departmental subject matter.

RAMSGATE
ADDINGTON STREET GALLERY, 49 Addington Street, Ramsgate, Kent. Tel. Thanet 57405. Opening: 10-1, 2.30-5.30, closed Thur. Contact: Mrs Pat Castle. Exhibitions: Paintings (not exclusively commercial), small sculptures, prints and craftwork. Thirty three and one third per cent commission of sales.

READING
THE HEXAGON, P.O. Box 6000, Civic Centre, Reading, Berks. Tel. Reading 55911. Opening: Mon-Sat 10-5 and during evening performances from 6.30. Contact: Tim Hulse. Exhibitions: Include amateur and professional artists and craftsmen, local societies, one and two-person shows. No restriction on style, medium or type of work. Space: Upper and lower foyers.

READING MUSEUM AND ART GALLERY, Belgrave Street, Reading, Berkshire. Tel. 55911 ext 2240 or 2192. Opening: Mon-Fri 10-5.30, Sat 10-5. Contact: Eric Stanford. Exhibitions: Local artists, loan exhibitions, touring shows. Space: Linear space of 50 metres plus additional screens.

ROTTINGDEAN
THE GRANGE, Rottingdean, E. Sussex. Tel. and Contact: As for Art Gallery and Museum, Brighton. Tel. 0273 63005, Duncan Simpson. Opening: Weekdays 10-6, closed Wed, Sat 10-5, Sun 2-5. Exhibitions: One-person and group shows, travelling shows. Space: 40ft x 15ft.

RYE
RYE ART GALLERY, East Street, Rye, E. Sussex. Tel. Rye 3218. Opening: Tues-Sat 10.30-5, Sun 2.30-5. Contact: John Hoar. Exhibitions: Paintings, sculpture, graphics. Also at Easton Rooms, 107 High Street, Rye. Tel. Rye 2433. Contact: Mrs Martha Money. Exhibitions: Local (s. east) artists, also craftwork. Space: Two connected galleries on ground floor.

ST. IVES
PENWITH GALLERIES, Back Road West, St Ives, Cornwall. Tel. St Ives 5579. Opening: Mon-Sat 10-5. Exhibitions: Contemporary fine art and permanent collection.

WILLS LANE GALLERY, Wills Lane, St Ives, Cornwall. Tel. Penzance 79. Contact: Henry Gilbert. Opening: 10.30-5.

ST. LEONARDS-ON-SEA
PHOTOGALLERY, The Foresters Arms, 2 Shepherd Street, St. Leonards-on-Sea, E. Sussex. Tel. 0424 440140. Opening: Wed-Sun 11-6. Contact: Morris Newcombe. Exhibitions: Best available photography. Maintains portfolios of young photographers. Also organises travelling shows, lectures and workshops.

SALISBURY
ST EDMUND'S ART CENTRE, Bedwin Street, Salisbury, Wilts. Tel. 4299. Opening: Mon-Sat 10-5.30. Contact: Peter Mason. Exhibitions:

Art, craft, photography and touring shows. Space: Two galleries with 72ft linear and 24ft linear.

SHAFTESBURY
GALLERY 24, Bimport, Shaftesbury, Dorset. Tel. Shaftesbury 2931. Contact: Roy Sanford.

MELBURY GALLERY, 28 Salisbury Street, Shaftesbury, Dorset. Tel. Shaftesbury 4428. Opening: Mon-Sat 9.30-5.30. Contact: John Drabik. Applications: Show samples of work. Exhibitions: Paintings, prints, sculpture, pottery and other crafts. About six one-person shows per year. Space: Green sandstone and hessian covered walls. Wall space for approx. 30 to 50 paintings, depending on size. Very large window space, fluorescent and spotlights. Equipment: Framing service, slide projector and tape recorder. Aims to exhibit and sell work by leading artists and craftsmen living and working in the south west, although work from further afield is also shown.

SOUTHAMPTON
THE JOHN HANSARD GALLERY, The University, Southampton. Tel. 559122. Opening: Mon-Sat 11-8. Contact: Leo Stable. Exhibitions: Young and well-established artists, including craftwork and photography. An extensive new gallery.

THE PHOTOGRAPHIC GALLERY, The University, Southampton. Tel. 559122. Opening: Mon-Sat 11-8. Contact: Leo Stable. Exhibitions: Work by well-known and less-established photographers. Space: 350 linear feet, 4000sq ft, concrete floor, daylight and spots.

SOUTHAMPTON ART GALLERY, Civic Centre, Southampton SO9 4XF. Tel. 0703 23855 ext 769. Opening: At present Tues-Sun but this may be changed 1981/82. Contact: Keeper of Art or Assistant Keeper. Applications: Group exhibitions are usually initiated by the gallery, but there is a small space (72 linear feet) for one-person shows, for which applications are invited. To apply, write for an application form. Exhibitions: No particular 'type' of work preferred, programme tends to reflect the taste of the organiser. Space: Large shows — painted walls, cork floor, roof light and spots (1320 linear feet). Small shows — stone walls (beige), stone floor, spotlights. Equipment: Slide projector, other equipment can be negotiated with other departments. There is a permanent collection of historical and contemporary art and the exhibition programme is also shaped to reflect this. There are one or two 'local' amateur shows, but the main policy is to bring work of good quality to the region, not to show local work, except where it is worthy of special attention. There is also a strong emphasis on education in the gallery, which is also reflected in the programme.

STEVENAGE

STEVENAGE LEISURE CENTRE, Lytton Way, Stevenage, Herts. Tel. 66291. Opening: 10-10 every day. Contact: Paul Lorne. Applications: Letter followed by appointment. Exhibitions: Basically, non-commercial, fine art, textiles and craft. Space: Large exhibition area plus theatre foyer, limited security.

STEVENAGE MUSEUM, St George's Way, Stevenage, Herts SE1 1XX. Tel. Stevenage 54292. Opening: Mon-Sat 10-5. Contact: Colin Dawes. Applications: Personally or by letter. Exhibitions: 3-D or flat, art exhibitions confined to 2 or 3 per year. Space: 22ft x 20ft and 16ft x 10ft, trackspots, showcases. Equipment: Slide projectors, tape/slide facility, tape recorders, 16mm cine projector, 20 aluminium frames 18in x 15in, 15 perspex covers 48in square. A community museum, showing local exhibitions, artists' work and exhibitions hired from national organisations.

STROUD

ROOKSMOOR GALLERY, Bath Road (A46), Nr. Stroud, Gloucester. Tel. Amberley 2577. Opening: 10-4.30 7 days a week (incl Sat & Sun). Contact: Nigel Ashcroft and Lawrence Lipsey. Applications: Professional artists only, telephone for appointment. Exhibitions: Contemporary prints, watercolours and sculpture. Space: Very extensive old mill – also used as showrooms for contemporary furniture. Work is shown in a domestic setting. Supports young artists particularly and helps educate the public about artists' original prints. Contributes annual exhibition to the Stroud Festival and also sponsors one print exhibition a year for the Stroud Festival put on by them in the town of Stroud itself.

TAUNTON

BREWHOUSE ARTS CENTRE, Coal Orchard, Taunton TA1 1JL, Somerset. Contact: Chris Durham.

SKITTLE GALLERY, The Railway House, Stogumber, Taunton, Somerset. Tel. Stogumber 414. Contact: Rev. R. D. F. Wild.

WYVERN GALLERY, 4 Magdalen Lane, Taunton, Somerset. Tel. Taunton 71066. Contact: Oliver Warman.

TIVERTON

TIVERTON ARTS CENTRE, Chapel Street, Tiverton, Devon. Tel. Tiverton 4242. Contact: Terry Northam.

TONBRIDGE

GALLERY 27, 27 Shipborne Road, Tonbridge, Kent. Tel. Tonbridge 358068. Opening: Tues-Sat 10-5.30, Sun 2-5. Contact: Sally Prowse. Exhibitions: Variety of work including sculpture and wood-carving. Space: Two areas about 12ft x 11ft. Lower gallery is rented out for one-person shows, which cost £20 per week for hire of the space.

TOTNES

DARTINGTON CIDER PRESS GALLERY, Dartington, Totnes, Devon. Tel. Totnes 864171. Contact: Douglas Bardrick.

DARTINGTON NEW GALLERY, Dartington, Totnes, Devon. Tel. Totnes 862224. Contact: Ivor Weeks.

TRURO

THE ROYAL INSTITUTION OF CORNWALL, The County Museum and Art Gallery, River Street, Truro. Tel. Truro 2205. Opening: Daily (Sundays and Bank Holidays excepted) April-Sept 9-5; 1 Oct-Mar 9-1, 2-5. Contact: Curator – H. L. Douch. Space: 2 Galleries 67ft x 22ft and 44ft x 22ft. The two galleries are very much part of the museum, designed to house the permanent collection, but there are occasional temporary shows.

TRAFALGAR GALLERY, Malpas Road, Truro, Cornwall. Tel. Truro 77888. Contact: M. Lewis.

TUNBRIDGE WELLS

GALLERY LARAINE LTD., Trading as Clare Gallery, 21 High Street, Tunbridge Wells, Kent. Tel. Tunbridge Wells 38717. Opening: Mon-Sat 8-5.30 and occasionally p.m. Sun. Contact: S. A. Ettinger and M. D. S. Ettinger. Applications: Professional artists only, by letter or telephone. Exhibitions: A permanent mixed exhibition. Space: 80ft x 30ft on each of two floors. Equipment: Frames. A private gallery, which has an international market.

MUSEUM AND ART GALLERY, Civic Centre, Mount Pleasant, Tunbridge Wells, Kent. Tel. 0892 26121. Opening: Weekdays 10-5.30, Sat 9.30-5.30. Contact: Miss Margaret Gill. Exhibitions: Two permanent collections and temporary shows.

TWICKENHAM

ORLEANS HOUSE GALLERY, Riverside, Twickenham, Middlesex. Tel. 01-892 0221. Opening: Apr-Sept Tues-Sat 1-5.30, Sun 2-5.30; Oct-Mar Tues-Sat 1-4.30, Sun 2-4.30. Exhibitions: Permanent collection of paintings and prints. Full programme of temporary exhibitions.

UXBRIDGE

HILLINGDON BOROUGH LIBRARIES, 22 High Street, Uxbridge, Middlesex UB8 1JN. Tel. Uxbridge 50111. Opening: Library hours daily Mon-Fri 9.30-8, Sat 9.30-5. Contact: Mrs M. Farley, Arts Liaison Officer. Applications: Apply direct to Mrs M. Farley. Exhibitions: Mostly pictures, only limited facilities for 3-D work. 30-40 exhibitions are mounted each year. Space: Two libraries have meeting/exhibition rooms attached and space is available within the body of other libraries for small exhibitions. Hanging space is also available in the foyer of the Alfred Beck Centre, the borough's theatre and concert hall. The Great

Barn at Ruislip is used for larger and more complex exhibitions. Equipment: Slide projectors, rear projection units. Local societies and artists are particularly encouraged.

WARMINSTER
ATHANAEUM ARTS CENTRE, High Street, Warminster, Wilts. Tel. 213891. Opening: Mon-Sat 10-12. Contact: Sue Conrad/Ian Marlow. Exhibitions: Art and crafts. Space: 16.48 metres linear hanging space, track lighting, carpeted floor.

WELWYN GARDEN CITY
DIGSWELL HOUSE GALLERY, Monks Rise, Welwyn Garden City, Herts. Tel. 070 73 21506. Opening: 10-5. Contact: Bill Parkinson. Applications: By letter, plus slides, in the first instance. Exhibitions: Emphasis on artists looking for first main show, particularly those whose work is unlikely to be shown elsewhere. About 10 one and two person shows are held each year. Space: Regency rooms, three gallery spaces, roughly 30ft x 20ft each, wooden floor in two, stone in third, mainly spotlighting. Extensive lawns, but security risk not good. Equipment: Slide projector and tape recorder. Shows the work of artists from all areas of involvement, including performance, installations and video. Digswell House Arts Centre runs a Fellowship Scheme, providing studio and living accommodation for 16 artists.

WINCHESTER
WINCHESTER SCHOOL OF ART EXHIBITIONS GALLERY, Park Avenue, Winchester, Hampshire. Tel. 61891. Opening: Normally 9-9. Applications: In writing to the Principal, for consideration by the Exhibitions Committee. Exhibitions: Emphasis on contemporary painting and printmaking, but a wide range of work is shown encompassing art and design. There are between 10 and 15 one-person shows held each year. Space: 1800sq ft, polished timber floor, top natural light. There are also some excellent exterior spaces. Equipment: Most things are available. The gallery aims to bring contemporary work of quality to Winchester, for students and the general public. Dance and music performances are also occasionally held.

WINDSOR
LIVE BRITISH ARTISTS, 67 Victoria Street, Windsor, Berks. Tel. Windsor 54925. Opening: 10-5.30. Contact: E. J. Quaddy. Applications: Phone for appointment. Exhibitions: Continuous exhibition of gallery artists, most of whom paint in oils. Space: Ground floor and lower floor, approx. 16ft x 14ft. A small private gallery, aiming to give value for money to the man in the street.

NORTHERN IRELAND

BELFAST
ARTS COUNCIL GALLERY, Bedford House, Bedford Street, Belfast 2. Tel. 44222. Opening: Mon-Sat 10-5. Contact: Brian Ballard. Applications: By letter to the Art Committee. Exhibitions: Any kind of work. Space: Upper Gallery 50ft x 40ft, with display board facilities. Lower Gallery 50ft x 20ft.

THE BELL GALLERY, 2 Malone Road, Belfast BT9 5BN. Tel. 662998. Opening: Daily 9-5, Sat 10.30-1, or by appointment. Contact: Nelson Bell. Applications: Send photographs and previous catalogues. Exhibitions: Established and young Ulster artists, some visiting artists. One-person shows. Space: One large room with two bay windows, one small connecting room, one medium room with two windows, ground floor, good daylight throughout, in a house in university area, plain walls, carpeted floor. A private gallery founded in 1964, aiming to support local artists, educate and cultivate local clients.

OCTAGON GALLERY LTD., 1 Lower Crescent, Belfast BT7 1NR. Tel. Belfast 46259. Opening: Tues-Sat 11-5. Contact: Ita Cregan. Applications: Bring in samples of work. Exhibitions: Mainly the work of young and less commercial artists. A young contemporaries show is held each year. Occasionally show established Irish artists or prestigious shows from outside Ireland. Also crafts and prints. Space: Ground floor 30ft x 18ft, leading to smaller room, good lighting. First floor – Crafts room 20ft x 18ft. Equipment: Projectors, tape recorders can be borrowed. The gallery gives lesser-known artists the chance to exhibit, it is not a commercial gallery. Mostly paintings and prints are shown, due to lack of space. The Crafts Room is the only outlet for the work of local craftsmen and designers.

ULSTER MUSEUM, Botanic Gardens, Belfast BT9 5AB. Tel. 0232 688251. Contact: E. V. Hickey, Keeper of Art. Permanent collection of contemporary international and Irish art and historical collections. Some temporary exhibitions. Bookshop, lectures and films.

DONAGHADEE
GEORGIAN GALLERY, Erin Lodge, Donaghadee, Co. Down BT21 0BQ. Tel. 0247 882282. Opening Mon-Sat 10-6. Contact: Austin McCracken. Applications: In writing or person, with samples of work. Exhibitions: Modern Irish plus British painting and sculpture. Space: Two areas – 15ft x 21ft and 9ft x 30ft.

LONDONDERRY

THE KEYS GALLERY, Ivy House, 34 Strand Road, Londonderry. Tel. 66411. Opening: Mon, Tues, Wed, Fri, Sat 9-5.30. Contact: N. A. Gordon. Applications: Submit works. Exhibitions: Paintings, sculpture, prints. Mostly one-person shows. Space: 41.5 metres of hanging space, white painted walls, specially hung tube lighting with backscreens plus spots. A private gallery showing a wide range of professional work, both abstract and figurative. Promising local artists may be shown in an occasional group show.

ORCHARD GALLERY, Orchard Street, Londonderry. Tel. 0504 69675. Opening: Tues-Sat 11-6. Contact: Declan McGonagle.

Applications: Send slides/photos/examples of work. Exhibitions: Everything from performance art to traditional painting (including photography) and crafts. One and two-person shows, with some group shows. Space: Main Room – 8m x 16m, plaster walls, carpeted floor, tungsten halogen lamps. Side Room – 5m square, stone walls, stone floor, tungsten halogen lamps. A walled-in courtyard is also available. Equipment: Carousel projectors, 16mm projectors, tape/slide unit, back projection unit, speakers, screen, frames. An entirely publicly-funded gallery aiming to act as an inlet to the local community for contemporary art and to some degree as an outlet for local work and ideas, also to touch and engage the community in art related activities.

SCOTLAND
A Guide to Scottish Galleries by Neil Read and Tom Wilson published by Paul Harris, Edinburgh £1.95, may also be of use.

ABERDEEN

ABERDEEN ART GALLERY & MUSEUMS, Schoolhill, Aberdeen. Tel. 0224 26333. Opening: Mon-Sat 10-5, Thur 10-8, Sun 2-5. Contact: Ian McKenzie Smith (Director), Gordon Robertson (Keeper of Exhibition Services). Applications: By letter, with examples of work. Exhibitions: Historic, documentary,

thematic, paintings, sculpture, prints, photographs, installations, A/V, video. About 50 exhibitions are held each year. Space: Several exhibition spaces of varying sizes. Equipment: Slide projector, film projector, cassette recorders. The major gallery in the north-east of Scotland.

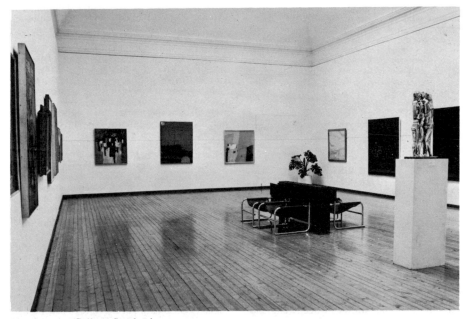

Aberdeen Art Gallery, Scotland

ARTSPACE, 37 Belmont Street, Aberdeen. Tel. Aberdeen 50126. Opening: Wed, Fri, Sat 10.30-5.30, Thur 10.30-8, Sun 2-5. Contact: Hazel Sanderson. Applications: Formally in writing, giving details of space required and attaching slides/photographs of work. Exhibitions: All aspects of modern art, national and international. Space: Six main spaces, each offering about 350sq ft, also a landing and stairway. Sculpture court available.

PEACOCK PRINTMAKERS, 21 Castle Street, Aberdeen. Tel. 0224 51539. Opening: Tues-Sat 9.30-12.30, 1.30-5.30. Contact: Arthur Watson. Applications: In writing, with slides. Exhibitions: Mainly prints, some drawings and photographs. Space: 50 linear feet. Equipment: Frames. The gallery is very much a secondary activity to the print workshop which provides open facilities for artists to make prints. The gallery is used to initiate a series of small exhibitions which tour the area.

ALLOWAY
MACLAURIN ART GALLERY, Rozelle, Monument Road, Alloway, Ayr. Tel. 0292 43708. Opening: Mon-Sat 11-1, 2-5. Sun: Apr-Oct only. Contact: Michael Bailey BA (Hon). Applications: Personal or written, with examples of work. Exhibitions: 30-40 shows are mounted each year, covering fine and applied art: sculpture, ceramics, painting, photography, stage design etc. Space: Four galleries providing from 70 to 100 linear feet of wall space in each. Walls are plyboard, hessian coated, Concord lighting system with dimmer control. There is also a cobbled courtyard. Equipment: Cassette recorder, small stock of frames. The gallery gives young artists an opportunity to show their work at relatively low cost. Local artists are encouraged, as well as those from further afield. Major national exhibitions are also shown.

DUMFRIES
GRACEFIELD ARTS CENTRE, 28 Edinburgh Road, Dumfries.

DUNDEE
CENTRAL ART GALLERY, Albert Square, Dundee DD1 1DA. Tel. 0382 25492/3. Opening: Daily Mon-Sat 10-5.30. Contact: Miss Clara Young M.A., A.M.A., Keeper of Art. Applications: To Keeper of Art. Exhibitions: Past and present, fine and decorative arts. About 12 shows per year, which are mostly group. Space: Five galleries, with from 100 to 200 linear feet of wall space in each. Hanging rails, variety of lighting. Plans for 3 new galleries to be built. Equipment: Slide and film projectors, tape recorders, frames, screens. Permanent collection of Scottish art. Various courses are organised and lunch-hour talks and slide-shows are held.

FOREBANK GALLERY, Forebank Road, Dundee DD1 2PG. Tel. 0382 21860. Opening: Mon-Sat 10-1, 2-5, Sun 2-6, closed Tues. Contact: Robert McGilvray/Sarah McNeilaire. A part of Forebank Studios, which houses about 30 artists and craftsmen. Exhibitions of work by Dundee Group artists. See studios section Chapter 3.

EDINBURGH
BACKROOM, Underneath the Arches, 42 London Street, Edinburgh. Tel. 031-556 8329. Opening: Mon-Sat 10.30-5.30. Contact: Michael J. Durnan. Applications: Mainly through calling in to the gallery/shop or by letter. Exhibitions: First time exhibitors, from craft to paintings, group shows of workshops plus group shows organised by the gallery. Space: 15ft square plus hallway wallspace of 6ft, polished wood floor, spotlights. The gallery is more a community gallery/space and encourages first time exhibitors and interesting group shows. Local community is encouraged to visit and comment as much as possible and the aim is to show a wide variety of work – photography, craft, traditional and contemporary art, as well as discussions and, when possible, more experimental shows.

369 GALLERY, 369 High Street, Edinburgh. Contact: Andrew Brown. Regular exhibitions of painting, photography, prints and sculpture.

ROYAL SCOTTISH ACADEMY, The Mound, Edinburgh. Major international exhibitions and annual Royal Scottish Academy exhibition open to professional Scottish artists.

FRUIT MARKET GALLERY, 29 Market Street, Edinburgh. Tel. 031 226 5781. Opening: Weekdays 10-5.30, closed Sundays. Contact: Robert Breen – Exhibitions Officer. Applications: Submit proposal to the Art Committee. Exhibitions: Emphasis on contemporary art from Britain and abroad. 8-10 shows presented annually, which are mostly group or thematic one or two-person shows. Space: 32ft x 75ft, converted warehouse, ground floor gallery, with two independent galleries upstairs. Walls – wood cladding, painted screens available; lighting – concorde; floor – wooden. Equipment: Basic equipment usually available. A very pleasant, spacious gallery, which has become one of Edinburgh's main venues for contemporary art. Coffee house on ground floor.

GRAEME MURRAY GALLERY, 2 Eyre Crescent, Edinburgh, Scotland. Tel. 031 556 8689. Opening: Tues-Sat 2-8 during exhibitions, otherwise by arrangement. Contact: Graeme Murray. Exhibitions: One-person shows by contemporary artists, some international, including Richard Tuttle, Gilbert and George, Alan Charlton and Joel Fisher. Space: About

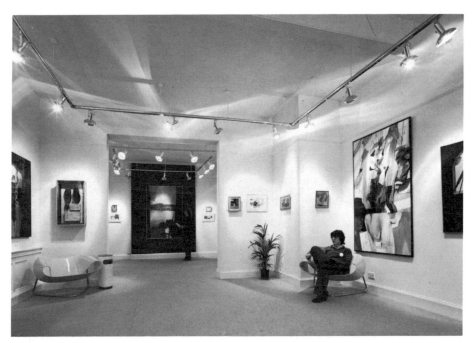

Hendersons Gallery, Edinburgh, Scotland

70 linear feet of hanging space. An interesting private gallery opened in 1976. Music, dance and performance are also shown.

HENDERSONS GALLERY, 98 Hanover Street, Edinburgh. Tel. 031 225 3400. Opening: Mon-Sat 10.30-5.30. Contact: Thomas Wilson. Applications: With slides, photographs or examples of work. Exhibitions: Contemporary sculpture, paintings and prints. Roughly 20 shows per year, group and one-person. Equipment: Sculpture stands only. A lively commercial gallery that shows a wide range of work from traditional to avant-garde, promoting younger artists and more established ones.

THE NETHERBOW, 43 High Street, Edinburgh EH1 1SR. Tel. 031 556 9579. Opening: 10-4, but exhibits on show when there are evening events. Contact: James Dey, David Heavenor. Applications: By writing and with a meeting to see work and talk. Exhibitions: About 24 are held each year, 12 in each gallery, mostly one-person shows, covering painting, sculpture, photography and crafts. Space: Two spaces, the walls of a ground floor restaurant and a gallery on an upper floor which is less accessible to passing trade. There is also a courtyard available for use. Equipment: Slide projectors and tape recorders. An arts centre funded mainly by the Church of Scotland, which includes a small theatre and a restaurant. Has shown mostly relatively unknown artists up till now, but there are plans to develop the gallery.

NEW 57 GALLERY, 29 Market Street, Edinburgh EH1 1DF. Tel. 031-225 2383. Opening: Mon-Sat 10.30-5.30. Contact: Alexander Moffat. Applications: By letter with slides/ photographs. Exhibitions: Mainly contemporary painting and sculpture, mixed media work occasionally. Not restricted to Scottish artists. The gallery was created for artists and is run by artists. Policy is to present a radical alternative in Scotland to the established galleries and institutions and to offer the serious artist a space to show his/her work. Many major Scottish artists first exhibited in the '57' and artists such as David Hockney, Marcel Broodthaers and Max Beckman were first shown in Scotland here.

PRINTMAKERS WORKSHOP GALLERY, 29 Market Street, Edinburgh EH1 1DF. Tel. 031 225 1098. Opening: Mon-Sat 10-5.30. Contact: Kenneth Duffy. Gallery acts as an outlet for prints made in its workshop and for work produced by other printmakers in Scotland. Facilities for etching, lithography, silk-screen and photography.

THE RICHARD DEMARCO GALLERY, 32 High Street, Edinburgh. Tel. 031 557 0707. Opening: Tues-Sat 11-5. Contact: Richard Demarco. Applications: By letter with slides/photographs, or by appointment. Exhibitions: Very wide range of contemporary Scottish, national and international work, including painting, sculpture, photography, installations and performance. The gallery is essentially international in character, particularly related to creating contacts between Europe and North America and extending the concept of European art to include the Celtic world from the Hebrides to the Mediterranean. There are often two or three one-person shows happening at the same time and many young artists have been given their first showing here. Joseph Beuys was first shown in this country by Richard Demarco and his gallery has been one of the liveliest and most interesting in Britain for many years.

CITY ART CENTRE, 2 Market Street, Edinburgh. New Edinburgh art centre with 2 large galleries, a restaurant/cafeteria, bookshop and basement gallery space. Major international exhibitions and work by contemporary Scottish artists. Tel. 031 225 2424.

SCOTTISH ARTS COUNCIL TRAVELLING GALLERY, Scottish Arts Council, 19 Charlotte Square, Edinburgh. Tel. 031 226 6051. Tours Scotland with major exhibitions visiting schools and city centres, town and village centres. Contact Scottish Arts Council Art Department for details.

THE SCOTTISH CRAFT CENTRE, 140 Canongate, Edinburgh. Tel. 031 556 8136 and 7370. Opening: Mon-Sat 10-5 (May-Sept 10-6). The best of Scottish craftsmanship by professional craftsmen and women.

SCOTTISH NATIONAL GALLERY OF MODERN ART, Royal Botanic Gardens, Edinburgh EH3 5LR' Tel. 031 332 3754. Opening: Mon-Sat 10-6 (or dusk if earlier), Sun 2-6 (or dusk). Contact: Douglas Hall. Permanent collection of 20th century paintings, sculpture and graphics, including the national collection of modern Scottish art. Temporary one-person, group and didactic exhibitions of 20th century art.

'STILLS' THE SCOTTISH PHOTOGRAPHY GROUP GALLERY, 58 High Street, Edinburgh EH1 1TB. Tel. 031 557 1140. Opening: Tues-Sat 12.30-6. Contact: Richard Hough. Applications: Submit portfolio. Exhibitions: Photography only. Ten one-person shows per year. Space: Rectangular room 9m x 6.5m, white walls, dark floor. Equipment: Slide projector, frames. The Scottish Photography Group is a non-profitmaking organisation set up to promote a public understanding of photography and to encourage and support activities related to the medium. The aim is to provide a gallery,

along with lectures, workshops and library facilities.

FINE ART SOCIETY, 12 Great King Street, Edinburgh. Tel. 031 556 0305. Opening: Mon-Fri 10-6, Sat 10-1. 19th and 20th century British art with strong Scottish connections. Also occasional contemporary exhibitions.

TALBOT RICE ART CENTRE, Talbot Rice Art Centre, University of Edinburgh, Old College, South Bridge, Edinburgh EH8 9YL. Tel. 031 667 1011 ext 4308. Opening: Mon-Sat 10-5. Contact: Curator, Dr J. D. Macmillan. Applications: By letter to the Curator. Exhibitions: Modern sculpture and paintings, contemporary photographs, photographs from historical archives, architectural drawings, tapestries, group shows, student work, historical collections of paintings. Space: Approx. 350 linear feet of hanging space on 2 floors. Walls are white painted plaster with white rails at 6ft and 10ft. Lighting is daylight in main space backed by mercury fluorescent lights mounted in the ceiling. In the upstairs space and in the smaller downstairs area there is provision for track lighting. Equipment: Slide projectors, frames and movable screens. Policy of gallery is to show contemporary art both Scottish and international, but also to show historical exhibitions from time to time.

GLASGOW
GLASGOW ART GALLERIES AND MUSEUM, Kelvingrove, Glasgow G3 8AG. Contact: Anne Donald – Keeper of Art, Alistair Auld – Director. Major Scottish art gallery and museum. Collection of Italian, French, British, Dutch and European paintings. Good impressionist collection also Scottish paintings. Holds major international and national exhibitions. Membership scheme. See membership section. Chapter 3.

Branch museums to the above
POLLOK HOUSE, 2060 Pollokshaws Road, Glasgow G43. Tel. 041 632 0274.
HAGGS CASTLE, 100 St Andrews Drive, Glasgow G41. Tel. 041 427 2725.
PEOPLE'S PALACE MUSEUM, Glasgow Green, Glasgow G40. Tel. 041 554 0223.
MUSEUM OF TRANSPORT, 25 Albert Drive, Glasgow G41. Tel. 041-423 800.

FINE ART GALLERY, 134 Blythswood Street, Glasgow G2. Tel. 041 332 4027. Opening: Mon-Fri 9.30-5.30, Sat 10-1. 19th and 20th century British art. Also occasional exhibitions of painting and sculpture.

Also run by Glasgow Art Gallery and Museum
ST ENOCHS EXHIBITION CENTRE, St Enochs Square, Glasgow. Tel. 041 221 5264. Opening: 10-5. Rented on a 3 year lease from the Scottish Development Agency. Regular contemporary exhibitions. Contact the relevant

department at the Kelvingrove Art Gallery to ask about proposed exhibitions. Past exhibitions have included "What is Abstract Art?" Glasgow Art School: Embroidery, furniture, theatre design. Good sizeable well looked after exhibition space, off Argyle Street in central Glasgow. To be demolished and new gallery planned as part of multi-million St. Enoch's Centre. Temporarily in use month by month from March 1982.

COLLINS EXHIBITION HALL, University of Strathclyde, 22 Richmond Street, Glasgow G1 1XQ. Tel. 041-552 4400 ext 2416. Opening: Mon-Sat 10-5. Contact: Fiona Wilson, Curator. Applications: By letter. Exhibitions: Painting, sculpture (mainly figurative), crafts, historical shows, mostly group. Not installations or performance usually. Space: 400sq metres, almost a square, walls light beige hessian, tilted ceiling, brown carpet, strip and track lighting. Display boards and cases are available. Equipment: Carousel projector, tape recorders, 20 aluminium frames. Audience is two thirds staff and students of the university, where the courses are mostly scientific and technological, so the aim is to provide a wide variety of exhibitions.

COMPASS GALLERY, 178 West Regent Street, Glasgow. Tel. 041 221 6370. Opening: Mon-Sat 10.30-5.30. Contact: The Directors. Cyril Gerber. Gallery holds continuous exhibitions throughout the year of Scottish and international painters, printmakers, sculptors and ceramic artists – many of whom are young and having their first shows. Other more well-known artists are shown for the first time in the west of Scotland.

HUNTERIAN MUSEUM AND ART GALLERY, University of Glasgow, Glasgow G12 8QQ. Tel. 041 339 8855. Opening: Mon-Fri 9-5, Sat 9-12. Contact: F. Willett. New art gallery houses paintings by Chardin, Rembrandt, Stubbs, Whistler, Pissarro, Corot; extensive print collections and the furniture of Charles Rennie Mackintosh. Collection of work by contemporary Scottish artists also. Major Whistler collection outside America.

GLASGOW PRINT STUDIO AND GALLERY, 128 Ingram Street, Glasgow G1 1EJ. Tel. 041 552 0704. Contact: Calumn McKenzie. Exhibitions of painting, printmaking, photography and sculpture. Printmakers workshop and gallery. Glasgow League of Artists, often show work here. Scottish and international exhibitions. Useful noticeboard for Scottish art exhibitions and events.

HILLHEAD UNDERGROUND GALLERY, 2 Cresswell Lane, Glasgow G12. Tel. 041 334 5778. Contact: Wilson Lochhead. Opening: 10-5. Applications: Artists should apply to the director with slides and examples of work. The director prefers to have group of 2 man shows of work by Scottish and West coast artists but also shows work by other artists such as photographer Sam Haskins. Strong

Collins Exhibition Hall, Strathclyde University, Glasgow, Scotland

emphasis on local professional artists. 30% commission taken by the gallery. 45 metres running wall space. Will consider applications from students as well. Coffee area to be added in early 1981 and gallery expanded. The gallery is off Byres Road in West Glasgow near Great Western Road but not next to the Hillhead Underground. Friends of Hillhead Underground Gallery £3 per annum for invitations to private views.

LILLIE ART GALLERY, Station Road, Milngavie, Glasgow. Tel. 041 956 2351. Opening: Tues-Fri 11-5 and 7-9, Sat and Sun 2-5, closed Mondays. Contact: Elizabeth M. Dent. Applications: In writing to Curator. Exhibitions: Scottish and contemporary painting, prints, photography, sculpture, ceramics, jewellery and associated decorative arts. One person, permanent collection and travelling exhibitions. Space: One large (140 linear ft) and two smaller galleries. Track lighting, spotlights. One gallery can be blacked out. Permanent collection of 20th century Scottish paintings. Temporary exhibitions are mainly of Scottish artists and subjects of local interest.

THIRD EYE CENTRE, 350 Sauchiehall Street, Glasgow G2 3JD. Tel. 041 332 7521. Opening: Tues-Sat 10-5.30, Sun 2-5.30. Contact: Chris Carrell – Director. Space: Gallery 1 – 75ft x 24ft, linoleum tiled floor, daylight and spots. Gallery 2 – 24ft x 24ft, linoleum tiled floor, daylight and spots. A lively arts centre with a visual arts and theatre bias, presenting an on-going programme of exhibitions of wide-ranging appeal, from contemporary painting and sculpture to cartoons. Shows touring exhibitions and the work of Scottish artists, including photography. Lecture and film programme, information centre for the arts in Scotland, restaurant, bar and good art bookshop.

GLASGOW ARTS CENTRE, Washington Street, Glasgow G3.

KILMARDINNY HOUSE ARTS CENTRE, Kilmardinny Avenue, Bearsden, Glasgow.

GREENOCK
McLEAN MUSEUM AND ART GALLERY, 9 Union Street, Greenock. Tel. 0475 23741. Opening: Mon-Sat 10-5, closed Saturday 1-2.

HAWICK
MUSEUM AND ART GALLERY, Wilton Lodge, Hawick. Tel. 0450 3457. Opening: Mon-Sat 10-5, Sun 2-5.

INTERKEITHING
SCOTTISH SCULPTURE TRUST, 2 Bank Street, Inverkeithing, Fife. Tel. Inverkeithing 412811. Contact: Barbara Grigor. The Sculpture Trust does not organise gallery exhibitions, but assists and advises ,on the commissioning and siting of sculpture for public sites, it also manages Scotland's first open-air Sculpture Park at Landmark, Carrbridge.

INVERNESS
INVERNESS MUSEUM AND ART GALLERY, Castle Wynd, Inverness IV2 3ED. Tel. Inverness 37114. Opening: Daily 9-5, closed Sundays. Contact: Mr R. W. Higginbottom – Curator. Applications: By letter and submission of work. Exhibitions: All media, including craftwork. Emphasis on Highland Region, but also representative important work from further afield. Space: 43ft x 25ft, neon and track lighting, linoleum floor. Equipment: Slide projector.

IRVINE
HARBOUR ARTS CENTRE, Harbour Street, Irvine KA12 8PZ.

KIRKCALDY
KIRKCALDY MUSEUM AND ART GALLERY, War Memorial Gardens, Kirkcaldy, Fife. Tel. 0552 60732. Opening: Mon-Sat 11-5, Sun 2-5. Contact: Andrew Kerr. Applications: To the Curator, with details of work. Exhibitions: Generally a Scottish, local bias. Anything can be shown apart from large sculpture. Mostly group shows. Space: 7 Galleries, 3 for temporary exhibitions: 2 measuring 34ft x 19ft, 1 measuring 25ft square, track lighting, polished wood floors. Equipment: Slide projectors, tape recorder.

PERTH
PERTH MUSEUM AND ART GALLERY, George Street, Perth. Tel. 0738 32488. Opening: Mon-Sat 10-1, 2-5. Contact: Joanna Mundy – Keeper of Fine and Applied Art. Exhibitions: General range of fine and applied art, crafts etc., historical, contemporary, local interest etc. About 12 group or thematic exhibitions per year, 5 of which are timed to coincide with the Perth Festival in May. Space: One gallery available for temporary exhibitions, measuring approx 40ft x 20ft. Daylight (with u.v. filters) and spotlights, hanging rods available. Permanent collection of 19th century Scottish painting.

ST. ANDREWS
BALCARRES GALLERY, 93 North Street, St Andrews. Tel. 0334 74610. Opening: Mon-Sat 10-5, Sun 2-5.

CRAWFORD ART CENTRE, 93 North Street, St Andrews, Fife KY16 9AJ. Tel. 0334 74610. Contact: Jennifer Wilson. Variety of exhibitions of paintings, prints, sculpture and photography. 1 large room.

STIRLING
MACROBERT ARTS CENTRE GALLERY, University of Stirling, Stirling FK9 4LA. Tel. 0786 3171 ext 2549. Opening: Mon-Sat 11-5, Sun 2-5. Also 30 mins before theatre performances and during intervals. Contact: Mrs D. G. Butler – Art Gallery Administrator. Applications: Telephone, or write with slides etc. Exhibitions: Wide range – all media, no particular Scottish or contemporary orientation. Space: About 150 linear feet plus 10 screens, in Main Gallery. Foyer/Coffee Bar space

approx 300 linear feet. Tungsten halogen floodlamps and spotlights, also dimming system. University grounds available for displaying sculpture outside. Equipment: Most audio-visual equipment can be borrowed. Stock of aluminium frames (30 @ 20in x 30in and 10 @ 10in x 15in). Caters for the university population and the local theatre-going public (the Arts Centre houses two theatres), so the aim is to show exhibitions which appeal to a wide audience.

STIRLING SMITH ART GALLERY AND MUSEUM, Albert Place, Stirling. Correspondence to: Old High School, Academy Road, Stirling FK8 1DZ. Tel. 0786 2849 (Office), 0786 71917 (Gallery). Opening: Daily 2-5. Contact: James K. Thomson – Curator.

STROMNESS
THE PIER ARTS CENTRE, Victoria Street, Stromness, Orkney. Tel. 0856 850209. Opening: Tues-Sat 10.30-12.30 and 1.30-5, Sun 2-5, closed Monday. Contact: Erlend Brown. Applications: In writing to the Curator, in the first instance. Local artists given priority. Exhibitions: Policy is to promote the work of artists working in Orkney and to show travelling exhibitions, but also open to new ideas and have links with Scandinavian countries. Shows are mounted monthly. Space: Permanent collection occupies two thirds of the warehouse

gallery. Also 150 linear feet of temporary exhibition space. White walls, picture rails, carpet and quarry tiles, spotlights. Equipment: Carousel projector, sculpture stands, frames. Pier Arts Centre is principally a visual arts centre, with permanent collection of 20th century art. It is a new venture and the first of its kind in Orkney.

WICK
LYTH ARTS CENTRE, by Wick KW1 4UD, Highland Region. Tel. 095584/270. Opening: Daily 10-6 from mid-June to mid-Sept. Contact: William M. Wilson. Applications: By letter. Exhibitions: Mostly contemporary Scottish art. Space: Old country school and schoolhouse beautifully converted and offering many small spaces and one 40ft x 20ft lined throughout with cotton/jute twill screens with aged polished redwood floor. Overhead spots about to be replaced by full rig. Building arranged to form a circular tour including main gallery, craft shop, snack bar, permanent collection and tapestry workshop. Gravel terrace 90ft x 60ft specially prepared for sculpture. Equipment: 2 Carousel projectors with sync tape system (Convar) H&H P.A. system with mikes and monitors (part of extensive equipment available for music). Photographic dark room equipment and cameras. A mixed programme of exhibitions and events, including lectures, theatre, dance and music.

WALES

ABERGAVENNY
THE WELSH GALLERY, 18 Cross Street (Above W. H. Smith), Abergavenny, Gwent NP7 5EW. Tel. 0873 4023. Opening: Mon-Sat 9.30-1, 2-5, half day closing on Thurs. Contact: Malcolm Lewis. Applications: By phone or letter. Exhibitions: Paintings, drawings and prints of a wide range of styles. Priority given to local Welsh artists. Space: About 60 linear feet of hanging space, wooden floor, spotlights and fluorescent lighting. Equipment: Framing service. A private gallery showing a broad range of work, with as many Welsh artists as possible.

ABERYSTWYTH
ORIEL 700, 4 Corporation Street, Aberystwyth, Dyfed. Tel. 0970 612007. Contact: Alan Williams.

ANGLESEY
ORIEL MON, Central Library, Llangefni, Isle of Anglesey, Gwynedd. Tel. Llangefni 723262 ext 63. Opening: Mon and Fri 10-7, Tues and Wed 10-5, Thurs 10-6. Contact: J. Clifford Jones, A.L.A. Applications: In writing. Exhibitions: The only real limitations are those of space but priority is given to local or Welsh artists, mostly one-person shows. Space: 600 square feet, 66 linear feet of wall space, natural light, spotlights and fluorescent lighting.

Equipment: Slide projector, film strip projector, audio console, 16mm film projector.

BANGOR
ORIEL BANGOR, Old Canonry, Bangor, Gwynedd. Tel. Bangor 53368. Contact: Mr M Cullimore.

CAERNARFON
ORIEL PENDEITSH, Swyddog Hysbysrwydd, Cyngor Sir Gwynedd, Swyddfa'r Sir, Caernarfon, Gwynedd. Tel. Caernarfon 4121. Contact: Alun Lloyd.

CAERPHILLY
ARTICHOKE, Piccadilly Square, Caerphilly, Mid Glamorgan CF8 1PA. Tel. Cardiff 863354. Contact: Dan Sullivan. Opening: Thurs-Sat 10-5. A small interesting gallery, showing mostly local contemporary painting and sculpture.

CARMARTHEN
HENRY THOMAS GALLERY, Dyfed College of Art, Jobs Well Road, Johnstown, Carmarthen, Dyfed. Tel. Carmarthen 5855. Opening: Mon-Fri 10-8. Contact: Gareth J. Evans – Principal. Applications: To the college. Exhibitions: Art, design and craft, approx 9-12 each year. Space: 18m x 6m, with 17 display boards to extend wall space. Spotlights and natural light.

CARDIFF

ALBANY GALLERY, 74b Albany Road, Cardiff. Tel. Cardiff 27158. Contact: Mrs Hughes or Mrs Yapp.

CHAPTER GALLERY, Chapter Workshops and Centre for the Arts, Market Road, Canton, Cardiff CF6 1QE. Tel. 0222 396061. Opening: Mon-Fri Noon-10, Sat Noon-4 and 6-9. Contact: David Briers. Applications: In the first instance, send slides or photographs with a proposal for the use of the gallery space. Exhibitions: Contemporary art from Wales and elsewhere (including painting, printmaking, photography, sculpture and installations). Most exhibitions originate at Chapter, although touring shows are also brought in. Space: (1) Unit Gallery – 58m hanging length, 3.7m high, white painted chipboard walls, lighting is daylight with tungsten halogen lamps and spots. Four interlinked spaces on the ground floor of the arts centre. (2) Concourse Gallery – part of the restaurant eating area, used for small exhibitions. 12.5m hanging length, 3.05m high, white painted chipboard walls, spotlighting, wooden floors. There is a patio at the rear of the building which is used occasionally for robust sculptures and performance. Equipment: 2 Carousel projectors (plus possible use of the centre's other resources i.e. film projectors). The gallery is part of a multi-discipline arts centre, which has two cinemas, a film workshop, a theatre (showing music, dance, drama etc.), a restaurant, bars and artists' studios and workshops. The gallery's policy is to show a wide range of art-forms by artists from Wales, elsewhere in the UK and from abroad, mostly by professional artists.

NATIONAL MUSEUM OF WALES, Cathays Park, Cardiff CF1 3NP. Tel. 0222 397951. Opening: Weekdays 10-5; Sundays 2.30-5. Contact: Dr. Peter Cannon-Brookes – Keeper of Art. Applications: By invitation only. Exhibitions: Painting, drawing and sculpture of the last 100 years, international loan exhibitions, occasionally works by Old Masters. The primary responsibility of the Department of Art of the National Museum of Wales is the display of the extensive permanent collection of painting, sculpture, prints, drawings, watercolours and applied arts from the Renaissance to the present day and the temporary exhibition programme is intended to develop these areas of interest within the very limited space available.

ORIEL, 53 Charles Street, Cardiff CF1 4EH. Tel. 0222 395548/9. Opening: Mon-Fri 9.30-6, Sat 9.30-5.30. Contact: Isabel Hitchman. Space: Two floors. Oriel is the major Welsh Arts Council gallery, showing mainly contemporary work by artists usually living or working in Wales. Mostly one or two-person shows. There is a comprehensive bookshop stocking a wide range of publications on the visual arts.

BUILTH WELLS

WYESIDE ART GALLERY, Wyeside Art Centre, Castle Street, Builth Wells, Powys.

Chapter Arts Centre, Cardiff, Wales.

Tel. Builth Wells 3668. Contact: John Bates. Applications: In person, by post, or by telephone, to the administrative director, Wyeside Arts Centre. Exhibitions: Almost any kind of two dimensional work, occasionally 3-D work. Space: Wallspace 32m x 2.44m, lighting – tracksystem, daylight can be excluded. There are two auditoria with facilities for most art forms including cinema. Local artists are encouraged as well as national ones.

HAVERFORDWEST
HAVERFORDWEST LIBRARY HALL, County Library, Dew Street, Haverfordwest, Dyfed SA61 1SU. Tel. Haverfordwest 2070. Opening: Mon, Wed, Thurs 9.30-5, Tues and Fri 9.30-7, Sat 9.30-1. Contact: Regional Librarian. Applications: By telephone or letter, local artists preferred. Exhibitions: Mainly work by local artists, some touring shows from the Welsh Arts Council. From 20 to 25 exhibitions are held each year. Space: Circular room, with foyer, 1370sq ft, walls 8ft high, with hanging rods, floor carpeted, artificial light (spotlights) only. Equipment: Movable display stands, slide projector, 16mm sound projector, 8ft square screen. The exhibition area is seen as a natural extension of the library service in attempting to provide cultural, educational and leisure facilities in the hope that the library will remain a focal point for the community. Local artists often express gratitude that the facilities exist, and according to them compare favourably with any in Wales.

LLANDUDNO
MOSTYN GALLERY, 12 Vaughan Street, Llandudno, Gwynedd. Tel. Llandudno 79201. Contact: Clive Adams. Space: Gallery 1 – 47ft x 23ft, stained wood floor, daylight and tungsten halogen lighting. Gallery 2 – 41ft x 25ft, stained wood floor, daylight and tungsten halogen lighting. Reopened in August 1979, after a closure of 70 years, it has been refurbished and is a significant new gallery for contemporary art.

LLANELLI
PARC HOWARD, Llanelli, Dyfed. Tel. 055 42 3538. Contact: Harold Prescott.

LLANTWIT MAJOR
ST DONAT'S ART CENTRE, Llantwit Major, South Glamorgan. Tel. 2151. Contact: Bill Hughes.

MENAI BRIDGE
ORIEL TEGFRYN, Ffordd Cadnant, Menai Bridge, Gwynedd. Tel. Menai Bridge 712437. Contact: Mr and Mrs H. Brown.

MOLD
DANIEL OWEN CENTRE, Public Library, Mold, Clwyd. Tel. Mold 4791. Contact: Mrs Rona Aldrich.

NEWPORT
NEWPORT MUSEUM AND ART GALLERY, John Frost Square, Newport, Gwent. Tel. 0633 840064. Opening: Mon-Fri 10-5.30, Sat 9.30-4. Contact: Cefni Barnett. Permanent collection of early English watercolours plus mainly British 20th century paintings, emphasis on Welsh artists. Temporary exhibitions programme.

WOODSTOCK TOWER GALLERY, Caldicot Castle Museum, Caldicot, Nr. Newport, Gwent NP6 4HU. Tel. Caldicot 420241. Opening: Mon-Fri 11-12.30, 1.30-5, Sat 11-12.30, 1.30-6, Sun 1.30-6. Contact: Mrs J. Pearson – Curator. Applications: By phone or in person in the first instance, then work is seen by the curator. Exhibitions: Oils, watercolours, acrylics, graphics, photography, crafts. Eight exhibitions per year, of one month duration, mainly one person shows. Space: Three tower galleries, one above the other, each approx. 12ft square. Fluorescent lighting. Intended mainly for the use of amateur artists who have not previously exhibited elsewhere.

NEWTOWN
DAVIES MEMORIAL GALLERY, The Park, Newtown, Powys SY16 2NZ. Tel. 0686 26220. Opening: 10-4. Contact: Chris Hopwood. Applications: In writing. Exhibitions: Mainly 2D e.g. paintings, photographs, drawings. Space: 45ft x 36ft, hessian covered walls plus display panels, spotlighting, wooden floor.

PENARTH
TURNER HOUSE, Branch Gallery of National Museum of Wales, Plymouth Road, Penarth, South Glamorgan. Tel. 0222 708870. Opening: Tues-Sat 11-12.45, 2-5, Sun 2-5. Contact: Dr. Peter Cannon-Brookes – Keeper of Art. Details: As for National Museum of Wales.

PWLLHELI
LLEYN GALLERY, 44 High Street, Pwllheli, Gwynedd. Tel. Pwllheli 2708. Opening: 9.30-5.30. Contact: Dafyad ap Tomos. Applications: By letter, or personal application, with work or slides. Exhibitions: All types of work. One-person shows on the ground floor and mixed artists' work on the upper floor. Equipment: Slide projectors and framing facilities. A new gallery has been renovated and is called "Glyn-y-Weddw Gallery", Llanbedrog, near Pwllheli. Local artists of merit are encouraged, young artists promoted, also artists from further afield.

ST. DAVIDS
PETERS LANE GALLERY, Peters Lane, Saint Davids, Dyfed, Pembrokeshire. Tel. Saint Davids 570. Opening: Easter-Oct 9-dusk, other times by appointment.

ALBION GALLERY, Nun Street, St Davids, Dyfed. Tel. 043 788 570. Contact: John Rogers.

SWANSEA
THE EXHIBITION ROOM, The Cross, Community Resource Centre, 1 High Street, Pontardawe, Swansea SA8 4HU. Tel. 0792 863955. Opening: Weekdays 10-5, Sat 10-1.

Contact: Simon Boex. Applications: In writing to the Leader. Exhibitions: Broad range of arts and crafts, professional and amateur, local and national, individuals and groups. About 20 shows per year. Space: Ground floor 23ft x 13ft, spotlights and windows, rails and hanging rods. The exhibition room is situated in a converted hotel in the centre of Pontardawe, a small valley town. The Centre is intended to stimulate community development in the area. The room has been used for exhibitions since the centre started and a very wide range of exhibitions is put on to stimulate the local people.

ATTIC GALLERY, 61 Wind Street, Swansea, W. Glamorgan. Tel. Swansea 53387. Opening: Mon-Sat 10-5, open lunchtime. Contact: Brenda Bloxam. Applications: Mostly by invitation. Exhibitions: Only one held each year, in University College Swansea. Otherwise, the gallery keeps a stock of contemporary work – including lithographs, screenprints and etchings.

GLYNN VIVIAN ART GALLERY AND MUSEUM, Alexandra Road, Swansea. Tel. 55006. Opening: Mon-Sat 10.30-5.30. Contact: John Blunt. Permanent collection of porcelain, pottery and glass plus paintings of many schools and periods. Continuous temporary exhibitions programme.

WREXHAM
WREXHAM LIBRARY ARTS CENTRE, Rhosddu Road, Wrexham, Clwyd, North Wales. Tel. Wrexham 261932. Opening: Mon-Fri 10-5.30, Sat 10-5. Contact: Steve Brake. Applications: By letter, with slides. Exhibitions: Main Gallery – The work of living artists and group shows. Foyer – travelling museum exhibitions and small one man and group shows. Space: In the Main Gallery, about 40 linear metres of wall space, lighting fluorescent on dimmers. The Foyer has about 12 linear metres of wall space. Equipment: No frames, but most other 'normal' equipment available. Gallery shows mostly local groups and individual artists, but also the work of major artists from outside the North Wales area.

ALTERNATIVE EXHIBITION SPACES

The so-called 'third area' of time-based media – installations, performance and video – is not well-served with suitable gallery spaces. Below is a list of galleries and other spaces where this kind of work can be exhibited. Several of the galleries are listed in the previous section.

Most colleges and polytechnics should provide a venue for performance and possibly video, contact the Fine Art Department if you are interested in staging something for a student audience.

Film is usually more easily catered for, because film projectors are more freely available.

NORTHERN IRELAND

LONDONDERRY – The Orchard Gallery, Orchard Street, Londonderry. Tel. 0504 69675 (performance).

SCOTLAND

ABERDEEN – Aberdeen Art Gallery, Schoolhill, Aberdeen. Tel. 0224 26333 (installations and video).
Artspace, 37 Belmont Street, Aberdeen. Tel. 0224 50126. Contact: Hazel Sanderson (any proposals).
EDINBURGH – The Richard Demarco Gallery, 32 High Street, Edinburgh. Tel. 031 557 0707. Contact: Richard Demarco (installations, performance and video, experimental art in general).
The Fruit Market Gallery, 29 Market Street, Edinburgh. Tel. 031 226 5781. Contact: Robert Breen (installations and video have been shown).
GLASGOW – Third Eye Centre, 350 Sauchiehall Street, Glasgow G2 3JD. Tel. 041 332 7521 (performance, installations and video).

WALES

CARDIFF – Chapter Arts Centre, Market Road, Canton, Cardiff. Tel. 396061 (performance).

NORTHERN ENGLAND

BRAMPTON – LYC Museum and Art Gallery, Banks, Brampton, Cumbria. Tel. Brampton 2328. Contact: Li Yuan-Chia (installations, performance and video, but no video equipment on the premises).
JARROW – Bede Gallery, Springwell Park, Jarrow, Tyne and Wear. Tel. 0632 891807. Contact: Vincent Rea (installations, performance and video).

LEEDS – Breadline Gallery, 138 Town Street, Rodley, Leeds 13. Tel. Pudsey 566960. Contact: Trevor Whetstone (installations, performance and video, no video equipment on the premises).
LIVERPOOL – Liverpool Academy of Arts, 34 Pilgrim Street, Liverpool 1. Tel. 051 709 4088. Contact: Murdoch Lothian (installations, performance and video).
Open Eye Gallery, 90-92 Whitechapel, Liverpool 1. Tel. 051-709 9460. Contact: Peter Hagerty (performance and video).
Walker Art Gallery, William Brown Street, Liverpool L3 8EL. Tel. 051 227 5234. Contact: Timothy Stevens (all media).
NEWCASTLE – The Basement, Spectro Arts Workshop, Bells Court, Pilgrim Street, Newcastle-upon-Tyne. Tel. 0632 614527 or 0632 733686. Contact: Belinda Williams (all media, particularly performance). This is at the moment, the only exhibition space in the country that specialises in performance art.
The Gallery, Spectro Arts Workshop, Bells Court, Pilgrim Street, Newcastle-upon-Tyne. Tel. 0632 22410. Contact: Lucy Krause (installations, occasionally performance).
Tyneside Cinema, Pilgrim Street, Newcastle-upon-Tyne. Contact: Brian Hoey (video workshop, editing facilities and a venue for video work).
SUNDERLAND – Ceolfrith Gallery, Sunderland Arts Centre, 17 Grange Terrace, Sunderland, Tyne and Wear. Tel. 0783 43976 (installations only at present, but performance and video in the future, when basement space is converted).
WASHINGTON – Biddick Farm Arts Centre Gallery, Biddick Lane, Fatfield, Washington, Tyne and Wear. Tel. 0632 466440. Contact: Wendy Brown (all media, especially video, notably the annual International Video Show).

MIDLANDS AND EAST ANGLIA

BIRMINGHAM – Birmingham Arts Lab, Holt Street, Birmingham B7 4BA. Tel. 021 359 4192. Contact: Gillian Clark (performance).
Ikon Gallery, 58/72 John Bright Street, Birmingham B1 1BN. Tel. 021 643 0708 (all media).
CAMBRIDGE – Kettles Yard Gallery, Northampton Street, Cambridge. Tel. 0223 352124. Contact: Jeremy Lewison (some installations and performance).
LOUGHBOROUGH – Cotes Mill, Nottingham Road, Leics. Tel. 0509 31786. Contact: Marie Leahy (performance and installations).
NORWICH – Premises, Reeves Yard, St Benedicts Street, Norwich. Tel. 0603 60352. Contact: Nicky Whitworth (performance).
NOTTINGHAM – Midland Group, 24-32 Carlton Street, Nottingham NG1 1NN. Tel. 0602 582636 (performance mainly).

SOUTHERN ENGLAND

BRACKNELL – South Hill Park Arts Centre, Bracknell, Berks. Tel. 0344 27272. Contact: Jennifer Walwin (performance, installations and video – there are extensive video facilities).
BRISTOL – Arnolfini Gallery, 16 Narrow Quay, Bristol BS1 4QA. Tel. 0272 299191. Contact: Lewis Biggs (all media).
Bristol Arts Centre, 4/5 King Square, Bristol 2. Tel. 0272 45008. Contact: Deborah Ely (installations and performance).
EXETER – Spacex Gallery, 45 Preston Street, Exeter, Devon. Tel. 0392 31786. Contact: Caroline Fox/Diane Howse (all media).
OXFORD – Museum of Modern Art, 30 Pembroke Street, Oxford OX1 1BP. Tel. 0865 722733. Contact: David Elliott (a little of all media).
WELWYN – Digswell House Gallery, Monks Rise, Welwyn Garden City, Herts. Tel. Welwyn Garden 21506. Contact: Bill Parkinson (all media).

LONDON

AIR Gallery, 6-8 Rosebery Avenue, EC1. Tel. 01-278 7751. Contact: Robert McPherson (all media).
Action Space, 16 Chenies Street, WC1. Tel. 01-637 7664 (performance).
Camden Arts Centre, Arkwright Road, NW3. Tel. 01-435 2643/5224. Contact: Zuleika Dobson (some performance).
Film-Makers Co-operative, 42 Gloucester Avenue, NW1. Tel. 01-386 4806 (performance, video and film – extensive film-making facilities).
The Gallery, 52 Acre Lane, SW2. Tel. 01-274 0577 (performance and installations).
I.C.A., The Mall, SW1. Tel. 01-930 3647. Contact: Sandy Nairn (all media). Also ICA Cinematheque, The Mall, London SW1. Tel. 01-930 3647. Contact: Alex Graham. Video and film shows.

London Video Arts, 79 Wardour Street, London W1. Tel. 01-734 7410. (Has a stock of video equipment for hire and organises showings of videotapes at various venues. Also has a library of artists' videotapes for hire and sale).

Oval House, 54 Kennington Oval, SE11. Tel. 01-735 2786 (performance).

Riverside Studios, Crisp Road, W6. Tel. 01-741 2251 (performance).

Serpentine Gallery, Kensington Gardens, W2. Tel. 01-402 6075. Contact: Sue Grayson (all media, mostly during the summer shows).

Waterloo Gallery, 23-61 Gray Street, off Webber Street, SE1 (all media, potentially, probably most suitable for installations).

Whitechapel Gallery, Whitechapel High Street, E1. Tel. 01-377 0107. Contact: Nicholas Serota (all media).

X6 Butlers Wharf, Shad Thames, SE1 (dance and dance-based performances).

The Arts Council will consider applications, through the appropriate Regional Arts Association, from *venues* that are interested in booking performance and similar experimental artists, but that lack funds to pay artists' fees or expenses. Your local gallery may not know about this scheme and it could be a way of encouraging them to exhibit your work. Further details from: The Special Applications Assistant, Arts Council of Great Britain, 105 Piccadilly, London W1V 0AU. Tel. 01-629 9495.

 There are also two schemes run by the Arts Council for the presentation of artists' film and video, called *Film-makers on Tour* and *Video-Artists on Tour*. Contact the Assistant Film Officer at the Arts Council for details.

Chapter 3
SURVIVAL

SUPPLIERS

This list has been compiled with the help of many artists throughout Britain. Note: Addresses are listed according to materials and not regionally, because many artists use addresses from all over the country rather than just in their own area.

Painting materials (see **General Section** also)

Brodie and Middleton, 68 Drury Lane, London WC2. Tel. 01 836 3280/89. Brushed enamels, paint and pigments.

Leetes, 129 London Road, Southwark, London SE1. Paint, pigments and beeswax.

JT Keep and Sons Ltd., 15 Theobalds Road, London WC1. Tel. 01 242 7578. Enamels, fluorescent paints, paint spray equipment, palettes.

J. W. Bollom and Co., Long Acre, London WC2. A variety of art materials.

A. S. Handover Ltd., Angel Yard, Highgate High Street, London N6. Brushmakers.

Cornelissens, 22 Great Queen Street, London WC2. Tel. 01-405 3304. Brushes and pigments.

Dykeshire Ltd., 22 Great Pulteney Street, London W1. Tel. 01 437 5777/8.

George Rowney, 12 Percy Street, London W1. Tel. 01 636 8241. Most art materials.

Winsor and Newton, 52 Rathbone Place, London W1. Tel. 01 636 4237. Most art materials.

Reeves, 178 Kensington High Street, London W8. Most art materials.

Bird and Davis, 52 Rochester Street, London NW1. Tel. 01 485 3797. Stretchers, machinist joiners. Stretchers have to be ordered.

Russel and Chapple Ltd., 23 Monmouth Street, London WC2. Tel. 01 836 7521. Canvas suppliers.

Artex, 115 Kings Cross Road, London WC1. Tel. 01 278 2175. Canvas suppliers.

Charles and Co., 45 Pembridge Road, London W11. Tel. 01 727 6306.

Prog, 32 Thornhill Road, London N1. Tel. 01-607 0357. Aquatex acrylic paint.

Ploton Supplies, Archway Road, London N6.

Acrylic Paint Co., 28 Thornhill Road, London N1. Tel. 01 607 0357.

Tiranti, 21 Goodge Place, London W1. Tel. 01 636 8565.

Michael Putman, 151 Lavender Hill, London SW11. Brushes made to order.

Aquatec, 28 Thornhill Road, London N1. Acrylic paint.

George Rowney, Bracknell, Berkshire.

George M. Whiley Ltd., Victoria Road, Ruislip, Middlesex. Tel. 01 422 0141. Brushes, gold and silver leaf paint.

Spectrum, Richmond Road, Horsham, Sussex. Tel. Horsham 63799. Acrylics and oils.

Joseph Metcalfes, Leenside Works, Canal Street, Nottingham. Canvas.

Robinsons Ltd., Victoria Street, Nottingham. Art materials.

Rohm and Haas (UK) Ltd., Lenning House, 2 Masons Avenue, Croydon, Surrey. Tel. 01 686 8844. Acrylic media (large quantities).

Thos. Owen Ltd., The Side, Newcastle. Canvas.

Tor Coatings Ltd., 9 Shadon Way, Portobello Industrial Estate, Burtley, Chester le Street, Co Durham. Paints.

Wards, Percy Street, Newcastle.

Thornes, Percy Street, Newcastle.

Binney and Smith (Europe) Ltd., Ampthill Road, Bedford. UK wholesalers for liquitex.

Alec Tiranti, 70 High Street, Theale, Berkshire.

Wm. Wheeldon and Son, Steep Hill, Lincoln. Painting materials, framing etc.

Mellors, West Street, Boston, Lincolnshire. Artists colours, framing etc.

Winsor and Newton Ltd., Wealdstone, Harrow, Middlesex. General art materials.

Billson and Grant Ltd., Clocktower Works, 59 Belgrave Gate, Leicester. Canvas, rope and webbing.

Gadsbys, 22 Mercer Place, Leicester. Acrylic, oils, paper and framing.

Su Barraclough Gallery, 9 Allander Road, Leicester. Liquitex paint.

Cank Street Galleries, 48 Cank Street, Leicester. Liquitex paint.

Textile Manufacturing (Greys) Ltd., 48 George Street, Manchester. Tel. 061 236 3506. Canvas.

F. G. Davis and Sons Ltd., 19 North Arcade, Belfast. Canvas, paints etc.

Card'n Art, West End, Gorseinen, Swansea. Acrylic, oils, brushes, paints.

The Craftsman, Killay Shopping Precinct, Killay, Swansea. Paints, canvas, DIY framing.

Art Repro, De la Beche Street, Swansea. Art materials.

Photo supplies, St Helens Road, Swansea. Framing. Handmade paper and other art materials.

Hensons Antiques, 7A Chapel Lane, Headingley, Leeds. Tel. 0532 75194.

Broomhead Publications, 74 Fore Street, Heavitree, Exeter. Tel. 0392 74095. Retail art materials shop.

Paper

Paperchase, 216 Tottenham Court Road, London W1. Tel. 01 637 1121.

Kettles, 127 High Holborn, London WC1. Tel. 01 405 9764.

Atlantis Papers, New Crane Wharf, Garnet Street, London E1. Tel. 01 488 1541.

Clyde Paper Co. Ltd., 26/32 Clifton Street, London EC2. Tel. 01 247 4871. Large quantities of paper.

Robert Fletcher and Co., Terminal House, 52 Grosvenor Gardens, London SW1. Tel. 01 730 9275. Thin paper specialists.

Falkiner Fine Papers, 4 Mart Street, London WC2. Good variety of handmade papers.

R. K. Burt, 37 Union Street, London SE10. Large quantities, handmade paper.

G. F. Smith, 2 Leathermarket, Weston Street, London SE1. Tel. 01 407 0445.

Berkshire Graphics, Gunn Street, Reading.

Clyde Paper Co. Ltd., Rutherglen, Glasgow, Scotland. Large quantities of paper.

Hackitts Ltd., Lillington Road South, Bulwell, Nottingham.

J. E. Wrights Ltd., Huntingdon Street, Nottingham.

Barcham Green and Co. Ltd., Hayle Hill, Maidstone, Kent.

Drawing Office Requisites, Leicester Plan Copying Co., 9-11 Marble Street, Leicester.

G. F. Smith, Lockwood Street, Hull.

Len Tabner, High Barlby, Easington, Saltburn, N. Yorkshire. Tel. 0287 40948.

Framing

Blackman Harvey Ltd., 29 Earlham Street, London WC2. 48-hour framing service.

Sebastian D'Orsai, 39 Theobalds Road, London WC1. Tel. 01 405 6663 and 8 Kensington Mall, London W8. Tel. 01 229 3888.

Charles and Co., Pembridge Road, London W11. Tel. 01 727 6306.

L. M. Frames Ltd., 96-98 Grafton Road, London NW5. Tel. 01-485 2248. Mouldings in different colours.

Format Frames, 18 Grove Lane, London SE5. Tel. 01 701 8952. Frame kits.

Picture Wise, 11 Tottenham Mews, London W1. Tel. 01 637 4905.

Sancreed Studios, Sancreed, Penzance, Cornwall. Large range of frames.

Pieter van Suddese, 101-103 Doncaster Road, Sandyford, Newcastle upon Tyne. Tel. 0632 27826.

James McClure and Son, 1373 Argyle Street, Glasgow, Scotland.

Pitch Pine Products, 23 Mill Dam, South Shields, Tyne and Wear.

City Art, 4 North Court, Glasgow G1. Tel. 041 221 7746.

Sculpture materials

Metals

Lazdan, 218 Bow Common Lane, London E3. Tel. 01 981 4632. Steel.

Johnson Edwards Ltd., Chain Bridge Road, Blaydon, Newcastle. Ferrous metal bar.

Henry Righton Ltd., Brough Park Way, Newcastle. Non-ferrous metal.

Walter Lakey, Beaumont Fee, Lincoln. Tel. Lincoln 29673. Workshop – specialist in wrought iron, cutting and welding metal.

A. H. Allen, Steel stockholders, Bedford Road, Northampton.

Jamison and Green, 102 Ann Street, Belfast 1. Copper, steel, aluminium.

Tools

Parry and Son (Tools) Ltd., 329 Old Street, London EC1. Tel. 01 739 9422.

Clay

C. H. Brannam Ltd., Litchdon Potteries, Barnstaple, Devon. Tel. 0271 3035.

Watts Blake Bearne and Co. Ltd., Park House, Courtenay Park, Newton Abbott, Devon.

English China Clays, St Austell, Cornwall. Not less than ten tons.

Bellman Carter Ltd., 358-374 Grand Drive, Raynes Park, London SW20. Tel. 01 540 1372. Plasters, latex, wax.

E. B. N. Atkins, Stewart Lanes Goods Depot, Saint Rule Street, Wandsworth Street, London SW8. Tel. 01 622 1022.

John Myland Ltd., 80 Norwood High Street, London SE27. Tel. 01 670 9161.

Anchor Chemical Co. Ltd., Clayton, Manchester.

Fordanacia Co. Ltd., Free Wharf, Brighton Road, Shoreham by Sea, Sussex.

Somerville Agencies Ltd., Meadowside Street, Renfrew, Scotland.

Whitfield and Sons Ltd., 23 Albert Street, Newcastle under Lyme, Staffs.

Deancroft Ceramic Suppliers, Hanley, Stoke on Trent, Staffs.

Potclays Ltd., Brickkiln Lane, Etruria, Stoke on Trent, Staffs.

British Industrial Sand, Etruria Vale, Stoke on Trent, Staffs.

C. E. Plant, 10 Old Course Road, Cleadon Village, Nr. Sunderland. Clay, plaster, glaze.

General sculpture addresses
Alec Tiranti, 21 Goodge Place, London W1. Tel. 01 636 8565. Sculpture, enamelling materials.
Aston Farmhouse, Remenham Lane, Henley. Tel. Henley 2603.
Hopkinsons Ltd., Station Road, Nottingham. Metal stockholders.
William Watts Ltd., Arnold Road, Bosford, Nottingham. Large metal stockholders.
British Oxygen, Raynesway, Derby. Welding supplies.
Fosters Welding Supplies, Church Street, Lenton, Nottingham.
Record Ridgway Tools Ltd., Parkway Works, Sheffield, Yorkshire.
The Maininger Foundry Ltd., Bord Close, Basingstoke, Hants. Tel. 0256 24033.
Burleighfield Casting Studios, Loudwater, High Wycombe. Tel. 0494 21341.
British Gypsum, Beacon Hill, Newark, Notts.
China and Ceramic Centre, 231 North Sherwood Street, Nottingham. Clay.
Podmore Ceramics, 105 Minet Road, London SW9. Aalco (Romford) Ltd., North Street, Romford, Essex. Tel. Romford 64161. Aluminium.
Browne and Tawse, St Leonards Street, London E3. Tel. 01 980 4466. Steel.
Poth Hille and Co. Ltd., Wax Manufacturers and Refiners, 37 High Street, Stratford, London E15. Tel. 01 534 7091. Waxes.
Strand Glass and Co. Ltd., 524 High Road, Ilford, Essex. Fibreglass resins.

Timber
Moss, 104 King Street, London W6. Hardwoods.
C. F. Anderson and Son Ltd., Islington Green, London W1. Tel. 01 226 1212.
D. and J. Simons and Sons Ltd., 122-128 Hackney Road, London E2. Tel. 01 739 3744.
Higgs, Woodley, Reading.
Fitchett and Woollacott, Willow Road, Lenton Lane, Nottingham.
Palmers Timber Yard, Skinner Burn Road, Newcastle. Second-hand joists, floor boards etc.
E. Robson and Co. Ltd., West Side, Tyne Park, South Shields, Tyne and Wear. Western red cedar for stretchers.
Harleston Heath, Timber Yard, Harlestone, Northampton. Green seasoned, good sizes, cheap off-cuts.
Woodlines, 75 Commercial Road, Grantham, Lincolnshire.
Sandell Perkins, various branches throughout London.
E. M. Chambers, 36 Bow Common Lane, London E3. Second-hand wood.
Tyzack and Son Ltd., 341 Old Street, London EC1. Tel. 01 739 8301. Wood and metal working tools.

Buck and Ryan Ltd., 101 Tottenham Court Road, London W1. Tel. 01 636 7475. Machine tools.

Stone
Stone Firms, 10 Pascal Road, London SW8.
Mansfield Quarries, Clipstone Drive, Forest Town, Mansfield.

Plastics and Perspex
Central Plastics, 178 Albion Road, Stoke Newington, London N16. Tel. 01 254 5082.
Transatlantic Plastics, 672 Fulham Road, London SW6. Tel. 01 736 2277. Polythene.
R. Denny and Co., 13/15 Netherwood Road, London W14. Tel. 01 503 5152. Perspex suppliers.
Fablon Ltd., Berkeley Square House, Berkeley Square, London W1. Tel. 01 629 8030. Polythene.
Richard Daleman, 325 Latimer Road, London W10. Tel. 01 969 7455. Perspex materials.
Tuckers Ltd., 5 Gateside Road, Queens Drive Industrial Estate, Nottingham. Perspex.
G. H. Blore, Perspex Merchants, 48 Honeypot Lane, Stanmore, Middlesex. Tel. 01 952 2391.
A. J. B. Plastics Ltd., Station Road, Hook, Near Basingstoke, Hants. Tel. 025672 2706.

Printmaking
Printmakers would be well advised to buy the *Handbook to Printmaking Supplies* published by the Printmakers Council, Clerkenwell Close which covers practically everything that the printmaker should need to know together with appropriate addresses. It is stocked by art bookshops and galleries such as the ICA.

The addresses below are ones recommended by printmakers throughout the UK as being the most useful.

General
Michael Putman, 151 Lavender Hill, London SW11. Tel. 01 288 9087. Etching, litho, engraving and wood block materials. Printing and fine art supplies.
Atlantis Paper Co., F3 Warehouse, New Crane Wharf, Garnet Street, London E1. Tel. 01 481 3784. Handmade papers for printmakers.
Mitchell Street Print Studio, 39 Mitchell Street, London EC1. Tel. 01 253 8930. Fine art printing and editioning by arrangement.
Hunter Penrose Ltd., 7 Spa Road, London SE16.
T. N. Lawrence and Son, 2 Bleeding Heart Yard, Greville Street, London EC1.
Modbury Engineering, Belsize Mews, 27 Belsize Lane, London NW3. Second-hand relief printing presses.
L. Correlisson and Son, 22 Great Queen Street, London WC2. Tel. 01-405 3304. Printing and fine art suppliers.
Lowick House Print Workshop, Lowick, Near Ulverston, Cumbria. Tel. 0229 85698. Editioning, litho, intaglio relief and photo silk screen.

75

Artspace Studios Bristol, McArthur's Warehouse, Gas Ferry Road, Bristol 1.
Sericol Ltd., Unit C13, Tyne Tunnel Trading Estate, North Shields, Tyne and Wear
Harry Rochat, Cotswold Lodge, Staplyton Road, Barnet, Herts. Second-hand etching presses.
Serigraphics Silk screen, Fairfield Avenue, Maesteg, Mid-Glamorgan, (John Gibbs). Tel. 0656 733171.
Bewick and Wilson, 29 Spennithorne Road, Grangefield, Stockton on Tees, Cleveland. Tel. 0642 62768. Etching and litho presses.
Art Equipment, Craven Street, Northampton. Tel. 0604 32447. Etching presses.
Len Tabner, High Barlby, Easington, Saltburn-by-Sea, North Yorkshire. Tel. 02087 40948.
Jim Allen, Print Workshop, 181a Stranmillis Road, Belfast 9. Tel. Belfast 663591. All printmaking materials.
Dryads, Northgates, Leicester. Relief printing materials.

Screenprinting
Sericol, 24 Parsons Green Lane, London SW6.
Selectasine Ltd., 22 Bulstrode Street, London W1.
E. J. Marler, Deer Park Road, London SW19.

Photography and film
Process Supplies, 13-19 Mount Pleasant, London WC1. Tel. 01 837 2179. General photo supplies.
Vic Oddens, 5 London Bridge Walk, London SE1. Tel. 01 407 6833. Cameras, film, enlargers etc. Good second-hand selection.
Pelling and Cross, 104 Baker Street, London W1. Tel. 01 487 5411. Professional photo suppliers and also hire photo equipment.
Brunnings, 133 High Holborn, London WC1. Tel. 01 405 0312. Second-hand equipment. Photo dealers.
Keith Johnson Photographic, Ramillies House, 1-2 Ramillies Street, London W1. Tel. 01-439 8811.
Leeds Camera Centre, 16 Brunswick Centre, Bernard Street, London WC1. Tel. 01 837 8030.
Fox Talbot Cameras, 179 Tottenham Court Road, London W1. Tel. 01 636 1017. Main Nikon retailers. Good range of quality used equipment.
ETA Labs, 216 Kensington Park Road, London W11. Tel. 01 727 2570. Colour and b/w processors. Reliable and good.
Sky Photographic Services, 2 Ramillies Street, London W1. Tel. 01 437 4666. B/w and colour processors. Extra large contact sheets.
Paulo Processing, Cubitts Yard, London WC2. Tel. 01 240 3172. B/w and colour processors and duplicate transparencies.
Buckingham Photographic, 459 Bromley Road, Bromley. Tel. 01 698 4349. Cibachrome and colour processors at reasonable prices.

P. & P. F. James Photographic Ltd., 496 Great West Road, Hounslow, Middlesex. Tel. 01 570 3974. Colour processors.
J. R. Freeman Group, 74 Newman Street, London W1. Tel. 01 636 4537. B/w and colour processing and mounting.
The Darkroom, 35 Wellington Street, London WC2. Tel. 01 836 4008. B/w and cibachrome processors. Professional work only.

Rest of Britain
Edinburgh Cameras, 55 Lothian Road and 60 Clark Street, Edinburgh.
Alexanders Photographic Dealers, 58 South Clark Street, Edinburgh.
Hamilton Tait, 141 Bruntsfield Place, Edinburgh.
Lizars, 6 Shandwick Place, Edinburgh 2. Camera suppliers.
Klick Photographic, 229 Mornington Road, Edinburgh 10.
Photo Express, 7 Melville Terrace, Edinburgh 9.
Robband Campbell Harper Studios, 11 South Street, David Street, Edinburgh 2.
The Photo Centre, 28/30 Pelham Street, Nottingham.
Independent Filmmakers Association, Midland Group Gallery, Nottingham. Film facilities and equipment.
Ilford Ltd., Northern District Office, Mobberley, Knutsford, Cheshire.
Kodak Ltd., PO Box 10, Dallimore Road, Manchester.
Tyne colour, Western Approach, South Shields, Tyne and Wear. All Kodak, Ilford, Patersons and Ademco products.
Mobile Photo Services, Carliol Square, Newcastle. Cameras, second-hand enlargers and processors.
Bonsers, Bigg Market, Newcastle 1.
Leeds Cameras, Leeds.
Colourworld Ltd., North Shields.
Pelling and Cross, Welsh Back, Bristol.
Hunter Penrose, Bridge Road, Kingswood.

Video and Film
London Video Arts, 12-13 Little Newport Street, London WC2. Tel. 01 734 7410. Useful address for video artists. Video library for reference.
Fantasy Factory, 42 Theobalds Road, London WC1. Tel. 01 405 6862. Video editing for ½ inch and ¾ inch tapes.
Hudson and Carter Ltd., Midland Video Systems, 3 Attenborough Lane, Chilwell, Nottingham.
Tyneside Cinema, Pilgrim Street, Newcastle. 8mm video viewing, splicing, editing Umatic.
Amber, The Side Gallery, Side, Newcastle. 16mm cutting room.

Pottery
The Fulham Pottery, 210 New Kings Road, London SW6.
Wengers Ltd., Etruria, Stoke-on-Trent. Tel. 0782 25126.

76

Podmore Ceramics Ltd., 105 Minet Road, London SW9. Tel. 01 737 3636.

Ferro (GB) Ltd., Wombourne, Wolverhampton, Staffs. Tel. 09077 4144.

Harrison Mayer Ltd., Meir, Stoke, Staffs. Tel. 0782 31611.

Degg Industrial Minerals Ltd., Phoenix Works, Webberley Lane, Longten, Stoke-on-Trent, Staffs. Tel. 0782 316077.

Northern County Pottery Supplies, 29/31 Frederick Street, Laygate, South Shields.

Podmore & Sons Ltd., Shelton, Stoke-on-Trent.

GENERAL SECTION

Yates, 146 Kensington High Street, London W8. Tel. 01 229 4276. Woodyard. Hardboard etc.

Carpenters, 49 Kensington High Street, London W8. Tel. 01 937 6158.

Ryman Conran, 227 Kensington High Street, London W8. Tel. 01 937 1107. Branches throughout London. Stationers, office equipment and general office suppliers.

Instant Print West One, 12 Heddon Street, London W1. Tel. 01 434 2813. Photocopying and printing at reasonable prices.

Winton, 13 Abingdon Road, London W8. Tel. 01 937 2024. Picture glass, hardboard etc.

J. E. Wrights, Huntingdon Street, Nottingham.

Bristol Fine Art, 74 Park Row, Bristol.

F. Keetch Ltd., 48 Bridge Street, Taunton, Somerset.

Drayton Decorations Ltd., 103 Middle Street, Yeovil, Somerset.

Lane and Co., 2 George Street, Bridgewater, Somerset.

Cowling and Wilcox, 26/28 Broadwick Street, London W1. Tel. 01 734 9558.

Philip Poole and Co. Ltd., 182 Drury Lane, London WC2. Pens, nibs, inks. Vast variety to choose from.

Rank Zerox, 20 Edgware Road, London W2. Tel. 01 402 7647; HQ Rank Zerox can do colour zerox printing and also at certain Rank Zerox branches.

Rymans Ltd., Office Equipment, 200 Tottenham Court Road, London W1. Tel. 01 580 0184.

Craft O'hans, 21 Macklin Street, London WC2. Enamel suppliers.

Braithwaite and Dunn, 1st Floor, Victoria Centre, Nottingham.

Newman Abbott Ltd., 7 Helpston Road, Glinton, Peterborough. Cardboard tubes, packaging.

Christopher Maddison, (Furniture maker), Wragby, Lincs. Tel. Wragby 450. Does one-off jobs e.g. light boxes etc.

Milton Keynes Development Corporation, Lloyds Court, Central Milton Keynes. Tel. 0908 679101. Stretchers, darkroom and other facilities for artists in the area.

Museum Easels, 3 & 4 Brookshill Cottages, Harrow Weald, Middlesex.

Midland Paper Co., Cank Street, Leicester. Polythene off the roll.

Norman Underwood, 11-27 Frees Chorlane, Leicester. Glass.

Central Tape Agency Ltd., Hagden Lane, Watford, Herts. Tel. Watford 39877.

McMordie Bros., 130-134 Ravenhill Terrace, Belfast. Perspex, acrylic sheet.

Celtic Ceramics, Newport, Gwent. Good range of supplies. All pottery materials and equipment.

S. H. Smith and Co., Barker Street, off Portland Road, Shieldfield. Newcastle upon Tyne. Framers, stretchers, mouldings etc.

Craven Art Centre, Coach Street, Skipton, North Yorkshire.

Chandler Craft Shop, Leyburn, North Yorkshire.

Ripon Picture Gallery, Kirkgate, Ripon, North Yorkshire.

Millers, 54 Queen Street, Glasgow G1. Tel. 041 221 7985. Canvas, art supplies, graphic supplies.

Millers, 411 George Street, Aberdeen. Tel. 0224 634308.

Millers, 52 Rose Street, North Lane, Edinburgh. Tel. 031 225 4678.

STUDIOS

Artists have always had difficulty in finding suitable studio space but in the last ten years several organisations run by artists for artists have helped set up blocks of studio space on short term leases for artists. In London SPACE Studios (set up in 1968) and ACME Housing Association (set up in 1972) have continued to increase the amount of studio space available to artists living in London. In most cases these properties can only be used for working and not living in. Apart from these two non-profitmaking organisations run by artists, there are many independent studio blocks in London where artists have got together and negotiated their own leases and terms. Some of these studios are listed below.

Outside London — both elsewhere in England, and in Scotland and Wales, similar organisations run by artists and studio blocks have been set up to help artists in these areas. Some of these studio blocks and artist organisations are listed below. Several were set up with the initial help of ACME and/or SPACE giving advice about drawbacks and disadvantages as well as the advantages. Even in Australia and the USA ACME and SPACE have helped initiate organisations such as Creative Space in Sydney Australia, and the Institute for Art and Urban Resources in New York (Alanna Heiss the Director once worked for SPACE Studios in London). Hopefully more of these organisations will be set up to meet the growing demand for studio space.

In Wales the Association of Artists and Designers have organised studio space for its members and in Scotland there are several organisations such as WASPS (Workshop and Artists' Studio Provision Scotland) recently set up, Forebank Studios (Dundee) and the Scottish Association of Visual Artists (formerly Glasgow League of Artists) who have studio space in Glasgow. In English cities such as Liverpool, Portsmouth, Bristol and in Yorkshire there are other similar artist-run organisations that have come about specifically to provide studio space for artists locally.

If you are thinking of setting up studio space make sure that you contact Artlaw Services, 358 Strand, London WC2, who give specialised free legal help for studio projects and also the Arts Council of Great Britain who give grants for studio conversions. Regionally each Regional Arts Association should be able to give grants towards studio conversion so contact your local arts association for details or possibly they could give you addresses of organisations in your area that might consider renting you studio space. Whatever you do persevere whether it's keeping on the SPACE waiting list or looking for a warehouse with friends.

LONDON

SPACE STUDIOS, 6 and 8 Rosebery Avenue, London EC1. Tel. 01-278 7795. Director: Sarah Strong.

AIR and SPACE (Art Services Grants Ltd.), a non-profitmaking charity, comprises SPACE Studios, AIR Gallery and Art Services Newsletter.

SPACE was founded in 1968 in response to the need of professional visual artists for low cost studio space. SPACE has begun to meet this need in two principal ways; by providing studios and information on establishing independent studios.

Due to the ever increasing demand and diminishing supply of studios in central London SPACE operates a waiting list system. Although it is impossible to predict accurately the length of time an artist will be on the list before being offered a studio, it can vary from six to twenty months. However, artists who are able to be flexible about the location and condition of a studio are likely to be offered a studio more quickly than those with very specific requirements.

At present SPACE leases 22 buildings in the Greater London area, providing studios for 230 artists. The buildings themselves range from listed historic buildings to old schools and warehouse floors, and the studio sizes vary from 159 square feet to 1,000 square feet. Since 1968 SPACE has continued to adapt to the economic circumstances and progressed from short-term leases to those

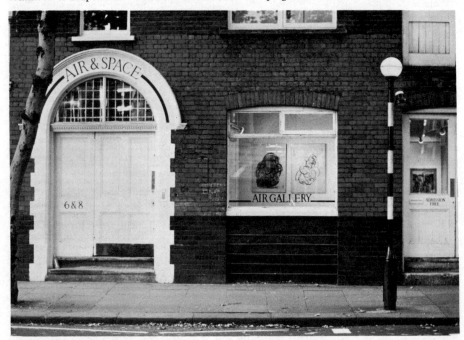

SPACE Studios and AIR Gallery, London

of medium term. The outlook on the property market points to SPACE being driven to bid for ever increasing lengths of leases and attempt to acquire suitable freehold buildings. The acquisition of such buildings will give SPACE the opportunity to provide artists with infinitely greater security of working space and ensure that the economic survival of the contemporary artist is a reality of modern society.

Existing SPACE Studio sites

8 Berry Street, EC1.
Belsham Street, Hackney
Bombay Wharf, 59 St Marychurch Street, SE16.
7-9 Boot Street, N1.
Charlton House, Hornfair Road, SE7.
49 Columbia Road, E2.
8-12 Deptford High Street, SE8.
Essex Road Baths, Greenman Street, N1.
Dockland Offices, Gate 3, Lower Road, SE16.
Leighton Court Road, Lambeth
10 Martello Street, E8.

Block C, Norfolk House, Brookmill Road, SE8.
Old Mill, Lewisham
Milborne Street, Hackney
15 Phipp Street, EC2.
18 Phipp Street, EC2.
Richmond Road, Hackney
6 & 8 Rosebery Avenue, EC1.
71 Stepney Green, E1.
45 Tabernacle Street, EC2.
47 Tabernacle Street, EC2.
82 Wapping Wall, E1.

Number of studios 240. Future acquisitions: Two further buildings at Norfolk House, Brookmill Road, SE8, providing 24 further studios. Latest development: Top floor studio, 6 and 8 Rosebery Avenue, EC1. Available to foreign arts institutions to rent for periods of not less than six months at a time. Nominated artist to live and work in a studio. Similar to a bursary scheme.

AIR Gallery details under "Gallery Section" and Art Services Newsletter (subscription £4) under "Art Magazines".

ACME HOUSING ASSOCIATION, 15 Robinson Road, London E2 (temporary address). A registered non-profitmaking charity comprising ACME Housing Association, and the International Visual Artists' Exchange Programme. (The ACME Gallery closed in November 1981). Tel. 01-981 6811.

ACME STUDIOS, 52 Acre Lane, London SW2. Tel. 01-274 0577 (studios and gallery). Hetley Road, London W12. Tel. 01-743 1843. Faroe Road, London W12.

ACME Housing Association was set up in 1972 by a group of artists who realised that in many parts of London there were a considerable number of council-owned houses lying empty and due for eventual but not immediate demolition. As a housing association they could approach the Greater London Council direct for this short life property. The properties were often in poor condition but initial expense was offset by the low rents charged. The properties were and still are large enough to allow generous studio space and accommodation which helps the artist and his family by finding him both living and working space.

Artists wishing to be considered for an ACME house or studio have to be interviewed first and then if accepted their names are put on a waiting list. At present artists could wait for between six months and a year for a house.

ACME houses some 200 artists and their families at present, and also has three studio blocks at Hammersmith and Brixton. The studio blocks provide working space only, not living accommodation, for some 50 artists. The houses in general provide working and living space for artists and are mainly in the East end of London. New studio block to be opened in the East End in 1982.

ACME also acts as a consultative and advisory body to other artists in Britain and has been involved initially in advising artists to set up studio blocks elsewhere in England and Wales. The International Visual Artists' Exchange Programme has been involved in setting up a chain of artists' organisations that can help artists exchange studios and living accommodation internationally.

Independent studio blocks (London)

SPACE INTER SPACE, Metropolitan Wharf, Wapping Wall, London E1. BARBICAN, Old St. Patrick's School, Buxton Street, London E1. 79-89 Lots Road, London SW10. ARTS GROUP, 2 Sycamore Street, London EC1. Tel. 01-253 7394. Fifteen studio spaces. KINGSGATE WORK-SHOPS, 110-116 Kingsgate Road, London NW6. Tel. 01-328 7878. Thirty-five studios, £2 per square foot.

Converted warehouses rented commercially at approximately £3 per square foot. Ads for these studios are often in *Time Out* magazine or passed by word of mouth by artists.

NEW CRANE WHARF STUDIOS, 4th Floor, East Warehouse, New Crane Wharf, Garnet Street, London EC1. Tel. 01-488 1819. ERROL STREET STUDIOS, London EC1. Tel. 01-588 5708. Chris Plowman and Tim Mara.

Printmaking studios with facilities for classes for professional printmakers.

STOCKWELL DEPOT, Stockwell, South London. ARTPLACE TRUST, Chisenhale Works, Chisenhale Road, Bow, London E3. Tel. 01-981 4518. £1 per square foot, 38 studios.

Studios for painters and sculptors.

LEB DEPOT, 52c Crooms Hill, Greenwich, London SE10. Another independent studio block for artists.

WATERLOO STUDIOS, 23-61 Gray Street, Off Webber Street, London SE1. Studios and gallery with regular exhibitions.
There are many other studio blocks run by small groups of artists throughout London. Ask friends if they know of any that might have space available.

ELSEWHERE IN ENGLAND

BRIGHTON OPEN STUDIOS, 166-168 Kings Road Arches, Brighton. Joss Whittle.

ARTSPACE BRISTOL, Top Floor, McArthur Warehouse, Gasferry Road, Bristol. Tel. 0272 36966.

DARLINGTON ART CENTRE, Vane Terrace, Darlington. Tel. 0325 483271.

KIRKLEES ART ACTION GROUP, The Hart Holes Studio, Greenfield Road, Holmfirth, Nr. Huddersfield. Tel. Holmfirth 2026.

START STUDIOS, St. Leonards Gate, Lancaster.

HOPE STREET STUDIOS, 32a Hope Street, Liverpool 1. Studios and gallery space.

MERSEYSIDE ART SPACE LTD., Bridewell Studios, Harper Street, Off Prescot Street, Liverpool. Tel. 051-260 6770.

KING STREET STUDIOS, 2 King Street, Quayside, Newcastle 1. Tel. 0632 812889. (Alison Dalwood).

OXFORD PRINTMAKERS CO-OPERATIVE, Christadelphian Hall, Tyndale Road, Oxford.

READING FINE ART STUDIO SPACE, 3 Regent Street, Reading, Berks.

YORKSHIRE ART SPACE SOCIETY, Washington Works, 86 Eldon Street, Sheffield. Tel. 0742 71769. Supported by ACGB and Yorkshire Arts Association; 4,500sq.ft. of studio space for artists. Founded 1977.

ART SPACE PORTSMOUTH, 27 Brongham Road, Southsea, Hants. Tel. 0705 812121.

PENWITH STUDIOS, St. Ives, Cornwall. Tel. 0736 795579.

CULLERCOATS, 57 Percy Park, Tynemouth, Tyne and Wear. (Edwin Easydorchik).

WINCHESTER ASSOCIATION OF WORKING ARTISTS, 4 Staple Gardens, Winchester.

FAR GONE STUDIO, Prince Albert Chambers, 1 Railway Street, Wolverhampton.

WALES

ASSOCIATION OF ARTISTS AND DESIGNERS IN WALES, CWS Building, Bute Terrace, Cardiff. Tel. 0222 372183. Available to AADW members only.

CHAPTER ARTS CENTRE, Market Road, Canton, Cardiff. Tel. 0222 396061.

SCOTLAND

SCOTTISH SCULPTURE WORKSHOP, 1 Main Street, Lumsden, Huntly, Aberdeenshire. Tel. Lumsden 372 (Frederick Bushe).

WASPS (Workshop and Artists' Studio Provision Scotland), 22 King Street, Glasgow G1 5QP. Tel. 041-552 0564. Administrator: George Docherty. WASPS is an independent organisation which receives funding from the Scottish Arts Council for the purpose of assisting artists by providing studios and workshops and studio conversion grants.
 Studios and Workshops: WASPS refurbishes to a basic non-equipped standard large studio blocks. These are sublet to artists on a monthly basis at low rents. There are at present 100 studio spaces for artists in Glasgow, Edinburgh and Dundee. A sculpture workshop equipped for use, and offering residential facilities is being established in Aberdeenshire.
 New Studio Conversion Grants: Groups of two or more artists who wish to establish and run their own studios can apply for up to £300 per artist towards 75% of decoration and refurbishing costs. The artists are expected to bear all subsequent running costs.

GLASGOW LEAGUE OF ARTISTS. For further information telephone 041-552 4067. C/o Ian McMillan, 22 King Street, Glasgow G2. (Lost their S.A.C. grant and therefore lost St. Vincent Lane studio space). Artist members listed below.
 Stan Bell, Malcolm Butts, Pat Quinn, Kaye Lynch, Ian McLeod, Mary Rintoul, Torquil Barker, Peter Kleboe, Cam Shaw, Denis Barns, Ellen McCann, Ian McMillan, Ronnie Forbes, Alex Nisbet, Donald Gray, Bill Gillon, Jim Taylor, Anthea Lewis, John Nelson, John Boyd, Mary Toms, Fred Parrish, Glen Coutts, Ti Armstrong, George Devlin.

DUNDEE GROUP (Artists) Ltd., Forebank Gallery and Studios, Forebank Road, Dundee. Tel. 0382 21860. Robert McGilvray and Sandra McNeilance. Aim is to provide a working space for practising artists. Run by WASPS who are now funded by Scottish Arts Council. Moving in June to Meadowside Buildings, Meadowside.

Artist occupants (July 1980): Brian McCann (Sculpture), Martin Stevenson (Painting), David Law (Painting), Don and Irma Ewen (Ceramics), Mike Beveridge (Ceramics), Bob and Christine Turnbull (Silversmithing), Eugene Jarych (Painting), John Boyle (Painting), Tom Haines (Painting), Len Morris (Painting), Grant Clifford (Painting), Les Mackay (Painting), Gerry Callaghan (Painting), Ian Richardson (Painting), Eddie Brand (Painting), Andy Stenhouse (Painting), Maggie Milne (Painting), Sandra McNeilance (Painting), Sandy Barr (Painting), Bob McGilvray (Painting), Jane Walker (Sculpture), Andy Nicol (Woodcarving), Colin Elder (Woodcarving), Lorraine Turnbull (Silkscreen), Gwen Swan (Silkscreen), Audrey White (Silkscreen), Jill Kinnear (Silkscreen). Members of the Dundee Group do not all work at Forebank studios but they often exhibit together.

ARTSPACE STUDIOS, 37 Belmont Street, Aberdeen. Tel. 0224 50126.

PRINT STUDIOS

All of these studios have either a membership scheme or access to professional printmakers.

GLASGOW PRINT STUDIO WORKSHOP AND GALLERY, 128 Ingram Street, Glasgow. Tel. 041 552 0704. Calum McKenzie.

DUNDEE PRINTMAKERS WORKSHOP, Dudhope Arts Centre, St Mary Place, Dundee.

KIRK TOWER HOUSE WORKSHOP, Kirkton of Craig, Montrose, Scotland.

EDINBURGH PRINTMAKERS WORKSHOP, 29 Market Street, Edinburgh. Tel. 031 225 1098.

PEACOCK PRINTMAKERS, 21 Castle Street, Aberdeen. Tel. 0224 51539.

ARGUS STUDIOS, Columbia House, Stisted, Braintree, Essex. Tel. 0376 25444.

BURLEIGHFIELD PRINTMAKING STUDIOS, Burleighfield House, Loudwater, High Wycombe, Bucks. Tel. 0494 25068.

ADVANCE GRAPHICS, 75 Tooley Street, London SE1. Tel. 01-407 4554.

CHARLOTTE PRESS LTD., 5 Charlotte Square, Newcastle-on-Tyne. Tel. 0632 27531.

MITCHELL STREET PRINT STUDIOS, 39 Mitchell Street, London EC1. Tel. 01 253 8930.

MID WALES INTAGLIO, Bridge Street, Corris, Nachynlleth, Powys, Wales.

OLD ST ETCHING CO, 39 Mitchell Street, London EC1. Tel. 01 253 8930.

SOUTH HILL PARK ARTS CENTRE, Bracknell, Berkshire. Tel. 0344 27272.

NORTH STAR STUDIOS, 65 Ditchling Road, Brighton, Sussex. Tel. 0273 601041.

BRISTOL PRINTMAKING WORKSHOP, The Macarthur Building, Gas Ferry Road, Bristol 1.

MOORLAND HOUSE PRINTMAKING WORKSHOP, Burrowbridge, Nr Bridgwater, Somerset. Tel. 082 369200.

AADW PRINT WORKSHOP, Tyndall Street, Cardiff, S Glamorgan. Tel. 0222 374049.

CHAPMANSLADE PRINT WORKSHOP, 107 High Street, Chapmanslade, Wiltshire. Tel. 037388 269.

THE GRAPHIC STUDIO, 18 Upper Mount Street, Dublin, Eire. Tel. 0001 766 149.

PRINT WORKSHOP, 36 Mount Pleasant Square, Dublin, Eire.

YORKSHIRE PRINTMAKERS LTD., The Gate House, Globe Mills, Victoria Road, Leeds 11. (could be moving in '81).

BRIDEWELL PRINT WORKSHOP, Bridewell Studios, The Old Police Station, Prescot Street, Liverpool 17. Tel. 051 260 6770.

PADDINGTON LITHOGRAPHIC WORKSHOP, Paddington Institute (ILEA), London. Tel. 01 289 3255.

PALM TREE EDITIONS, Mornington Court, 1 Arlington Road, London NW1. Tel. 01 388 3952.

PRINT WORKSHOP, 28 Charlotte Street, London W1. Tel. 01 636 9787.

PRINTERS INK AND ASSOCIATES, 27 Clerkenwell Close, Unit 355, London EC1. Tel. 01 251 1923.

THE ROSENSTIEL ATELIER, 33/35 Markham Street, Chelsea Green, London SW3. Tel. 01 228 8330.

81

STUDIO PRINTS, 199 Queens Crescent, London NW5. Tel. 01 485 4527.

WHITE INK LTD., 2 Shelford Place, London N16. Tel. 01 254 8566.

IAN BRICE, 5th Floor, Warehouse D, Wapping Wall, London E1. Freelance lithographic printing.

OXFORD PRINTMAKERS COOPERATIVE, Christadelphian Hall, Tyndale Road, Oxford. Tel. 0865 726472.

PENWITH PRINT WORKSHOP, Back Road West, St Ives, Cornwall. Tel. 0736 795 579.

BRACKEN PRESS, 2 Roscoe Street, Scarborough, N. Yorkshire. Tel. 0723 71708.

CRESCENT ARTS WORKSHOP, The Art Gallery, The Crescent, Scarborough.

CURWEN STUDIO, Midford Place, 114 Tottenham Court Road, London W1. Tel. 01 387 2618.

DOG'S EAR STUDIO, F3 Warehouse, New Crane Wharf, Wapping, London E1. Tel. 01 481 9563.

NEW CRANE STUDIO, E4 Warehouse, New Crane Wharf, Garnet Street, London E1. Tel. 01 488 1819.

OMELETTE PRESS, 18 Phipps Street, London EC2.

PALM TREE EDITIONS, The Basement, Mornington Court, 1 Arlington Road, London NW1. Tel. 01 388 3952.

MANCHESTER ETCHING WORKSHOP, 3/5 Union Street, Manchester. Tel. 061 832 5439.

MANCHESTER PRINT WORKSHOP, University of Salford, Meadow Road Building, Salford. Tel. 061 736 5843.

CHARLOTTE PRESS, 5 Charlotte Square, Newcastle-on-Tyne. Tel. 0632 27531.

SPECTRO ARTS WORKSHOP, Bells Court, Pilgrim Street, Newcastle-on-Tyne. Tel. 0632 22410.

PRINT WORKSHOP, Gainsboroughs House, 46 Gainsborough Street, Sudbury, Suffolk. Tel. 0787 72958.

PRINT WORKSHOP, Ceolfrith Gallery, Sunderland Arts Centre, 17 Grange Terrace, Stockton Road, Sunderland. Tel. 0783 41214.

MOAT LANE EDITIONS, Taynton, Gloucester. Tel. 045 279 465.

DOLF RESIER, 98 Sumatra Road, London NW6. Tel. 01 435 4768. Open to professional printmakers. Dolf Reiser trained with Hayter in Paris.

VIDEO WORKSHOPS AND ACCESS FACILITIES

ENGLAND

Avon
AVON COMMUNITY COMMUNICATIONS ASSOCIATION, McArthur Warehouse (Artspace), Gasferry Road, Bristol. Tel. 0272 28497.

BATH ARTS WORKSHOP, 146 Walcot Street, Bath. Tel. 0225 310154. (Brian Popay, Paul Nachman).

Berkshire
SOUTH HILL PARK ARTS CENTRE, Birch Hill, Bracknell RG12 4PA. Tel. 0344 27272. (Francis Dobbs, Richard Thorneycroft).

Buckinghamshire
GREAT LINFORD COMMUNITY WORKSHOP AND MEDIA CENTRE, St Leger Court, St Leger Drive, Great Linford, Milton Keynes MK14 5HA. Tel. 0908-613875. (Bob Jardine, Elspeth Varley, Andy Collins).

Cambridgeshire
VIDEO CAMBRIDGE, 7 Priory Street, Cambridge. (David Jakes).

Cumbria
AIDANVISION STUDIOS, Westmorland Street, Carlisle. Tel. 0228 36480 or 44633. (Roy Thompson, Clare Crossman).

Aidanvision aims to explore video as an art form, to research and produce pilots for new types of programme, to look at new technical developments in relationship to visual perception, to provide a resource for anyone wishing to use it, to originate implement and service a simple distribution system and to act as an agent for studio and independent work. In the long term, Aidanvision aims to become a major visual research facility for experimental and new work in the UK.

The studio is well equipped for colour and black and white. It has three Philips 3 tube LKD broadcast cameras and a Marconi 7, 4 tube camera with Evershed powered Angenieux lens + Varitol lenses, with full shot box controls and mounted on Vinten pedestals with Mk 3 panning heads. Sound control is via a PYE – T.V.T. 99 imput desk with 41 channel mixing and all auxilliary systems. The studios use 1in Helical, 1in C Format (contract only) and U-matic machines for vision recording. The main studio is 191 square meters – sound stage with Armourfloor and PMP studio floor.

BREWERY ARTS CENTRE, 122a Highgate, Kendal. Tel. 0539 25133. (Chris Taylor, David Longmire).

Devon
NORTH DEVON WORKSHOP, South Molton Community College, Alswear Road, South Molton, Devon. Tel. 076 952834. (Wyn Smith).

London
ACTION SPACE, The Drill Hall, 16 Chenies Street, London WC1. Tel. 01 637 7664. (Rob La Frenais, Helen Vivian, Pete Shelton).

ELECTRIC NEWSPAPER, 90 Charing Cross Road, London WC 2H 0JE. Tel. 01 836 5391. (Steve Herman).

FANTASY FACTORY, 42 Theobald's Road, London WC1. Tel. 01 405 6862 (Sue Hall, John Hopkins). Half-inch EIAJ 625 and 525 playback (b&w). Half-inch EIAJ 625 and ¾ inch Umatic colour editing. Access to time base corrector, inter-standard dubbing. Two-camera b&w studio with Genlock vision mixer and audio mixing and processing. Video post-production courses are run using this equipment; the group is in favour of all types of independent production, systemic anarchy, diversity, and new ideas.

INTER-ACTION COMMUNITY MEDIA DIVISION, Talacre Open Space, 15 Wilkin Street, London NW5. Tel. 01 485 0881.

LONDON VIDEO ARTS, 79 Wardour Street, London W1. Tel. 01 734 7410. A library of artists' video tapes plus equipment available for hire. Also arrange showings of video tapes and installations at various venues.

TWO BOROUGH VIDEO ACCESS, Oval House Theatre, 52-4 Kennington Oval, London SE11. Tel. 01 735 2786. (Nick Fry, Jon Dovey).

Merseyside
DUNBOBBIN OASIS GROUP, 46 St Christopher Way, Liverpool 18.

KNOWSLEY VIDEO (Community Action TV), Video unit, Prescot Civic Hall, Aspinal Street, Prescot, Merseyside. Sony rover portapak, black and white editing suite, small TV studio (monochrome), Philips video cassette recorder (limited availability), 16mm Bolex, super 8mm, standard 8mm, dual-standard projector 8mm/super-8, 16mm projector (magnetic and optical sound), 8mm editing facilities, 16mm editing facilities (inc. sound sync.).

Nottinghamshire
MIDLAND GROUP, 24-32 Carlton Street, Nottingham. Film/video workshop established by East Midlands Art Association.

Oxford
THE OPEN UNIVERSITY RESEARCH UNIT OXFORD, Foxcombe Hall, Boars Hill, Oxford. Tel. 0865 730731. (Simon Nicholson, Ray Lorenzo). Half-inch Sony (high density).

Tyne and Wear
Biddick Farm Arts Centre, Biddick Lane, Fatfield, District 7, Washington, Tyne and Wear. Tel. 0632 466440. (Brian Hoey, Wendy Brown, Rosemary Herd). Video artists and organizers of video art exhibitions (annual event).

West Midlands
BIRMINGHAM FILM-MAKER'S COOPERATIVE, Arts Lab, Holt Street, Gosta Green, Birmingham B7 4BA. Tel. 021 359 4192/2403. (Tony Bloor, Roger Hewins). The cooperative was set up two years ago to establish a regional film workshop with facilities for 16mm and 8mm, for use by independent film-makers in the area, and to encourage distribution of members' work. Production is by individuals rather than as a group. Well-equipped facilities now exist for 16mm pic/sound editing and sound transfer.

WALES

Clwyd
GLEN MCIVER, Quevain, Mold Road, Ewlow Green, Clwyd CH5 3AU. Tel. 051 647 9059. EIAJ-1 625 line portapaks and edit decks,. monitors etc.

CHAPTER FILM AND VIDEO WORKSHOP, Chapter Arts Centre, Market Road, Canton,

Cardiff CF5 1QE. Tel. 0222 31194. (Steve Gough, Richard Watkins). Production/post-production (editing) facilities for 16mm film-making; community video resource centre (portapaks plus editing) for local area, plus workshop-initiated community projects.

INDEPENDENT FILM WORKSHOPS AND FACILITIES

FOUR CORNER FILMS, 113 Roman Road, London E2. Tel. 01 981 4243.

INDEPENDENT FILM-MAKERS' ASSOCIATION, 12/13 Little Newport Street, London WC2 HJ77. Tel. 01 734 8508/9.
Branch Offices as follows:
IFA EAST MIDLANDS, Midland Group, 24-32 Carlton Street, Nottingham. Tel. 0602 582636. (Robert Sheldon, Jeff Baggot).
IFA WEST MIDLANDS, Birmingham Arts Lab, Holt Street, Birmingham. Tel. 021 359 4192. (Roger Hewins).
IFA NORTH WEST, Manchester Film Workshop, 5 James Leigh Street, Manchester. Tel. 061 236 6953. (John Crumpton, Bob Jones, Greg Dropkin, Pete Bainbridge).
IFA NORTH EAST, Amber Associates, 5 The Side, Newcastle, Tyne and Wear. Tel. 0632 22208. (Murray Martin).

LONDON FILM-MAKERS' CO-OPERATIVE, 42 Gloucester Avenue, London NW1. Tel. 01 722 1728 (Workshop), 01 586 4806 (Distribution, Cinema). (James Mackay – Cinema; Felicity Sparrow, Mick Kidd – Distribution; Susan Stein, Nicky Hamlyn – Workshop). The London Film Co-op is a non-profit organisation established in 1966 to help independent film makers in the distribution, production and screening of their films. All aspects of the co-op are run by and for its members; membership is open to all those active in the production of independent film. Please feel free to contact the co-op for further information about any of its activities. Workshop membership £10 p.a. Co-op catalogue available. In 1978 extensive customized rebuilding was carried out and now more facilities (editing booths, printing, processing sound transfer booths are available). The cinema encourages seminars and discussions as part of its programming. Distribution open to ALL film-makers; details and catalogue from office. In the same building: LONDON MUSICIANS' COLLECTIVE, 42 Gloucester Avenue, London NW1.

MANCHESTER FILM AND VIDEO WORKSHOP, 5 James Leigh Street, Manchester M60 1SX. Tel. 061 236 6953.

SHEFFIELD INDEPENDENT FILM GROUP, Walkley Junior School, Greaves Street, Walkley, Sheffield 6; or 147b Rustlings Road, Sheffield. Tel. 0742 665381. (Russ Murray – Secretary).

WOMEN'S ARTS ALLIANCE, 10 Cambridge Terrace Mews, Albany Street, London NW1. Feminist Film Distribution.

COMMUNITY RADIO

COMMUNITY RADIO MILTON KEYNES, 161 Fishermead Boulevard, Fishermead, Milton Keynes MK6 2AB. Tel. 0908 678428/9. (Ray Price, Station Manager, Roy Simson, Senior Producer, Julia Martin, Advertising Manager). Community Access cable radio station used by any MK resident to inform, educate or entertain. The emphasis of the station is to report and comment on all aspects of life in the new city.

FREE RADIO ASSOCIATION, 339 Eastwood Road, Rayleigh, Essex SS6 7LG. (Geoffrey Pearl).

THAMESMEAD INSOUND, St Pauls Centre, Bentham Road, London SE28 8AR. Tel. 01 310 5025. (Frank Warren, Nick Hennegan). Home Office licensed cable radio experiment on expanding GLC development.

WSM COMMUNITY RADIO, 215 Willowfield, Woodside, Telford, Salop. Tel. 0952 583520. (Allan Peterson – Producer).

PHOTOGRAPHIC WORKSHOPS

LONDON

BLACKFRIARS PHOTOGRAPHY PROJECT, 44 Nelson Square, London SE1. Contacts: Carol Webb, Barbara Hartley. Session fee £2.50 plus materials. 10-5.30 weekdays plus evening sessions. Classes available.

LONDON NORTH PADDINGTON COMMUNITY DARKROOM, 510 Harrow Road, London W9. Tel. 01 969 7437. Contacts: Ulrike Preuss and Philip Nolmuth. Facilities available to anyone who lives or works in North Paddington. 50p an hour. Open 10.30-6 Mon-Fri. Classes given. Part of a large community centre.

HALF MOON PHOTOGRAPHY WORKSHOP, 119-121 Roman Road, London E2. Tel. 01 980 8798. Contact: Richard Harris. Phone for details.

84

SOUTH HILL PARK ARTS CENTRE, South Hill Park, Bracknell, Berkshire. Tel. 0344 27272. Contact: Francis Dobbs. £5 membership a year. Open 9-11pm seven days a week. Classes available. Other film and video facilities available.

BRISTOL ARTS CENTRE, 4-5 King Square, Bristol. Tel. 0272 45008. Contact: Deborah Ely. Open soon. Basic black and white darkroom facilities. Membership fees. Gallery also.

BATH CENTRAL CLUB, 6 Lower Boro' Walls, Bath, Avon. Contact: Martin Winson. Facilities open to all. Fee to cover costs and materials. Workshops arranged if needed.

ASTON UNIVERSITY CENTRE FOR THE ARTS, Gosta Green, Birmingham. Tel. 021-359 3979. Contact: Frank Taylor. Session fee for darkroom facilities £4 per term. Gallery also attached. Open seven days a week.

AADW Print Workshop, AADW Building, Tyndall Street, Cardiff. Tel. 0222 374049. Contact: Peter Cole. Open to anyone Session fee £3 per day. AADW membership £10 per annum. Also print workshop.

PHOTOGRAPHERS PLACE, Bradbourne, Ashbourne, Derbyshire. Tel. 033525 392. Contact: Paul Hill. Session fee £8 per day (£12 including B&B and evening meal). Open 9-5 except for those staying. Workshops £90 per week. Contact Paul Hill for further details of organised courses.

OPEN EYE, 90-92 Whitechapel, Liverpool. Tel. 081-709 9480. Contact: John Craig. Open to anyone. 9am onwards. Evening classes. Reduced price materials.

DARLINGTON ARTS CENTRE, Vane Terrace, Darlington. Contact: Richard Grassick. Photographer in residence. Session charge 50p and 50p per 3 hour session. Also Arts Centre facilities with gallery, studios, bar etc.

CASTLE CHARE COMMUNITY ARTS CENTRE, Castle Chare, Durham. Tel. 0385 46226. Contact: Ken Payne. Membership £2 per annum. Open 9-10pm every day. Workshop courses.

BREWERY ARTS CENTRE, 122A Highgate, Kendal, Cumbria. Tel. 0539 25133. Contact: David Watt. Facilities available to anyone. Session fee negotiable. Materials available at reduced price.

SPECTRO ARTS WORKSHOP, Bells Court, Pilgrim Street, Newcastle-on-Tyne. Tel. 0632 22410. Contact: John Kilpin, Chris Wainwright. Open Tues-Sat 10-6, Sat 6-10 by arrangement. Membership fee £23 per annum, £8.60 a quarter.

SPLIT IMAGE, 17/21 Mumps, Oldham. Tel. 061 620 4063. Contact: Richard Raby, Helen Bridges. Open Mon-Fri 10-5.30. Courses on request. Open to groups and individuals.

PLYMOUTH ARTS CENTRE, 38 Looe Street, Plymouth. Tel. 0752 60060. Contact: Bernard Samuels. £5 membership fee a year. Session fee 60p an hour, students 30p, non members £1. Open Mon-Sat 10-9.

ST EDMUNDS ART CENTRE, Bedmin Street, Salisbury. Contact: Peter Mason. £3 per annum. Open Mon-Sat 10-5.30. Two galleries in the art centre.

CRESCENT ARTS WORKSHOP, The Crescent, Scarborough, North Yorkshire. Contact: John Jones. £10 membership a year. Small session fee also. Workshop, lectures etc.

SOUTH YORKSHIRE PHOTOGRAPHY PROJECTS, 173-175 Howard Road, Walkley, Sheffield. Tel. 0742 340369. Contact: Alex Laing. Annual Membership fee £5 plus £5 to use photographic facilities. Open Wed-Sun 10-1, 2-5, 6-9.

CEOLFRITH PRINT WORKSHOP, Sunderland Arts Centre, 17 Grange Terrace, Stockton Road, Sunderland. Tel. 0783 41214. Contact: Susan Jones. Membership £15 a year, £8 a quarter, £2 a month. Open Mon-Fri 9.30-6 and Wed 6-9.30.

IMPRESSIONS GALLERY OF PHOTOGRAPHY, 17 Colliergate, York. Tel. 0904 54724. Contact: Val Williams. £10 membership and 50p per session. Open Tues-Sat 10-6, Sundays June-Sept. Discount for materials to members. Good photographic gallery attached.

ARTISTS ORGANISATIONS AND OTHER USEFUL ART ADDRESSES

ARTISTS ORGANISATIONS – LONDON

SHAPE, 9 Fitzroy Square, London W1. Tel. 01 388 9622/388 9744. Shape introduces professional visual artists, musicians, actors, dancers and puppeteers to hospitals, prisons, youth centres, day centres and to elderly, mentally and physically handicapped people and to homeless, disturbed adolescents and offenders.

AUDIO ARTS, 6 Briarwood Road, London SW4. Tel. 01-720 9129. Editor Bill Furlong. Sells editions of tapes by known artists whose work is best promoted in this medium.

ACME HOUSING ASSOCIATION, 15 Robinson Road, London E2. Tel. 01-981 6811. Directors Jonathan Harvey and David Panton. A non-profitmaking charity that houses artists mostly in the East end of London. Currently has some 250 houses and three studio blocks. Waiting list after artists have been interviewed.

INTERNATIONAL VISUAL ARTISTS EXCHANGE PROGRAMME, 15 Robinson Road, London E2. Tel. 01-981 6811. Run by ACME housing Association to help artists swap studio and living accommodation with artists in the USA, Canada, Australia, New Zealand and Europe. £5 to receive quarterly newsletter with listings of overseas addresses.

INTERNATIONAL ASSOCIATION OF ART, 31 Clerkenwell Close, London EC1. Tel. 01 250 1927. Administrator Matthew Collings. £2.50 membership to professional artists. Card to enable artists to gain reduced entry to galleries in UK and overseas, also discount at certain supply shops, travel agents, books etc.

SPACE STUDIOS, 6 & 8 Rosebery Avenue, London EC1. Tel. 01 278 7795. Space Studios was set up in 1968 to help artists find cheap studio space. See Studios section for details. Waiting list and interview for studios. AIR gallery also run below SPACE offices and ASG newsletter for artists.

THE ARTISTS' UNION, 9 Poland Street, London W1. Tel. 01 437 1984. Active Artists' Union open to all professional artists. Newsletter and latest developments. £10 subscription.

FEDERATION OF BRITISH ARTISTS, 17 Carlton House Terrace, London SW1. Tel. 01 930 6844. Secretary General Carl de Winter. Federation of British art societies including many Royal Art societies. Leases the Mall Galleries where members have the opportunity to submit work for exhibitions. Membership by subscription.

NATIONAL SOCIETY OF PAINTERS, SCULPTORS AND PRINTMAKERS, 17 Carlton House Terrace, London SW1.

NEW ENGLISH ART CLUB, 17 Carlton House Terrace, London SW1.

INDUSTRIAL PAINTERS GROUP. As above. Also: Royal Institute of Oil Painters; Royal Institute of Painters in Watercolour; Royal Society of British Artists; Royal Society of Marine Artists; Royal Society of Miniature Artists; Royal Society of Painters Etchers and Engravers; Royal Society of Portrait Painters; Senefeld Group of Artist Lithographers; Society of Mural Painters; Society of Women Artists; United Society of Artists; Society of Architect Artists.

CHELSEA ART SOCIETY, Chenil Art Galleries, Kings Road, London SW3.

ART REGISTRATION COMMITTEE, 5 Aysgarth Road, London SE21. John Alexander Sinclair.

FREE PAINTERS AND SCULPTORS, 15 Buckingham Gate, London SW1.

ROYAL SOCIETY OF BRITISH SCULPTORS, 108 Old Brompton Road, London SW7.

ROYAL SOCIETY OF PAINTERS IN WATER-COLOUR, 26 Conduit Street, London W1.

SOCIETY OF INDUSTRIAL ARTISTS AND DESIGNERS, 12 Carlton House Terrace, London SW1.

SOCIETY OF DESIGNERS AND CRAFTS-MEN, 6 Queen Square, London WC1.

ROYAL ACADEMY, Burlington House, Piccadilly, London W1. Membership by election. President Sir Hugh Casson.

ARTISTS PLACEMENT GROUP, Riverside Studios, Crisp Road, London W6. Barbara Steveni. Short term to long term projects that allow artists the possibility to work within industry educational and other social systems. Interesting past projects in new communities, government offices and British Rail.

ARTLAW SERVICES, 358 Strand, London WC2. Tel. 01 240 0610. Assistant Director David Binding. A legal service for the visual arts. Useful publications available for artists to refer to legal matters affecting artists, galleries, and many other art related fields. See Chapter 11 for Artlaw details that specifically refer to artists. Subscription rates vary according to whether you are an artist, institution or arts association. Free advice thereafter from solicitors.

FEDERATION OF BRITISH CRAFT SOCIETIES, 43 Earlham Street, London WC2. Tel. 01 836 4722.

GREENWICH PRINTMAKERS ASSOCIATION, 7 Turnpin Lane, Greenwich, London SE10. Tel. 01 858 2290.

PRINTMAKERS COUNCIL, 31 Clerkenwell Close, London EC1. Regular bulletin and promotion of printmakers' interests. Professional membership.

WOMEN'S INTERNATIONAL ART CLUB, Chandlers Cross, Rickmansworth, Herts. Tel. 8762642.

WOMEN'S ART ALLIANCE, 10 Cambridge Terrace Mews, London NW1. Tel. 01 935 1841. Facilities and gallery for women artists.

ARTISTS' GENERAL BENEVOLENT INSTITUTION, Burlington House, Piccadilly, London W1. Tel. 01 744 1194. Artist-run to provide financial assistance to professional artists in old age or in times of misfortune. Also Artists' Orphan Fund.

ARTISTS' LEAGUE OF GREAT BRITAIN, c/o Bankside Gallery, Hopton Street, London SE1. Advice and assistance for the fine arts field.

RAINBOW ART GROUP, 45 Randall Street, Maidstone, Kent. Tel. 0622 674940. Group of artists from ethnic minorities.

VARS, Visual Artists Rights Society, 180 Old Brompton Road, London SW7. Tel. 01 373 3581.

THE CORPORATE ARTS. Tel. 01 402 0361. Director Sarah Hodson. Non-profit. Helps artists exhibit work in city offices.

ELSEWHERE IN THE UK

EUROPEAN GROUP, Old Castle House, Malmesbury, Wiltshire. Charles White.

GLASGOW ART CLUB, 12 Sandyford Place, Glasgow G3. Tel. 041 248 7411.

ROYAL GLASGOW INSTITUTE OF FINE ARTS, 12 Sandyford Place, Glasgow G3. President Alan Cuthbert.

ROYAL CUMBRIAN ACADEMY OF ART, Plas Mawr, Conwy.

OXFORD PRINTMAKERS COOPERATIVE, Christadelphian Hall, Tyndale Road, Oxford.

WINCHESTER ASSOCIATION OF WORKING ARTISTS, 4 Staple Gardens, Winchester.

YORKSHIRE ART SPACE SOCIETY, 4 Chapel Terrace, Ranmoor, Sheffield.

ASSOCIATION OF ARTISTS AND DESIGNERS IN WALES, 111 Plymouth Road, Penarth, South Glamorgan. Tel. 0222 372183.

BIRMINGHAM ARTISTS' GROUP, 3 Hermitage Road, Edgbaston, Birmingham. 40 members. Exhibitions, Magazine.

WASPS, 22 King Street, Glasgow G1. Tel. 041 552 0564. See studio section.

GLASGOW LEAGUE OF ARTISTS, c/o Ian McMillan, 22 King Street, Glasgow G2. Tel. 041 552 4067. For further information contact Ian McMillan. Lost their grant in 1981 and future plans unknown at this stage.

DUNDEE GROUP (Artists) LTD., Forebank Studios, Forebank Road, Dundee. Tel. 0382 21860. For list of members see under studio

section – list of members using Forebank Studios. Formed to enable the artist members to show their work together. Also exchange exhibitions with Paris and Hamilton, Canada.

ROYAL BIRMINGHAM SOCIETY OF ARTISTS, 69A New Street, Birmingham 2.

ROYAL HIBERNIAN ACADEMY, 15 Ely Place, Dublin.

ROYAL SCOTTISH ACADEMY, The Mound, Edinburgh. President Robin Phillipson.

ROYAL SCOTTISH SOCIETY OF PAINTERS IN WATERCOLOUR, 17 Sandyford Place, Glasgow G3.

ROYAL ULSTER ACADEMY OF PAINTING, SCULPTURE AND ARCHITECTURE, 10 Coolson Park, Lisburn, County Antrim.

ROYAL WEST OF ENGLAND ACADEMY, Queens Road, Clifton, Bristol.

ST IVES SOCIETY OF ARTISTS, Old Mariners Church, Norway Square, St Ives, Cornwall.

SCOTTISH ARTISTS' BENEVOLENT ASSOCIATION, Scottish Society of Women Artists, Netherlea, Old Mill Lane, Edinburgh 16.

SOCIETY OF SCOTTISH ARTISTS, 119 York Place, Edinburgh.

GLASGOW GROUP, c/o 7 Station Road, Bearsden, Glasgow. Tel. 041 942 4680. Hold regular annual exhibitions.

GLASGOW ART CLUB, 185 Bath Street, Glasgow G3. Tel. 041 248 5210.

USEFUL ART ADDRESSES

ARTS COUNCIL OF GREAT BRITAIN, 105 Piccadilly, London W1. Tel. 01-629 9495.

BRITISH COUNCIL, 11 Spring Gardens, London SW1. Tel. 01 930 8466. Fine Art. Dept, 11 Portland Place, London W1. Tel. 01-636 6888.

VISITING ARTS UNIT, 65 Davies Street, London W1. Tel. 01 499 8011.

CENTRAL BUREAU FOR EDUCATIONAL VISITS AND EXCHANGES, 43 Dorset Street, London W1. Tel. 01 486 5101.

ASSOCIATION OF BUSINESS SPONSORSHIP FOR THE ARTS, 3 Pierrepoint Place, Bath. Tel. 0225 63762.

GREATER LONDON ARTS ASSOCIATION, 25-31 Tavistock Place, London WC1. Tel. 01 388 2211.

SCOTTISH ARTS COUNCIL, 19 Charlotte Square, Edinburgh. Tel. 031 226 6051.

WELSH ARTS COUNCIL, Holst House, Museum Place, Cardiff. Tel. 0222 394711.

THE ARTS COUNCIL OF NORTHERN IRELAND, 181A Stranmillis Place, Belfast. Tel. 0232 663591.

ARTS COUNCIL IN EIRE, 70 Merrion Square, Dublin 2. Tel. Dublin 764695.

BRITISH AMERICAN ARTS ASSOCIATION, 49 Wellington Street, London WC2. Tel. 01 379 7755. Jennifer Williams. Useful organisation for artists travelling to USA and need information prior to departure on scholarships, art schools etc.

ARLIS (Art Libraries Society), Kingston Polytechnic Art Library, Knights Park, Kingston-on-Thames. Tel. 01549 6151 ext 259. National society for anyone involved in art libraries.

INTERNATIONAL ASSOCIATION OF ART CRITICS, (President Jeffery Daniels), 5 Edith Grove, London SW10. Tel. 01 352 7692. Membership open to art critics in the UK. Meets regularly and discusses problems relating to art criticism and arranges appropriate seminars from time to time. AICA also has organisations in many other countries overseas and membership gives art critics reduced entry to exhibitions and other benefits. Members are elected with reference to curriculum vitae or previous experience in the field of art criticism.

CONTEMPORARY ART SOCIETY, Tate Gallery, Millbank, London SW1. Tel. 01 821 5323. Director Pauline Vogelpoel. Acquires works by living artists for gift or loan to public galleries. Membership £6 per annum.

COUNCIL FOR NATIONAL ACADEMIC AWARDS, 344-354 Grays Inn Road, London WC1. Tel. 01 278 4411. List courses currently being offered by colleges and polytechnics throughout the UK.

CRAFTS COUNCIL, 12 Waterloo Place, London SW1. Tel. 01 930 4811.

MUSEUMS ASSOCIATION, 87 Charlotte Street, London W1. Tel. 01 636 4600.

NATIONAL ART COLLECTIONS FUND, 26 Bloomsbury Way, London WC1. Tel. 01 405 4637. Helps galleries and museums acquire works of art of historical interest. £5 annual subscription.

NATIONAL ASSOCIATION OF DECORATIVE AND FINE ARTS SOCIETIES, Room 625, Grand Building, Trafalgar Square, London WC2. Tel. 01 930 1693.

NATIONAL SOCIETY FOR ART EDUCATION, Champness Hall, Drake Street, Rochdale, Lancashire. Represents interests of teachers of art and design.

ROYAL SOCIETY OF ARTS, 6-8 John Adam Street, London WC2. Tel. 01 839 23661. Holds occasional art exhibitions, but acts as a link between practical arts and the sciences.

THE SOCIETY OF LONDON ART DEALERS, c/o Secretary, OT Galloway, 41 Norfolk Avenue, Sanderstead, South Croydon. Founded to uphold the good name of the art trade.

SOTHEBY PARKE BERNET & CO., Fine Art Courses, 34/35 New Bond Street, London W1. Tel. 01 408 1100. Variety of specialised courses open to students.

THE ARTS CLUB, 40 Dover Street, London W1. Tel. 01 499 8581. Exchange arrangements· for members to use overseas art clubs and other UK art clubs.

For the addresses of all Regional Arts Associations see under "Awards" section in Chapter 1.

SURVIVAL

See studio section for practical work survival. Refer to Preparation for an Exhibition for exhibiting details. Refer to Scholarships, Awards and Grants section.

WORK

Trying to find work in the art world is extremely difficult as everyone knows, so below we have listed useful addresses and possible suggestions on a practical basis.

Work in the art world falls into several categories that you might consider:
(1) Art administration.
(2) Secretarial which could lead to administration or being a gallery director later on.
(3) Art teaching at schools, colleges and studios.
(4) Community art, i.e. SHAPE work within the community.
(5) Art therapy.
(6) Art history teaching.
(7) Painting and decorating (horror of horrors, but many artists do it for survival for months and years).
(8) Shop work – framers, art materials.
(9) Gallery work on different levels.
(10) Art magazines.
(11) Art criticism.
(12) Setting up a gallery, art supply shop, magazine etc. Good relations with your local bank essential.
(13) Conservation specialist courses at certain UK centres.

USEFUL ADDRESSES FOR WORK IN THE ART WORLD

ARTS COUNCIL OF GREAT BRITAIN, 105 Piccadilly, London W1. Tel. 01 629 9495. Joan Thompson Smith. Arts administration courses for art administrators already employed but needing additional practical information and for art administrators who have yet to find employment. Small intake for visual arts as there seem to be more jobs available in the theatre, music and literary world. They also run a new sheet listing arts administration jobs available. Send an sae for regular newsheet or ring first for up-to-date details.

ILEA ARTS CAREERS ADVISORY SERVICE, Central London Careers Office, 145 Charing Cross Road, London WC2. Tel. 01 734 8531. Anne Francis. Recently set up so possibly only finding its feet but see if they have any positive jobs available or advice. They circulate firms that might wish to employ artists.

SHAPE, 9 Fitzroy Square, London W1. Tel. 01 388 9622 and 01 388 9744.
Regional SHAPE offices
Yorkshire: Shape Up North, The Belle View Centre, Belle View Road, Leeds 3. Tel. 0532 31005. Co-ordinator: Peter Taylor.
Lincolnshire and Humberside: Lincolnshire and Humberside Arts Assoc., St Hugh's, 23 Newport, Lincoln. Tel. 0522 33555. Co-ordinator: Chris Buckingham.
East Midlands: East Midlands Shape, New Farm, Walton by Kimcote, Nr Lutterworth, Leicestershire LE1 7RL. Tel. Lutterworth 3882. Director: Anne Peaker.
West Midlands: Art Link 12 Homesford Terrace, North Street, Newcastle-under-Lyme. Tel. 0782 614170. Co-ordinator: Lee Corner.
North West: North West Shape, 21 Whalley Road, Whalley Range, Manchester M16 8AD. Organiser: Hazel Roy.
South: TOOT, c/o Cowley St Christopher First School, Temple Road, Cowley, Oxford. Tel. 0865 778119. Organiser: Jenny Bostock.
South West: South West Arts Association, Community Arts Office, 15 Cranbrook Road, Redland, Bristol. Tel. 0272 49340. Organiser: Roger Stennett (not yet operative).
Scotland: The Scottish Council for Arts and Disability, 18/19 Claremont Crescent, Edinburgh. Tel. 031 556 3882.
Shape introduces professional visual artists along with actors, dancers, musicians, clowns, puppeteers and mime artistes to hospitals, day centres, reception centres, youth projects, prisons, borstals and community centres. They also visit mentally and physically handicapped, homeless, disturbed adolescents and elderly people. Contact them if you like working with people and your artwork lends itself to this kind of contact.

Magazines that list jobs in the art world are listed below

Art Services Newsletter, 6 & 8 Rosebery Avenue, London EC1. Tel. 01 278 7795.

Artists Newsletter, 17 Shakespeare Terrace, Sunderland, Tyne and Wear. Tel. 0783 73589.

Art Monthly, 37 Museum Street, London WC1. Tel. 01 405 7577.

Artscribe, 5 Dryden Street, London WC2. Tel. 01 240 2430.

Time Out, Tower House, Southampton Street, London WC2. Tel. 01 836 4411.

Arts Review, 16 St. James Gardens, London W11. Tel. 01 603 7530/8533.

Newspapers

The Guardian, 119 Faringdon Road, London EC1. Tel. 01 278 2332. Mondays (creative and media) but also other days for art related jobs. Tuesdays (Educational).

The Times, New Printing House Square, Grays Inn Road, London WC1. Tel. 01 837 1234.

Times Educational Supplement, as above. Tel. 01 837 1234 (art teaching and art history jobs).

Regionally: Local papers and national art magazines.

Art teaching

If you decide to do an art teaching qualification after art school there are several choices open depending on what level of student or pupil you wish to teach.

Goldsmiths College, Lewisham Way, London SE14. Tel. 01 692 0211. Middlesex Polytechnic, Trent Park, Cockfosters, Herts. University of London, 1 Malet Street, London WC1. Art teacher training for secondary and possibilities of college level teaching practice.

Garnett College, Roehampton Lane, London SW15. Teaching qualification for teaching art and art history at further and higher education level. Teaching practice at Foundation level in an art college or FE college. Advantages are that the course offers media studies for video and film-making and teaching practice lets you see other art combined courses rather than just straight life work.

Elsewhere in the UK: Too numerous to list all the teacher training courses that train art teachers but contact your local education authority for addresses of the nearest college.

Art teaching jobs are advertised in the "Times Educational Supplement" and often internally at teacher training colleges. Also in "The Times" and "The Guardian" and in "Time Out" for London, "Glasgow Herald", "The Scotsman" and sometimes in art magazines nationally. Contact art schools and adult education institutes where art evening classes take place, as once you have started teaching art it is easier to find full time jobs.

Art organisations and galleries

Ask locally at art organisations if they need some part time help which could lead to more full time work or start as the secretary and work your way up. Galleries often need extra help before exhibitions open. Voluntary work is not necessarily advisable but could help to let you see what the work would be like. Galleries usually need a reliable hard working secretary who is helpful to visitors and willing to learn as he/she goes along. This could help you learn the ropes even if you don't like secretarial work and eventually you could change to administration or set up your own gallery. Contacts is the name of the game really and once you have a job however menial you will meet the people who will tell you about other jobs, sometimes before they come on the market. Take a good secretarial course before applying for jobs though.

Art criticism

Unless you are in the fortunate position to have a secure job as a regular art critic for a news-paper, art criticism is rarely lucrative but often very interesting and satisfying. Usually it is an idea to contact an art magazine before you write a review or article and see if they might be interested, unless you don't mind writing it anyway and they might just take it when you ring up. Again, perseverance helps and try to find out about more off-beat art magazines and art outlets as the better known magazines are usually well covered.

Another approach is to write to overseas art magazines once you have written and had several items published and send copies of these and a covering letter to an overseas art magazine asking if they need coverage for London. For example France, Italy and Germany rarely cover British art and if your languages are good there could be an opening, or else write the articles in English and they will translate them. You do lose money for this however. Typical overseas rates vary but could be £50-£100 for 1000 words plus photos, to £300 for 2000 words plus colour photograph. In London £25 or £10 is usual for an art magazine, so hardly a lucrative career.

As London is well covered London art critics could contact their home town paper to see if they might be interested in reviews or profiles of exhibitions, artists who are showing in London but come from your home area. Local boy/girl makes good is always a popular angle in local papers.

Art school noticeboards often have jobs listed so check your local art schools.

Skills
Any skills, especially building skills can be useful, or typing, and you will often have to use these on a temporary basis until you find an appropriate job.
Part time work. Most serious professional artists find that it is essential to work only part time so that they can continue their own work, rather than full time, but obviously this depends on your personal financial situation.

GRANTS, AWARDS, SCHOLARSHIPS, PRIZES

Official awards from the regional arts associations and the Arts Councils in each country.

Arts Council of Great Britain
For up to date details contact: Art Awards Officer, Anthony Reynolds, Arts Council of Great Britain, 105 Piccadilly, London W1. Tel. 01 629 9495 (Fine Art). Barry Lane, Photography Officer (Photography).
Purchase awards: £2000–£6000 (total of £50000). Open to all professional artists. Application forms must be completed and 10–12 slides returned with the application form and any appropriate additional information. Awards take the form of work acquired for the ACGB collection. Awards made on the basis of the quality of the artist's work.
Art for public sites; assisted purchase schemes; provision of studios; artists in residence; incentive grants: Contact Alister Warman for art for public sites and assisted purchase schemes. Contact Anthony Reynolds for details of the other schemes. The awards for artists scheme is to be discontinued. Instead the above will have increased funds available.
Studio conversions: Up to £300 per artist (total £50000). Usually given three times a year for assistance towards studio conversion for multiple occupation.
Photography bursaries: £2000–£6000. Open to photographers in England. An application form must be completed and returned along with 10–30 photographs of recent work. Awards made according to the quality of the photographer's work and the ACGB can buy prints at cost price.
The Arts Council of Great Britain also awards grants for art books and art publications, video bursaries and documentary film grants. Training course for Arts administrators. Video artists and film-makers on tour.

Crafts Council of Great Britain
Awards Officer, Amanda Hare, 12 Waterloo Place, London SW1. Tel. 01-930 4811. Contact the awards officer for details of all craft awards for equipment, maintenance, workshop training and other bursaries. Open to craftsmen and women in England and Wales.

Welsh Arts Council
For up to date details contact: Visual Arts Awards Officer, Isabel Hitchman, Oriel, 53 Charles Street, Cardiff. Tel. 0222 395548. Crafts Award Officer, Roger Lefevre. Awards to artists currently under review so contact the appropriate officer for relevant details.

Scottish Arts Council
For up to date information contact: Awards Officer, 19 Charlotte Square, Edinburgh. Tel. 031 226 6051.
Bursaries: Two awards up to £5000. Three awards up to £2500 plus £5000 shared for materials. Open to artists resident or working in Scotland who have left art school for at least two years. Application form to be completed and returned with slides of recent work. Studio visits made when a purchase is recommended.
Awards: Up to £1500 given three times a year April, August and December for purchase of materials, services, exhibition costs or travel.
Travel/studio bursaries: Allowance of £500 per month, total £10,000. Usually in April but also at other times. To enable artists to work outside Scotland for 3–12 months (travel, subsistence, materials). Application by letter giving details of purpose of travel, costings etc.
Travel grants/international exchange: No limit set but grants up to 50% of costs six times a year. To enable artists to attend courses, conferences, hold exhibitions etc. Also to bring similar artists on exchange to Scotland.

WASPS (Workshop and Artists Studio Provision) Scotland
Value of up to £300 and not more than 75% of costs. To enable artists to convert studios and workshop spaces for groups of 2 or more who have located suitable premises to convert. Studio must have a lease of at least 1 year, or longer preferred. WASPS is an independent organisation grant aided by SAC, 22 King Street, Glasgow. See Artists' Organisations, Chapter 1, for further details.

The Scottish Arts Council supports other schemes and exchanges with countries such as the USA and Holland. Total grant 1980/81 £162,000.

Scottish Development Agency
102 Telford Road, Edinburgh. Tel. 031 343 1911. Variety of grants, bursaries and fellowship schemes to craftsmen and women in Scotland. Write to the Crafts Manager for further details.

Arts Council of Northern Ireland
For up to date information contact: Awards Officer, Bill Collins, 181A Stranmillis Road, Belfast. Tel. 0232 663591.
Major Awards: Three awards of £5,000 to enable artists to concentrate on their work. Application form must be completed and returned with slides of work. Awards offer the opportunity to exhibit at the Arts Council Gallery where appropriate.
Bursaries: £100–£2,000 – total £25,600 for study, research, materials and equipment. The Arts Council in Northern Ireland has one committee for all art forms.
Although Southern Ireland is not part of the United Kingdom we are listing the address for use by artists visiting or going to live in Eire. Arts Council in Eire, 70 Merrion Square, Dublin 2. Director Colm O'Brian. Tel. Dublin 764695. Contact the Awards Officer for details of awards available to artists in Eire.

REGIONAL ARTS ASSOCIATIONS

Greater London Arts Association
For up to date information contact: Lesley Greene, 23/25 Tavistock Place, London WC1. Tel. 01 388 2211. London boroughs and city of London – artists living and working in this area.
Visual Arts Awards: £500–£2,000 – total awards £24,000. Open to professional artists and photographers in Greater London. Application form must be completed and returned with up to ten slides or photographs. Photographers submit 12 original prints. Awarded to enable artists to concentrate on work.
Production grants: Small grants twice a year in spring and autumn for studio conversion, equipment, materials, performance art events etc. GLAA does not deal with craft applications.

Northern Arts
For up to date information contact: Visual Arts Officer, Peter Davies, 10 Osborne Terrace, Newcastle, Tyne and Wear. Tel. 0632 816334 (Fine Art); John Bradshaw (Photography and Film); Barbara Taylor (Craft). Co. Durham, Cumbria, Northumberland, Tyne and Wear, Cleveland.
Grants to artists: Total £9,000. No upper limit. Considered throughout the year. Artists must live and work in the region. Application form and slides or photographs of recent work. Artists are expected to exhibit within 12 months of receiving an award.
Awards to artists: Up to £2000 awarded annually in the autumn. Application form and slides of work. To enable artists to concentrate on their work.
Awards to Photographers: Total £5,500 awarded annually in the spring. Application form and not more than 10 photographs.
Awards to craftsmen: Up to £2,000 and total of £6,000 awarded annually in November. Application form and slides of work.
Small grants to craftsmen: Small grants total of £2,000 awarded throughout the year. Exhibition costs, to enable craftsmen and women to attend courses etc. Slides, biography and details.

Eastern Arts Association
For up to date information contact: Visual Arts Officer, Jane Heath, 8/9 Bridge Street, Cambridge. Tel. 0223 67707. Bedfordshire, Cambridgeshire, Essex, Hertfordshire, Norfolk and Suffolk.
Awards (fine art, photography, craft): Up to £1500 and total of £6,000. Awarded annually in the autumn under two schemes: (1) Purchase of work by Eastern Arts; (2) Financial assistance to buy time, equipment, materials, studio conversion etc. Application forms and up to 10 slides or photographs. Studio visits for awards. A report is usually required after an award.
Grants (fine art, photography and craft): Up to £250 and total of £2,000 estimated. Grants awarded four times a year. Application forms and up to twenty slides of work. Eastern Arts has one overall budget for Fine art, photography and craft.

East Midlands Arts Association
For further information contact Sarah Hosking, Visual Arts Officer, Mountfields House, Forest Road, Loughborough. Tel. 0509 218292. Derbyshire except Peak district, Leicestershire, Northamptonshire, Nottinghamshire and the borough of Milton Keynes.
Grants (fine art, photography and craft): Up to £500. Fine art £6,000. Craft £4,000. Photography £3,000. Awarded every two months for studio conversion, materials, equipment etc. Letter

and biography, exhibitions, 10-20 slides or photographs. East Midlands normally awards up to £1,000 in awards but due to cuts none were available for 80/81.

Lincolnshire and Humberside Arts Association
For further information contact: Visual Arts Officer, Diana Pain, St Hughs, 23 Newport, Lincoln. Tel. 0522 33555. Lincolnshire and Humberside.
Grants (fine art, photography and craft): Up to £500. Fine art £2,150. Craft £1,700 and photography £600. Awarded twice a year in summer and autumn for equipment, studio conversions, exhibitions etc. Application forms and 3/4 examples of work. Award winners are expected to show evidence that grant has been spent for the purpose of an award. Separate budget allocations for fine art, craft and photography.

Merseyside Arts Association
For further information contact: Visual Arts Officer, Roman Piechocinski, Bluecoat Chambers, 6 School Lane, Liverpool. Tel. 051 709 0671. Merseyside Metropolitan County and West Lancashire.
Visual Arts Grants (fine art and photography): Up to £500 and a total of £3,500 awarded six times a year for purchase of equipment, materials, studio conversion etc. Application forms and ten slides or photographs. Grant winners are expected to hold an exhibition.
Craft Grants: Up to £500 and a total of £4,000.

Yorkshire Arts Association
For further information contact: Visual Arts Officer, Simon Roodhouse, Glyde House, Glydegate, Bradford, Yorkshire. Tel. 0274 23051. North Yorkshire, South Yorkshire and West Yorkshire.
Grants: Up to £500 offered four times a year. A total of approximately £4,000 will be available. Fine art and photography assessed separately. Application form and 6-12 slides of recent work.
Photographers should submit a portfolio of recent work.
Awards to craftsmen and women: Awards of between £500 and £1,000. Application form and 6-12 slides of recent work.
Foreign travel award for craftsmen: £1,000 to enable an established craftsman or woman travel abroad.

South West Arts
For further information contact: Visual Arts Officer, Tony Foster, 23 Southernhay, Exeter, Devon. Tel. 0392 38924. Counties of Avon, Cornwall, Devon and Dorset, Gloucestershire and Somerset.
Major Awards: Awarded annually in the autumn. £250-£1,000 allocated. Either a purchase or project award. Forms available from September.
Minor Awards: Twice yearly amounts of up to £250 are available to assist individual artists, craftsmen and photographers with specific projects. Forms available from January.

South East Arts Association
For further information contact: Visual Arts Officer, 9/10 Crescent Road, Tunbridge Wells, Kent. Tel. 0892 41666. Kent, Surrey and East Sussex.
Awards: Awards of between £500 and £2,000 usually in the form of a purchase award and to be available for display to the public. Closing date 31st October.
Grants: Small grants up to £250 for immediate needs relating to specific projects eg exhibition costs. Closing dates 14th May and 14th November. Payment to artists for exhibiting work in certain public galleries in the South East.

Southern Arts
For further information contact: Visual Arts Officer, Marilyn Carr, 19 Southgate Street, Winchester. Tel. 0962 69422. Berkshire, Hampshire, Isle of Wight, Oxfordshire, West Sussex, Wiltshire and the Bournemouth, Christchurch and Poole areas of Dorset.
Bursaries: Up to £3,000. Closing date November. Application form and slides of recent work.
Project/equipment grants: Available throughout the year for specific urgent needs such as materials, exhibitions, studio conversion etc.

West Midland Arts
For further information contact: Visual Arts Officer, Lisa Henderson, Lloyds Bank Chambers, Market Street, Stafford. Tel. 0785 59231. Counties of Hereford, Worcester, Metropolitan County of West Midlands, Shropshire, Staffordshire and Warwickshire.
Grants (fine art, photography and craft): Fine art deadline November. Photography deadline November and craft.

North West Arts
For further information contact: Visual Arts Officer, Sally Medlyn, 52 King Street, Manchester. Tel. 061 833 9471 (Fine Art). Liz Fletcher, 4th Floor, 12 Harter Street, Manchester. Tel. 061 228 3062 (Film). Greater Manchester, High Peak district of Derbyshire, Lancashire, Cheshire.
Major art awards and craft awards: Contact the Visual Arts Officer for information. Be persistent as we did not find the visual arts department particularly helpful. The film department were able to list awards.
Film grants: Either a major grant or several bursaries for experimental films in either 8mm or 16mm.

Many of the Regional Arts Associations run slide registries and newsletters with local information. Check with your area association to see what facilities they offer visual artists.

ARTIST IN RESIDENCE SCHEMES

LOWICK HOUSE PRINT WORKSHOP, Lowick Green, Near Ulverston, Cumbria. Tel. 0229 85898. 2 short term residences, £250 each, November-June. Write for further details.

DIGSWELL ARTS TRUST, Digswell House, Monks Rise, Welwyn Garden City, Herts. Tel. Welwyn 21506. Set up in 1959 by Henry Morris as a residential centre for artists. 3-4 vacancies a year for artists to stay there. Supported by Eastern Arts, Welwyn District Council and the Commission for New Towns. 5 year term of residence. Cheap studio space. 2 bedroom cottages and 60 sq yds of studio space. Approximately £15.50 a week. Supervised workshops and specialist facilities.

GRIZEDALE FOREST, write to: Peter Davies, Northern Arts, 10 Osborne Terrace, Jesmond, Newcastle-on-Tyne. Tel. 0632 816334. Short term residences supported by Northern Arts. 3-6 months – £3,000. Workshop/studio provided and basic living accommodation. Also Kielder FOREST (Photography residency), Contact John Bradshaw, Northern Arts, 10 Osborne Terrace, Jesmond, Newcastle-on-Tyne.

SOUTHAMPTON UNIVERSITY, Registrar, Southampton University, Southampton. £3,000 annual fellowship. Artist to work in the university for 1 year.

SUSSEX UNIVERSITY, 1 year artist in residence at the Gardner Arts Centre, Brighton. Contact Registrar.

BRASENOSE COLLEGE OXFORD, apply to the Director, Museum of Modern Art, 30 Pembroke Street, Oxford (over 35). Artist in residence.

UNIVERSITY OF YORK, Granada Arts Fellowship, Heslington (Registrar York University), York.

YORKSHIRE TV LTD, PO Box ITN, Newcastle-on-Tyne NE99 2RP. 2 fine art fellowships for 1 year.

UNIVERSITY OF SUSSEX, Registrar, PO Box 363, Brighton. Fine art fellowships 1 year.

GREGORY FELLOWSHIP IN FINE ART, Registrar, Leeds University, Leeds. £1857 approximately. By invitation.

MANCHESTER POLYTECHNIC, Art Dept., Manchester Polytechnic, Manchester. Granada Fellowship, £700.

NOTTINGHAM UNIVERSITY, Registrar, Nottingham University, Nottingham. 1 year artist in residence scheme.

GLOUCESTERSHIRE COLLEGE OF ART. To carry on work and art teaching.

LANCHESTER POLYTECHNIC. Resident artist, approximately £1800.

NORWICH COLLEGE OF ART. John Brinkley Fellowship £720. Printmaking annual fellowship.

EXETER COLLEGE OF ART, p/t teaching rates paid.

CARDIFF COLLEGE OF ART. 2 lecturing fellowships. FE scale salary.

ST ANNES COLLEGE OXFORD. Research into painting, sculpture, music or literature. £800 approximately.

KENDAL, CUMBRIA, Arts and Community Centre, Kendal, Cumbria. Artist in residence. £1800 approximately.

ULSTER COLLEGE, Northern Ireland Polytechnic, Jordanstown, Northern Ireland.

NEWTON ABBEY, CO ANTRIM. Fellowship in fine art, £800.

KETTLE'S YARD, Dr. N.O.A. Bullock, Kings College, Cambridge. Visiting fellowship. £5,000 approximately.

LONDON BOROUGH OF LEWISHAM. Newly created post-1982 onwards.

AWARDS

ANDREW SPROXTON AWARD, The Secretary, Andrew Sproxton Memorial Fund, 17 Colliergate, York. Annual award for photographers aged 25 or under. Bursary of £500. Deadline October 1st.

BASS CHARRINGTON ARTS AWARD, Awards Secretary, Arts Council of Northern Ireland, 181A Stranmillis Road, Belfast. 1st prize £1,000, 2nd prize £400, 3rd prize £100.

VIDEO BURSARY, Contact Arts Council of Great Britain, 105 Piccadilly, London W1. ACGB and Brighton Polytechnic, 1 year. £3,000 and use of studio space and polytechnic facilities.

VIDEO BURSARY, Contact ACGB, 105 Piccadilly, London W1. Maidstone College of Art, 1 year. £3,000 and use of studio space.

PRIZES

JOHN MOORES, Exhibition Secretary, Walker Art Gallery, Liverpool. Entrance form, labels and handling fee £3. Open to all artists living in the UK. Painting and constructions only. Sending-in dates September. 1st prize £6,000, 2nd prize £3,000, 3rd prize £2,000, 10 prizes of £250. Well worth entering as this exhibition is well publicised and well reviewed nationally.

JOHN LAING ANNUAL PAINTING COMPETITION, Forms from Ms DW Griffin, John Laing Ltd, 14 Regent Street, London SW1. Tel. 01 930 7271 ext 24. Submit up to two paintings. Landscapes and seascapes. Prize of £1,250 or to be chosen for the Laing calendar with appropriate fee.

IMPERIAL TOBACCO PORTRAIT AWARD. Full details from The Competitions Officer, National Portrait Gallery, 2 St Martins Place, London WC2. £4,000 and a further commission of £3,000 is offered. Open to artists aged 18-40. Submit photos of portraits in oil.

HUNTING GROUP ART PRIZES. Forms available from the Secretary of the particular society, 17 Carlton House, Terrace, London SW1. £5,000 for best oil painting, £5,000 for the best water-colour, £1,000 divided amongst the finalists. Royal Society of Marine Artists. Royal Institute of Oil Painters. Royal Society of Miniature Painters, Sculptors and Engravers. New English Art Club. All artists can enter as well as society members.

TOLLY COBBOLD. Jackie Ford, 49 Ellington Street, London N7. Prizes of up to £9,000 and possible purchases. Exhibition to include work in all media, but not to exceed 20 feet or project more than 8in. Exhibition will be at the Fitzwilliam, Cambridge, and Ipswich, Sheffield and at the ICA London.

ON THE OPEN ROAD. Contact the Secretary, RAC, 89 Pall Mall, London SW1. Set up by the RAC and the Contemporary Art Society. 4 prizes of £500. Representational work given preference. Any medium except photography. Not larger than 48in or smaller than 28in. Open to all artists who have graduated from art college since 1970.

INTERNATIONAL ART COMPETITION, Raja Yoga Centre, 98 Tennyson Road, London NW6. To stimulate the creativity of spiritualism. 1st prize £1,000, 2nd £800, 3rd £250.

RIBA AND SAINSBURYS, Stamford House, Stamford Street, London SE1. Open to all archi-tects, artists designers and students. Supermarket car park for Sainsburys. 1st prize £3,500, 2nd

£2,250, 3rd £1,250, 4th 4 prizes of £250 each. This competition was for 1980. Check to see if any other competitions are being organised by the same organisations.

PRINTMAKERS MINIATURE PRINT EXHIBITION. Contact the Printmakers Council, Clerkenwell Close, London WC1 for further details and other print competitions, prizes.

CLEVELAND DRAWING BIENNALE, Dept 11, Drawing 81, PO Box 52, Middlesbrough, Cleveland. Total of £5,000 and other possibilities of purchase. Supported by ACGB and Northern Arts. Check with ACGB for annual changes for applications from artists.

INTERNATIONAL PRINT BIENNALE, Catwright Hall, Bradford. Entry fee £2.50. Closing date 30th September. Sending-in day 31st December.

SCHOLARSHIPS

ELIZABETH GREENSHIELDS FOUNDATION, 1814 Sherbrooke St West, Montreal, Quebec, Canada. 1 year scholarship to an artist from any country. 30 awards.

THE LEVERHULME TRUST, The Secretary, Research Awards Advisory Committee, 15-19 New Fetter Lane, London EC4. Tel. 01 248 1910. Up to 6 studentships overseas (not UK, Europe or USA). £1,000 p.a. + £200 for 1/2 years. Closing date 15th January, interview by March. 1st degree graduates of a UK University or CNAA degree course. Under age of 30 on October 1st of the year of award.

YALE UNIVERSITY SCHOOL OF ART, 180 York Street, NewHaven, Connecticut 06520. Advance scholarship in British Art. 3 months and upwards. November annually.

FULBRIGHT AWARDS, USA/UK Educational Commission, 6 Porter Street, London W1. Tel. 01 486 7697. 1 year + travel. Maintenance. Exchange visitor visa. Closing date 23rd November, interview February. Several scholarships available.

INSTITUTE OF INTERNATIONAL EDUCATION, 809 United Nations Plaza, New York, NY 10017. For further details of possible USA awards.

MACDOWELL COLONY INC., Peterborough, New Hampshire 03458, or MacDowell Colony Inc., 680 Park Avenue, New York, NY 10021. Open to nationals of any country. Resident fellowships to professional painters sculptors film-makers. Use of studio for 3 months.

HARKNESS FELLOWSHIPS, Harkness House, 38 Upper Brook Street, London W1. 20 offered annually for advance study and travel in the USA in various subjects including art. 2 academic years and 3 months travel. Age 21-30. Must have degree or equivalent. Closing date 20th October. (Enclose 9 x 7 envelope + sae with 25p postage) + covering letter asking for details.

ENGLISH SPEAKING UNION OF COMMONWEALTH, 37 Charles Street, London W1. Tel. 01 629 0104. Ask for details of scholarships to Commonwealth countries.

WINSTON CHURCHILL MEMORIAL TRUST, 15 Queens Gate, London SW7. 100 fellowships for travel and work abroad. Various categories. Entrants can come from any walk of life but must have a good reason for applying for the scholarships. £1,500 average award.

USA/UK EDUCATIONAL COMMISSION, 6 Porter Street, London W1. Tel. 01 486 7697. Run the Fulbright Hays awards as well as other awards.

ABBEY MAJOR AND MINOR AWARDS, 1 Lowther Gardens, Exhibition Road, London SW7.

DAVID MURRAY SCHOLARSHIPS, Royal Academy Schools, Burlington House, London W1. For travel, landscape painting and drawing.

BOISE SCHOLARSHIP, Slade School of Art, University College, Gower Street, London WC1.

USEFUL ADDRESSES FOR INFORMATION ON SCHOLARSHIPS

BRITISH COUNCIL, 10 Spring Gardens, London SW1. Scholarships Abroad: £1 lists 33 countries with details of all scholarships available in these countries. Apply for details about Hungarian summer schools in art.

BRITISH AMERICAN ARTS ASSOCIATION, 49 Wellington Street, WC2. Tel. 01 379 7755. Directories available for reference listing awards, scholarships in the USA and names of USA art schools, art organisations etc. Phone first to check office hours.

CENTRAL BUREAU FOR EDUCATIONAL VISITS AND EXCHANGES, 43 Dorset Street, London W1. Tel. 01 486 5107. Art teaching bursaries for Europe and elsewhere.

ASSOCIATION OF COMMONWEALTH UNIVERSITIES, 36 Gordon Square, London WC1. Write for details of Commonwealth scholarships.

FRENCH EMBASSY, Cultural Attache, 27 Wilton Crescent, London SW1. Scholarships to postgraduate students in fine art.

ITALIAN INSTITUTE, 39 Belgrave Square, London SW1. Send sae for details of scholarships open to artists and art students.

JAPAN INFORMATION CENTRE, 9 Grosvenor Square, London W1. Scholarships to Japan.

ROYAL NETHERLANDS EMBASSY, 38 Hyde Park Gate, London SW7. Re scholarships to Holland. The Stedelijk Museum in Amsterdam offers artists studio space every year. Apply to the director for details.

GERMAN ACADEMIC EXCHANGE SERVICE, DAAD, 11-15 Arlington Street, London SW1. Tel. 01 493 0614. 15 scholarships to UK artists to study at art academies and other institutions. Up to 32 years old. Closing date March.

THE GREEK EMBASSY, 1A Holland Park, London W11. Closing date March. Scholarships to Greece open to art students and artists. Apply for further details.

CZECHOSLOVAKIA. Academy of Arts, Smetanovo Nabr 2, Prague 1, Czechoslovakia. Exchange scholarship, cost of tuition and certain expenses. Candidate should hold a BA. Closing date end of December.

USA. Academy of Motion Pictures, Arts and Sciences, Philip Chamberlain, 8449 Wilshire Boulevard, Beverley Hills, California 90211, USA. Student film awards (5) USA $1000. Any student who has compiled a film in college or university. Apply after 15th October.

EDWARD ALBEE FOUNDATION. Write to: The Secretary, Edward Albee Foundation, 226 West 47th Street, New York, NY 10036. Twelve talented but needy writers and artists may spend a year at the Barn Montauk in the USA. Free accommodation and evening meal.

AUSTRALIA. Graduate Careers Council of Australia, PO Box 28, Parkville, Victoria 3052. Awards for postgraduate study in Australia. Lists fellowships and scholarships available at universities in Australia.

GRANTS HANDBOOK AND SURVEY OF LEA AWARDS. NUS, 3 Endsleigh Street, London WC1. £1.20 + 30p postage. Lists all UK local authorities. Details of major grant awards.

STUDY ABROAD, UNESCO, Place de Fontenoy 75, Paris 7eme, France. £1.80 Lists international scholarships.

SUMMER STUDY ABROAD. Institute of International Education, 809 United Nations Plaza, New York, NY 10017, USA. $2.00. Lists summer study opportunities outside the USA sponsored by US colleges and foreign institutions.

BRITISH FILM INSTITUTE, 42/43 Lower Marsh, London SE1 7RG. Grants value £300-£15,000. Applicant must submit a script, synopsis outline idea a storyboard. Film experience not necessary/ essential except for feature length proposals.

BRITISH INSTITUTION FUND, Royal Academy, Piccadilly, London W1. Scholarship prizes for painting, sculpture, architecture and printmaking. £100 p.a. and travel scholarships £100.

BROOKLYN MUSEUM ART SCHOOL (open to nationals of all countries), 187 Eastern Parkway, Brooklyn, NY 11238, USA. Closing date 30th April. Painting, sculpture, ceramics. 25 scholarships annually. Free tuition. Tenable for 1 year. Portfolio of 10 slides and 2 letters of recommendation.

CALIFORNIA COLLEGE OF ARTS AND CRAFTS, Graduate Division, 5212 Broadway, Oakland, CA 94618, USA. 3-8 scholarships annually. Must have BA (Fine Art). Free tuition.

CANADA COUNCIL, Cultural Exchange Section, PO Box 1047, Ottawa, Ontario. (Open to many nationalities). On behalf of the Dept of External Affairs cultural exchanges between cultural organisations and universities. Film and video grants and travel grants.

CORCORAN SCHOOL OF ART, NY Avenue and 17th St NW, Washington, DC 20006, USA. Open to US and foreign nationals-fine art students. USA $350-$20250.

COURTAULD INSTITUTE, Ms Robertson, Combe Hay Manor, Bath, Somerset. 12 scholarships annually. Open to students (UK) of art history and architecture. Closing date 31st May.

KODAK LTD, PO Box 66, Kodak House, Station Road, Hemel Hempstead, Herts. 1 award of £2,500 and 2 of £3,500. Open to UK photographers.

PRATT GRAPHICS CENTER, 831 Broadway, New York, NY 10003. Open to USA and foreign nationals. Opportunity to study at the centre for printmakers from September-July.

NEW ZEALAND. QE11 Arts Council of New Zealand, PO Box 6032, Te Aro, Wellington, New Zealand. Write to the New Zealand Arts Council for details of awards to study in New Zealand.

ROYAL SOCIETY OF ARTS, 8 John Adam Street, Adelphi, London WC2. £75-£1,500. Travel awards for individual designers (industrial).

VIRGINIA CENTER FOR THE CREATIVE ARTS (USA), at Sweet Briar University, Virginia 24595, USA. Open to artists. $210 per week. 1-3 months per annum.

GRANTS REGISTER, St James Press, 3 Percy Street, London W1. Available for reference at most libraries.

ART SCHOOLS

This section includes information about art schools throughout Britain. Questionnaires were sent round to some 200 art schools throughout Britain and this has enabled us to give additional information to help artists and art students when choosing a college. When detailed information has not been received from the college the name and address are listed below.

The colleges in this list offer a variety of Foundation, BA (Hons), Vocational and Advanced courses in sculpture, painting, printmaking, graphics, textiles, ceramics, jewellery and silversmithing, furniture, photography, film and television, video, interior and general design, fashion and other relevant courses.

LONDON

CAMBERWELL SCHOOL OF ART AND CRAFTS, Peckham Road, London SE5 8UF. Tel. 01 730 0987. BA Hons courses in most departments. Postgraduate courses.

CENTRAL SCHOOL OF ART AND DESIGN, Southampton Row, London WC1B 4AP. Tel. 01 405 1825. BA Hons courses in most departments. Postgraduate courses.

CHELSEA SCHOOL OF ART, Manresa Road, London SW3 6LS. Tel. 01 351 3844/6. BA Hons courses in most departments. Postgraduate courses in painting, sculpture, printmaking. Postgraduate art history course (one year). Good art library. Visiting lecturers.

CITY OF LONDON POLYTECHNIC – SIR JOHN CASS SCHOOL OF ART, Central House, Whitechapel High Street, London E1 7AF. Tel. 01 283 1030.

COLLEGE FOR THE DISTRIBUTIVE TRADES, Department of Display, 107 Charing Cross Road, London WC2. Tel. 01 437 6151.

CORDWAINERS TECHNICAL COLLEGE, Mare Street, Hackney, London E8. Tel. 01 985 0273/4. 2/3 year courses in footwear design to SIAD. 2/3 year courses in leathergoods design to SDO. No fine art courses.

BYAM SHAW SCHOOL OF ART, 70 Campden Street, London W8 7EN. Tel. 01 727 4711. Principal Geri Morgan. Courses: 3 year London diploma in art and design; 3 year diploma course; post diploma course and short term studies course. Space: Two buildings. One is at Campden Street with 4 studios in an old Edwardian building. Second building is a converted church with 4 large studios. Space is divided up for the art students according to their needs. Photography and printmaking facilities as well as painting and sculpture. Bandsaw and welding equipment available to students. Materials: Shop in the school. Discount prices for students only. Exhibition space: For students only during diploma shows. Holiday lettings available by arrangement.

Scholarships: Jubilee Scholarship (a free place for one year); Ernest Jackson Scholarship (year's free tuition); Award of Merit (free tuition); London Weekend/Byam Shaw Bursary £300 and remission of fees); Byam Shaw Scholarship (£130 p.a.). Prizes: Graham Hamilton Drawing Prize — best drawing £75; James Byam Shaw Painting Prize — £100; Bateson Mason Drawing Prize £50; Peta Katzenellenbogen Prize £15 worth of materials. Library: Books, magazines, slides for students and staff only. Visiting lecturers: Practising artists given termly contracts or invited to give lectures. Information available on "Life after art school".

LONDON COLLEGE OF FASHION, 20 John Princes Street, London W1. Tel. 01 629 9401.

LONDON COLLEGE OF PRINTING, London SE1 6SB. Tel. 01 735 8484.

POLYTECHNIC OF NORTH LONDON, Dept of Environmental Design, Holloway Road, London N7 8DB. Tel. 01 607 2789.

POLYTECHNIC OF THE SOUTH BANK, Division of Arts, 83 New Kent Road, London SE1. No fine art courses. B.Ed for primary teachers with art specialisation in pottery, photography and embroidery. Facilities for all of these available to students.

SCHOOL OF ART AND DESIGN, NORTH EAST LONDON POLYTECHNIC, 89 Greengate Street, Plaistow, London E13 0BG. Courses: BA Hons degree in fine art; BA Hons degree in communication design; Polytechnic diploma fashion/textiles (CNAA validation imminent); post diploma individual study programme; post graduate research MPhil PhD.

Space: Large open plan. C.D. and fine art at Greengate House. Fashion/textile at Barking precinct. Fine art mixed years. CD discreet years. Fashion/textile mixed years. Equipment: 3D workshops — most materials. Print/typo print/film/photography/audio/colour video studios and editing facilities. Materials: Materials freely available. All basics supplied to fine art students. Exhibition space: Gallery at Greengate House available to students/staff and outside artists. Foreign exchanges: Both in fine art. Library: Specialist library with good visual aids. Visiting lecturers: Mainly fine art only. Considerable efforts made on all three courses to tell art students about "Life after art school".

ROYAL COLLEGE OF ART, Kensington Gore, London SW7 2EU. Tel. 01 584 5020. Courses: Postgraduate courses only in painting, sculpture, graphic design, ceramics and glass, environmental, media, furniture and industrial design, silversmithing and jewellery, fashion design, photography, film, video. (2/3 year courses). Master of Arts (RCA), Master of Design (RCA) PhD (RCA) and Dr (RCA). Space: Painting. Open studios, subdivided. Mixed across the years. Sculpture: Large open plan mixed across the years.

Equipment: Machinery for stretchers, structures, frames, mounts, etc. Equipment available in other departments for photography, casting etc. Equipment available to students for sculpture. Materials: College shop — discount for students. Allowance to students. Sculpture allowance £250 per annum per student. Not limited to college shop. Exhibition space: Permanent space. Student exhibitions. Annual postgraduate show is the largest in May/June. Gallery at Kensington Gore also shows large exhibitions from outside from time to time. Scholarships and Prizes: Numerous scholarships. See Yearbook. Foreign Exchanges: None to date. Visiting lecturers: Variety. No information available on "Life after art school".

SAINT MARTINS SCHOOL OF ART, 107 Charing Cross Road, London WC2. Tel. 01 437 0058/9. BA Hons courses in fine art, and postgraduate courses.

UNIVERSITY OF LONDON GOLDSMITHS COLLEGE, School of Art and Design, New Cross, London SE14 6NW. Tel. 01 692 0211.

WILLESDEN COLLEGE OF TECHNOLOGY, Denzil Road, London NW10. Tel. 01 459 0147.

MIDDLESEX POLYTECHNIC (Hornsey), Fine Art Department, Alexandra Palace, London N22. Tel. 01 883 1012. BA Hons fine art courses.

SLADE SCHOOL OF ART, University College, Gower Street, London WC1. Tel. 01 387 7050. Postgraduate and undergraduate fine art courses. Painting, sculpture, printmaking, film, experimental and stage design. Large annual degree and postgraduate show in the summer term. Rigorous selection procedure.

ROYAL ACADEMY SCHOOLS, Burlington House, London W1. Tel. 01 734 9052. Postgraduate fine art courses only.

WIMBLEDON SCHOOL OF ART, Merton Hall Road, Wimbledon, London SW19. Tel. 01 540 0231. BA Hons fine art courses.

GREATER LONDON

BARKING COLLEGE OF TECHNOLOGY, Department of Design and Printing, Charlecote Annexe, Charlecote Road, Dagenham, Essex. Tel. 01 592 2217.

BARNET COLLEGE OF FURTHER EDUCATION, Wood Street, Barnet, Hertfordshire. Tel. 01 440 6321. Foundation course. DATEC diploma in Art and Design. Vocational design courses.

CROYDON COLLEGE, School of Art and Design, Fairfield, Croydon. Tel. 01 888 9271.

EALING COLLEGE OF HIGHER EDUCATION, School of Humanities, St Marys Road, Ealing, London W5. Tel. 01 579 4111.

EAST HAM COLLEGE OF TECHNOLOGY, High Street South, East Ham, London E6. Tel. 01 472 1480 ext 204.

HARROW COLLEGE OF HIGHER EDUCATION, Northwick Park, Harrow, Middlesex. Tel. 01 864 5422.

HAVERING TECHNICAL COLLEGE, Ardleigh Green Road, Hornchurch, Essex. Tel. 04024 55011.

HOUNSLOW BOROUGH COLLEGE, London Road, Isleworth, Middlesex. Tel. 01 568 0244. Fine art foundation course and college art diploma. Also a combined course including film, drama, design and general studies.

KINGSTON POLYTECHNIC, Art and Design Department, Knights Park, Kingston-on-Thames, Surrey. Tel. 01 549 6151. BA Hons fine art course in painting, sculpture and printmaking. The Polytechnic consists of 22 schools offering a wide range of subjects. In the fine art area. There are 4 schools: Fine Art, Graphic Design, Fashion Design and 3-Dimensional Design. All these areas offer a BA Hons degree 3 year course. History of art and complementary studies include the history of film and options in music, film, psychology, philosophy and languages. Visits to galleries frequently and visits from outside lecturers.

LOUGHTON COLLEGE OF FURTHER EDUCATION, Borders Lane, Loughton, Essex. Tel. 01 508 8311.

RAVENSBOURNE COLLEGE OF ART AND DESIGN, Walden Road, Chiselhurst, Kent. Tel. 01 468 7071. BA Hons degrees in fine art. Large open plan space. Access to equipment in all departments. Good library for fine art/graphics/fashion/design. Visiting lecturers although cuts recently. Organised information on life after art school. No prizes, scholarships etc. No exchanges but interested.

RICHMOND UPON THAMES COLLEGE, Egerton Road, Twickenham. Tel. 01 892 6656.

ROEHAMPTON INSTITUTE OF HIGHER EDUCATION, Roehampton Lane, London SW15. Tel. 01 878 5751.

ENGLAND
ACCRINGTON
 Accrington and Rossendale College, Blackburn Road, Accrington. Tel. 0254 33090. Courses: Foundation course in fine art covering printmaking, painting, sculpture, history or art and pottery. Also GCE A level and O level art. Space: 2 open studies, 1 life room, 2 print studios,

1 ceramic studio, 1 darkroom, 2 storerooms, 1 art history room. Open plan for studio space. Equipment: Equipment available to studios for photography, ceramics, photo silkscreen printing and textiles. Materials: £54. About to be axed. Materials freely available: Paper, photography, printing and ceramic materials. Exhibition space: One corridor for staff/student work and studio wallspace. Outside artists have also used this space. Scholarships: Kenyon scholarship worth £30. Foreign exchanges: None. Library: Large selection of art books, magazines, slides. Visiting lecturers: None. Careers advice given in general.

AMERSHAM
Amersham College of Further Education, Art and Design, Stanley Hill, Amersham, Buckinghamshire. Tel. 02403 211.

ASHTON-UNDER-LYNE
Tameside College of Technology, Beaufort Road, Ashton-under-Lyne, Lancashire. Tel. 461-330 6911.

BANBURY
North Oxfordshire Technical College and School of Art, Brougnton Road, Banbury, Oxfordshire. Tel. 0295 52221.

BARNSLEY
Barnsley College of Art and Design, Fairfield House, Churchfields, Barnsley, South Yorkshire. Tel. 0226 85623. Courses: Foundation course in art and design 184; graphic design; 164; general education – art and design: 164; A level art. Space: Two sites, one an annexe. Large converted victorian building, large rooms high ceilings, previously a primary school, the other purpose built. Equipment: Spray equipment, portable compressor, circular saw, jigsaw, drills, sanding machine, guillotine. Easels, benches. Printmaking presses for litho, silkscreen, drying racks etc. Darkroom equipment, ceramic studio etc. Materials: Materials made available to students as required. Scholarships: None. Exchanges: None. Limited library facilities.

BARNSTAPLE
North Devon College, Barnstaple, Devon. Tel. 0271 5291.

BATH
Bath Academy of Art, Corsham, Wiltshire. Tel. 0249 712571. Courses: BA Hons degree – Painting, sculpture, ceramics, graphic design. Space: Variety of large open plan, individual and shared spaces. 1st year painters are separate from the 2nd and 3rd years generally. Equipment: Usual sculpture and printmaking equipment and some photographic equipment. Materials: No material allowance. Special exceptions at discretion of Head of Dept. Materials freely available: Wood, plaster and metal. Exhibition space: For assessments mainly. Foreign Exchanges: Two to France, 1 to USA, 1 French art student here. Library facilities: Excellent facilities. Visiting lecturers: More or less all teachers are part time and practising professional artists. Information on "Life after art school"; mainly from staff experience. Seminars.

City of Bath Technical College, Department of General Education, Avon Street, Bath. Tel. 0225 312191.

BATLEY
Dewsbury and Batley Technical College, Cambridge Street, Batley, West Yorkshire. Tel. 0924 474401.

BIRKENHEAD
Wirral College of Art and Design, Park Road East, Birkenhead, Wirral. Tel. 051 647 9236. Courses: Foundation course in fine art; vocational courses in photography, ceramics, jewellery, graphic design. Space: Housed in 3 buildings. Each course has individual workshops and/or open plan painting or design studios. Equipment: All equipment available to f/t students. Materials: allowance for students under 18. College shop on each site. Freely available to students. Exhibition space: No formal exhibition area. Prizes: Two small annual prizes awarded by local arts society. Library: Good facilities. Lecturers: Annual programme or Wirral college lecturers and visiting lecturers in the art field.

BIRMINGHAM
City of Birmingham Polytechnic, Faculty of Art and Design, Gosta Green, Birmingham. Tel. 021 359 6721. BA Hons fine art and MA fine art from September 1981. Flexible working

arrangement. Equipment widely used. Excellent exhibition space. Selection of prizes. Exchanges considered. Good library facilities. Regular termly visits and one-off visits from artists. Information on life after art school available to art students.

Bournville School of Art and Crafts, Linden Road, Bournville, Birmingham. Tel. 021 472 0953.

Handsworth Technical College, Whitehead Road, Aston, Birmingham. Tel. 021 327 1493.

BLACKPOOL
Blackpool College of Technology and Art, Palatine Road, Blackpool. Tel. 0253 293071.

BOLTON
Bolton Technical College, Dept of Art and Design Studies, Hilden Street, Bolton.

BOOTLE
The High Baird College of Further Education, Balliol Road, Bootle, Merseyside. Tel. 051 922 6704.

BOURNEMOUTH
Bournemouth and Poole College of Art, Royal London House, Lansdowne, Bournemouth. Tel. 0202 20772.

BRADFORD
Bradford College, Great Horton Road, Bradford BD7 1AY. Tel. 0274 34844.

BRAINTREE
Braintree College of Further Education, Church Lane, Braintree, Essex. Tel. 0376 2711/2. Courses: 1 or 2 year foundation courses (conversions of both to DATEC pending); vocational studio pottery (EAD Des ELSDC). Space: 2 specialist potteries; 6 other studios including small annexe away from main building. Equipment: 6 kilns, 16 wheels. Fabric printing tables, screen facilities, darkroom, printmaking (litho, etching, relief) jewellery 3D workshop. All available to all students. Materials: At LEA discretion variable sums allotted. College shop. Small charge for paper and photographic materials, clay and paints. Others provided free. Exhibition space: Very small and unsuitable. Provision in local area also small.
Scholarships: Periodic project funds from various local authorities. Annual William Beard Lake Prizes. Exchanges: None. Library: Specialist art section backed by county library service. Visiting lecturers: Teaching by part-time staff, assessments by outside lecturers. Information on life after art school: Studio pottery course includes experience in workshop or studio. High proportion of foundation students placed on BA or other high level courses in HE job opportunities good through contacts with local industry. Small college with a reputation for the quality of its work, its friendly atmosphere and care for individual students.

BRIGHTON
Brighton Polytechnic, Faculty of Art and Design, Grand Parade, Brighton, Sussex. Tel. 0273 604141. Courses: BA Hons fine art; MA printmaking (starts 1981). Space: Large open plan space. Equipment: All usual workshops for painting, sculpture, printmaking and audio visual. Materials: £140 per capita. Canvas, paint, clay and wood freely available. Exhibition space: Large permanent gallery space. Scholarships, prizes: Various. Exchanges: None. Library: Large library. Visiting lecturers: Variety of visits for off days and termly visits. Information on "Life after art school". Regular seminars. The department has one of the highest student application rates and one of the highest success rates in the gaining of MA places elsewhere.

BRISTOL
Bristol Polytechnic, Faculty of Art and Design, Clanage Road, Bristol, Avon. Tel. 0272 660222. Courses: BA Hons fine art. Space: Fine art department is one building. Open plan studios with individual divisions. Some painting students also work in sculpture studios. Integrated fine art courses. Equipment: Workshops fully equipped for metal working and casting, welding, woodworking and mixed media. Printmaking studios, lithography, etching and silkscreen. Equipment in other faculty departments available by arrangement i.e. 3D construction, ceramics, glass, photography, printing, film and video, textile printing.
Materials: Materials allowance in student grant. Can be used anywhere including college shop. Materials freely available include: nearly all sculpture materials, printmaking materials, timbers for stretchers, canvas and priming materials. Part assistance with photographic materials. Some financial assistance with special materials. Exhibition space: Faculty gallery available to student staff and for arranged exhibitions. Details from chairman, exhibition committee.

Scholarships: No project funds, scholarships or prizes. Exchanges: French art school student exchange annually. Foreign staff exchanges possible. Library: Specialised library for art and design. 2,000 books including catalogues and bound periodicals. 4,500 slides on all art subjects. Visiting lecturers: Extensive programme of visiting artists, individual and block visits. Information on "Life after art school". Lectures and seminars on all art professional matters. Prospectus available from Admissions Officer, Bristol Polytechnic, Coldharbour Lane, Frenchay, Bristol BS16 1QY.

Brunel Technical College, Ashley Down, Bristol BS7 9BU. Tel. 0272 41241.

Filton Technical College, Filton Avenue, Filton, Bristol. Tel. 0272 694217.

BURNLEY
Burnley College of Arts and Technology, School of Art and Design, Ormerod Road, Burnley BB11 2BX. Tel. 0282 36111. Courses: Pre-foundation (A level art/craft); foundation (post-A level); NWRC fashion; NWRC advertising design. Space: Course studios and specialist studios. Specialist equipment: Specialist equipment for the following: pottery, sculpture painting/drawing, photography, printmaking/graphics, fashion textiles. Materials: All students have a materials allowance. Most materials are also freely available to students in the workshops and studios. Exhibition space: Limited. Scholarships: College prizes. Exchanges: None. Library: Comprehensive art and design library with slides and film strips available. Visiting lecturers: One-off days. Information on "Life after art school". College tutorials and counselling system.

CAMBRIDGE
Cambridge College of Arts and Technology, Collier Road, Cambridge CB1 2AJ. Tel. 0223 63271.

CANTERBURY
Canterbury College of Art, New Dover Road, Canterbury, Kent CT1 3AN. Tel. 0227 69371. Courses: BA Hons fine art; BA Hons graphic design; BA and diploma RIBA architecture; College diploma/SIAD course in fashion clothing and textiles; College diploma/SIAD course in graphic design; Foundation Course in Art. Space: Large open plan studio (painting) divided as required; 2 medium sized open plan studios (painting); one small studio (painting); large sculpture area comprising 4 substantial studios/workshops; outdoor hard standing working space for sculpture; materials store; student work store; staff room; office. Specialist equipment: All types of sculpture equipment available: cutting, welding, foundry, forge, spray booth, vacuum forming, lifting gear etc. These available to fine art students under supervision only. Also extensive facilities available for printmaking (silkscreen, litho, etching, relief) and photography. Well equipped college workshop for work in wood metals, plastics also enamelling, jewellery. Audio visual unit (16mm film, sound recording, sound syncronising, 35mm slides).
Materials: A sum is incorporated into the student grant to cover materials, books etc. Materials are available at the college shop at educational discount. The levy system operated by the school of Fine Art enables students to benefit from the school's bulk buying policy. Exhibition space: Permanent exhibition hall about 75 x 33 feet used for exhibitions of work of students, full time staff, visiting staff. Not available to outside artists on a private basis. Scholarships, prizes: The college prize has been built up over the last few years by donations from staff, friends of the college etc. Modest prizes for students are available annually. School of Fine Art offers materials subsidy by competition to assist in the expenses of major works. Exchanges: Under active consideration, especially in regard to French colleges. Library: 24,000 books (including exhibition catalogues) 300 periodicals, 14,000 slides, 400 maps, 110 video cassettes. Also history of art/design department slide collection of c. 50,000 slides. Library's material within fields of art, design and architecture. Visiting lecturers: a large number of part time and visiting lecturers are employed to supplement the full time staff. Appointments are usually made on a regular basis (1/2 days per week) but one off visits/lectures, termly visits and block teaching are also arranged. Full time short term lectureships have also been arranged with some success. Information on "Life after art school". Advisory seminars arranged from time to time. Information as available is circulated to students (concerning vacant studio accommodation) especially final year students. Advice also available via visiting staff.

CARLISLE
Cumbria College of Art and Design, Brampton Road, Carlisle, Cumbria CA3 9AY. Tel. 0228 25333/4. Courses: Foundation studies one year; Northern diploma in Applied Design 2 years; Proposed DATEC courses; Northern Higher Diploma courses in graphic design, textiles, ceramics; fine art, painting and sculpture 1 year. Space: Generous purpose-built studio accommodation for all disciplines on an 11 acre wooded site. Specialist equipment: Full equipment complement

for all courses available as necessary within timetable commitment. Materials: None directly to students other than through grants. Capitation for materials and equipment all allocated upon college basis. Exhibition space: Approximately 4,000 square feet permanent exhibition space for programmed use.

Scholarships: two major scholarships available for students of £200 each. Exchanges: None. Library: Extensive book, slide and reference library of specialist art nature. Visiting lecturers: Comprehensive programme of visiting lecturers according to course needs. Information on "Life after art school" contained in course programme. Cumbria College of Art and Design was first founded in 1836 and remains one of the 10 independent art schools now existing. Although the college is now mainly concerned with courses in applied design and art it still has a substantial history of fine art training in both painting and sculpture. The college is establishing a 1 year fine art course and is able to offer an ideal situation for students to study landscape portrait and figure painting and sculpture in very pleasant studios situated in ideal painting country.

CLEVELAND (MIDDLESBROUGH)

Cleveland College of Art and Design, Green Lane, Linthorpe, Middlesbrough, Cleveland. Tel. 0642 821441. Courses: Northern Diploma in Applied Design; Northern Higher Diploma in Applied Design — textiles, 3D design, graphics; foundation studies, dress and light clothing. Space: The college has three main sites at Nelson Terrace Stockton, Church Square, Hartlepool and Green Lane Middlesbrough. Equipment: All college equipment is utilised to the maximum by all students. Materials: No allowance but some materials freely available. Exhibition space: Green Lane — permanent exhibition hall available to staff, outside artists and travelling exhibitions. Church Square — theatre with exhibition space available as above. Scholarships, prizes: Students eligible for travel awards 4 x £100 awards given each academic year. Exchanges: None. Library: 10,000 books and magazines 100,000 slides. Visiting lecturers: Intended to supplement full time staff by a combination of contractual appointments (up to 3 terms) and one off specialist lecturers as and when appropriate. Information on "Life after art school": Nil.

CHELTENHAM

Gloucestershire College of Art and Design, Pittville, Cheltenham. Tel. 0242 32501 (Cheltenham); 0452 24676 (Gloucester).

CHESTER

Chester College of Further Education, School of Art, Easton Road, Handbridge, Chester. Tel. 0244 26321/2/3.

CHESTERFIELD

Chesterfield College of Art and Design, Sheffield Road, Chesterfield. Tel. 0246 70271.

COLCHESTER

Colchester Institute, Sheepen Road, Colchester, Essex. Tel. 0206 70271 ext 40.

COVENTRY

Lanchester Polytechnic, Priory Street, Coventry. Tel. 0203 24166.

DERBY

Derby Lonsdale College of Higher Education, Kedleston Road, Derby. Tel. 0332 47181.

DONCASTER

Doncaster Metropolitan Institute of Higher Education, Kedleston Road, Doncaster. Tel. 0302 22122 ext 269. Courses: Foundation art and design. Space: Individual/shared. Equipment: Print shop, pottery, 3d workshop and photographic equipment. Materials: Freely available. Exhibition space: Permanent exhibition space 37 x 29 wall space 112 feet. Gallery available for outside exhibitors. Visiting lecturers: Variety of contracts and one-off visits. Library: 12,000 books, 5,000 slides and 100 magazines. No specific information on "Life after art school".

DUNSTABLE

Dunstable College, Kingsway, Dunstable, Bedfordshire. Tel. 0582 69451.

EASTBOURNE

Eastbourne College of Art and Design, Eversley Court, St Annes Road, Eastbourne, East Sussex. Tel. 0323 28674.

EPSOM
Epsom School of Art and Design, Ashley Road, Epsom, Surrey. Tel. 03727 28810.

EXETER
Exeter College of Art and Design, Earl Richards Road North, Exeter. Tel. 0392 50381.

FALMOUTH
Falmouth School of Art, Woodlane, Falmouth, Cornwall. Tel. 0328 313269/312948. Courses: BA Hons fine art; Foundation course. Equipment available in all departments painting, sculpture, film and photography, printmaking. Visiting lectures: Variety of one-off visits and termly contracts. Prizes: English Clay's prize £75. Other prizes at the discretion of the examiners. Exchanges: Anglo-French exchange scheme with French art schools. Library: Excellent library facilities.

FARNHAM
West Surrey College of Art and Design, Falkner Road, The Hart, Farnham, Surrey. Tel. 02513 22441.

GRAYS
Thurrock Technical College, Woodview, Grays, Essex. Tel. 0375 71621.

GREAT YARMOUTH
Great Yarmouth College of Art and Design, Trafalgar Road, Great Yarmouth, Norfolk. Tel. 0493 3557.

GUILDFORD
Guildford County College of Technology, Stoke Annexe, Markenfield Road, Guildford, Surrey. Tel. 0483 31251. Small art department that offers A level and O level art.

HALIFAX
Percival Whitley College of Further Education, School of Art and Design, Francis Street, Halifax. Tel. 0422 58221. Courses: Full time foundation course in art and design (1-2 years). Space: Individual studios for classes on one floor of the building. Equipment: Equipment for printmaking, photography, modelling and sculpture. For use by full time students only. Materials: No allowance, freely available to full time students under 18. Scholarships. Prizes: None. Exchanges: None. Library: New library with good facilities. Visiting lecturers: Regular appointments as part of full time course.

HARLOW
Harlow Technical College, College Gate, The High, Harlow, Essex. Tel. 0279 20131.

HARROGATE
Harrogate College of Arts and Adult Studies, 2 and 5 Victoria Avenue, and Harrogate Arts Centre, Church Square, Harrogate. Tel: 0423 62446/7/8.

HARTLEPOOL
Hartlepool College of Art, Church Square, Hartlepool. Tel. 0429 63211.

HASTINGS
Hastings College of Further Education, Archery Road, St Leonards-on-Sea, East Sussex. Tel. 0424 423847.

HEREFORD
Herefordshire College of Art and Design, Folly Lane, Hereford. Tel. 0432 3359/2309. Courses: DATEC diplomas; general art and design and general vocational design; foundation courses in graphics, ceramics, textiles, jewellery, photography; part-time UEI Certificate in Art and Design. Space: Individual work spaces for full time students. Full range of specialist studios and workshops including printmaking, drawing, 3D design, ceramics, dress, printed and woven textiles, graphics, photography, display and jewellery. Equipment: Appropriate equipment available for all areas. Materials: Basic materials provided for all full time students. Exhibition space: Large entrance hall and corridors available to staff, students and outside artists.
Scholarships, prizes: Approximately £500 in annual awards to full time students. Library: Specialised art and design library + 20,000 slides. Visiting lecturers: One-off visits and regular teaching visits. Information on "Life after art school" included in full time course. It is the only art college in the county of Hereford and Worcester, also serving a large area of mid-Wales.

Strong craft/design tradition. Occupies purpose-built building in beautiful surroundings. Excellent record of preparing students for BA courses and for employment. Two departments community arts and professional studies.

HIGH WYCOMBE
Buckinghamshire College of Higher Education, Queen Alexandra Road, High Wycombe, Buckinghamshire. Tel. 0494 22141/9.

HUDDERSFIELD
Huddersfield Polytechnic, Queensgate, Huddersfield. Tel. 0484 22288.

IPSWICH
Suffolk College of Higher and Further Education, Department of Art and Design, High Street, Ipswich, Suffolk. Tel. 0473 52386.

ISLE OF MAN
Isle of Man College of Further Education, Homefield Road, Douglas, Isle of Man. Tel. 0624 23113.

KETTERING
Tresham College (Kettering Centre), St Marys Road, Kettering, Northamptonshire. Tel. 0536 85353.

KIDDERMINSTER
Kidderminster College of Further Education, Hoo Road, Kidderminster, Worcestershire. Tel. 0562 66311.

KINGSTON-UPON-HULL
Hull College of Higher Education, Faculty of Design Studies, Wilberforce Drive, Kingston-upon-Hull, North Humberside. Tel. 0482 224311.

LANCASTER
Lancaster and Morecambe College of Further Education, Department of Art, Morecambe Road, Lancaster. Tel. 0524 66215 ext 66/67.

LEAMINGTON SPA
Mid-Warwickshire College of Further Education, School of Art, Warwick New Road, Leamington Spa. Tel. 0926 311711. Courses: College diploma in painting and printmaking (2 days a week for 2 years). Space: 2 studios. Equipment: Generally available. Materials: No allowance. Part time students buy their own materials. Exhibition space: Permanent — main foyer and corridors with display and lighting facilities. Scholarships, prizes: None. Exchanges: None. Library: Specialist art area. Slide collection.

LEEDS
Jacob Kramer College, Vernon Street, Leeds. Tel. 0532 39931.

Leeds Polytechnic, Calverley Street, Leeds. Tel. 0532 462934. Courses: BA fine art. Space: Open plan, mixed across disciplines and alter initial period with 1st year mixed across years. Specialist equipment: Available to all students. Materials: Approximately £30 per term so far. Might have to be reduced. Materials freely available according to approved orders. Exhibition space: Permanent. Available to staff, students and outside artists. Scholarships, prizes: Travel scholarship. Years prizes. Library: Specialist art section in Polytechnic library. Visiting lecturers: Regular weekly lectures and visiting artists per term. Information on "Life after art school". Joint weekly seminars with Fine Art Department at Leeds University.

The University of Leeds, Leeds LS2 9JT. Tel. 0532 31751.

LEEK
Leek School of Art and Crafts, Nicholson Institute, Stockwell Street, Leek, Staffordshire. Tel. 0538 382787.

LEICESTER
Leicester Polytechnic, PO Box 143, Leicester. Tel. 0533 50181.

106

LINCOLN

Lincoln College of Art, Greestione Centre, Lindum Road, Lincoln. Tel. 0522 23260/8/9. Courses: Vocational courses in art and design including: Full time graphic design (4 years); F/T conservation crafts; F/T Foundation studies; Preliminary studies fashion, hairdressing, painting and decorating; P/T printing, photography, hairdressing, painting and decorating, pottery, drawing and painting, dress and embroidery. Space: 3 buildings: (1) Trade crafts; (2) Art and design; (3) Fine art and crafts. Equipment: Well equipped for sculpture, photography and printing. Available to students under technical supervision.

Materials: College provides specialist materials but students are required to purchase basic materials themselves. Wood, metal, plastic, clay, photographic materials, are freely available. Exhibition space: Two areas 900 and 100sq feet. Permanent and available to staff students and outside artists. Scholarships, prizes: Tom Bayles award for drawing £100 per annum; Gibney scholarship £40 per 2 years; Old Bolingbroke award £150 per annum. Exchanges: None. Library: Specialised reference library 15,000 books 10,000 slides. Visiting lecturers: One-off days or several single days. Information on "Life after art school". Careers officer and other speakers from time to time.

LIVERPOOL

Liverpool Polytechnic, Faculty of Art and Design, 68 Hope Street, Liverpool. Tel. 051 709 9711. Courses: BA Hons fine art. Space: 4 large Victorian life studios. Numerous small individual studios for 3rd year painting students. Specialist equipment: All equipment available to BA students and used with student/tutor collaboration. Materials: Freely available to a diminishing extent. Annual increase does not keep pace with inflation. Exhibition space: Limited but useful. Supplemented by Liverpool Academy and numerous galleries in the vicinity.

Scholarships, prizes: Sculpture competition arranged with local industry. Fine Art – Annual John Moores scholarship £1,000; Painting–Liverpool Artists Club prizes £80. Exchanges: None. Library: Excellent art library. Visiting lecturers: 8 to 10 two day visits per term by invited artists. Information on "Life after art school". Nothing specific.

Central Liverpool College of Further Education, Clarence Street, Liverpool. Tel. 051 708 0423. Courses: Department of printing, photography and design, foundation course in visual communication processes (1 year f/t); diploma in design for printing (2 years f/t); City and Guilds photography course (p/t); Printing craft courses p/t.

Mabel Fletcher Technical College, Sandown Road, Liverpool. Tel. 051 735 7211/7.

LOWESTOFT

Lowestoft School of Art, St Peters Street, Lowestoft, Suffolk. Tel. 0502 4177/8. Courses: Foundation (1 year, fine art); DATEC diploma in general vocational design. Space: Main building only. Specialist equipment: Available in all departments. Materials: No college shop. All materials provided. Students under 19 may claim £30 or £45 worth of materials. All materials freely available. Exhibition space: Lowestoft Art Centre (Art school annexe). Available to all. Scholarships, prizes: Grace Musson annual scholarship – post-student. Money award for travel and materials. Exchanges: None. Library: Very adequate art and craft sections. Visiting lecturers: One-off day visits and block periods for printmaking and painting. Information on "Life after art school". Self employment and basic business practice included on vocational courses.

LUTON

Barnfield College, School of Art and Design, New Bedford Road, Luton. Tel. 0582 507531.

MAIDENHEAD

Berkshire College of Art and Design, Marlow Road, Maidenhead. Also at Kings Road, Reading. Tel. 0628 24302 and Reading 0734 583501.

MANCHESTER

Manchester Polytechnic, Faculty of Art and Design, Cavendish Street, All Saints, Manchester. Tel. 061 228 6171.

MANSFIELD

West Nottinghamshire College, Art and Design Department, Chesterfield Road, Mansfield, Nottinghamshire. Tel. 0623 27191. Courses: 1 year preliminary art and design course; 1 year foundation art and design course; 2 year general art and design course; 3 year graphic design, 3 year fashion design courses. Space: Specialist, shared and across courses. Equipment:

Available to all students. Materials: Department allowance. Clay and wood freely available. Exhibition space: Yes. Scholarships: None. Exchanges: None at present. Library. Visiting lecturers: Varies but some availability. Careers information for other subjects but not fine art.

NELSON

Nelson and Colne College, Scotland Road, Nelson, Lancashire. Tel. 0282 66411. Courses: Foundation fine art. Space: Limited individual studio space. Equipment: Available for all departments printmaking, photography, ceramics and textiles. Materials: Provided. Exhibition space: Permanent exhibition space available. Monthly exhibitions. Scholarships: None. Exchanges: Past exchanges with USA. Library: Art section. Visiting lecturers: One-off days.

NEWCASTLE-UPON-TYNE

Newcastle upon Tyne College of Arts and Technology, School of Art and Design, Bath Lane, Newcastle-upon-Tyne. Tel. 0632 24155.

Newcastle Polytechnic, Faculty of Art and Design, Squires Building, Sandyford Road, Newcastle-upon-Tyne. Tel. 0632 26002 ext 434. Courses: BA Hons Fine Art CNAA. Space: Custom built space with specialist facilities e.g. furnace, darkrooms, studio and workshops, video studio. Divided between painting area (including fine art printmaking). Sculpture area and time based studies (film, video). Specialist equipment: Available for all areas of fine art. Other equipment available from other departments within the Polytechnic, e.g. computer. Materials: Per capital allowance per student. Materials provided freely but not through a college shop. Exhibition space: Large exhibition area available to both staff and students, also "A" category polytechnic gallery for outside artists, programme of 15 exhibitions per year.
 Project funds, prizes: Funds for students to visit Amsterdam, London and field study projects. Exchanges: Yes − staff on a reciprocal basis, students only one way so far. Library: Specialist art and design library with art faculty library staff. Visiting lecturers: It is policy to employ a large number of visiting lecturers and artists both for specific lectures and block teaching. Information on "Life after art school": Yes − a survival programme of lectures including the "Life after art school" package but also including Arts Council, RAA, gallery owners, arts organisers etc. The art gallery has its own staff including an exhibitions officer and can therefore present a busy programme of some 15 exhibitions per annum. With each exhibition there is a seminar by the artist or major contributor. These have been well attended. The School of Fine Art is part of a faculty with five other degree courses in art and design, as a large art and design faculty it has a proper say in the affairs of the Polytechnic.

NORTHAMPTON

Nene College, School of Art and Design, St George's Avenue, Northampton. Tel. 0604 713505. Courses: Foundation pre degree course (1/2 years); Vocational graphic design course (4 years); Vocational fashion design (4 years); Vocational applied design course (4 years); BEd art options; BA and BSc combined honours art options (Leicester University). Space: Studios and workshops at two sites. Equipment: A large range of specialist equipment for each discipline. Materials: A fairly large proportion of materials allowed for students in each department. A school shop operates on a small discount basis. Exhibition space: Larger studios including college main hall are used for exhibition purposes. 100 sq metres planned for permanent use. Scholarships, prizes: Two travelling scholarships each year. Funds for field courses. Foreign Exchanges: Occasional foreign exchange − staff. Library: 16,000 slides on art and design, 130,000 books. Visiting lecturers: Artists, historians, practising designers from industry.

NORTHWICH

Mid Cheshire College of Further Education, Cheshire School of Art and Design, London Road, Northwich, Cheshire. Tel. 0606 75281 ext 37.

NORWICH

Norwich School of Art, St George Street, Norwich, Norfolk. Tel. 0603 610561/5.

NOTTINGHAM

Trent Polytechnic, Dryden Street, Nottingham. Tel. 0602 48248. Courses: Foundation fine art; BA Hons fine art; textiles; theatre design; interior design; furniture design; fashion design; diplomas in photography and graphic design. Space: Large open plan and smaller studios. Mixed course areas on degree course.
 Specialist equipment: All equipment necessary to run a high level fine art course. Materials: Allowances are not made on an individual basis but materials are bought for the course in a wide range of media and are fully available for approved student use. Exhibition space: Large

exhibition hall available for use by the school (50x40). Scholarships, prizes: None. Foreign Exchanges: Annual exchange now arranged with French art school, Quimper, Brittany. Library: Full and excellent range of books, magazines and slides readily available. Visiting lecturers: Broad programme of visiting lecturers and studio visitors (usually single visits) as well as regular part timers. Information on self employment and life after art school included on the course. Large video studio, light and performance workshop and sound workshop, film workshop and animation. Open plan sculpture studio. Painting two general studios.

NUNEATON
North Warwickshire College of Technology and Art, Hinckley Road, Nuneaton, Warwickshire. Tel. 0682 69321.

OLDHAM
Oldham College of Technology, Rochdale Road, Oldham. Tel. 061 624 5214.

OXFORD
Oxford Polytechnic, Headington, Oxford. Tel. 0865 64777.

PLYMOUTH
Plymouth College of Art and Design, Tavistock Place, Plymouth, Devon. Tel. 0752 27633.

PORTSMOUTH
Portsmouth College of Art and Design, Winston Churchill Avenue, Portsmouth. Tel. 0705 26435.

PRESTON
Preston Polytechnic, School of Art and Design, Corporation Street, Preston, Lancashire. Tel. 0772 51831.

W.R. Tuson College, St Vincent's Road, Fulwood, Preston, Lancashire. Tel. 02772 716511.

READING
University of Reading, Department of Fine Art, Department of Typography and Graphic Communication, 2 Earley Gate, Whiteknights, Reading. Tel. 0734 85123. Courses: BA Hons fine art, graphic design.

REDRUTH
Cornwall Technical College, School of Design and Visual Studies, Pool, Redruth, Cornwall. Tel. 0209 712911.

REIGATE
Reigate School of Art and Design, Blackborough Road, Reigate, Surrey. Tel. 0737 66661.

ROCHDALE
Rochdale College of Art, St Mary's Gate, Rochdale, Lancashire. Tel. 0706 40421.

ROCHESTER
Medway College of Design, Fort Pitt, Rochester, Kent. Tel. 0634 44815.

ROTHERHAM
Rotherham College of Arts and Community Studies, Eastwood Lane, Rotherham, South Yorkshire. Tel. 079 61801.

RUGBY
Rugby School of Art, East Warwickshire College of Further Education, Clifton Road, Rugby, Warwickshire. Tel. 0788 73133.

ST ALBANS
Hertfordshire College of Art and Design, 7 Hatfield Road, St Albans, Hertfordshire. Tel. 0727 644414. Courses: Foundation course in art and design; combined diploma in fine art (part time); fine art adult education courses (sculpture, prints and painting). Space: 3 painting studios; 3 sculpture studios; 2 printmaking studios. Specialist equipment: Full art school facilities. Materials: Students buy most of their own materials. Exhibition space: Permanent exhibition hall. Available to outside artists as well as internally on application. Scholarships,

prizes: St Albans Sand and Gravel Co Ltd have recently sponsored a competition in the college. Foreign Exchanges: None. Library: Specialist art library 14,000 books, 60,000 slides. Visiting lecturers: Regular termly and one off day practising artists.

ST HELENS
St Helens College of Art and Design, Gamble Institute, Victoria Square, St Helens, Merseyside. Tel. 0744 28343. Courses: Foundation fine art (1/2 years); many non vocational courses. Space: Established art school and technical college. Studios for vocational and non vocational art courses. Specialist equipment: Studios equipped for painting, printmaking, fabric printing photography, ceramics, jewellery. Materials: No material allowance. Vocational students have good material provision. Exhibition space: Access to a gallery for staff and students and some circulating exhibitions. Exchanges: None. Scholarships: None. Library: Small specialised library. Visiting lecturers: One-off days for p/t lecturers. Information on "Life after art school" included in the courses.

SALFORD
Salford College of Technology, Department of Art and Industrial Design, Frederick Road, Salford. Tel. 061 736 6541. Courses: Foundation studies in fine art. Space: Large open plan. Specialist equipment: Photographic, printmaking, ceramics and wood cutting equipment. Materials allowance: Wood, metal, plastic, photographic and printmaking materials freely available. Exhibition space: Permanent. Available to students and staff only. Scholarships: None. Exchanges: None. Visiting lecturers: One-off days.

SALISBURY
Salisbury College of Art, Southampton Road, Salisbury. Tel. 0722 23711.

SCARBOROUGH
Scarborough Technical College, Lady Edith's Drive, Scalby Road, Scarborough, Yorkshire. Tel. 0723 72105.

SHEFFIELD
Granville College, Granville Road, Sheffield. Tel. 0742 760271.

Sheffield City Polytechnic, Faculty of Art and Design, Psalter Lane, Sheffield. Tel. 0742 56101. Courses: 1 year foundation fine art; 3 year BA Hons course in fine art. Space: separate buildings on same site. Large new block opened 1968. Specialist equipment: Full range of workshop machinery. Spray booth, vacuum forming foundry, glass kilns, welding, ceramics. Well equipped printmaking studios, also film and photography. Materials: From student grant plus special equipment allowance for tools. Students pay percentage of total cost for most materials. Exhibition space: Faculty has a public gallery. Scholarships, prizes: Johnson Matthey (silver) RSA bursaries plus open competitions; Harmstone Bequest (students and staff); prizes negotiable with industry. Foreign Exchanges: Under negotiation. Library: Excellent facilities. One of the best in the UK. Visiting lecturers: Distinguished visitors from associated fields. Visiting artists for termly visits and one-off days. Active career guidance in Sheffield Polytechnic. Largest fine art course in UK.

SHREWSBURY
Shrewsbury Technical College, London Road, Shrewsbury. Tel. 0743 51544.

SOLIHULL
Solihull College of Technology, Blossomfield Road, West Midlands. Tel. 021 705 6376.

SOUTHAMPTON
Southampton College of Higher Education, School of Art and Design, East Park Terrace, Southampton. Tel. 0703 28182.

SOUTHEND-ON-SEA
Southend College of Technology, Carnarvon Road, Southend on Sea, Essex. Tel. 0702 353931. Courses: Foundation art and design; East Anglian diploma in design in graphics, fashion, textiles, photography and point of sale; SIAD 4th year courses in visual communications, fashion, display and presentation. Space: 30 studios/work rooms. Purpose built art school 1969. Specialist equipment: Comprehensive equipment in all art departments. Materials: Fixed capitation from LEA but students expected to fund most of cost of materials. Photographic and printmaking materials freely available. Exhibition space: 4 large showcases, 5 small

showcases for in college exhibitions. Scholarships, prizes: Continuous competitions for outside work funded by private organisations. Travelling scholarships funded by contributions. Foreign Exchanges: Hoping to arrange some soon. Library: 2 libraries 23,000 slides (art and design) 150 magazines. Visiting lecturers: regular p/t staff 60-80 visiting staff artists and designers on a casual basis. All vocational courses have a work experience element with students spending at least two weeks in 3rd and 4th years working in an appropriate industrial design company. Educational visits to London, Paris and other European cities are supplementary to all course.

SOUTHPORT
Southport College of Art, Mornington Road, Southport, Merseyside. Tel. 0704 42411 ext 224.

STAFFORD
Stafford College of Further Education, Earl Street, Stafford, Staffordshire. Tel. 0785 42361.

STEVENAGE
Stevenage College, Monkswood Way, Stevenage, Hertfordshire. Tel. 0438 2822.

STOCKPORT
Stockport College of Technology, Art and Design Department, Wellington Road South, Stockport, Cheshire. Tel. 061 480 7331.

STOKE-ON-TRENT
North Staffordshire Polytechnic, Department of 3D Design, College Road, Stoke on Trent, Staffordshire. Tel. 0782 45531.

Stoke on Trent Cauldon College, Stoke Road, Shelton, Stoke on Trent. Tel. 0782 29561.

STOURBRIDGE
Foley College of Further Education and Stourbridge College of Art, Church Street, Stourbridge, West Midlands. Tel. 038 43 4202.

SUNDERLAND
Sunderland Polytechnic, Faculty of Art and Design, Ryhope Road, Sunderland, Tyne and Wear. Tel. 0783 41211. Courses: BA Hons fine art. Space: Separate buildings. Large open plan, shared and individual spaces. Specialist equipment. Printmaking, sculpture, photographic and video equipment available to art students. Materials: There is an allowance but virtually all wishes can be met through placing an appropriate order. Wood, metal, canvas, printing plates, screen materials, bronze, blocks and other casting materials freely available. Exhibition space: Primarily for staff and students of the faculty. Scholarships, prizes: Travelling scholarship (2nd year annually). Echo painting/sculpture prize. Echo photography prize. Backhouse prize for drawing (3rd year annually). Foreign Exchanges: As and when arranged on individual basis. Library: Our own library and video viewing facility. Visiting lecturers: Primarily artists. Regular termly visits and one off days. We have a careers and information section in the Polytechnic. We use Artlaw etc on a regular basis — annual visits. We introduce further material when and where appropriate.

SUTTON COLDFIELD
Sutton Coldfield College of Further Education, School of Art and Design, Lichfield Road, Sutton Coldfield, West Midlands. Tel. 021 355 5671.

SWINDON
Swindon College, Regent Circus, Swindon, Wiltshire. Tel. 0793 29141.

TAUNTON
Somerset College of Arts and Technology, Wellington Road, Taunton, Somerset. Tel. 0823 83403 ext 220.

TORQUAY
South Devon Technical College, Newton Road, Torquay, Devon. Tel. 0303 35711. Courses: Foundation 18+; pre degree 16-18; 3 year graphic design plus 4th year Dip Mem SIAD; 3 year interior design plus 4th year Dip Mem SIAD.

WAKEFIELD
Wakefield College of Technology and Arts, Margaret Street, Wakefield, West Yorkshire. Tel. 0924 70501.

111

WALSALL
Walsall College of Art, Goodall Street, Walsall, West Midlands. Tel. 0922 24279.

WARE
Ware College, Scotts Road, Ware, Hertfordshire. Tel. 0920 5441.

WARRINGTON
Warrington College of Art and Design, Museum Street, Warrington. Tel. 0925 32712.

WATFORD
Cassio College, Langley Road, Watford, Hertfordshire. Tel. 0923 40311.

Watford College, Department of Art and Graphic Design, Ridge Street, Watford. Tel. 0923 269816.

WESTON-SUPER-MARE
Weston-Super-Mare Technical College, School of Art, Knightstone Road, Weston-Super-Mare, Avon. Tel. 0934 21301 ext 21.

WIGAN
Wigan College of Technology, School of Art and Design, Library Street, Wigan. Tel. 0942 41711.

WINCHESTER
Winchester School of Art, Park Avenue, Winchester, Hampshire. Tel. 0962 61891. Courses: BA Hons fine art.

WOLVERHAMPTON
The Polytechnic Wolverhampton, Faculty of Art and Design, Molineux Street, Wolverhampton. Courses: BA Hons fine art; BA Hons graphic design; BA Hons ceramics; BA Hons wood, metal and plastics; BA Hons design of carpets and related textiles. Space: Accommodation includes studios and workshops available to all students. Equipment: Available in all departments. Materials: Students are not required to pay for materials. Exhibition space: Two permanent galleries for varied exhibitions which are coordinated by the faculty exhibitions curator. Scholarships: Faculty travelling scholarships awarded annually. Foreign Exchanges: With colleges in the USA and art schools in France on an individual basis. Library: Specialist faculty library – books, magazines and slide collection. Visiting lecturers: Part time staff and special visiting lecturers in all disciplines. Information on life after art school included as part of the programme.

WORTHING
West Sussex College of Design, Union Place, Worthing, West Sussex. Tel. 0903 31116.

YEOVIL
Yeovil College, Ilchester Road, Yeovil, Somerset. Tel. 0935 23921.

YORK
York College of Arts and Technology, Department of Art and Design, Dringhouses, York. Tel. 0904 704141 ext 45.

WALES

ABERYSTWYTH
University College of Wales Aberystwyth, Visual Art Department, Llanbadarn Road, Aberystwyth Tel. 0970 3339.

CARMARTHEN
Dyfed College of Art, Job's Well Road, Johnstown, Carmarthen, Dyfed, South West Wales. Tel. 0267 5855.

CARDIFF
South Glamorgan Institute of Higher Education, Faculty of Art and Design, Howard Gardens, Cardiff. Tel. 0222 22202.

NEWPORT
Gwent College of Higher Education, Faculty of Art and Design, Clarence Place, Newport, Gwent. Tel. 0633 59984. Courses: BA Hons fine art. Space: Separate buildings partly mixed

112

across media and years. Variety of annexes. Specialist equipment: Free access to art students. Wood and metal shops, printmaking facilities, full video post production facilities, as also for film, animation, photography and sound. Extensive computer and micro processor access. Materials: Allowance varies with student needs. Exhibition space: Small octagon gallery available to staff, students and outside artists. Scholarships, prizes: Staff research grants. Foreign exchanges: By arrangement for individuals. Library: Specialist fine art library. Visiting lecturers: Mostly artists but also other individuals. At least 3 visitors a week (1/2 day visits) throughout autumn/spring terms.

SWANSEA
West Glamorgan Institute of Higher Education, School of Art, Alexandra Road, Swansea. Tel. 0792 55907.

WREXHAM
North East Wales Institute of Higher Education, College of Art, 49 Regent Street, Wrexham, Clwyd. Tel. 0978 56601. Courses: DATEC fine art; 2 year diploma; 2 year higher diploma. Space: Large open plan and separate added facilities. Specialist equipment: Full range for painting, sculpture, ceramics, glass and textiles. Materials: Approximately £30 per student. Not limited to college shop. Exhibition space: Permanent and available to staff, students and outside artists. Scholarships, prizes: Liaison with various companies for project support. Foreign exchanges: None to date but interested with USA. Library: New 2 storey library and resource centre. Visiting lecturers: Range of fixed and visiting contracts. Business adviser on staff and close links with developing centre in Clwyd and Liverpool. DATEC courses are new and some don't start until 1982 so courses will develop in next few years. We have 7 DATEC submissions. Part of a complex of visual arts with theatre, music and audio visual resources which probably gives the college wider openings than some BA courses offer.

NORTHERN IRELAND
BELFAST
Ulster Polytechnic, Art and Design Centre, York Street, Belfast. Tel. 0232 28515.

SCOTLAND
ABERDEEN
Aberdeen College of Commerce, Holburn Street, Aberdeen. Tel. 0224 572811.

Gray's School of Art, Robert Gordon Institute of Technology, Garthdee Road, Aberdeen. Tel. 0224 33247. Courses: Diploma courses in painting and sculpture soon to be CNAA BA Hons degrees. Space: Changing from large open plan to shared individual spaces. Equipment. Widely used equipment relevant to all studies. Materials: Allowance part of SED grant. Not limited to college shop. Exhibition space: Some limited space. Scholarships, prizes; Several. Exchanges: None to date. Library: Good facilities for art students. Visiting lecturers: 1/2 day visits from artists and lecturers on a regular basis. Information available to art students about life after art school.

DUNDEE
Duncan of Jordanstone College of Art, Perth Road, Dundee. Tel. 0382 23261. Courses: BA Hons fine art. Good facilities in all departments and well respected art school.

Dundee College of Commerce, 30 Constitution Road, Dundee. Tel. 0382 27651.

EDINBURGH
Edinburgh College of Art, Lauriston Place, Edinburgh. Tel. 031 229 9311. BA Hons in fine art; BA Hons in architecture. Large art school with excellent facilities, library, equipment in all departments. One of Scotland's four main art schools.

Napier College of Commerce and Technology, Colinton Road, Edinburgh. Tel. 031 447 7070.

Telford College of Further Education, Crewe Toll, Edinburgh. Tel. 031 332 7431.

GALASHIELS
Scottish College of Textiles, Netherdale, Galashiels. Tel. 0896 3351. Specialist college for students wishing to enter the textile and related industries.

113

GLASGOW
Glasgow School of Art, 167 Renfrew Street, Glasgow G3 6RQ. Tel. 041 332 9797. Courses: BA Hons fine art; BA Hons architecture; other courses in design, architecture and planning. Space: Housed mainly in building designed for the purpose by Charles Rennie Mackintosh (1868-1928). Studios for life and open plan. Specialist equipment: Usual equipment for painting, printmaking, sculpture, jewellery, pottery and ceramics. Materials: As part of Scottish Education Department grant. Exhibition space: Two exhibition spaces available for staff and students. Scholarships, prizes: Various awards, prizes and scholarships for students. Library: Magnificent Rennie Mackintosh designed library. 35,000 books, 200 magazines and 21,000 slides on art, design, architecture, planning and related studies. Visiting lecturers: Some block visits, other one day visits. Information on life after art school: One day seminar annually called "Happily ever after" and booklet of information. One of Scotland's main art schools.

Glasgow College of Building and Printing, 60 North Hanover Street, Glasgow. Tel. 041 332 9797. Variety of technical courses for students wishing to enter the printing industry and related employment.

Central College of Commerce, 300 Cathedral Street, Glasgow G1 2TA. Tel. 041 552 3941.

Cardonald College of Further Education, 690 Mosspark Drive, Glasgow. Tel. 041 883 1119.

KIRKCALDY
Kirkcaldy Technical College, St Brycedale Avenue, Kirkcaldy, Fife. Tel. 0592 68591.

ART HISTORY
Most Scottish Universities have art history departments and as in the case of Edinburgh University there are often links with art schools. Glasgow, Edinburgh, St Andrews, Aberdeen in particular.

Chapter 4
ART AND THE LAW

Although there are many lawyers who would be interested in dealing with legal problems in relation to the art world it is obviously of great help to artists if there is an art organisation that specialises in art legal problems. Artlaw Services in the Strand was set up several years ago to deal specifically with art problems and has dealt with a variety of cases since then. Barristers working on a voluntary basis will listen to your problem and then offer advice about where you stand in relation to the law of the land. Remember that what is law in England and Wales is not necessarily so in Scotland where there is an entirely different legal system.

Artlaw has dealt with many cases of landlord v tenant, artist v gallery, artist v sponsor, artist v VAT (Customs and Excise) and many more varied cases. Prior to the existence of Artlaw many artists were referred to the Artists League of Great Britain where they were offered advice and provided with lawyers who fought their cases and all in return for a small fee to join the art organisation.

If however an artist feels that consulting a specialist art organisation is not appropriate he will be faced with enormous professional fees to pay if the case is taken to court and also even before he reaches the court. This in most cases is beyond the average artist's means unless of course the artist is commercially successful internationally. The children of the famous American abstract artist Rothko, went to court over large sums of money that they felt that they had been cheated of and in their case the expensive battle was worth the outlay as they won the case against certain commercial galleries and justice prevailed. In most cases however the artist is talking about fighting cases that could cost him or her half an annual art teacher's salary for example and if the artist is married with children it would be unthinkable to consider such an outlay of money.

Artlaw Services Ltd., 358 Strand, London WC2. Tel. 01 240 0610. Director David Binding. Deputy Director David Howlett.

Artists League of Great Britain, 26 Conduit Street, London W1. Tel. 01 629 8300.

Artlaw sells a booklet giving examples of problems that artists could face such as **Contracts of Sale, commissions, exhibitions, consignment, copyright, VAT, Customs and Excise, Import and Export of work.** These are mostly articles taken from a monthly column written by Henry Lydiate in *Art Monthly* magazine. The articles are very useful for reference and the booklet is available at Artlaw Service's office in the Strand. (75p)

Art Monthly, 37 Museum Street, London WC1. Tel. 01 405 7577.

Art Monthly still runs a weekly Artlaw column. The magazine can be bought at the Arts Council shop, 8 Long Acre, London WC2, and at galleries and art bookshops throughout the country or else pay an annual subscription direct to the London Office. £6 per annum.

LAW FOR ARTISTS, or ARTLAW

1. INTRODUCTION

Visual artists are subject to the law of the land, just like every other citizen. The law affects them both as private individuals, and as they set about trying to make a living as practising artists.

As practitioners, artists experience many and varied problems, not just lack of money! The law interprets these problems and may often provide the solution. For instance, after an exhibition the gallery returns a print to the artist, who discovers that it has been damaged. There are several parties involved – gallery, carrier, artist, insurance company – and the law operates to define who is responsible for the damage and how much the aggrieved party can claim and recover.

This specialised application of the law to the working situation of the visual artist is called 'artlaw'. It includes those areas of law relating directly to the visual arts, like contract and copyright. And it also includes less obvious areas like problems with studios and landlords; censorship

and obscenity; problems with executors of a will; entitlement to unemployment and social security benefits; the status of foreign artists in the UK.

Many, but by no means all, of the problems discussed below can be solved by recording agreements and deals *in writing*. This is the most important 'legal' problem experienced by most artists. In reality it is not a legal problem at all, since just about all verbal agreements are legally binding, without written evidence. But there are obvious practical problems about enforcing such contracts. In the words of the late Sam Goldwyn, the M.G.M. magnate, "a verbal contract ain't worth the paper it's written on".

2. SELLING WORK

When an artist sells a work to a buyer, the law will interpret the arrangement they have made in accordance with the statutes and general principles of the law of contract. If they have agreed a particular point, e.g. whether the price includes the frame, then this specific agreement overrides the general law.

But when nothing is said or written the law imposes the following obligations on an artist who sells his/her work by "silent contract":—

(i) to sell the work to the buyer;
(ii) to deliver the work to the buyer;
(iii) to allow the buyer to lose, damage or destroy the work;
(iv) to allow the buyer to reframe the work;
(v) to allow the buyer to restore and conserve the work, without allowing the artist first option to do so and without prior consultation with the artist;
(vi) to pay the buyer the cost of any restoration and conservation necessitated by unreasonable deterioration of the work;
(vii) to allow the buyer to exhibit the work anywhere in the world and under any circumstances;
(viii) to allow the buyer to sell or give the work to any individual or organisation;
(ix) to allow the buyer to prevent anyone seeing the work, including the artist;
(x) to allow the buyer to prevent anyone reproducing the work, including the artist.

The only obligation which the buyer undertakes in this "silent contract" is
(i) to pay the purchase price to the artist — sometime.

Bill of Sale

To circumvent the obvious dangers of such "silent contracts", artists should use a Bill of Sale when selling work. The Bill of Sale should contain the following 10 points.

(1) Name and address of artist;
(2) Name and address of buyer;
(3) Title of work;
(4) Description of work;
(5) Price;
(6) Terms of payment;
(7) Date of sale;
(8) Place of sale;
(9) Who owns copyright;
(10) Signatures of artist and buyer.

Contract of Sale

Appropriate points and clauses can be added to the Bill of Sale, so as to expand it into a full-blown Contract of Sale. These might include terms for the protection of the buyer:-

(i) Warranty by artist that work is original and unique;
(ii) Covenant by artist that edition is limited.

Alternatively, they may be terms for the protection of the artist:—

(iii) Promise by buyer to preserve the work;
(iv) Promise by buyer to consult the artist if restoration work is necessary;
(v) Promise that artist will be acknowledged as creator;
(vi) Promise to allow artist to borrow the work for exhibition purposes.

There may also be terms for the mutual benefit of both parties.

(vii) To notify each other of change of address;
(viii) Which law governs the agreement.

3. COMMISSIONS

A "commission" is technically a contract for skill and labour. Someone commissioning an artist (the commissioner) purchases the time and expertise of the artist, who produces the work. The commissioner will often pay the cost of materials.

Problems usually arise due to conflict between the artist's freedom to create what he/she wishes and the commissioner's right to know for what he/she is paying. These are, frankly, irreconcilable interests. Most problems can be pre-empted by careful planning on both sides.
The following points should be considered: —
 (1) Identity of the commissioner;
 (2) Dates of commencement/completion of work;
 (3) Preliminary designs/sketches;
 (4) Description of work;
 (5) Scale of fees;
 (6) Terms of payment;
 (7) Who owns copyright;
 (8) Delivery/access to site;
 (9) Commissioner's right to terminate contract/reject work;
 (10) Which law governs the agreement.

Commission AND Sale
Most "commissions" are contracts involving the creation of a work by the artist using his skill and labour *and* the subsequent sale of the completed work. It is important to recognise the two legal transactions, combining together in the single arrangement.
In such a case, the commissioner and the artist should consider together the appropriate terms for both the commission and the sale situations. Particular regard should be had to the commissioner's right to reject the completed work. It is a source of much legal contention as to whether this right exists automatically i.e. without being specifically mentioned. The right should be closely defined.

4. SALE OR RETURN
Many painters, printmakers and artist-craftsmen have arrangements with galleries/retail outlets who take work on sale or return. *Consignment* is a more accurate term than 'sale or return' because it makes clear to both sides that the artist does not intend to sell the works to the gallery at any stage, but merely intends to leave them for sale by the gallery as artist's agent or consignee on a commission basis.
In these circumstances a written agreement should be signed by the artist when sending or delivering works to the gallery whose representative should then sign and return it to the artist. The following points should be considered by artist (the consignor) and gallery (the consignee).
 (1) Identity of consignee;
 (2) List of works;
 (3) Retail price of works;
 (4) Rate of commission;
 (5) Time for payment to artist;
 (6) Liability for damage to/loss of works.
A most contentious area is whether the artist is entitled to know to whom work has been sold by the gallery — acting as his agent. Many galleries are reluctant to reveal the names and addresses of buyers to artists, in these circumstances. Artists who wish to know the identities of those who buy their work should bear this in mind from the start.
It is important to distinguish consignment from the situation where the artist parts with work to a gallery which "buys in" the work. The gallery may even take some work on consignment, and "buy in" other work, whether for resale or other purposes. The legal status is very different for each such class of work and the legal implications, e.g. as to the revelation of identity of buyers, quite far-reaching.

5. EXHIBITIONS
It is important for artists to distinguish between exhibition agreements (where the primary purpose is to show the work) and consignment arrangements (where some or all of the work may nevertheless be on show). An artist will usually conclude an exhibition agreement with a publicly-funded gallery. A consignment deal more often with a privately owned profit-making gallery.
Many of the points to be considered jointly by artist and gallery proprietor are sound common-sense. Many are mere administrative detail. But by considering them in advance, both parties can preclude misunderstandings and omissions at the crucial moment. A written record should be made of the following: —
 (1) Identity of exhibiting gallery;
 (2) Exact venue of show and opening hours;
 (3) Dates of show and private view;
 (4) List of works for exhibition;
 (5) Responsibility for collection and delivery of work;

(6) Insurance;
(7) Liability for damage to/loss of works;
(8) Responsibility for hanging/invigilation;
(9) Sales;
(10) Hire fees and commission on sales;
(11) Responsibility for publicity and catalogue.

6. COPYRIGHT

Copyright is the complicated, much-misunderstood right of an artist to protect his/her work. It is, simply stated, the right 'not to have your work copied' i.e. to prevent copying by someone else.

Copyright law, principally contained in the Copyright Act 1956, has developed over 200 years, since its introduction at the behest of William Hogarth for the protection of his work against plagiarism. It is very complicated. The important features are:—

(i) Paintings, sculpture, drawing, engravings and photographs all enjoy copyright protection. Copyright arises naturally, there are no formal requirements e.g. registration or deposit of copies. The artistic merits/demerits of the piece are irrelevant.

(ii) Copyright does not protect ideas. It will protect the work itself and any preliminary designs/sketches, provided that the work is original i.e. not a copy of another copyright work. But a fine art performance piece will not be protected in this way, although any notes belonging to the artist will be.

(iii) The artist owns the copyright from the moment the work is made. He owns the copyright in the work even if he/she is commissioned to produce the work, unless the work is a photograph/painted or drawn portrait/engraving. In the latter instances, the commissioner owns the copyright. This rule produces anomalous results e.g. an artist commissioned to produce a portrait will own copyright if he/she sculpts a bust, but not if the portrait is painted.

(iv) The employer of an artist owns the copyright in any work produced in the course of that employment. But any of these rules about ownership of copyright can be varied by the artist agreeing with the commissioner/employer to the contrary.

(v) Copyright in artworks lasts for the lifetime of the artist, plus 50 years after his/her death (during which time it is owned by the artist's heirs). The exception to this rule is in the case of photographs, where protection lasts for 50 years from the year in which the photograph is first published. Unpublished photographs are protected indefinitely.

(vi) An artist selling a painting does not thereby automatically sell the copyright along with the work. Copyright remains vested in the artist unless he/she specifically elects to part with it, and this "assignment" is recorded in writing and signed by the artist.

(vii) It is important to distinguish assignment, which is irrevocable, from the grant of permission to reproduce a copyright work e.g. to a publisher. In this situation, the publisher enjoys a "license" to make copies of the copyright work, upon the agreed terms, and the artist retains the residual copyright. If he/she "assigns" copyright to the publisher, the artist retains nothing.

(viii) The artist's copyright is infringed if the work is copied, e.g. by reproducing/photographing/publishing it, without express or implied permission. In these circumstances the artist can claim an injunction and/or damages and/or an account of the profits, where the copying has been profitable. The artist cannot prosecute the copier, since infringing copyright is a civil, not criminal, offence.

(ix) Copyright protection is only given to a citizen/resident of the UK and Eire, or of a county with reciprocal arrangements with the UK under the international copyright conventions. In practice this means the majority of countries in the world, except China. Although no formalities have to be complied with in the UK, it is sensible to put the following information on all your work, the copyright symbol, your name (and address?) and the year of creation e.g. © John Painter 1981. This will ensure that your work is protected overseas, as well.

(x) Under UK law an artist can prevent the attribution of the name of another to his/her work. But he/she cannot insist on acknowledgement or credit as the author of the work unless this has been agreed, for instance with a publisher as part of a "license" arrangement. The artist in the UK does not enjoy any moral rights (droit moral) or resale rights (droit de suite) at the present time, apart from the limited provision above.

7. PROBLEMS?

John Lennon referred to lawyers as "big and fat, vodka-lunch, shouting males, like trained dogs trained to attack all the time". Not all lawyers conform to this sterotype. Many solicitors are well-equipped to lend a sympathetic and informed ear to an artist facing such problems as outlined above.

118

If you don't know a solicitor, or you're worried whether your problem is indeed a legal one, you are welcome to contact Artlaw Services, 358 Strand, London WC2. Tel. 01 240 0610. Their work is described elsewhere in this guide, but they will certainly be able to diagnose the symptoms and direct you towards the most effective cure for your legal ailment. However, you should never forget that prevention is the best form of cure!

Adrian Barr-Smith
(Previously Director, Artlaw Services Ltd.)

ARTLAW SERVICES LTD.
Chairman: Henry Lydiate
Director: David Binding
Deputy Director: David Howlett

Non-profit making organisation providing a free legal service for visual artists, artist-craftsmen, art administrators and organisations. ARTLAW can solve art-related legal problems and will provide information and advice in response to any queries about the visual arts community in the UK.
In addition to legal work, the staff of ARTLAW

1. Give "survival" lectures to both design and fine art students.
2. Organise legal workshops in the regions for the benefit of practising artists and artist-craftsmen.
3. Promote conferences (1980: "Legal Change for the Visual Arts?" Whitechapel Art Gallery, London).
4. Organise training courses on artlaw for the benefit of the legal professions.
5. Give talks at the request of organisations, for the benefit of their members.
6. Maintain a list of sympathetic solicitors and accountants throughout the UK with appropriate expertise in artlaw.
7. Publish a Newsletter for subscribers.
8. Research, monitor and write articles about legal matters affecting the arts.
9. Publish guides to the law relating to the visual arts (publications list available).
10. Offer an insurance service for cover of artwork, whether in transit, in storage, consigned to or exhibited by a gallery.
11. Offer an arbitration service to resolve art-related disputes.
12. Liaise regularly with other individuals/organisations and maintain reciprocal arrangements with similar bodies in Europe and throughout the U.S.A.

ARTLAW is run by a Council of Management comprising artists, lawyers and administrators. It is subsidized by the Arts Council, Crafts Council, Welsh Arts Council and by income from lecture fees and sale of publications.
Any individual or organisation wishing to support the work of ARTLAW can become a subscriber.
Details of the subscription scheme and/or help is available from Artlaw Services Ltd., 358 Strand, London WC2. Tel. 01 240 0610.

. TAXATION AND ACCOUNTING FOR ARTISTS

1. INCOME TAX
There are two broad areas of taxation of earned income. Schedule D for profits from a profession and Schedule E for income from an employment. For the first tax is payable in two equal instalments on the previous year's profits and for the second tax is deducted under PAYE from the current year's salary. A taxpayer normally has more latitude in claiming expenses against Schedule D earnings than against Schedule E earnings.
Under Schedule D if you can show that you are engaged in a profession with the view to realisation of profits you should prepare an annual account of your professional earnings and expenditure and submit it to your local Inspector of Taxes. If you can agree the figures with him you will then be liable to tax on the net profit, less normal personal allowances, mortgage interest and other allowable deductions. If you make a loss you may claim to have it carried forward against subsequent profits or alternatively to have it deducted from another source of income of the same year.
There are four main areas when you may have to negotiate with the Inspector of Taxes;
(a) Whether certain earnings, such as part time lecture fees are taxable under Schedule D as earned income in your profession as artist or under Schedule E as separate employment.
(b) what expenses may be claimed as allowable deductions from your earnings.
(c) whether, in a loss making period the losses are available for relief.
(d) whether certain grants, prizes, bursaries awards etc. are taxable.

119

You are entitled to argue these points if you disagree with the Inspector and there are certain appeal procedures if you and he cannot reach agreement. It may be advisable to consult an accountant if you come across these problems.

Official forms that you may receive include:

Tax Returns

These are normally issued shortly after 5th April (the fixed year end) and you are required to enter all sources of income for the previous year and claims for allowances for the subsequent year and then return the form to the Inspector. There are penalties for false declarations.

Notices of assessment

These are the Inspector's calculations of the tax due. If you consider that the assessment is incorrect you must appeal against it within 30 days. This is particularly important when there is a delay in submitting your accounts, as the Inspector has the power to issue an estimated assessment and this is frequently excessive.

Notices of Coding

These show the allowances to be set off against your salary before tax is charged. If the Inspector does not have all the information he thinks he needs he may issue a Basic Rate (BR) coding which means that tax will be deducted at full standard rate without the benefit of deduction of allowances.

Notices to Pay

These are tax demands and if there is any delay in payment you may be charged with interest.

2. VALUE ADDED TAX (VAT)

If your gross annual freelance income exceeds certain limits (currently £15,000) you are required to register with the Customs and Excise and you will have to charge VAT currently 15% on all your sales, fees, etc. You will have to account to Customs and Excise every three months for the VAT you have charged your customers, less VAT you have suffered on your expenses.

3. NATIONAL INSURANCE CONTRIBUTIONS (NIC)

There are three main types of NIC that you may have come across.

Class 1: a proportionate deduction from salaries.

Class 2: a weekly stamp purchased from the Post Office where you are self employed.

Class 4: a percentage of your annual freelance profits which is assessed and paid at the same time as your income tax.

There are special rules about low earnings, mixed employments and freelance activities etc and in cases of difficulty you should contact your local Social Security Office.

4. ACCOUNTING ARRANGEMENTS

Make sure that you keep bank statements, cheque book stubs, paying in counterfoils, payslips, bills, receipts, invoices, correspondence etc. Buy an analysis book from a stationers and head the columns with each main item of expense. List chronologically the expenses under the relevant headings, using the information that you have retained. Keep a notebook with you and note small cash payments such as fares, postage, magazines, catalogues etc. Make a similar analysis of income.

Expenses that may be claimed include upkeep of studio (proportion of rent, rates, electricity, gas, repairs etc.) telephone (proportion), art materials, frames and framing charges, photography, carriage, postage, stationery, travel (UK) travel (foreign), car expenses (proportion of petrol, oil, repairs, insurance, road fund, licence) submission and hanging fees, subscriptions, exhibition entrance fees, catalogues, books, journals, commission, cleaning and replacement of clothes etc.

From this information you should be able to provide the Inspector of Taxes with an acceptable summarised set of accounts and negotiate your tax liability. However if you find yourself unable to cope with this, an accountant would be able to assist you, providing you have retained the basic documentation.

Robert Coward, FCA.

Chapter 5
BUYING AND SELLING ART

BUYING AND COLLECTING PRINTS

No art form is better designed for the collector than the print. The concept of making the same image available to many suggests this purpose. Unlike china or other artifacts, pictures serve no other end than being looked at. Paintings, and the massive literature that surrounds and sustains them, exist in a complex of art historical discussion and connoisseurship which can exclude all but those who have the will and ability to devote a lifetime to study.

The literature of prints, however, is not a matter of theories but of facts. A substantial proportion of it is in the form of the Catalogue Raisonné, which illustrates, dates and describes an artist's oeuvre, being an aid to identification and authentication, rather than subjective judgement.

The past decade has seen a number of books about collecting prints, some of which highlight the pitfalls into which the unsuspecting can fall, but most of which illustrate and describe prints of merit, many of which can be bought on an average salary.

London has printsellers in profusion. The auction houses hold frequent sales of prints, but dealers offer a degree of protection for the collector, incorporated in their markups. Most good dealers guarantee authenticity, which auctioneers do not, and the fact of the multiplicity of the printed image often allows comparison of price.

This is not to suggest that the collecting of prints is simply a matter of investment and value for money. The best and only true criterion for buying a print should be desire and interest. The growth, more especially in America, of art investment schemes negates the basic appeal of collecting: that ordinary people can buy what they like, hang it on their wall and enjoy it. Greater knowledge and growing interest can lead to a satisfying pastime which, if the collector buys wisely, can result in long-term financial gain.

For the beginner, the best thing is to find out what is available. This can be done by reading, rummaging through dealers' stock or museum collections. Dealers publish catalogues, and through consulting these, a potential collector can establish whether the prints which interest him are within his price range.

Most reputable dealers give advice willingly. This is not a matter of altruism, but stems from the fact that a successful printselling business depends upon the cultivation of regular clients and a trusting relationship between dealer and customer. This personal touch is rewarding for both, and should appeal to a collector who wishes to develop his interest.

Most printsellers in London carry a varied stock but have their own specialist area. If you know what you want and it is not their field, they will usually direct you to the right dealer. This, combined with the fact that their premises tend to be less intimidating than picture galleries, will help the beginner of modest means to find what he or she wants.

It is only in recent years that various organisations have sprung up to help offices decorate their corridors, boardrooms, reception areas and generally also making the visual arts more accessible to the public. In the USA and Canada this is and has been very common practice for years but for some reason contemporary art has always remained a mystery to the man in the street. This is partly due to the fact that he is not surrounded by it in his everyday life and partly because contemporary work is given such poor coverage in the national and local press and on television. Hopefully this will change over the next few years and the more the public becomes used to being surrounded by contemporary work the more they will want to buy original artwork for their own homes. Although several artists produce work that is not suitable for the average house, rather for museums and galleries, there are many printmakers, photographers, painters and sculptors who are only too glad to sell work and know that the buyer will look after the work. For the artist this is a matter of concern rarely considered by the buyer and the more the buyer comes into contact with artists the more he will come to understand the artist's world.

A potential buyer of artwork is often uncertain where to find original work at a reasonable price and many gallery directors find it difficult to put themselves in the place of the potential buyer who is unwilling to admit his ignorance possibly about what he does or does not know about art. This is possibly why Bond Street and Cork Street galleries for example could frighten off a potential young buyer. Possibly it is advisable to get to know some local galleries in your area and visit the galleries regularly so that you can see what price range you would consider and the kind of work you would like to buy. Refer to the gallery section at the beginning of this book for galleries in your area. Otherwise you could visit print workshops direct, artists' studios, college degree shows in the summer months where original artwork is reasonably priced and the student is often only too glad to sell work. If you really want good advice then visit your Regional Arts Association (see Chapter 7) and ask to see their slide index of work by local artists, craftsmen and photographers. The slide indexes show work by professional artists not amateurs.

Below is a list of **useful addresses for potential buyers** and conversely for artists eager to sell their work. For example a local print gallery is an ideal place for a potential buyer to visit and also for a local professional artist to sell.

ROYAL ACADEMY, Business Art Galleries, Burlington House, Piccadilly, London SW1. Tel. 01 734 1448. A permanent gallery but also acts as an organisation that **helps companies decorate office space,** carries out commissions and sells original contemporary artwork.

THE CORPORATE ARTS. Tel. 01 402 0361. Director: Sarah Hodson. A non-profit organisation that seeks to help artists exhibit work in company offices. Interested in professional painters, sculptors, printmakers and photographers.

REGIONAL ARTS ASSOCIATIONS, Arts Council of Great Britain, Scottish Arts Council, Welsh Arts Council, Arts Council of Northern Ireland and other similar bodies. See slide registries list for your local office. The public can consult these slide indexes to look at different kinds of artwork before buying.

SCOTTISH DEVELOPMENT AGENCY and the WELSH DEVELOPMENT AGENCY often encourage local craft work and act as a contact between the public and the artist.

DEGREE SHOWS AT LOCAL ART COLLEGES usually take place in May, June and July. See your local press for details of opening times or phone your local colleges. In this way you will be able to see a variety of work and also help young artists survive at an early stage in their career.

See other sections of this book for useful information. **Chapter 3 Studios section** for groups of artists in your area. Often these groups have exhibitions that you could visit or you could visit the artists in their studios and consider buying work by the artists. **Chapter 2 Galleries section.** Refer to local galleries in your area and see whether they stock the kind of work you might be interested in buying.

Consult this chapter for MEMBERSHIP SCHEMES where you could be invited to gallery private views and gradually find out more about painting, sculpture, photography, printmaking and other art forms. For example the Photographers gallery in London would be a good place to start if you are interested in buying photographs but are not sure where to start. Regionally artists groups such as the Stills Photography Gallery, Edinburgh, and the Glasgow Printmakers Workshop, and many others have "Friends" of schemes which would enable you to go to local openings and buy work by local professional artists.

PRINT WORKSHOPS, PRINT GALLERIES AND PRINT PUBLISHERS sell original prints by known and not so well known artists. See **Chapter 1 Studios** section for **print workshops.**

SOME LONDON GALLERIES THAT WOULD OFFER WORK
AT ACCESSIBLE PRICES
For regional equivalents consult Chapter 1 Galleries section regionally

ZELLA 9, 2 Park Walk, London SW10. Tel. 01 351 0588. Open 10-9 Mon-Sat. Vast selection of prints at reasonable prices. Regular openings. Friendly and helpful.

GRAFFITI, 44 Great Marlborough Street (3rd floor), London W1. Tel. 01 437 6848. Open 10-6 Mon-Fri. Variety of prints by British artists.

ART FOR OFFICES, Riverside Gallery, O & N Block, Metropolitan Wharf, Wapping Wall, London E1. Tel. 01 481 1337. Useful address for designers, architects and businessmen who wish to either buy or rent artwork. Clients can look at slides of work and then choose to see the originals. 3000 sq ft of viewing space.

ABERBACH FINE ART, 17 Savile Row, London W1. Tel. 01 439 6686. Open Mon-Fri 10-6.30. Variety of prints by famous and relatively famous artists — both British and European as well as American.

CHRISTIES CONTEMPORARY ART, 8 Dover Street, London W1. Tel. 01 499 6701. 100 new editions published a year. Colour brochure available with details of prints for sale. Works by known British printmakers.

CURWEN GALLERY, 1 Colville Place, London W1. Tel. 01 636 1459. Prints by known British printmakers.

PHOTOGRAPHERS GALLERY, 5 & 8 Great Newport Street, London WC2. Tel. 01 240 5511. 5 Great Newport Street has a viewing room where staff will help advise and give prices for photographs by British contemporary photographers as well as photos by famous names in the USA and Britain. Wide selection of work and very helpful to buyers at whatever level.

AIR GALLERY, 6/8 Rosebery Avenue, London EC1. Tel. 01 278 7751. Consult the gallery director for advice about paintings, prints, sculpture and photography by young British artists.

JORDAN GALLERY, Camden Lock, Chalk Farm Road, London NW1. Tel. 01 267 2437. Young contemporary artists. Prints on sale.

WADDINGTON GRAPHICS, 31 Cork Street, London W1. Tel. 01 439 1866. If you want to buy a print by a known name such as Joe Tilson, Hockney, Patrick Caulfield, Frink, Hoyland and many other artists. Good place to look at the prints available at main London galleries and get to know work by a variety of artists.

MARLBOROUGH GRAPHICS, 6 Albemarle Street, London W1. Tel. 01 629 5161. Leading contemporary names. Ask to look at drawers of work by a particular artist you are interested in.

Consult **Chapter 1 Galleries section** for names of all other possible galleries to visit. Pick up a copy of the monthly bulletin *New Exhibitions of Contemporary art* for listings of monthly exhibitions in the central London area. *Time Out Visual Arts* section and *Art Monthly* exhibitions section also list regular exhibitions in London and in some cases regionally, also *Arts Review*.

MOIRA KELLY FINE ART, 97 Essex Road, London N1. Tel. 01 359 6429. Work by contemporary young British artists.

EDITIONS ALECTO, 27 Kelso Place, London W8. Tel. 01 937 6611. Prints by known British artists.

MEMBERSHIP SCHEMES

If you are at all interested in becoming an art buyer, collector, or are just interested in visiting exhibitions regularly it is worthwhile thinking about joining one or several of the **membership schemes** available in your area. Alternatively as a potential buyer many galleries would be interested in considering putting you on their regular **mailing list.** This means that you would be mailed details of private views and dates of exhibitions at specific galleries.

Membership schemes sometimes offer various facilities such as discount on cards, books and materials, visits to galleries and museums elsewhere, visits to artists' studios, invitations to private views and openings and a chance to meet other people interested in art and add to your knowledge about painting, sculpture, performance, video, film and other events in the art world.

LONDON

Information on Friends Organisations throughout the UK can be obtained by writing to The Hon Secretary, The British Association of Friends of Museums, 66 The Downs, Altrincham, Cheshire. Tel. 061 928 4340. A selection is given below.

FRIENDS OF THE ROYAL ACADEMY, Royal Academy of Arts, Burlington House, Piccadilly, London W1. Tel. 01 734 9052. Benefactors £1,000 or more. Sponsore £500, corporate £100, individual artist Subscribers £22.50 (includes reduction on art materials at the shop. Friends £12.50 or £10.00, £7.00 OAPs (museum staff, teachers, and young Friends 16-25).

FRIENDS OF THE COURTAULD INSTITUTE, 20 Portman Square, London W1. £5 per annum. Students under 26 £3 p.a. Life Members £50 or over.

FRIENDS OF THE TATE GALLERY, The Tate Gallery, Millbank, London SW1. Tel. 01 834 2742. Benefactor £1,000 or over. Patron £100 or over annually. Associate £25. Corporate £25. Member £8. Educational £6. Young

Friend under 26 £5. Young Friends also organise visits to the theatre and film evenings occasionally.

FRIENDS OF THE V&A, Victoria and Albert Museum, London SW7. Tel. 01 589 4040. Membership £15. Deed of Covenant £12. Educational £10.

FRIENDS OF ARTLINK, c/o 105 Blackheath Road, Greenwich, London SE10. Tel. 01 691 2240. As yet not in operation but if you live in Deptford, Greenwich, Blackheath or Lewisham (SE London) enquire about latest plans for SE London Arts Centre project.

THE BRITISH MUSEUM SOCIETY, c/o The British Museum, London WC1. Tel. 01 637 9983. £8 Member, £12 additional lectures and private views. Life Membership £150 single, £200 husband and wife.

THE INSTITUTE OF CONTEMPORARY ARTS, Nash House, The Mall, London SW1. Tel. 01 930 0493. Member £5 per annum. Associate, or £8 membership, Day membership 40p.

PHOTOGRAPHERS GALLERY, 5 & 8 Great Newport Street, London WC2. Tel. 01 240 5511/12. £15 member (private views), £10 advance mailing only.

CONTEMPORARY ART SOCIETY, c/o The Tate Gallery, Millbank, London SW1. Tel. 01 821 5323. Member £6 p.a.

NATIONAL ART COLLECTIONS FUND, 26 Bloomsbury Way, London WC1. Tel. 01 405 4637. Subscription £5 annually.

FRIENDS OF THE IVEAGH BEQUEST, Kenwood House, Hampstead Lane, London NW3. Tel. 01 348 1286. £3 entry to lectures, £5 to include private views, £1 (under 18).

ELSEWHERE IN THE UK
GLASGOW ART GALLERIES AND MUSEUMS ASSOCIATION, Art Gallery and Museum, Kelvingrove, Glasgow G3. Tel. 041 334 1134.

STILLS PHOTOGRAPHY GALLERY, 58 High Street, Edinburgh. Tel. 031 557 1140.

FRIENDS OF THE CITY OF EDINBURGH ART CENTRE, Market Street, Edinburgh. Tel. 031 552 7073.

FRIENDS OF THE ROYAL SCOTTISH MUSEUM, 49 Queen Street, Edinburgh. Tel. 031 226 5084.

FRIENDS OF THE TALBOT RICE ARTS CENTRE, University of Edinburgh, Old College, South Bridge, Edinburgh. £2.50 pa ordinary, £1 pa student, £3 pa family, £25 life.

FRIENDS OF ABERDEEN ART GALLERY AND MUSEUMS, Aberdeen Art Gallery, Schoolhill, Aberdeen. Tel. 0224 53517.

TAYSIDE MUSEUMS AND ART SOCIETIES, Central Museum and Art Gallery, Albert Square, Dundee. Tel. 0382 25492.

DUNFERMLINE MUSEUMS SOCIETY, Hon Secretary, 72 James Street, Dunfermline. Tel. 0383 21814.

FRIENDS OF THE MERSEYSIDE COUNTY MUSEUMS AND ART GALLERIES, The Museum, William Brown Street, Liverpool. Tel. 051 207 0001.

FRIENDS OF KIRKCALDY MUSEUMS, Museum and Art Gallery, War Memorial Grounds, Kirkcaldy, Fife. Tel. 0592 60732.

FRIENDS OF THE HOLBURNE OF MENSTRIE MUSEUM, Great Pulteney Street, Bath. Tel. 0225 66669.

FRIENDS OF THE ULSTER MUSEUM, Ulster Museum, Botanic Gardens, Belfast. Tel. 0232 668251.

FRIENDS OF THE CITY MUSEUMS AND ART GALLERY, City Museum and Art Gallery, Birmingham. Tel. 021 235 2833.

ALDERNEY SOCIETY AND MUSEUMS, Alderney, Channel Islands. Tel. 048 182 2539.

CHICHESTER MUSEUM SOCIETY, Chichester District Museum, 29 Little London, Chichester, West Sussex. Tel. 0243 784683.

AVONCROFT MUSEUM MEMBERS SOCIETY, 33 Old Station Road, Bromsgrove, Worcestershire. Tel. 0527 31363.

FRIENDS OF BOLTON MUSEUM AND ART GALLERY, c/o Gray, Le Mans Crescent, Bolton, Lancashire. Tel. 0204 22311 ext 379.

FRIENDS OF THE LEEDS CITY AND ABBEY HOUSE MUSEUMS, Municipal Buildings, Leeds 1. Tel. 0532 462495.

LEICESTER MUSEUMS ASSOCIATION, The Leicester Museum, 96 New Walk, Leicester. Tel. 0533 712271.

FRIENDS OF LINCOLN MUSEUM AND ART GALLERY, c/o Willimas, 20 Queensway, Lincoln. Tel. 0522 26029.

FRIENDS OF ABBOT HALL, Abbot Hall Art Gallery and Museum, Kendal, Cumbria. Tel. 0539 22464.

BOURNEMOUTH MUSEUM AND ARTS SOCIETY, Art Gallery and Museum, East Cliff, Bournemouth. Tel. 0202 21009.

FRIENDS OF THE ROYAL PAVILION, Art Gallery and Museums of Brighton, Friends Organiser, The Royal Pavilion, Church Street, Brighton. Tel. 0273 603005.

FRIENDS OF THE BRISTOL ART GALLERY, City Museum and Art Gallery, Queens Road, Bristol 8. Tel. 0272 299771.

FRIENDS OF THE FITZWILLIAM MUSEUM, Fitzwilliam Museum, Cambridge. Tel. 0223 69501.

FRIENDS OF EXETER MUSEUM AND ART GALLERY TRUST, c/o The Secretary, Little Hawkridge, Nynet Rowland, Crediton, Devon. Tel. 0392 56724.

FRIENDS OF THE NATIONAL MUSEUM OF WALES, National Museum of Wales, Cathays Park, Cardiff. Tel. 0222 397951.

SLIDE REGISTRIES

Anyone interested in buying artwork should consider looking at one or two of the slide registries available for reference. The visitor can then follow up looking at slides with a studio visit to see the artist's work for himself. Unfortunately the public are often unaware that such registries exist.

There are two kinds of registry. One is for use by for example an organisation such as the Arts Council so that they can refer to work by established British artists and for example show an overseas gallery director work by British artists to save them starting from scratch. These registries are often highly selective. The other kind is also selective but aims to help the artist/craftsman show/sell his work to a wider public. The Regional Arts Associations and the Crafts Council have such registries, although the Crafts Council is again highly selective.

CRAFTS COUNCIL, 12 Waterloo Place, London SW1. £4.95 for an illustrated guide to the works of 350 artist craftsmen and women throughout England and Wales. Selective index. Photos of work, address and details of where further work can be seen by a particular craftsman. Tel. 01 930 4811.

EASTERN ARTS, 8/9 Bridge Street, Cambridge. Tel. 0223 67707. Artists register. Available for consultation whether professionally or privately interested in the visual arts. Open to all professional artists and craftsmen.

SOUTH EAST ARTS, 9 & 10 Crescent Road, Tunbridge Wells, Kent. Tel. 0892 41666. Artists register. Up-to-date selective register of professional artists, photographers and craftsmen working in the area. Available for consultation by gallery directors, organisers, patrons of the arts etc. Artists can apply twice a year in June and December.

WEST MIDLAND ARTS, Lloyds Bank Chambers, Market Street, Stafford. Tel. 0785 59231. Artfile is an index of work by artists, craftsmen and photographers working in the region. 10/20 slides by each artist. Open to all professional artists.

EAST MIDLAND ARTS, Mountfields House, Forest Road, Loughborough. Tel. 0509 218292. Artists register of work by artists, craftsmen and photographers. About 250 on list.

LINCOLNSHIRE AND HUMBERSIDE ARTS, St Hughs, 23 Newport, Lincoln. Tel. 0522 33555. Register of work by artists, craftsmen and photographers.

SOUTH WEST ARTS, 23 Southernhay, Exeter, Devon. Tel. 0392 38924. Register of work by artists, craftsmen and photographers. South West film directory of work available by SW filmmakers. (50p)

NORTHERN ARTS, 10 Osborne Terrace, Newcastle, Tyne and Wear. Tel. 0632 816334. Register of work by artists, photographers and craftsmen.

SCOTTISH ARTS COUNCIL, 19 Charlotte Square, Edinburgh. Tel. 031 226 6051. Register of work by Scottish artists both living in Scotland and elsewhere in Britain.

THE ARTS COUNCIL OF GREAT BRITAIN is compiling a selective register of work by known British artists. Not open to artists to apply. Open to the public to use (next to the Arts Council Shop at 9 Long Acre London WC2). Contact Alister Warman at the Arts Council 01 629 9495 for details or to view slides of work.

THE BRITISH COUNCIL, Fine Art Dept, 11 Portland Place, London W1. Tel. 01 636 6888. The library has a selective register of work by British artists. Only available to visitors with a genuine reason to refer to it. Contact the Fine Art Department.

Chapter 6
SPONSORSHIP AND ART
FOR PUBLIC PLACES

SPONSORSHIP

Most art organisations, as registered charities in many cases, have had to think seriously about how they can approach companies and individuals for sponsorship of projects, exhibitions, administration costs and other similar items, at some point. The visual arts, they have soon discovered, are sadly neglected in favour of music, opera and theatre. The British it would seem are a nation of music lovers and theatregoers, not art buyers and art collectors or at least not of contemporary art. There are of course odd exceptions and in these cases it is often one individual who has a particular interest in contemporary art, such as Richard Cobbold (Tolly Cobbold exhibition), Alex Bernstein of Granada TV (The Granada Foundation) and Peter Stuyvesant (Peter Stuyvesant Collection).

Advantages for companies entering into sponsorship are many. For example if a major exhibition at the Royal Academy is sponsored, the company can expect publicity from articles in newspapers, television and readio, and of course from posters advertising the event. There are also tax advantages although these are small in comparison with similar tax advantages, for example in the USA and Europe. American art organisations have learned to live with the daily strain that if they want to survive, they have to battle for sponsorship and support from the commercial sector, as well as organisations such as the National Endowment for the Arts. An arts administrator in the USA has to be well trained in approaching companies for sponsorship and has to hassle to be successful. This is acceptable in the USA but totally unacceptable in Britain. In Britain, as many successful art organisations will agree, the personal contact story is the most successful and a gentle word in the company director's ear, by an influential personal friend, will often gain more results than endless letters. Below I have tried to offer some advice step by step for artists, small art organisations and other bodies that have little experience of how to start applying for sponsorship.

The one thing you must bear in mind is that business is built on profit, not benevolence for the arts and that hard as it may seem to you, the artist, anyone considering sponsorship will bear in mind whether the event will give them publicity or possible investment. This explains why contemporary art is a gamble and very few companies are prepared to buy or sponsor contemporary work until the artist has made a name for her/himself. Again in the USA, Australia and Canada for example, possibly as they are younger countries where traditional ideas are not so entrenched, companies are willing to consider sponsoring young artists and new work. Perhaps Britain can learn from this, and the resultant interest in contemporary work by the general public would make a refreshing change to the cultural scene in Britain in general. In Australia recently, during the summer months, Sydney, Adelaide and Perth held art events for children, to encourage their future citizens to take an interest in art and these festivals on a local and international level were sponsored by national and local companies. This attitude surely helps promote culture generally and helps art and artists on several levels rather than a negative attitude where contemporary art is ignored until it is a safe investment.

There are many dangers of sponsorship that organisations need to bear in mind. A gallery can literally be almost taken over by a company wishing to make as much publicity as possible out of an event. Sponsors often tend to sponsor events that are already doing well and really do not need more help and tend to ignore avant garde contemporary work or promotion of exhibitions of narrow appeal. Also the business side to sponsorship is always evident and if artists participate in an exhibition sponsored by a company with political leanings then there could be endless complications that art administrators had never dreamed of.

ASSOCIATION OF BUSINESS SPONSORSHIP FOR THE ARTS, 3 Pierrepoint Place, Bath. Tel. 0225 63762. Director Luke Rittner. Formed by a number of leading British companies with the help of a government grant to encourage business organisations to become involved in arts

sponsorship and thereby encourage the growth of arts sponsorship. *As such they are not really in a position to help artists or art organisations find funding but they can send you a list of companies that have supported the arts in the past and the companies are listed according to which area of the arts they have sponsored.* The visual arts I might add are the smallest section.

ASBSA/DAILY TELEGRAPH ANNUAL AWARDS FOR BUSINESS SPONSORS FOR THE ARTS. Companies are nominated for the best support for sponsorship of the arts. Please note that an arts organisation does not benefit directly from this but this is supposed to encourage sponsorship nationally.

THE CORPORATE ARTS. Tel. 01 402 0361. Director Sarah Hodson. Helps artists exhibit work in offices. Non-profit.

MARKETING AND THE ARTS, 5th Floor, Berkeley Square House, London W1. Alistair Sedgewick. Annual subscription £5. News and views on art sponsorship.

KALLAWAY ASSOCIATES, Carlton Cleve, Nielsen Sedgwick (see above). Involved in helping art organisations promote themselves to sponsors. Again the Visual Arts are not their best customers.
It is probably better for a small art organisation or group of artists to organise their own plans for approaching sponsors and they will certainly learn much along the way.

ART FOR OFFICES. Tel. 01 481 1337. See page 16, *Buying Art* for details, Chapter 3.

SOME SUGGESTIONS FOR APPROACHING SPONSORS

1. Consult the **Directory of Grantmaking Trusts** at your local library and list all the trusts that seem to have any remote connection with your project. You will be surprised at how many trusts could be possibilities.

2. Contact the **Charities Aid Foundation,** 48 Pembury Road, Tonbridge, Kent. Ask for their checklist of do's and don'ts for people approaching trusts. Compiled by Redford Mullin.

3. Once you have consulted the latter compile a letter to sponsors, as short as possible including the areas mentioned below.

(a) Mention the specific area you are involved in. (b) The sum you require and whether it is one off or over several years. (c) Is the sum to cover salaries, equipment or a project or what? Say who you are, what the organisation has done in the past and what you plan to do in the future and give a 3 year cost projection for example. Also mention that you will be sending along someone to see them.

4. Set up an advisory committee with as wide a coverage as possible to meet regularly. This committee should potentially have members who have influential friends in the business or art world. The committee should be able to help with both advice and contacts for sponsorship.

5. If the committee do have any appropriate friends who could approach a director or chairman of one of the companies that you plan to approach so much the better. In many successful cases of sponsorship this approach has proved to be the most fruitful. Any contact however remote can be useful when searching for sponsorship and find out who might be sympathetic to your particular project in advance.

6. Once you have hopefully acquired a personal introduction arrange to send someone round to discuss the project and give very well prepared details of your organisation and what you are seeking. Also offer possible advantages to the sponsor concerned if you feel that this is appropriate.

7. Local sponsors have often proved to be the most helpful. For example of all the art schools mentioned in this handbook many receive sponsorship for scholarships from local companies however small for travel, fees and materials.

NAMES OF ORGANISATIONS
THAT HAVE BEEN INVOLVED IN ART SPONSORSHIP RECENTLY

Olivetti (exhibition sponsorship).
Peter Stuyvesant (major art collection).
Esso (British Art Now at the Royal Academy – Exxon in the USA).
Imperial Tobacco (portrait commissions).
Sothebys (ICA events, catalogues, awards).
Marks and Spencer (arts centres).
Tolly Cobbold (exhibition/prizes).
John Moores (exhibition).
Sainsburys (many projects for sculpture, architecture etc).
Alistair McAlpine.
IBM.
BP.

Shell.
Calouste Gulbenkian Foundation (community art, purchases of contemporary art, support of
 individual artists).
Nuffield Foundation.
The Pilgrim Trust.
The Sainsbury Charitable Fund.
Peter Moores Foundation.
The Wolfson Foundation.
European Educational Research Trust.
The Commonwealth Foundation.
Glaxo Charity Trust.
Strauss Charitable Trust.
Slater Trust Ltd.
Schroder Charity Trust.
Normanby Charitable Trust.
I. J. Lyons Charitable Trust.
Rothschild Charitable Trust (several).
The Rayne Foundation.
Leverhulme Trust Fund (author's note – I owe my art school fees to the generosity of a Leverhulme
 bursary to an art school).
 Consult the **Directory of Grantmaking Trusts** for details on all the above. We have selected
trusts that seem to be appropriate to the Visual Arts.
 Art suppliers locally and nationally have also been known to support **competitions, scholarships
and awards.** See awards section in Chapter 1.

MEDIA SUPPORT FOR THE VISUAL ARTS
The Times (exhibitions).
The Observer (exhibitions).
London Weekend Television (scholarships, bursaries, exhibitions).
Granada (collections, exhibitions etc).
Westward TV (exhibitions).
Thames TV (exhibitions).
The Sunday Times (exhibitions).

ART FOR PUBLIC PLACES

Over the past few years, partly as a reaction against the conventional gallery system and partly
from a desire to communicate more directly with the general public, many artists have been
producing work for public places – murals, sculptures and environmental pieces, to be seen in
cities and landscapes.
 There follows a list of murals and details of some collections of public sculptures.

MURAL LOCATIONS
The following locations for murals in England, Scotland and Wales were submitted by muralists
and mural groups following a conference at Battersea Arts Centre in November 1978.

AVON
Windmill Hill City Farm Mural 1978. Windmill
Hill City Farm, Bedminster, Bristol. Dir:
Dave Gittings.

BERKSHIRE
Garden 1977. East Hampstead Community
Centre, Berks. Artist: John Upton.

CHESHIRE
Mosaic Seating 1978. Moat House Drive,
Crewe. Dir: Free Form together with T.A.
and summer playscheme.
Narrowboats. Portland Street, Runcorn. Dir:
Pete McFerran.

CORNWALL
Laburnham Drive Church 1977. Falmouth,
Cornwall. Artist: David Bratby.

Benverris Infants School 1977. Falmouth,
Cornwall. Artist: David Bratby.
Falmouth Church of England Infants School
1977. Falmouth. Artist: David Bratby.
Fish and Chip Shop 1977. Quay Hill, Fal-
mouth. Artist: David Bratby.
Falmouth Comprehensive School 1977.
Dracenea Avenue, Falmouth. Artist: David
Bratby.
Penryn and Mabe Boys Club 1978. Penryn.
Artist: David Bratby.
Treuegie Junior School 1978. Redruth. Artist:
David Bratby.

DEVON
Dryden Clinic Mural 1976. Exeter. Dir: Dave
Gittings.
Starcross Hospital Mural 1974. Starcross.
Dir: Dave Gittings.

128

Barbican Mural 1972. The Barbican, Plymouth. Artist: Robert Lenkiewicz.
Exeter City Gate Mural 1978. Exeter. Artist: Andy Stacey.

ESSEX
Mardyke Estate Mural 1974. Rainham. Dir: Peter Carey.

GREATER MANCHESTER
Children's X-Ray Room Mural, Interior. St Mary's Hospital, Whitworth Park. Dir: Hospital Arts Project. For viewing contact H.A.P., 2nd Floor, St Mary's Hospital.
7 Arches, Interior. Main Corridor, Manchester Royal Infirmary. Dir: Hospital Arts Project.
Transport Hall Mural, Interior, Manchester Royal Infirmary. Dir: Hospital Arts Project.
Hathersage Road Corridor Mural, Interior. St Mary's Hospital, Whitworth Park. Dir: Hospital Arts Project.
Longsight Adventure Playground Mural 1977, 120ft x 11ft. Longsight Adventure, Plymouth Grove West, Longsight. Dirs: Carol Betera and Liz Faunce together with children.
The Hideaway 1977, 20ft x 8ft. The Hideaway Youth Club, Moss Side, off Moss Lane West. Dirs: Carol Betera and Liz Faunce together with children.
Birley High School Youth Club Mural 1978. Royce Road, Hulme, Manchester. Dirs: Wendy Humphries, Peggy Ralph, Sue Ralphs.
Queens Park Mural 1978. Queens Park Crescent, Bansall Drive, Harpeley, Manchester 10. Dir: Community Arts Workshop.
Collyhurst Community Centre Mural, 22 Willert Street, Collyhurst, Manchester 10. Dir: Community Arts Workshop.
Mural. Opposite 100 Oxford Road, Manchester 13. Dir: Glenn Burton.
Belfield Community School Mural 1978. Samson Street, Rochdale. Dir: Free Form. Mosaics, Murals.
Canal Bridge Decorations. Bottom Road Bridge, Bury. Dirs: Walter Kershaw, Eric Kean, Graham Cooper.
King George V Locomotive. Peelway, Bury. Dirs: Walter Kershaw, Eric Kean, Graham Cooper.
Spitfire. Peelway, Bury. Dirs: Walter Kershaw, Eric Kean, Graham Cooper.
Machinery 1977-78. The North Western Museum of Science and Industry, All Saints, Manchester. Designer: Ken Billyard; Painter: Walter Kershaw.
Alvin Stardust. Manchester Road, Manchester. Dirs: Walter Kershaw, Eric Kean, Paul O'Reilly.
House Interior 1976. Derby Street, Deeplish, Rochdale. Artist: Walter Kershaw.
The Chinese Dragon 1977. Edward Street, Rochdale. Artists: Linda Hulse, Walter Kershaw.
Pansies 1973. Entwhistle Road, Rochdale. Artist: Walter Kershaw.
Water Temple 1974. Halifax Road, Rochdale.

Artists: Walter Kershaw, Eric Kean.
Pennine Landscape. Cote Lane, Littleborough, Rochdale. Artists: Walter Kershaw, Eric Kean, Paul O'Reilly, Graham Cooper.
Condor Ironworks. Feathersall Road, Oldham. Artist: Walter Kershaw.
H-Bomb Explosion. Burlington Street, Ashton-Under-Lyne. Artists: Tameside College Students.
Alice in Wonderland 1976. Market Place, Ashton-Under-Lyne. Dir: David Vaughan.
Staircase Illusion Design. The Precinct, Bury. Artist: Graham Cooper.
Van Gogh Bus Shelter. Walshaw, Bury. Dir: Graham Cooper with schoolchildren.
The Oasis. Taylors Lane, Higher Ince, Wigan. Artist: David Vaughan.

HAMPSHIRE
Landport Adventure Playground Mural 1977. Lake Road, Portsmouth. Dirs: Mick Hudson, Dave Thomas with children and playleaders.
Hello Decadence. 18 Adelaide Road, Portsmouth. Dir: Mick Hudson.
Bramble Road Nursery Mural 1978 on. Bramble Road, Southsea. Dir: Mick Hudson.

LANCASHIRE
Club Members Portraits 1977. Fullidge Community Centre, Burnley. Dir: Walter Kershaw.
Iron Bridge Decoration. Hammerton Street, Burnley. Artist: Walter Kershaw.

LEICESTER
The Wall 1978. Branstone Adventure Playground. Dir: John Upton.
Highfields Community Centre Mural 1978. Highfields Community Centre, Leicester. Dir: John Upton with children.
Flower 1978. Belgrove Neighbourhood Centre, Leicester. Dir: John Upton.
Black Gang Mural. Public Toilets, Belgrove Park, Leicester.

LONDON – NORTH
Laycock School Murals and Playground Structures 1976. Laycock School, Laycock Street, Islington, N1. Dirs: Dave Cashman, Roger Fagin, Dave Stone with children, teachers and parents.
Charles Lamb School Murals and Structures 1978. Popham Road, Islington, N1. Dirs: Islington Schools Environmental Project.
Triptych 1977. New Whittington Hospital, Highgate Hill, Islington. Artist: Ray Walker.
De Beauvoir Adventure Playground Mural Summer 1976. De Beauvoir Road, N1. Dir: Free Form (may no longer exist).
Snail Mural. 541 Seven Sisters Road, Harringay, N15. Dir: Public Pictures.
Community Centre Murals, Interior and Exterior 1978. Dir: Art Workers Co-op.
Bridge Mural 1973. King Henry's Road, NW1. Dir: Fine Heart Squad.
Blashford Mural 1977. Children Play Area,

Blashford House, Adelaide Road, NW3. Dir: Art Workers Co-op.
Queens Crescent Community Centre Mural 1978. Queen's Crescent, Gospel Oak, NW5. Dir: Art Workers Co-op.
Acland Burghley School Mural 1977. Interior. Burghley Road, NW5. Dir: Peter Carey.
Lismore Circus Mural 1975-76. Gospel Oak Estate, Southampton Road, NW5. Dir: Fine Heart Squad.
Lismore Circus Mural, End Wall 1976. Southampton Road, NW5. Dir: Art Workers Co-op.
Abbey Community Centre Mural 1978. Belsize Road, nr. junction with Abbey Road, NW6. Dir: Art Workers Co-op.
Palmerston Road Adventure Playground Mural 1978. Palmerston Road off Kilburn High Road, NW6. Dir: Art Workers Co-op.
Mill Lane Bridge Mural 1977. Mill Lane, NW6. Dir: West London Mural Workshop.
Abstract Mural 1977. Iverson Road, NW6. Artists: Architectural Students.
College Park Youth Club Mural 1977. Waldo Road, NW10. Painted by young people and workers of club.
Compendium Bookshop Mural 1977. 234 Camden High Street. Artist: Chris Render.

LONDON – SOUTH
Theatre Hoardings 1973. Worls Centre for Shakespeare Studies, Bankside, Southwark, SE1. Dir: Ray Walker (currently in store).
Ascension Mural. St. Hugh's Church, Porlock Street, SE1. Artist: Peter Pelz.
Calabans Dream. Opposite National Theatre, Upper Ground, SE1. Dir: Peter Pelz.
Floyd Road 1976. Floyd Road, Charlton, SE7. Dir: Greenwich Mural Workshop with Floyd Road Tenants and children.
Water and Land Animals 1977. Pound Park Nursery School, Pound Park Road, SE7. Dir: Greenwich Mural Workshop with parents.
The Albany Murals, Exterior Back Wall, Interior Staircase to Albany Empire 1973. The Albany, Creek Road, SE8. Artist: John Upton.
History of Deptford 1973. Deptford Broadway, SE8. Artists: 395 Association.
Peoples River 1975. Creek Road, Greenwich, SE10. Dir: Greenwich Mural Workshop.
Meridian Estate Project 1977 continuing. Meridian Estate, Thames Street, SE10. Dir: Greenwich Mural Workshop with Tenants and children.
Lewisham Bridge Infants School Mural 1974. Almeira Street, SE13. Dir: 395 Association.
Milton Court Estate Murals 1977. Woodpecker Road, Clifton Rise, SE14. Dir: 395 Association.
Telegraph Hill Youth Club Mural 1975. Kitto Road, SE14. Dir: 395 Association.
Peckham Grove Murals 1975. Peckham Grove Estate, Southampton Way, SE15. Artists: Camberwell School of Art Students, Fashion Dept.
Nursery Mural 1978 . Stillness Infants School, Stillness Road, Brocley Rise, SE23. Artist:

LONDON – WEST
Work 1977. Harrow Road, nr. Royal Oak Tube Station, W2. Artists: Dave Binnington, Des Rochfort.
Westway Murals 1975 on. Start out from Ladbroke Grove Tube Station and walk towards Portobello Road. Dir: Public Pictures.
The Town House 1978. Goldhawk Road, Shepherds Bush, W6. Artist: Ken White.
Irish Landscape Mural 1978. Bartoum Gardens, Lions Road, W6. Dir: Hammersmith Mural Arts.
Pearly Appeal Ailver Jubilee Bus 1977. Dir: Hammersmith Mural Arts.
The Factory Mural 1978. The Factory Chippenham Mews, W9. Artist: Rhonda Whitehead.
Skateboarders 1977. Harrow Club, Freston Road, W10. Artist unknown.
Front Line Record Promotion Mural 1978. Virgin Records, Shepherds Bush Roundabout, W12. Dir: Hammersmith Mural Arts.
Tom Petty and Heartbreakers Record Promotion Mural 1978. Virgin Records, Shepherds Bush Roundabout, W12. Dir: Hammersmith Mural Arts.
Pop Hero Mural 1977. White City Estate, Australia Road, White City, W12. Dir: Russell Barrett.
Covent Garden Murals 1978. Hoardings around new garden, Shelton Street, WC2. Artist unknown.
Garden Mural 1977. Earlham Street, WC2. Artist: Stephen Pussey.
The Venue? Interior. The Venue, Victoria, SW1. Artist: Ken White.
St. Matthews Centre Mural 1978. St. Matthews Meeting Place, Community Centre, Brixton Hill, SW2. Interior. Dirs: Brixton Mural Workshop.
Bagleys Lane Mural. Opposite William Parnell Houe, SW6. Artist: Debbie Eastham.
Thessaly Road Mural 1978 on, 7.8ms. x 9.6ms. Thessaly Road, SW8. Dir: Brian Barnes and Wandsworth Mural Workshop.
Battersea Arts Centre Mural 1977. Lavendar Hill, SW11. Dir: Amanda Webb.
Shellwood Road Mural. Shellwood Road, SW11. Artist unknown.
Latchmere Junior School Murals 1977. 469 Battersea Park Road, SW11. Dir: Oliver Bevan and Kingston College Students.
Battersea The Good The Bad and The Ugly or Tenants and Workers United Sweeping Away The Evils of Capitalism. 1977-78, 276ft x 18ft. Morgans Walk, SW11, nr. Battersea Bridge. Dir: Brian Barnes and Wandsworth Mural Workshop.
Hughes Ironmongers Wall, Heartfield Road, SW19. Dir: Peter Pelz.
St. Andrew's Church Mural. Herbert Road, SW19. Artist: Peter Pelz.

LONDON – EAST
Magic Train. Robert Montefiore Infants School, Buxton Street, off Valance Road, E1. Dir:

Anne Margret Bellavoine.
The Grand Magic Circus and Fairground. Robert Montefiore Junior School, Buxton Street, off Valance Road, E1. Dir: Anne Margret Bellavoine.
Shadwell Basin Mural 1976. Entrance in Glamis Road, E1. Dir: Helen Hare with children.
Great Wall of Spitalfields, E1. 1977. Dir: John Newbigan with children.
Stephen and Matilda Co-op Mural. 50 Matilda House, St. Katherines Way, E1. Artist unknown.
Spitalfields Floodlit Football Pitch Mural. Corner of Heneage Street and Chichsand Street, E1. Artist unknown.
Adventure Playground Mural 1978. Spitalfields Parish Church Commercial Street, E1. Dirs: Carolyn Beal, Kate Morris.
Hanbury Street Mural. 105 Hanbury Street, E1. Dir: David Evans.
Ben Jonson School Mural 1976. Ben Jonson Primary School, Harford Street, E1. Painted by teachers and pupils.
Cayley Street Mural 1978. Cayley Street, E1. Dir: Community Industry.
E1 Festival Wall 1976. Corner of Cannon Street Road and Bigland Street, E1. Artists: Alan Gilbey, Harvey Mildener.
Glamis Road Aventure Playground Mural. Glamis Road, E1. Painted by children and workers.
Glamis Road Community Centre and Nursery Mural 1978. Glamis Road, E1. Dir: Community Industry.
Highway Club Community Centre Mural, E1. 1977. Dir: Community Industry.
London Hospital Mural, Mile End, E1. Dir: Robert Montefiore School Teacher and Pupils.
A Man and A Dog Visiting Mars. Robert Montefiore Infants School, Buxton Road, off Valance Road, E1. Dir: Anne-Margret Bellavoine.
Phoenix School Mural, 976.49 Bow Road, E2. Dir: Anne-Margret Bellavoine.
Rochelle School Mural 1976. Rochelle Street, E2. Painted by teacher and pupils.
St. Hilda's East Community Centre Mural 1977. 18 Club Row, E2. Dir: Community Industry.
Beatrice Tate ESN School Mural 1976. St. Judes Road, off Cambridge Heath Road, E2. Dir: Cassandra Burgess with pupils of Grenfell ESN School.
University House Mural 1978. 16 Victoria Park Square, E2. Dir: Community Industry.
Virginia School Mural 1978. Virginia Road, E2. Dir: Annie Sloan.
Weavers Field Youth Club Mural 1978. Weavers Field School, Mape Street, E2. Dir: Community Industry.
The Well and Bucket Pub Mural, 143 Bethnall Green Road, E2. Artist unknown.
Wessex Street Community Centre Mural 1977. Wessex Street, E2. Dir: Community Industry.
Whitechapel Baths Mural 1976. Goulston Street. Artist: Jeanette Sutton.

Wind/Horse Mural 1978. Buddhist Centre, Roman Road, E2. Painted by Buddhist Centre Workers.
Berner Youth Club Mural. Penler Street, off Cannon Street Road, E. Dir: Alan Gilbey and friends.
Eastbourne House Community Centre Mural 1977. E2. Dir: Community Industry.
Children's Ward Mural 1979 on. Mile End Hospital, Mile End, E3. Dir: Community Industry.
Rayham House Mural 1970. Norfolk Estate. E3. Artist: unknown.
St. Andrew's Hospital Mural 1978. Devons Road, E3. Dir: Community Industry.
Saxon Youth Club Mural 1977. Dir: Community Industry.
Southern Grove Social Workers Centre Mural 1977. South Grove E3. Dir: Community Industry.
Bow Mission Mural 1978. Merchant Street, E3. Artist: Ray Walker.
Lincolns Estate Youth Club Mural, E3. Dir: Jeanette Sutton with children.
Roman Road School and Brampton Youth Centre 1977. Roman Road, E6. Dir: Newham Community Murals with children and members of Youth Centre.
St. Edward's R.C. Church 1977 or 1978. Upton Park, E6. Interior murals. Dir: Newham Community Murals.
Vicarage Youth Centre Murals 1977 or 1978. Interior murals. Dir: Newham Community Murals with members of Youth Centre.
Nelson Street School Mural 1977 or 1978. Nelson Street, E6. Dir: Newham Community Murals with the children.
Durning Hall Community Centre Mural 1977 or 1978. Earlham Grove Forest Gate, E7. Dir: Newham Community Murals. An exterior and interior mural.
Holly Street Adventure Playground Mural 1975/76. Holly Street, E8. Dir: Free Form. Murals, mosaics inside main hall, front entrance, back wall.
The Snatch 1978. Hackney Marsh Truancy Project, Daubeney Fields, E9. Dir: Free Form (painted over).
Jubilee Street Party 1977. Chats Palace, Brooksby Walk, E9. Dir: Free Form (painted over).
Upton House Youth Club Mural 1977. Upton House School, Homerton Row, E9. Dir: Free Form. Painted Girls Toilets.
East Goes West 1976. Daubeney Fields. Hackney Marshes, E9. Dir: Free Form (painted over).
Picture Show 1978. Daubeney Fields Hackney Marshes, E9. Dir: Free Form with local children for Hackney Marsh Fun Festival.
Newham Alternative Project Mural 1976. 59 Dames Road, Forest Gate, E7. Artists: Anne-Margret Bellavoine, Mary Gayton.
Games Paintings 1977. Kingsmead Estate, Bike Sheds, Hackney, E9. Dir: Free Form with

131

Hackney Marsh Adventure Playground Playscheme.
Rivetts Motorbike Shop Mural. Leytonstone High Street, E11. Artist: Anne-Margret Bellavoine.
Aberfeddy Festival Mural 1976. Theseus House, Blair Street, Poplar, E14. Painted by local teacher and children.
Kingsbridge Estate Mural 1977/78. Isle of Dogs, E14. Dir: Free Form. 1978 extended by Tower Hamlets Arts Team with local residents.
Tenants Association Flat Mural 1977. Kingsbridge Estate Isle of Dogs, E14. Dir: Free Form with local children and adults (painted over).
Mudchute Farm Mural autumn 1978. Pier Street Isle of Dogs, E14. Dir: Free Form with local adults and children. Mural, cast animals, mosaics.
Mudchute Farm Mural Spring 1978. Farm Road, Isle of Dogs, E14. Dir: Free Form with Island House Playscheme and local adults. 2 entrances and set of billboards.
Alpha Grove Community Centre Murala 1977. Alpha Grove, Isle of Dogs, E14. Dir: Free Form Murals, mosaics inside main hall front entrance, back wall.
Two Murals. Milwall Estate, E14. 1977. Dir: Free Form. 1978 Dir: ILEA Arts Team.
North East London Polytechnic Mural 1976. Livingstone House, Livingstone Road, Stratford, E15. Dir: Anne-Margret Bellavoine, Mary Gayton, Manda King(5).
Stratford Theatre Mural 1975. Stratford, E15. Dir: Free Form with passers-by for Stratford Festival. (2ft of wall left standing).
Manor Road School Mural 1977 or 1978. Dir: Newham Community Murals with schoolchildren.
The Refectory Mural 1978. West ham branch of North East London Polytechnic, E15. Dir: Newham Community Murals.
The Canteen Pub Mural 1978. Vicarage Lane, Stratford, E15. Dir: Newham Community Murals.
Mayflower Family Centre Mural 1978. Cooper Street, E16. Dir: Community Industry.
Shipham Youth Centre Mural 1977. Prince Regents Lane, E16. Dir: Newham Community Murals.
Eastlea Youth Centre Mural 1977 or 1978. Hilda Road, Canning Town, E16. 2 exterior murals, 1 interior mural. Dir: Newham Community Murals with members and staff.
St. John's Church Centre Mural. Interior. Albert Road, N. Woolwich and Silvertown. Dir: Newham Community Murals in consultation with Youths and Pensioners. Telephone first to arrange a visit.

MURALS IN PROGRESS
Bow North Youth Centre Mural, E3. Dir: Community Industry.
Cable Street Mural 1978 on. St. George's

Town Hall, Cable Street. Dir: Dave Binnington. Community Industry Offices, Tower Hamlets. Dir: Community Industry.

MERSEYSIDE
Titchfield Community Centre Mural 1976. Titchfield Street, Vauxhall, Liverpool. (film location). Dir: Free Form.
Flannen Isle Mystery 1977. Tower Hill Community Centre, Tower Hill, Kirkby. (film location). Dir: Free Form.
Hyde Park Street Painting 1975. Foxhill Street Corner, Liverpool. Dir: Free Form with Elfrida Rathbone Project. (painted out).
Street Change 1976. Hyde Park Street, Foxhill Street Corner, Liverpool. Dir: Free Form. Landscaping, mosaic pavement, stone stage for fantasy garden.

MITCHAM
Hexagons 1977. Locomotors Housing Estate, London Road, Mitcham. Artist: Graham Cooper.
St. Peter's Church Mural. Bishopford Road, Mitcham. Artist: Peter Tlez.

WEST MIDLANDS
Dudley Market 1977. Market Square, Dudley. Dir: John Upton. Painted on boards, so may be moved to new site.
Jessom School Mural 1977. Jessom School, Dudley. Dir: John Upton together with children of the school.
Geometric Designs. Talfourd Street, Smallheath, Birmingham. Dir: Bryan Blumer.

SUSSEX
Christ Entering Brighton 1977. Arts Building, Sussex University. Dir: John Upton.
Lets Make It This Summer 1968. West Street, Brighton. Dir: John Upton (under threat of demolition).
The Secret Island 1975. Milner and Kingswood Flats, Brighton. Dir: John Upton.
Choice 1977. Presbyterian Church, North Road, Brighton. Dir: John Upton.
Transport and General Workers Union Mural 1976, Interior. Eastbourne Centre, Seafront, Eastbourne. Dir: Art Workers Co-op.
Bourne Infants Mural 1973. Brighton. Dir: Nigel Austin with children and parents. Check exact location with N. Austin, 30 Talbot Terr, Lewes.
St. Andrews Primary School Mural 1974. Dir: Nigel Austin, commissioned by PTA. Check location with N. Austin.
St. Mary's Middle School Mural 1975, Brighton. Dir: Nigel Austin with 2 students from ATC Course at Brighton Polytechnic.
St. George's Hall Mural 1977. St. George's Hall, Brighton. Dir: Nigel Austin.
Eastgate Hoarding 1978. Lewes, Sussex (hoarding around shopping redevelopment scheme).

SURREY

Corridor Murals 1975. Royal Marsden Hospital, Downes Road, Sutton, Surrey. Dirs: David Cashman, Keith Crichlowe with Rosalind Cuthbet, John Smalley. Contact Registrar to plan time and date of visit.

TYNE AND WEAR

Spaceman Walking. Byker, Newcastle upon Tyne. Artist: Duncan Newton.
Bird of Paradise. Gladstone Terrace, Jesmond, Newcastle upon Tyne. Artist unknown.
Abstract. Northairdes Road, Wallsend. Dir: Duncan Newton.
Old Seamans General Stores Mural. Moor Court, Sunderland. Artist: Ken Watts.
The Lampton Worm 1978. Neville Court, Selgrove, Washington. Dir: Free Form with children.

WILTSHIRE

George and The Dragon 1975. Rodbourne Road, Swindon. Dir: Thamesdown Community Arts Project with young people from a local school.
King George V. Harding Street Car Park, Swindon. Dir: Thamesdown Community Arts Project with young people.
Golden Lion Bridge Mural. Medgbury Road, Swindon. Artist: Ken White.
Bavarian Castle Mural. Westcott Place, Swindon. Dir Thamesdown Community Arts Project.
Castlecombe Mural. Cricklade Road, Swindon. Dir: Thamesdown Community Arts Project with local Scout Troop.
Letherbridge Road Infants School Mural. Lethbridge Road, Swindon. Dir: Job Creation Project with children from Senior School and members of staff.
Noah's Ark Hotel Mural. Opposite Railway Station, Swindon. Artist: Ken White.
Fish Mural. Pharoh and Clarke Restaurant, Marlborough. Artist: Ken White.
Magh Mayal Mural. Indian Restaurant, opposite College, Swindon. Artist: Ken White.

SOUTH YORKSHIRE

Mosaic Mural 1978. First Aid, Doncaster. Dir: Free Form with local youths.

WEST YORKSHIRE

Mural 1978. Corner of Woodhouse Lane and Cookridge Street, (nr. Merrion Centre) Leeds. Dir: Yorkshire Mural Artists Group.
Battle of Wounded Knee, Behind Bradford University, Bradford. Artist: David Vaughan.

SCOTLAND – DUNDEE

Intro July 1976. Court Street, facing Tarnadice Street, Dundee. 15 minutes from Town Centre heading North-East. Dir: Bob McGilvray.
Outro June 1976. Wolsely Street, facing Tarnadice Street, Dundee. Dir: Bob McGilvray.

EDINBURGH

Mural. Broughton Street. Artist: Miguel Vivanco.
Relief Mural 1977-78. Theatre Workshop, 34 Hamilton Place. Artist: Ken Wolverton.
North Merchiston Boys Club Mural 1975-78. Interior. Watson Crescent, Edinburgh. Dir: Mike Greenlaw.
Groundsman's Shed Mural 1976. Harrison Park, Bryson Road, Edinburgh. Dir: Mike Greenlaw.
Jack Kane Centre Mural Nov. 1976. Interior. Arts and Crafts Room, Jack Kane Centre, off Niddrie Mains Road, Edinburgh. Dirs: Beth Shadur Craigmillar Arts Team.
Craigmillar Community Centre Mural Dec. 1976. 63 Niddrie Mains Terr., Edinburgh. Interior. Dir: Craigmillar Arts Team with volunteers.
Murals in area between Niddrie Mains Terrace and Bingham Drive. Tunnel Mural Summer 1977. Youth Hut Mural Summer 1977. Bus Shelter Mural Summer 1978. Mosaic Panel December 1978. Environmental Improvements Summer 1977-78. Dir: Craigmillar Arts Team and volunteers.
Bingham Community Centre Mural March 1977-78. Bingham Avenue, Craigmillar. Dir: Craigmillar Arts Team and volunteers.
Craigmillar Boys Club Mural Jan. L978. Craigmillar Castle Avenue, Craigmillar. Dir: Linda Porteus, CAT member.
The Brew Murals, Richmond Craigmillar Church, Wauchope Road, Craigmillar. Large Hall Murals Jan. 1978. Entrance Mural Oct. 1978. Dir: Craigmillar Arts Team.
Shop Shutter Murals Nov. 1978. Grieves No. 5, Post Office No. 11, Bingham Crescent. Dir: Craigmillar Arts Team and volunteers.
Craigmillar is south east of Edinburgh's city centre and can be reached from the east end by buses no. 14, 21 or no. 2 from Haymarket. Visitors can obtain a map showing the locations from Craigmillar Festival Society, 63 Niddrie Mains Terrace, Mon-Fri 9.15-5.15.

EASTER ROSS

Invergordon Playgroup Mural Aug. 1978. Interior. Cromlet Building, Invergordon. Dir: 5 Spot Arts.
Alness Youth Centre Mural Oct. 1978 on. Alness Youth Centre, Alness. Dir: 5 Spot Arts with the children of Alness.

GLASGOW

St. Ninians Chapel Mural Aug. 1976. St. Ninians Chapel, off High Street, Kirkintilloch nr. Glasgow. (½hr North of Glasgow). Dir: Bob McGilvray.
Boy on Dogs Back 1974. Crawford Street, Partick. Artist: John Byrne.
Celtic Knot 1975. 30 Annandale Street, Govanhill. Artist: Jim Torrance.
Hex 1975. 244 St. George's Road. Artist: Stan Bell.

Klah-P11 1975. 148 Bellfield Street, Deen-istoun. Artist: John McColl.
Architectonic. 54 Ancroft Street. Artist: Tim Armstrong.
Man and Machine 1976. Special Unit, Barlinnie Prison. Dir: Beth Shadur with Prisoners and Staff.
Garnethill Mural Project 1978 onwards. 102 Hill Street, Glasgow. Contact: John Kraska. 2 gable end murals, mosaic wall.

GLENROTHES
Glenrothes Town Artist: Michael Robertson, Artists Workshop, Direct Labour, Whitehill, Glenrothes, Fife. Contact Michael Robertson for locations of Murals, mosaics, structures.

LEITH
Leith Adventure Playground Mural 1973. Tolbooth Wynd, Leith. Dir: Mike Greenlaw.

LIVINGSTON
Livingston New Town, Town Artist Dennis Barnes, Town Artists Studio, Livingston, Village, West Lothian. Tel. Livingston 37108. From Kenny Munro "Anyone interested in visiting Livingston to see murals or any other aspects of the town. should contact the workshop and we will be pleased to show you around".

WESTER ROSS
Millcroft Hotel Mural 1975. Garloch, Wester Ross. Dir: Mike Greenlaw.

WALES
Good Food Sept. 1975. Grocers Shop, 35 Holyhead Road, Bangor, N. Wales. Artist: Ed Povey.
Storage Jars Sept. 1975. 43 Holyhead Road, Bangor, N. Wales. Artist: Ed Povey.
Futility of War Aug. 1976. Library Building, Normal College, Bangor. Artist: Ed Povey.
Street Circus Mar. 1977. Mountpleasant Road, Cowy. Artist: Ed Povey.
Mount Ogre Mar. 1978. 21 College Road, Bangor. Artist: Ed Povey.
The Cookhouse Spring 1978. St. Mary's Primary School, nr. Swimming Pool, Bangor. Artist: Ed Povey.
The Gangster Mural Oct. 1978. Capone's Restaurant, 10 Holyhead Road, Upper Bangor. Artist: Ed Povey.
The Nut Pantry Mural Nov. 1978. 15 Holyhead Road, Bangor. Artist: Ed Povey.
The Toy Bakers Shop June 1977. Opposite Pontmerion Pottery, High Street, Bangor. Artist: Ed Povey.
The Scales. Relief sculpture. New Magistrates Courts, Holyhead, Anglesey. Artist: Ed Povey.
Ships Hold Mural. Ship Launch Hotel, Garth Road, Bangor. Artist: Ed Povey.

PUBLIC SCULPTURES

The Yorkshire Sculpture Park, Bretton Hall College, West Bretton, Wakefield, W. Yorks WF4 4LG. Tel. 092 485 261. Contact: Peter Murray. The Sculpture Park has a steadily growing collection of sculpture and also mounts temporary exhibitions.
South Hill Park Arts Centre, Bracknell, Berks. Tel. 0344 27272. Contact: Jennifer Walwin. The grounds of the Arts Centre contains a permanent collection of outdoor sculpture, including work by Wendy Smith.
Scottish Sculpture Trust, 2 Bank Street, Inverkeithing, Fife. Tel. Inverkeithing 412811. Contact: Barbara Grigor. The Trust displays two permanent exhibitions – 'Sculpture in Landscape' at Landmark, Carrbridge, Inverness-shire, and at Glenshee in the mountains of Perthshire. At Glenshee, five sculptures stand on a bare hillside, near the skiing centre. At Landmark eighteen sculptures are placed in a Sculpture park on the edge of a forest. Artists whose works are exhibited are – Denis Barns, Anthony Caro, Hubert Dalwood, John Foster, Catherine Gili, Jake Kempsell, Roy Kitchen, Gerald Laing, Andrew Mylius, John Panting, Eduardo Paolozzi, William Pye, Malcolm Robertson, Gavin Scobie and Anthony Smart.
Glenrothes, Fife. A new town halfway between Edinburgh and Dundee, had David Harding as a 'town artist' from 1968 onwards. He produced several sculptures on various sites, some in colla-boration with other artists and poets. Other artists involved were – Alan Bold, John Gray, Malcolm Robertson, Hugh Graham.

ART FOR PUBLIC PLACES

The following passage, by Alister Warman of the Arts Council, gives details of a scheme for spon-soring public art projects.
 1. In partnership with the Regional Arts Associations, the Arts Council is able to provide financial assistance towards the commission or purchase of works by contemporary British artists. Enquiries are invited from public or private organisations able to offer opportunities for the commission of sculpture or murals in whatever medium, and from institutions interested in acquiring paintings, prints and drawings for display in spaces with adequate public access.

2. Grants offered will not normally exceed 50% of the total cost of a purchase or commission. However, where an artist is to be engaged for a lengthy period in association with a public building or landscaping project, the Arts Council can consider paying the artist's fee if all other costs are provided for.

3. The capacity to respond to requests for assistance will be determined by the availability of funds in any financial year; all offers will be subject to Regional Arts Association recommendation of the given proposal.

4. Priority will be given to opportunities afforded by new building projects, but it is recognised that many requests will relate to empty walls and spaces of existing buildings. In this context special consideration will be given to such buildings as hospitals, schools, libraries, civic centres etc. and, in general, publicly funded organisations will have first claim on the available funds. However, it is not the intention to exclude the private sector from the scheme: factories and office entrances, for instance, can sometimes qualify as 'public spaces' provided they have adequate public access.

Application procedure (application forms available on request)

5. All applications should be addressed to the Visual Arts Officer of the relevant Regional Arts Association and a copy sent to the Assistant Art Director at the Arts Council, 105 Piccadilly, London W1V 0AU.

6. The following information should be supplied:

(a) Documentation of the proposed site, with an indication of the degree of public access/ details of the projected building and its purpose.

(b) The financial contribution offered by the applicant and any further contribution available in kind.

(c) The financial contribution requested.

(d) Details in the form of slides/photographs of the work(s) to be purchased/commissioned together with information on the artist proposed. NB: This is only required if the artist or work has already been decided upon.

7. It is recommended that the Regional Arts Association is consulted in advance of any formal application being made. Most Regional Arts Associations hold information on artists working in their particular areas; a central information source is provided by the Arts Council's Long Acre index. Applicants are encouraged to make use of these services, but to qualify for assistance under the scheme it is not a condition that an artist be represented in the Long Acre index or an RAA register.

8. In all cases the recommendation of a grant will be conditional on the RAA being satisfied with the quality of the work proposed: when opportunities are to be offered through open or limited competition the RAA will expect to be represented on the selection panel. In the event of a competition requiring submission of initial proposals in maquette form, it will be understood that each of the funding parties can withdraw support if unconvinced by the quality or practicability of the proposals presented.

9. The beneficiary of any grant will be expected to take responsibility for the maintenance of work purchased or commissioned through the scheme. Sale of work(s) so acquired will only be permitted in exceptional circumstances and with the prior consent of the RAA and the artist concerned. In such cases any funding provided would be required to be returned, and the artist also should benefit from appreciation of the value of the work.

NB

(1) The procedures outlined above apply only to England but similar schemes are operated by the Scottish Arts Council (19 Charlotte Square, Edinburgh EH2 4DF) and the Welsh Arts Council (Holst House, Museum Place, Cardiff CF1 3NX).

(2) Applications relating to the commission of tapestries or stained glass will normally be best addressed to the Crafts Council.

(3) Museums and art galleries are excluded from the scheme but not libraries or educational institutions with collections of contemporary art.

Alister Warman

Chapter 7
THE ROLE OF THE ARTS COUNCIL, THE BRITISH COUNCIL AND THE REGIONAL ARTS ASSOCIATIONS

THE ROLE OF THE BRITISH COUNCIL

The British Council differs from apparently comparable organisations by reason of its function as in effect the cultural arm of the Diplomatic Service. The aim of arts work in the Council has been defined as "to help establish British achievement in the creative and performing arts as an accepted valued part of the cultural life of people of other countries".

The Council was instituted in 1934 with the principal aim of promoting the English language and the image of Britain abroad. It maintains a representation in countries where diplomatic relations exist and works closely with the British embassies in each country. In some countries the representative is also the embassy's cultural attaché, although the Council premises may be independent of the embassy. In countries where appropriate, subsidiary regional offices are established in addition to the main office in the capital.

In London the headquarters building in Spring Gardens houses the co-ordinating administrative departments and throughout the UK, generally in university towns, there are local regional offices.

The Council is principally concerned with the teaching of English; with technical training of all kinds, either by sending teachers abroad or by sponsoring foreign students at British universities, art colleges and other educational institutions. It sends specialists to give lectures or tours on invitation from institutions abroad and arranges visits for foreign experts sent here on the recommendation of representatives in their countries.

Arts division departments, based in London, are concerned broadly with exporting British culture, by arranging tours by drama companies, orchestras, music groups or soloists, ballet companies, poets and writers. Fine arts department deals with the visual arts and general exhibitions with technical and didactic exhibitions.

Thus the Council does not exist primarily to help artists, although this is very often a result of its promotional activities. A proportion of fine arts department's exhibition work is concerned with pre-20th century art but there is a growing emphasis on living artists as the security and conservation hazards of handling old master works increase.

The department's **exhibition programme** is planned in response to requests from institutions abroad, generally through the representative but sometimes directly, for a specific project. At any given time there is a long queue of proposals, which are considered by the Fine Arts Advisory Committee and incorporated into the programme as budget and staff time allow. If a proposal leaves a measure of selection to the Council, a small committee or a single expert is invited to make an appropriate choice of artists for the event. Broadly speaking the criteria for selection of artists would be their intrinsic merit, as assessment of their potential, their relevance to the particular event and their relevance in an international context.

Exhibitions handled by the Department fall into 3 categories: **loan exhibitions, using work borrowed from institutions** or individuals for a limited period of time; **the official British section of an international event** such as the Venice Biennale; and **circulating exhibitions** which are small permanent travelling exhibitions made up from works bought for the Council's collection. Additionally the department may sometimes make a financial contribution to an institution in Britain or abroad which is organising an exhibition of British art for showing overseas.

Limited help for individuals is available through the **grants to artists scheme,** where artists who have secured a definite invitation to exhibit abroad may apply for a grant towards the expenses of transport or fares. The scheme is administered by a small committee which meets quarterly to consider applications and awards are made on the basis of artistic merit and the suitability of the event in relation to Council policy in the country. A smaller fund is available to help with attendance at professional conferences by delegates who have been invited to make a specific

contribution to the meeting, such as a paper or workshop. Fine arts department is responsible also for manifestations involving performance artists, video, artists' films and crafts.

The Council's collection has been built up over 40 years and now constitutes one of the principal public collections of modern British art. Acquisitions are made from an annual allocation and major purchases are considered by a sub-committee of the Fine Arts Advisory Committee. The collection is functional and almost all purchases are made with a specific purpose in mind, either as constituents of new circulating exhibitions, as supplements to loan exhibitions, or as decoration for Council premises overseas, since these are frequently buildings with public rooms affording good opportunities for the display of works of art. Loans from the collection are made to exhibitions organised by other bodies in Britain and abroad. A catalogue is available, but the store where works not currently in use are kept is not normally accessible to the public, for practical reasons of security.

The Department's **information service** covers a wide range of resources. The Advisory Services Officer deals with enquiries received from abroad relating to British art educational facilities and advice may be sought by artists and administrators on educational institutions overseas. Many enquiries on scholarships, bursaries, fellowships and residencies are however referred to foreign embassies as the Council does not itself administer any awards of this kind. The Advisory Services Officer also deals with recommending suitable specialists for visits abroad as requested by representatives, such as artists to hold workshops, lectures or run summer schools.

Additional informational services include a **reference library of publications on British art, a photo-library and slide collection,** all of which are accessible to members of the public who have a particular reason to consult them. Enquirers should write or telephone in advance for an appointment.

Muriel Wilson
Fine Art Department
The British Council
11 Portland Place
London W1.

ARTS COUNCIL OF GREAT BRITAIN

105 Piccadilly, London W1. Tel. 01 629 9495.

Aim: "To improve the knowledge, understanding and practice of the arts; and to increase the accessibility of the arts to the public".

Funds for dance, drama, literature, music, opera and the visual arts.

1. Runs the Hayward and Serpentine galleries in London.
2. Annual report published each autumn with details of the Council's work and finances. Price £1.20.
3. Bi monthly bulletin with Arts Council information.
4. ACGB publications include: Directory of Arts Centres; Festivals in Great Britain; Guide to Awards and Schemes. Many other publications available at the Arts Council Shop, 8 Long Acre, London WC2. Tel. 01 836 1359. Open 10-7.45 Monday-Saturday.

The Arts Council Shop sells books, postcards, artists books, catalogues, slides, ACGB publications and sections on poetry, visual arts, photography, music books etc. also magazines.

5. Booklet. The Arts Council of Great Britain — What it does.
6. Major Awards and bursaries for artists. See **Awards Chapter 3.**
7. An Education Liaison Officer to encourage co-operation between arts organisations and education providers at all levels.
8. Funds for Housing the Arts goes towards the cost of building new theatres, art centres, galleries and concert halls.
9. Grants towards running art organisations.

An example of grants: 4 national companies Covent Garden (Royal Opera and Royal Ballet); National Theatre; English National Opera; Royal Shakespeare Company; 4 symphony orchestras in London and 4 in the regions; 60 regional theatres; 40 small drama companies; 7 national and regional dance organisations; 21 major music and arts festivals; 10 arts centres; 17 galleries that mount exhibitions of art and photography.

10. Administers training schemes for arts administrators, actors, directors, designers and performers. **ACGB Arts Administration courses.** In service and prior to first employment as an administrator.
11. Tours by dance, drama and opera companies and tours of contemporary music and arts films.
12. Specialist panels to choose awards annually.
13. Touring art exhibitions. e.g. The British Art Show chosen by William Packer.
14. Awards to performance artists at certain galleries.
15. Major art exhibitions at the Hayward and the Serpentine.

16. Annual shows open to professional artists to enter for at the Serpentine gallery. Exhibitions during the summer months.

17. Purchases for Arts Council of Great Britain art collection.

18. Selective slide index open to the public next to the Arts Council Shop, 9 Long Acre, London WC2. Contact Alister Warman 629 9495 for details.

SCOTTISH ARTS COUNCIL

19 Charlotte Square, Edinburgh. Tel. 031 226 6051. Art, drama, music, opera, literature, dance, film and video. Visual Arts Officer: Lindsay Gordon.

1. Awards and bursaries. See Chapter 3 "Awards" section.

2. List of galleries, artists organisations and art centres in Scotland that receive annual grants from the Scottish Arts Council.

3. Advice and information about the arts in Scotland.

4. Register of artists and slide index. Scottish artists working in Scotland and also elsewhere in Britain. Contact Lindsay Gordon if you wish to consult it or register with it. 500 artists plus on the list at present.

5. Information about artist in residence schemes, exchange schemes with Europe and elsewhere open to artists. **Contact the Visual Arts Officer for further details.**

6. Exchange exhibitions encouraged between Scotland and other countries.

7. Grants to art organisations, artists groups and art galleries and arts centres.

8. Travelling art exhibitions such as Cartier Bresson, Scottish painters such as W. G. Gillies, Hornel, McTaggart etc.

9. Encouragement of art in schools. Exhibitions of 6th form art work.

10. Gallery at Charlotte Square. Sadly to close. Major art and photography exhibitions.

11. Exhibitions at the Fruit Market gallery Edinburgh.

12. Some 63 exhibitions mounted all over Scotland in one year.

13. Grants to art publishers.

14. Bursaries for art critics and writers on the Visual Arts.

15. Grants to set up studio blocks such as WASPS in Glasgow, Dundee, Edinburgh and Aberdeen.

16. Purchases for Scottish Arts Council Collection.

17. Assistance towards fees for Scottish arts administrators to attend the ACGB arts administration course in London.

WELSH ARTS COUNCIL

Museum Place, Cardiff, Wales. Tel. 0222 394711.

North Wales Association for the Arts, 10 Wellfield House, Bangor, Gwynedd. Tel. 0248 53248. Area: Clwyd, Gwynedd, and the District of Montgomery in the County of Powys.

South East Wales Arts Association, Victoria Street, Cwmbran, Gwent. Tel. 063 33 67530. Area: City of Cardiff, Gwent, Mid Glamorgan, Districts of Radnor and Brecknock in the County of Powys.

West Wales Association for the Arts, Dark Gate, Red Street, Carmarthen, Dyfed. Tel. 0267 4248. Area: Dyfed, West Glamorgan.

Welsh Arts Council. See Chapter 3 Awards section for details of major awards open to Welsh artists. Supports the Association of Artists and designers in Wales. See "Studios" Chapter 1. Has its own gallery — Oriel gallery in Cardiff — primarily for exhibitions of work of artists in Wales or with Welsh connections. Work by artists throughout Wales. One-off awards also for individual artists. Aid for artists organisations and art galleries. Purchases for Welsh Arts Council collection. Contact Visual Arts Officer for further details. Register of artists working in Wales and slide index for consultation purposes.

North Wales Association for the Arts. Compiling an index of artists working in North Wales in conjunction with the Mostyn gallery Llandudno.

ARTS COUNCIL OF NORTHERN IRELAND

181A Stranmillis Road, Belfast. Tel. 0232 663591. Committees for art, drama, film, literature, music, traditional arts and community arts. Art director: Brian Ferran.

1. Major awards and bursaries (see Chapter 1 for Awards section).

2. Annual report listing events supported and awards given and other details.

3. Rome Fellowship to study at the British School at Rome.

4. Bass Ireland Arts Award.

5. Community arts — local performances in music and drama — very active in Belfast.

6. Film directions published quarterly.

7. Regional development committee — Young Arts, Youth Drama and Community Arts.

8. Artslink mailing to 6,500 subscribers with information about the arts in Northern Ireland.

9. Young Arts has initiated several projects to encourage art activity in schools. Editions of prints available to schools for pupils to look at.

10. Exhibitions in Northern Ireland.

11. Permanent collection. New works acquired by Northern Ireland artists.

12. Print workshop at the above address in Belfast which is run very successfully and professional printmakers can work there.

13. Touring print exhibitions to galleries and arts centres throughout Northern Ireland.

14. Register of Northern Ireland Artists with slides of their work. The public art administrators, gallery owners and other potential buyers can refer to this. Enquire at the above address.

GREATER LONDON ARTS ASSOCIATION
23/25 Tavistock Place, London WC1. Tel. 01 388 2211. Visual Arts Officer: Lesley Greene. Area: Greater London.

1. Awards and bursaries. See Chapter 3 "Awards" section for further details.

2. Runs "Arts Alert" a free magazine with art news, events, views and other useful information.

3. Contact with local arts organisations, schools, colleges and general contact with London arts events.

4. Supports local festivals and ethnic minorities arts events as well as performance, video, film, photography and other art related events.

LINCOLNSHIRE AND HUMBERSIDE ARTS ASSOCIATION
St Hughs, 23 Newport, Lincoln. Tel. 0522 33555. Visual Arts Officer: Diana Pain. Area: Lincolnshire and Humberside. Director, Assistant director, Humberside Area Officer, administrative officer, 4 Arts Officers and clerical staff. Drama, dance, visual arts, literature, craft and film.

Membership subscriptions: £3 individuals, £5 Family, £6 Corporate (educational organisations – 100), £7.50 (up to 200 members), £10 (over 200 members).

Diary of events every two months. Lending of pictures. Exhibition openings for members.

1. Two self contained mobile galleries to visit schools, festivals. Exhibitions of photographs, paintings, prints and other work.

2. Free service of circulating art and craft exhibitions that tour libraries, arts centres and small galleries. Photography, prints, sculpture, watercolours, ceramics and embroidery.

3. Major exhibitions in Hull and Lincoln.

4. Awards and bursaries. (See Chapter 1 for Awards section)

5. Permanent collection of original works of art bought from regional exhibitions.

6. Display equipment available to help local societies mount their own exhibitions.

7. Register and slide index of professional artists, craftsmen and photographers in the region. Advice and information on commissioning work available. Contact the Visual Arts Officer if you wish to consult the register.

8. Art and craft gallery at Posterngate Hull (area centre)

9. Information centre for arts information.

10. Craft and fine art fellowships in silversmithing, weaving, glassmaking, bookbinding, jewellery, printmaking, film making and photography.

11. Special projects awards for individuals – artists, craftsmen. Grants for equipment, materials, studio conversion and individual schemes of work. (See Chapter 1 Awards section for details)

12. Diary of events locally and news and details of grants, competitions etc.

13. Contact for SHAPE (see Survival section Chapter 1) Chris Buckingham.

Education and the Arts. Close contact with schools and colleges of further and adult education. Also performances and workshops in hospitals, prisons, day centres and for the elderly and handicapped. Community arts project to help local people learn new skills.

WEST MIDLAND ARTS
Lloyds Bank Chambers, Market Street, Stafford. Tel. 0785 59231. Visual Arts Officer: Lisa Henderson. Area: Counties of Hereford, Worcester, Metropolitan County of West Midlands, Shropshire, Staffordshire and Warwickshire.

1. Major awards and bursaries (See Chapter 1 for Awards section).

2. Diary poster for the areas arts events.

3. Artspost – mailing service for individuals.

4. Monthly bulletin available to all organisations with arts interests.

5. Book on *Artist, Craftsmen and Photographers in the West Midlands.*
A very effective way of listing artists in the area. Details of all the artists and photographs in black and white of their work listing address, name, details of where they work and where they have exhibited. A section for each category. 210 artists in all. At the back it also lists galleries in the area, museums, arts centres, craft shops and organisations.

6. Slide index also and artists register with additional names and addresses of those not already in the book mentioned above.

139

7. Touring exhibitions.
8. Collection of artists work.
9. General advice available about artists in the area.

SOUTH WEST ARTS

23 Southernhay, Exeter, Devon. Tel. 0392 38924. Visual Arts Officer: Tony Foster. Area: Avon, Cornwall, Devon, Dorset, Gloucestershire and Somerset.

Music, theatre, visual arts, film and video, literature, dance and community arts. **Leaflets available:** South West Arts At Your Service; Our Grants and Awards; Transport and Subsidy Scheme; How we work; Services to Amateurs.

1. Arts South West. News about the arts in the south west area, available every two months with diary of events. Free of charge to individuals and organisations.
2. Annual report.
3. South West Review – appears three times a year.
4. Information centre at 23 Southernhay East, Exeter, Devon. Bookshop for art, poetry, fiction and catalogues.
5. Transport Subsidy scheme. Parties of 10 or more people travelling to professional arts events by coach or public transport are entitled to a refund of up to half the travel costs, subject to certain conditions being fulfilled.
6. Touring exhibitions in the area.
7. Artists and craftsmen lecture service in the area.
8. See More Art Schemes.
9. Artist and craftsmen exhibition schemes.
10. A slide index and register of addresses of professional artists and craftsmen and photographers working in the area.
11. Hire of film and video equipment. Cameras, projectors, splicers and screens. Contact the film officer.
12. Specialist advisory service for individuals and organisations throughout the region.
13. **South West Film Directory** which lists films made in the south west region with South West Arts funding and projects in film done in local schools. Useful books at the back.
14. Register of South West artists.
15. Contact for SHAPE (see Survival section Chapter 3).

YORKSHIRE ARTS ASSOCIATION

Glyde House, Glydegate, Bradford, Yorkshire. Tel. 0274 23051. Visual Arts Officer: Simon Roodhouse. Area: North Yorkshire, South Yorkshire and West Yorkshire.

1. Major awards and bursaries. (See Chapter 3 for Awards section)
2. Register of artists working in the area. Slide index.
3. Arts diary listing arts events in the area and art news.
4. Touring exhibitions.
5. Festivals and projects.
6. Contact with local arts organisations and schools and colleges in the area.
7. Information and advice available to the public about arts events in the area. Contact the Visual Arts Officer for further information.

SOUTH EAST ARTS ASSOCIATION

9/10 Crescent Road, Tunbridge Wells, Kent. Tel. 0892 41666. Visual Arts Officer: Richard Moore. Area: Kent, Surrey and East Sussex. Music, drama, literature, dance, visual arts.

1. Awards and bursaries. (See Chapter 3 for Awards section)
2. Artsnews a monthly newsletter and diary of events.
3. South East Arts Review – quarterly of creative writing.
4. Touring exhibitions.
5. Encourage sponsorship of galleries, exhibitions and local arts events.
6. Advice on purchases to the public.
7. Register of artists living and working in the area. Slide index that the public can consult and then be advised on how to approach the local artist.
8. Links with local schools and colleges to encourage interest in the various arts.

NORTHERN ARTS

10 Osborne Terrace, Newcastle, Tyne and Wear. Tel. 0632 816334. Visual Arts Officer: Peter Davies. Photography and Film: John Bradshaw. Area: County Durham, Cumbria, Northumberland, Tyne and Wear, Cleveland.

1. Awards and bursaries. (See Chapter 1 for Awards section)
2. Touring exhibitions.

3. Sponsorship along with other arts associations of the "Artists Newsletter", a practical informative newsletter for artists that lists supply shops, galleries, courses, awards etc. See "Art magazines" (Chapter 1) for details of address, subscription etc.

4. Supports Artist in Residence scheme at Grizedale Forest.

5. Supports photographer in residence at Kielder Forest (see Chapter 1 Artist in Residence Schemes).

6. Slide index and register of professional artists, craftsmen and photographers working in the area.

7. Information available about galleries, art organisations and arts events in the area.

8. Contact with local schools, colleges to encourage interest in arts events.

9. Support for local art galleries and arts centres such as Sunderland Arts Centre.

EAST MIDLAND ARTS ASSOCIATION

Mountfields House, Forest Road, Loughborough. Tel. 0509 218292. Visual Arts Officer: Sarah Hosking. Area: Borough of Milton Keynes, Derbyshire except Peak District, Leicestershire, Northamptonshire, Nottinghamshire.

1. Awards and bursaries. See Chapter 3 for Awards section.

2. Register of professional artists working in the area and slide index. Open to the public to consult. Contact the Visual Arts Officer for information.

3. Regular newsletter with events and news of awards, competitions in the area.

4. Touring exhibitions.

5. Contact with local arts organisations, schools, colleges.

MERSEYSIDE ARTS ASSOCIATION

Bluecoat Chambers, 6 School Lane, Liverpool. Tel. 051 709 0671. Visual Arts Officer: Roman Piechocinski. Area: Merseyside Metropolitan County and Lancashire.

1. Awards and bursaries, see Chapter 3 for Awards section.

2. Touring exhibitions.

3. Register of artists working in the area and slide index.

4. Contact with local schools and colleges and arts organisations.

5. Support for local art organisations and galleries.

6. Newsletter with arts events in the area.

SOUTHERN ARTS

19 Southgate Street, Winchester. Tel. 0962 69422. Visual Arts Officer: Marilyn Carr. Area: Berkshire, Hampshire, Isle of Wight, Oxfordshire, West Sussex, Wiltshire and the Bournemouth, Christchurch and Poole areas of Dorset.

1. Awards and bursaries. See Chapter 3 for Awards section.

2. Touring exhibitions.

3. Register of artists working in the area and slide index that can be consulted by the public. Contact the Visual Arts Officer for further details.

4. General advice about arts events in the area.

5. Contact with local schools, colleges and arts organisations.

EASTERN ARTS ASSOCIATION

8/9 Bridge Street, Cambridge. Tel. 0223 67707. Visual Arts Officer: Jane Heath. Area: Cambridgeshire, Bedfordshire, Essex, Hertfordshire, Norfolk and Suffolk.

1. Awards and bursaries. (See Chapter 3 for Awards section)

2. Register of artists and craftsmen and slide index. Open to the public and arts administrators to consult. Advice available about possible purchases.

3. Lists of art galleries and art centres in the region.

4. Help for artists and craftsmen leaflet outlines various support schemes for individual artists and craftsmen.

5. Touring exhibitions.

6. Contact with local arts organisations, schools, colleges.

NORTH WEST ARTS

52 King Street, Manchester. Tel. 061 833 9471. Visual Arts Officer: Sally Medlyn. Area: Greater Manchester, High Peak District of Derbyshire, Lancashire and Cheshire.

1. Awards and bursaries (see Chapter 3 for Awards details).

2. Register of professional artists working in the area and slide index. Contact the Visual Arts Officer for further information.

3. List of galleries in the North West Arts area.

4. Touring exhibitions.

5. Contact with local arts organisations, schools, colleges.

SOME OTHER APPROPRIATE REGIONAL ARTS ASSOCIATIONS

Bury Metro Arts Association, The Derby Hall, Market Street, Bury. Tel. 061 761 7107.

Mid Pennine Association for the Arts, 20 Hammerton Street, Burnley, Lancashire. Tel. Burnley 29513. Art Dance, film, photography, graphics, music, literature and theatre. Compiling a register of artists in the area.

Fylde Arts Association, Grundy Art Gallery, Queen Street, Blackpool. Tel. 0253 22130. Supported by North West Arts. Exists to bring the professional arts to this area (Blackpool, Fylde and Wyre). Blackpool Grundy gallery, Fylde Borough Art gallery and Garstang art gallery in Preston.

Chapter 8
INTERNATIONAL SECTION

This section covers useful addresses of galleries, organisations, art schools and general art information for specific countries overseas. It is hoped that artists and the art public in general will find these useful when travelling overseas or planning a visit. In many instances the reader will find that it is necessary to refer to other sections such as "Grants and Awards", "Useful Addresses" and "Useful Books" to find out which organisations deal with awards exchanges, grants and details for specific countries.

When travelling to any country it is advisable to enquire if there is a cultural section of the particular country's embassy in your own country and if so to contact them to see if they have specific information that you may require and details about visa requirements in relation to artists. In many cases Cultural Affairs sections have lists of art schools, galleries, Arts Councils and addresses of organisations in their country that deal specifically with cultural visits. This is advisable as in the long run it will make your eventual visit more profitable and worthwhile and enable you to make contact with art counterparts overseas.

In London, Canada House, New Zealand House, USA Embassy Cultural Affairs, French, Dutch, Italian, Belgian and German embassies are particularly helpful.

INTERNATIONAL ORGANISATIONS

Most of these organisations have offices in London and in many countries overseas.

International Association of Art, Clerkenwell Workshop, 31 Clerkenwell Close, London EC1. Tel. 01 250 1927. UK President: Robert Coward, UK Administrator: Matthew Colling.

The IAA was set up by UNESCO in Paris to enable artists in 60 countries throughout the world to associate with other artists and art organisations overseas, to enable artists to improve and defend their situation internationally. There are national committees in each country and artists meet regularly nationally and every three years representatives meet internationally at IAA congresses where information and ideas are exchanged for the benefit of artists internationally.

At local and national level artists and art organisations can join the IAA and benefits vary according to each country but range from receiving a special card that will allow the artist reduced or free entry to certain overseas galleries and museums, to discount on artists' materials and ability to participate in national and international exhibitions, competitions and exchanges.

The UK committee has recently formed a sub committee which is organising a major national exhibition open to artists, discount to artists on supplies and other similar benefits.

For addresses of overseas IAA committees contact: Dunbar Marshall, International Association of Art, 1 Rue Miollis, 75015 Paris, France.

There are IAA committees in USA, Canada (CAR), Australia, New Zealand, all European countries and in India and certain African countries.

International Visual Artists Exchange Programme, c/o ACME Housing Association, 15 Robinson Road, London E2. Tel. 01 981 6811.

Set up by ACME Housing Association and ACME gallery in London to enable artists to exchange studios and houses internationally. Artists join the programme in their own country and in return receive an international newsletter which lists addresses of artists overseas who wish to exchange studios/houses for periods of 3 weeks to 3 years. £8.00 membership fee to receive quarterly newsletter.

Overseas IVAEP addresses

IVAEP, Deborah Gardner, PO Box 207, Village Section, New York, NY 10014, USA. Tel. 212 227 3770.

IVAEP, Hennie Wolff, Visual Arts Ontario, 417 Queens Quay West, Suite G100, Toronto M5V 1A2. Tel. 416 366 1607.

IVAEP, Manon Blanchette, Conseil de la Peinture du Quebec, 3774 St. Denis Street, Room 201, Montreal, Quebec. Tel. 514 842 8955.

IVAEP, Polly MacCallum, Creative Space, 27 Abercrombie Street, Chippendale, Sydney, NSW 2008, Australia. Tel. 02 698 9540.

IVAEP, Experimental Art Foundation, 169 Payneham Road, Adelaide, South Australia. Tel. 08 42 4080.

IVAEP, Judy Annear, Ewing Paton Galleries, Melbourn University Union, Melbourne, Victoria 3052. Tel. 03 347 3811 ext 57.

IVAEP, Ian Hunter, PO Box 9323, Wellington, New Zealand.

Artists should contact the IVAEP in their own country for further information. Italy now also included.

International Association of Art Critics (British section), c/o The President, Jeffery Daniels, 5 Edith Grove, London SW10 0JZ.

The International Association of Art Critics similarly to the IAA has national committees in many countries throughout the world and international meetings take place every year in different countries.

The aim of this assocation is to discuss problems relating to art criticism and maintain contact with other closely related art associations. Members are elected by the national committee and confirmed by the Central Office in Paris. There are associations in USA, Canada, France and most European countries and in many other countries throughout the world.

The IAA (UK section) is planning a major Zwemmer exhibition in London. Major works collected by the late Arnold Zwemmer in the 30s will be on show.

Institute of International Education, 809 United Nations Plaza, New York 10017.

Information service on educational exchanges particularly higher education.

USEFUL BOOKS FOR INTERNATIONAL ART TRAVELLERS

Art Diary, 36 Via Donatello, Milan 20131, Italy. Editor: Giancarlo Politi.

An international art directory $20 (£11) of artists, galleries and organisations in 38 countries. Very useful for artists travelling overseas, especially good on New York and USA and Italy. Pocket size therefore ideal to carry with you. UK distributors Art Guide Publications, 89 Notting Hill Gate, London W11. Tel. 01 229 4669. Also distributes Flash Art International Magazine published 5 times a year. £2.50 per issue.

Visual Arts Handbook, Visual Arts Ontario, 417 Queens Quay West, Suite G100, Toronto, Ontario, Canada. Editor: Hennie Wolff.

This handbook is a must for all professional Canadian artists and covers advice on the business of art (Tax, PR exhibitions, copyright), suppliers in Canada, galleries, organisations and information for Canadian artists, wishing to travel overseas. $8.95.

London Art and Artists Guide, Art Guide Publications, 89 Notting Hill Gate, London W11 3JZ. Tel. 01 229 4669. Editor: Heather Waddell.

Price £2.95. Second edition published June 1981. A complete guide to London's art scene, including all 500 galleries, art schools, useful addresses and also a general guide to London restaurants, parks, markets and sport. Pocket guide.

Australian Arts Guide (Dec '81) Price £2.50 and **New York Art Guide** (March '82) Price £2.95 Art Guide Publications.

Paris Art Guide, Art Guide Publications, 89 Notting Hill Gate, (1st floor), London W11 3JZ. Tel. 01 229 4669. Editor: Fiona Dunlop.

Price £2.50. First edition published May 1981. A guide to Paris art galleries, organisations and general guide to good cheap eating places, parks, markets, etc. French edition (enlarged and revised) due out Spring '82.

Arts Review Yearbook, 16 St James Gardens, London W11. Tel. 01 603 7530/8533.

The London art guide for art dealers and the art public in general. Covers London and elsewhere in Britain. Articles by art critics at the beginning. Published annually in large book format. Price £8.00 plus £1 postage.

Anderson and Archer's SOHO, The essential guide to Art and Life in Lower Manhattan, Simon and Schuster, Rockefeller Center, 1230 Avenue of the Americas, New York 10020.

Available at Stanfords in Covent Garden (London, England) price £4.50. A must for all art travellers visiting New York. A general guide to Soho, the definitive New York art area, with details on art organisations, galleries, art eating places, shops, old Soho buildings.

New York Art Guide price £2.95 March '82 Art Guide Publications, 89 Notting Hill Gate, London W11. Tel. 01 229 4669. Pocket guide covering art and tourist information.

Art Now, Gallery Guide, Art Now Inc, 144N 14th Street, Kenilworth, New Jersey 07033.
$1.50 each month. Available at most New York galleries. This small magazine lists all exhibitions in New York's 800 galleries and has clear maps to each area with galleries in it, i.e. uptown galleries, midtown and downtown Soho galleries.

Handbook of Printmaking Supplies, Printmakers Council of Great Britain, 31 Clerkenwell Close, London EC1. Editor: Silvie Turner.
Price £2.00. Covers all areas of printmaking. A must for British printmakers. It also has addresses of overseas print workshops, supply shops and galleries dealing with prints. Second edition out 1980.

USEFUL ART MAGAZINES FOR ART TRAVELLERS

See art magazine section also.

Art Forum, 667 Madison Avenue, New York 10021. Editor: Joseph Masheck. London reviewer: Adrian Searle. Available monthly with articles and regular art reviews. Along with Art News and Art in America one of the more important USA art magazines. Glossy and in colour.

Art News, PO Box 969, Farmingdale, New York 11737. London correspondent: William Feaver. $3.00 per issue or $19.95 for foreign subscribers (10 issues per annum). Covers all USA art news and overseas reviews and art articles and US reviews. Good value.

Arts Magazine, 23 East 26th Street, New York NY 10010. Published ten times a year. $32.00 USA Foreign postage $9.00. $4.00 per copy. Wide selection of articles, reviews on contemporary current exhibitions and art historical articles. Glossy with good colour photos.

Art in America, 850 Third Avenue, New York 10022. Editor: Elizabeth Baker. London correspondent: Suzi Gablik. $3.50. Annual subscription $34.95 (12 issues). USA art glossy. Reviews, art historical articles and contemporary art.

Flash Art International, 36 Via Donatello, Milan 20131, Italy. Editor: Giancarlo Politi. Published in English. Covers art reviews in UK, USA, Australia and Europe. UK distributors Art Guide Publications, 89 Notting Hill Gate, London W11. Tel. 01 229 4669. £2.50 per issue 5 times a year.

Umbrella Magazine, PO Box 3692, Glendale, California 91201. Editor: Judith Hoffberg. Useful art news news-sheet for art people internationally as it lists new art publications, new art galleries, job changes, etc, art gossip internationally. British American Arts Association office, 49 Wellington Street, Covent Garden, has a copy for reference each month.

Art International, Via Maraini 17-A, Lugano, Switzerland. Tel. 091 54 34 61. Editor and Publisher: James Fitzsimmons. International art glossy. Worth looking at for reference but expensive for artists. Regular subscription 150 Swiss francs ($95). Special reduced subscription rate for artists, art critics and art dealers — 80 Swiss francs ($50).

Studio International, 25 Denmark Street, London WC2. Tel. 01 836 0767. Editor: Varies according to the issue. UK art glossy when it appears and now more expensive. £2.50.

Art Monthly, 37 Museum Street, London WC1. Tel. 01 405 7577. Editors: Peter Townsend and Jack Wendler. 60p monthly. Good value. $25.00 for USA subscribers. £7.50 for European subscribers. £6.00 p.a. in the UK. Excellent art news magazine with regular art news and art reviews. National and international art news and articles.

Fuse, 2nd Floor, 31 Dupont Street, Toronto, Canada. Tel. 416 366 4781. Canadian avant garde art magazine. Video and performance and conceptual work covered internationally and nationally.

Vie des Arts, 373 Rue St. Paul Ouest, Montreal, Quebec. Tel. 282 0205. Editor: Andrée Paradis. London correspondent: Heather Waddell. $4.25. 20 French Francs. $16 p.a. overseas subscribers and $15.00 for Canadian subscribers. 4 issues a year. Canadian art articles and reviews and letters from New York, London, Germany and France in French.

Art and Australia, 34 Glenview Street, Gordon, NSW 2072, Australia. Editor: Mervyn Horton. London correspondent: Dr. Ursula Hoff. A$16.00 within Australia. A$20.00 for overseas subscribers. Published quarterly. Up to date news on Australian art scene – articles and reviews. Glossy and colour.

Art New Zealand, Art Magazine Press, PO Box 7008, Auckland, New Zealand. Editor: Ross Fraser. $14.00 (4 issues in N.Z.) $17.00 overseas subscribers. New Zealand art glossy and covers art reviews and art articles about NZ artists.

High Performance, 240 South Broadway, 5th Floor, Los Angeles, California 90012. Interested in receiving b/w photos of performances (8 x 10) and 1 page factual history of the event accompanying it. Send to Linda Burnham. Magazine covers performance events in USA and internationally.

The Performance Magazine, PO Box 421, London NW1. UK performance events and news. UK subscription £4.

Art Network, PO Box 439, Broadway, Sydney, NSW 2007, Australia. Tel. 212 5928. Co-ordinator: Ross Wolfe. A$3.00 quarterly. Art newspaper for Australian and New Zealand artists covering art events and news, views in both countries. Very useful for overseas art visitors. The alternative art magazine in Australasia rather than Art and Australia, the art glossy. A$16.00 per annum. A$18.00 (overseas).

Virus Montreal, CP 187, Succursale E, Montreal H2T 3A7. A Montreal "Time Out" covering Visual Arts, films, music, theatre, radio, restaurants and other useful information. A must for visitors to Montreal.

OVERSEAS DIRECTORY

ARGENTINA

Centro de Arte y Comunicacion, Elpidio Gonsalez 4070, Buenos Aires 1407. Tel. 566 8046. Library and showrooms Viamonte 452 Buenos Aires. President: Jorge Glusberg. Gallery consists of two floors each 16 x 20 metres. Documentation center consists of two floors each. CAYC is a non-profit institution. Regular exhibitions of art and video. International and national exhibitions shown at CAYC. Collection includes 400 video tapes, 7,000 photographic prints, 5,000 slides, 150 films and catalogues of all past art exhibitions. Helps circulate travelling art exhibitions throughout Argentina.

Comite Argentino de la Asociacion Internacional de Artes plasticas, Defensa 945, Apto no 7, Buenos Aires. IAA Argentina committee.

AUSTRALIA

See **Australian Arts Guide** (Art Guide Publications) £2.50 for details.

Visual Arts Board, Australia Council, Northside Gardens, 168 Walker Street, North Sydney, NSW 2060. Tel. 922 2122. Director: Nick Waterlow. The Visual Arts Board deals with all matters relating to Fine Artists whereas crafts people would contact another department of the Australia Council. As with the Arts Council in Great Britain the VAB awards grants to artists, funds artist in residence programmes, public galleries acquisitions and helps bring major international exhibitions to Australia. They also have overseas studios for Australian artists in France, Ireland, New York, Exeter (England) and Berlin.

Artbank (Australia), PO Box 3652, Sydney, NSW, Australia. Tel. 298351. Director: Graeme Sturgeon. Artbank is funded by the department of Home Affairs and is a Federal Government agency. It started in 1980 and will gradually acquire works in the fields of painting, sculpture, printmaking, photography, craft and aboriginal art to build up a representative collection of contemporary Australian art. Works can be leased for display in government offices around Australia and abroad.

SYDNEY, NEW SOUTH WALES

Art Gallery of New South Wales, Art Gallery Road, The Domain, Sydney NSW 2000 Tel. 221 2100. Director: Mr. Edmund Capon. Permanent Australian and European art collection. Ideal gallery for visitors to become acquainted with the works of great Australian painters such as the impressionists Tom Roberts, Arthur Streeton and Sydney Long. The gallery consists of two

floors both with large exhibition areas. The gallery also exhibits annually the work entered for major art competitions such as the Archibald, Wynne and Sulman prizes. At such exhibitions visitors can see the work of contemporary Australian painters such as Brett Whitely, Sydney Ball, Tony McGillick and many others.

The gallery also has an excellent Education Department and talks and lectures are given in the lecture hall. A booklet is available published annually about all competitions open to artists in Australia. Entry to the gallery is free on Tuesdays and Sundays.

Australian Centre for Photography, 257 Oxford Street, Paddington, Sydney, NSW 2021. Tel. 356 1455. Director: Christine Godden. Open Wed-Sat 11-6.00. First started in 1973 and now a flourishing gallery. Work by Australian photographers and exhibitions of work by overseas photographers can be seen here. Two floors of gallery space. The centre is a non-profit organisation and is funded by the Australia Council and the New South Wales Department of Cultural Activities.

Power Institute of Fine Arts, University of Sydney, Broadway, NSW 2006.

Sculpture Centre, Cambridge Street, The Rocks, NSW 2000. The Sculpture Centre is a non profit organisation. It has a small gallery space where exhibitions and performances take place. Sculpture classes take place on the first floor. Situated in the Rocks in Sydney, an area somewhat similar to Covent Garden in England. Tel. 241 2900.

Contemporary Art Society and ICA Gallery Space, 1 Central Street, Sydney. Tel. 263116.

Sydney Film Co-op, St Peters Lane, Darlinghurst, Sydney. Tel. 313237.

Port Jackson Printing Press, 23 McLaren Street, North Sydney, NSW 2060. Tel. 924181. Director: David Rankin. Open Mon-Fri 10-5.00. Commercial print studio. Publish prints by 20 Australian artists including John Olsen, Arthur Boyd and Clifton Pugh.

Sydney College of the Arts, 58 Allen Street, Glebe, Sydney. Tel. 692 0266. Fairly new art school with growing campus. Lively Fine Art Department.

Alexander Mackie College, The Rocks, 200 Cumberland Street, East Sydney. Principal: Ken Reinhard. The older and more established art school in Sydney. Lively art department that helped create Art Network, the Australasian art newspaper. Tel. 277 204.

Paddington Video Centre, Paddington Town Hall, Oxford Street, Sydney. Gallery and video access facilities.

Creative Space, c/o 27 Abercrombie Street, Chippendale, Sydney, NSW 2008. President: Dian Lloyd. New art organisation that is in the process of setting up studios for Sydney artists and are acting as the Sydney contact for the International Visual Artists Exchange Programme.

Julian Ashton School of Art, 117 George Street, Sydney, NSW 2000.

Gallery A, 21 Gipps Street, Paddington. Tel. 336 720. Good commercial gallery.

Watters Gallery, 109 Riley Street, East Sydney. Tel. 331 2555. Lively commercial gallery.

Newcastle College of Art Education, PO Box 84, Waratah, NSW 2298.

MELBOURNE, VICTORIA

Ewing and Paton Galleries, Melbourne University Union, Parkville 3052, Australia. Tel. 347 3811 ext 57. Directors: Judy Annear and Alkes Danko. Open Mon-Fri 10-6.00. Wed 10-8.00. Regular exhibitions of work by contemporary Australian artists. Two galleries 32 and 50 metres running length.

Womens Art Register, Carringbush Library, 415 Church Street, Richmond Victoria. Tel. 429 3644.

National Gallery of Victoria, St. Kilda Road, Melbourne. Tel. 62 7411. Director: Eric Rowlison. Open Tues-Sun 10-5.00, closed Mondays. Three floors of gallery space housing a permanent collection and a large Temporary Exhibitions Area on the ground floor. Large Educational department for talks and lectures. Collection covers European Art, Australian art both historical and contemporary and Asian art, also American paintings post 1800.

Victorian College of the Arts, 234 St. Kilda Road, Melbourne, Victoria 3000.

Prahran College of Advanced Education, School of Art and Design, 142 High Street, Prahran, Victoria.

Ballarat College of Advanced Education, Art Department, Lydiard Street South, Ballarat.

Caulfield Institute of Technology, Department of Art and Design, PO Box 197, Caulfield East.

School of Art, Royal Melbourne Institute of Technology, 124 La Trobe Street, Melbourne.

School of Visual Arts, Gippsland Institute of Advanced Education, PO Box 42, Morwell, Victoria 3840.

Art Department, State College of Victoria, PO Box 179, Coburg, Victoria 3058.

Victorian Ministry for the Arts, 9th Floor, 168 Exhibition Street, Melbourne. State Arts Council for Victoria.

City of Mildura Arts Centre, 199 Cureton Avenue, Mildura, Victoria 3500. Tel. 233733. Open Mon-Fri 9-4.30, Sat and Sun 2-4.30. Permanent collection of painting and sculpture. Best known for its national Sculpture Triennial when sculptors and performance artists throughout Australia met up. Overseas artists also exhibit here.

The state of Victoria is generally very art conscious and there are several other art schools

apart from the above mentioned. Melbourne also has several film co-operatives for film makers, and many commercial galleries of high standing.

QUEENSLAND

Institute of Modern Art, 24 Market Street, Brisbane. Tel. 229 5985. Director: John Nixon. Open Tues-Sat 10-5.00. Australia's most flexible and innovative exhibition area. Experimental projects by overseas and Australian artists are encouraged by the Director. It has a particularly close link with British artists. Michael Craig Martin, John Danvers and Charles Garrard have all shown work there. Two large gallery spaces running length 21 and 25 meters.

Queensland Art Gallery, 160 Ann Street, Brisbane. Tel. 229 2138. Open Mon-Sat 10-5.00, Sun 2-5.00. Temporary space until the permanent gallery is opened in 1981. Main emphasis on Australian art but also European collection. There are also galleries at the University in Brisbane and at the Civic Centre, and several commercial galleries with lively exhibitions such as the Ray Hughes gallery in Brisbane.

SOUTH AUSTRALIA

Experimental Art Foundation, 169 Payneham Road, St. Peters, Adelaid. Tel. 424080. Open Mon-Fri 10-5.00. Two floors of gallery space. Ground floor running length 40 metres, first floor 38 metres. The EAF is known internationally as a centre for alternative art work such as performance and video. It has a collection of video and performance documentation from work done by both Australian and overseas artists. Situated in the Jam Factory, a crafts centre and workshop in Adelaide. They hope to exchange artists with overseas galleries in 1981/2.

Contemporary Art Society, 14 Porter Street, Parkside. Holds exhibitions of work by CAS members regularly at this gallery space.

Art Gallery of South Australia, North Terrace, Adelaide. Tel. 223 8911. Director: David Thomas. Open Mon-Sat 10-5.00, Wed 10-9.00, Sun 1.30-5.00. Large collection of European and Australian art. There is also a special exhibitions gallery for temporary exhibitions.

Arts Development Branch, Premiers Department, State Government Offices, Victoria Square, Adelaid, SA 5000. State Arts Council equivalent.

WESTERN AUSTRALIA

Art Gallery of Western Australia, 47 James Street, Perth. Tel. 328 7233. Director: Frank Ellis. Open Mon-Fri 10.30-5.00, Sat 10.30-5.00, Sun 1-5.00. Specialised Aboriginal art collection, historical collection and Australian collection of paintings, drawings, ceramic and sculpture. Also holds temporary exhibitions.

Undercroft Gallery, University of Western Australia, Perth, WA 6000. Tel. 380 2006. Director: Mrs. Rie Heymans. Good choice of contemporary Australian art exhibitions. Purchases contemporary Australian art. Ground floor gallery holds temporary exhibitions.

West Australian Arts Council, 6 Outram, West Perth. Tel. 322 6766. State Arts Council.

West Australian Institute of Technology, Heyman Road, South Bentley, WA 6102. Main WA art school with excellent facilities for fine art, film and video. Gallery space and excellent WAIT library.

Praxis Art Group, c/o WAIT, as above. Group of artists that exhibit together locally and in other states.

BELGIUM

International Association of Art, Belgian committee, Mr. Walter Vilain, Melkvoestraat 24B, 3500 HASSELT.

Ecole nationale supérieure d'architecture et des arts visuels, 21 Abbaye de la Cambre, 1050 Bruxelles. Tel. 648 9619. Principal: R. L. Delevoy. Large art school with lively fine art department and also film and animation department. Keen on the idea of exchange of art students and art teachers. French speaking.

Academie Royale des Beaux Arts, 144 Rue du Midi, Bruxelles. Director: Mr. Claude Lyr. More traditional art school with emphasis on drawing and painting from life.

Atelier de Recherches sur la Communication, 20 Rue Ste Anne, Sablon, Bruxelles. Tel. 02 511 16 57. Director: Françoise van Kessel. An alternative art centre especially interested in music, performance and sound experimental projects. Especially keen to exchange exhibitions with galleries overseas in USA, Canada, UK and the rest of Europe.

Palais des Beaux Arts, 10 Rue Royale, Bruxelles 1000. Tel. 512 0403. Large central Brussels gallery for major art exhibitions.

ASBL Pluriel, 25 Rue des Cygnes, Bruxelles 1050. Tel. 649 0915. Performances, video and concerts.

ANTWERP

International Cultureel Centrum, Meir 50, B2000, Antwerp. Tel. 231 319182. A large art centre with gallery space, restaurant, cinema space for small films and video and performance events.

National Hoger Instituut en Koninklijke voor Schone Kunsten, 31 Mustaerdstraat, Antwerp. Director: Theo Van Looy. Traditional art school. Emphasis on painting, sculpture and printmaking. Antwerp does have a lively young art community though.

KASTERLEE
Rijkscentrum Frans Masereel, Zaardendijk 20, 2460 Kasterlee, Belgium. Funded by the Ministry for Dutch culture, this print workshop offers facilities for lithography, silkscreen and etching. A stay in the centre is free of charge also free use of materials for printmakers wishing to stay.

BRAZIL
International Association of Art, Associacao Internacional de Artes Plasticas, Rua Noruega 275, Jardim Europa, Sao Paolo SP 01448.

BOLIVIA
International Association of Art, Casilla 5788, La Paz.

BULGARIA
International Association of Art, Association des artistes bulgares, UI Schipka 6, Sofia.

CANADA
See **Visual Arts Handbook** (Visual Arts Ontario, Canada) for detailed addresses. $8.95.
Canada Council, 255 Albert Street, Ottawa, Ontario. Tel. 613 237 3400. Geoffrey James. Canada Council awards grants to artists throughout Canada and helps fund non-profit art organisations in Canada. They can advise overseas artists about artist in residence schemes, summer schools etc. as can Canada House in London where Griselda Bear can advise artists who best to contact in Canada depending on their specialism.
Canada House, Trafalgar Square, London SW1. Tel. 01 629 9492. Exhibitions Officer: Griselda Bear. Canada House gallery in London holds regular exhibitions of work by Canadian artists and as the exhibitions officer is constantly looking at Canadian work she is in touch with the latest developments on the Canadian art scene.
Canadian Artists Representation (CAR), Room 44, 221 McDermot Avenue, Winnipeg, Canada. Tel. 204 943 5948. National Representative: Bill Lobchuk. Also branches in each state. Canadian Artists Union and also the Canadian committee of the IAA International Association of Art. CAR is very active in Canada and has a large membership right across the country. They have actively changed laws affecting artists studios and taxes on art materials in some instances.
Parallelogramme, 217 Richmond Street West, Toronto. Tel. 416 366 4781. Funded by Canada Council. Parallelogramme is published 6 times a year by ANNPAC the Association of National non profit Artists Centres which represents 25 artist initiated centres of parallel galleries that aim to encourage new art work in all directions. Galleries throughout Canada.
Parallel Galleries (ANNPAC)

A Space
299 Queen St West
Suite 507
Toronto
Tel. 416 595 0790

Artspace
190 Hunter St
Peterborough
Ontario
Tel. 705 745 0976

Center for Art Tapes
1671 Argyle St
Halifax
Nova Scotia
Tel. 902 429 7299

Clouds'N Water
516A 9th Avenue S.W.
Calgary
Alberta
Tel. 403 266 5936

Direct Media Association
RR no1
Port Washington
British Columbia
Tel. 604 629 6124

ED Video
72B Norfolk Street
Guelph
Ontario

Eye Level
1672 Barrington
Halifax
Nova Scotia
Tel. 902 425 6412

15 Dance Lab
155A George St
Toronto
Ontario
Tel. 416 869 1589

Forest City Artists Assocation
213 King St
London
Ontario
Tel. 519 434 5875

KAAI
21A Queen St
Kingston
Ontario
Tel. 613 548 4883

Mercer Union
29 Mercer St
Toronto
Tel. 416 368 0230

The Music Gallery
30 St Patrick St
Toronto
Tel. 416 598 2400

Niagara Artists Co
109 St Paul Crescent
St Catherines
Ontario
Tel. 416 934 1640

Open Space
510 Fort St
Victoria
British Columbia
Tel. 604 383 8833

Optica
1029 cote Beaver Hall
Montreal
Quebec
Tel. 514 866 5178

Photographers Gallery
236 2nd Avenue
Saskatoon
Saskatchewan
Tel. 306 244 8018
Powerhouse
3738 St Dominique
Montreal
Quebec
Tel. 514 844 3489
Pumps
40 E Cordova St
Vancouver
British Columbia
Tel. 604 688 7405
Saw Gallery
55 Byward Market
Ottawa
Ontario
Tel. 613 236 6181

Thirty One
31 Mercer St
Toronto
Tel. 416 367 9660
Vehicule
Musee d'art vivant
307 rue Ste Catherine
Montreal
Tel. 514 844 9623
Video Inn
261 Powell St
Vancouver
British Columbia
Tel. 604 688 4336

The Western Front
303 East 8th Avenue
Vancouver
British Columbia
Tel. 604 876 9343
Women in Focus
No 6
45 Kingsway
Vancouver
British Columbia
Tel. 604 872 2250
YYZ
567 Queen St
Toronto
Tel. 416 868 6380

Visual Arts Ontario, 417 Queens Quay West, Suite G100, Toronto. Tel. 416 366 1607. Director: Bill Boyle. VAO is a federation of art organisations in Ontario comprising some 5,000 members. It runs workshops, colour xerography programme, runs international exhibitions and the International Artists Exchange Programme for Canada. They produce the useful **Visual Arts Handbook** which is a must for any artist visiting or staying in Canada, editor Hennie Wolff. $8.95 plus postage.

Vehicule Art Inc., 307 Ste Catherine Ouest, Montreal, Quebec. Tel. 844 9623. Nancy Petry, Trevor Gorins, Tom Konyves. Open Tues-Sat 12-5.00, Thurs and Fri 12-6.00. Large gallery space in central Montreal. Exhibitions, performances, video library and generally useful for visiting artists as an information centre. Virus Montreal Montreal's Time Out can be picked up here.

La Societé des Artistes en arts visuels du Quebec Inc., (previously Conseil de la Peinture), 3774 St Denis Street, Room 201, Montreal. Tel. 842 8955. Manon Blanchette. A non profit organisation with some 300 + members. They run the Quebec part of the International Artists exchange Programme and are also keen on international art exchange exhibitions especially with Europe and the USA.

Canadian Centre of Photography and film, 596 Markham Street, Toronto.

Art Metropole, 217 Richmond Street West, Toronto. Tel. 362 1685. Open Tues-Sat 12-6.00. Facilities include an archive of information on contemporary art, books by artists, video library for ½ and ¾ tapes. Viewing by appointment. Most information about the Canadian art scene is available in the "Visual Arts Handbook" available from Visual Arts, Ontario, address as above.

DENMARK
IAA, Mrs. Bodil Kaalund, Louisevej 7, 2800 Lyngby.

FEDERAL REPUBLIC OF GERMANY
IAA, Nr. Gerhard Pfennig, 5300 Bonn, Bennauerstrasse 31.

IAA, Mrs. Ursula Ancke, Nationaler Museumstrat der DDR, Wildensteiner Strasse 7, 1157 Berlin.

Kunstlerhaus Bethanien GMBH, Mariannenplatz 2, 1B36, Berlin. Tel. 614 9021. Studio space for Berlin artists.

DAAD, German Academic Exchange Service, Steinplatz 2, Postfach 12640 1B12, Berlin. Tel. 310 461. Overseas artists can apply to stay in Berlin on this exchange programme. Artists are given studio and living space if their application is successful. (Film and Visual Arts) 25/30 scholarships awarded annually for one year. There are Kunstlerhaus (art centres) in most German cities such as Hamburg, Stuttgart and Cologne. Refer to Art Diary for endless list of art contacts in Germany.

FINLAND
Suomen Taiteilijaseura, Ainonkatu 3, 00100 Helsinki 10. Tel. 493 919. Maaretta Jaukkuri. Director: Relmo Helno. This Finnish Artists Association is also the IAA representative for Finnish artists. They have one studio house in Helsinki, one in Espoo (an adjoining town) a working and recreation centre for artists some 70km from Helsinki in the village of Samatti as well as a studio house in Florence, Italy and one in Marbella, Spain. They are interested in studio exchanges and exchange exhibitions. They have some 2,000 metres and produce a book with details of their work.

FRANCE

See **Paris Art Guide** (Art Guide Publications) £2.50 for detailed addresses.
 Cairn, 151 Rue Faubourg St. Antoine, 75011 Paris. Tel. 307 08 88/307 08 48. Open every day 2-7.00. A co-operative gallery and group of French artists based in Paris, started in 1976. They are keen to make contact with other artist run groups overseas and exchange ideas.
 International Association of Art (HQ), 1 Rue Miollis, 75015 Paris. Dunbar Marshall Malagola.
 Centre Culturel Canadien, 5 Rue de Constantine, 75007 Paris. Tel. 551 3573. Director: Gilles Lefevre. Regular exhibitions of work by Canadian artists.
 Centre Georges Pompidou, 75191 Cedex 04. Tel. 277 1233. The major modern art centre in Paris with permanent collection and regular changing temporary exhibitions of work by French artists and overseas artists.
 Katia Pissarro gallery, 59 Rue de Rivoli, 75001 Paris.
 Groupe 30 x 40, 30 Rue Rambuteau, 75003 Paris. Gallery space and edits a magazine called NDLR.
 Vidéoglyphes, BP 327 75064 Paris Cedex 02. Group of artists interested primarily in video. Edit a magazine called Videoglyphes.
 Calibre 33, Is it Art? 33 Blvd de la Republique, 06300, Nice. Gallery space. Edit a magazine called "Calibre 33" and "Le Guep'art", "Contre" and "L'anti-Egouttoir".

GREECE

IAA, National Greek committee, Kalitechnikon Epimelitirion Ellados, 38 Mitropoleos Street, Athens 126.
 National Gallery of Art, 50 Constantinos, Athens. Tel. 711 010.
 Contemporary Graphics, 9 Haritos Street, Athens. Tel. 732 690.

HOLLAND

BBKB, Bureau Beeldenoe Kunst Buitenland (Visual Arts Office for Abroad), Oostelijke Handelskade 29, Amsterdam. Tel. 223 501. Dutch equivalent to the British Council. Very helpful to enquiries from overseas artists. Publish "Dutch Art and Architecture Today" monthly.
 Nederlandse Kunstichting, Oostelijke Handelskade 29. Tel. 220 414. Dutch Arts Council for affairs within Holland rather than overseas.
 BBK, Beroepsvereniging van Beeldenee Kunstenaars, Nieuwe Herengracht 29, Amsterdam. Tel. 249 585. IAA also at same address. Dutch Artists Union. Has several thousand members so therefore a very active union. Artists in Holland have far greater rights than in most other countries.
 Gerrit Rietveld Academie, Frederick Rosskstraat 96, 1076 ED Amsterdam. Tel. 72 0406. Director R. Van Der Land. Modern art school with wide variety of art departments. Interested in student and art teacher exchanges. Good atmosphere.
 Stedelijk Museum, Paulus Potterstraat 13, Amsterdam. Tel. 73 2166. The Stedelijk is the Modern Art museum in Amsterdam but is also actively involved in educational art programmes and has two studios available to overseas artists. Artists apply to the director E. de Wilde for further details.
 De Appel, Brouwersgracht 196, Amsterdam. Tel. 255 651. Wies Smals: Director: De Appel is well known to overseas performance artists. Artists performing there can sometimes stay at the gallery.
 Art and Project (gallery), Prinsengracht 785. Tel. 220 372.
 Ateliers 63, Zijlsingel 6, 2013 Haarlem. Tel. 32 1375. Director Wessrl Couzyn. Art school run along the studio rather than usual art school lines. Known artists visit students regularly.
 Nederlandse Filmakademie, Overtoom 301, Amsterdam 1054. Film Academy.

INDIA

IAA, Mr Shantanu, The Indian Art Association, 1 Parkview Annexe, Ajmalkhan Park, New Delhi 110005.

IRELAND

IAA, Mrs Elizabeth Ballagh, 3 Temple Cottages, Broadstone, Dublin.
 Arts Council, 70 Merrion Square, Dublin 2.
 Project Art Centre, 39 East Essex Street, Dublin 2. Tel. 781 935. Lively Art Centre with good exhibitions, performances, video and film events.
 Arts Council of Northern Ireland, 181A Stranmillis Road, Belfast 9. Tel. 663 591.

ISRAEL

IAA, The Israel Painters and Sculptors Association, 9 Alharizi Street, Tel Aviv.

ITALY
See **Art Diary** (Giancarlo Polite) for detailed addresses. £11.00.
IAA, Dr Mario Penelope, 27 Piazza Firenze, 00186, Rome.
Laboratorio, Via degli Ausoni 3, 00185, Rome. Alternative art space.
Galleria Cavallino, San Marco 1725, 30124 Venice. Tel. 20528. Lively exhibitions, performances, video and film events.
Art Diary, 36 Via Donatello, 20131 Milano, Italy. Art Diary $20.00 plus $2.00 air mail postage. International Art Diary listing 35 countries. Largest sections on Italy. UK distributors Art Guide Publications, 89 Notting Hill Gate, London W11. Tel. 01 229 4669.

JAPAN
IAA, Mr Heikichi Kurata, Japan Artists Center Building, Ginza 3-10-19, Chuo-ku, Tokyo.

POLAND
IAA, Zwiazek Polskich Artystow Plastykow, Ul. Foksal 2, 00 366, Warsaw.

SPAIN
Centro de Documentacio d'Art Actual, San Gervasio de Cassolas 31/35 22, Barcelona.
Museo Español de Arte Contemporaneo, Avenida Juan de Herras/n, Ciudad Universitaria. Tel. 449 2453. Madrid.

USA
British American Arts Association, 49 Wellington Street, London WC2. Tel. 01 379 7755. Director: Jennifer Williams. Essential to visit this organisation prior to visiting the USA. Reference books for awards galleries, art schools, organisations etc.
National Endowment for the Arts, 2401 E Street, Colombia Plaza, NW Washington DC20506. Tel. 202 634 1566. Director of Visual Arts Jim Melchert. The National Endowment for the Arts is the USA Arts Council equivalent although per ratio of US population it does not offer as many awards to artists as the UK Arts Council does.

NEW YORK
See New York Art Guide (Art Guide Publications) £2.95 for detailed addresses.
Art schools
Art Students League of New York, 215 West 57th Street, New York 10019.
Cooper Union School of Art, New York 10013.
Pratt Institute, School of Art and Design, Brooklyn, NY 1205 and also 160 Lexington Avenue, NY 10016.
New York Studio School, 8 West 8th Street, NY 10011.
Yale University School of Art, 180 York Street, New Haven, Connecticut 06520.

Organisations
Artists Space, 105 Hudson Street, New York 10013. Tel. 212 226 3970. A non profit art organisation with gallery space, a visiting artists programme, a register of some 1000 artists in New York and an independent exhibitions programme for group exhibitions in non commercial venues.
Institute for Art and Urban Resources, 108 Leonard Street (Clocktower Office), New York 10013. Tel. 212 233 1096. Director Alanna Heiss. A non profit art organisation that runs studio space for artists in Soho and in Brooklyn. Regular exhibitions of work by USA and overseas artists. They also run an open Studio Programme for overseas artists to use studio space at the Clocktower.
CAPS (Creative Artists Public Service Programme), 250 West 57th Street, New York 10019. Tel. 212 247 6303. CAPS runs a programme to give financial support to some 100 artists for a specific period. US artists only.
Artists Equity Association of NY Inc., 1780 Broadway, NY 10019. Tel. 212 736 6480. Very established Artists Union. Started in the 30's with many known names.

Galleries
Art Now Gallery Guide available monthly for $1.50 in most NY galleries lists most New York galleries and current exhibitions.
Franklin Furnace, 112 Franklin Street, NY 10013. Franklin Furnace has a unique collection of Artists Books from all over the USA and overseas. Gallery space for exhibitions, performances and video events. Tel. 925 4671.
The Kitchen, 484 Broome Street, New York. Tel. 212 925 3615. Open Tues-Sat 1-6.00. Performances in the evening, ring for details and times.
Museum of Modern Art, 11 West 53rd Street, New York 10019. Tel. 756 7070. Closed Wednesdays. Open 11-6.00, Thurs 11-9.00.
Whitney Museum of American Art, 945 Madison Avenue, New York. Tel. 794 0663.
Whitney Downtown, 48 Old Slip, New York. Tel. 483 0011. Open Mon-Fri 12-2.00.

Galleries that have shown work by British artists
(Uptown) Robert Elkon, Theo Waddington, Bernard Jacobson. (Downtown — Soho) Elise Meyer, Ian Birksted, Betty Cunningham, Drawing Center, Susan Caldwell, Frank Merino.

Galleries that often show work by British Artists
Bernard Jacobson Ltd, 24 West 57th Street, New York. Tel. 581 8346. Tues-Fri 10-6, Sat 10-5.
Terry Dintenfass Inc, 50 West 57th Street, New York. Tel. 581 2268. Tues-Sat 10-5.30.
Robert Elkon, 1063 Madison Avenue, New York. Tel. 535 3940. Tues-Sat 10-5.45.
Elise Meyer, 410 West Broadway, New York. Tel. 925 3529. Tues-Sat 10-6.
The Drawing Center, 137 Greene Street, Soho, New York. Tel. 982 5266. Mon-Sat 11-6, Wed -8.
Betty Cunningham, 94 Prince Street, Soho, New York. Tel. 966 0455. Tues-Fri 10-5, Sat 2-6.
Susan Caldwell Inc, 383 West Broadway (2nd floor), Soho, New York. Tel. 966 6500. Tues-Sat 10-6.
Frank Marino, 489 Broome Street, Soho, New York. Tel. 431 7888. Tues-Sat 12-6.
Ian Birksted, 152 Mercer Street, Soho, New York. Tel. 226 2196.

SOME OTHER USEFUL GALLERIES
Photographic
Light, 724 Fifth Avenue, between 56 and 57th Streets. Tel. 582 6552. Tues-Fri 10-6, Sat 10-5. One of the best New York photographic galleries.
International Centre of Photography, 1130 Fifth Avenue, New York 10028. Tel. 212 860 1777.
Robert Friedus, 158 Lafayette Street, Soho, New York. Tel. 925 0113. Tues-Sat 11-5. Various others — see New York Times Arts listings for photographic galleries (Fridays) and Sunday New York Times.

Sculpture
The Sculpture Center, 167 East 69th Street, New York 10021. Tel. 2121 737 9870. Sculpture exhibitions throughout uptown and downtown galleries — check Gallery Guide monthly.
American International Sculptors Symposium, 799 Greenwich Street, New York 10014. Tel. 212 242 3374.

Other useful contact addresses
American Council for the Arts, 570 7th Avenue, New York 10018.
National Association of Schools of Art, 11250 Roger Bacon Drive, 5, Reston, Virginia 22090.
Foundation for the Community of Artists, 280 Broadway, Suite 412, New York 10007. Tel. 212 227 3770. (producing a New York Art Guide)
Solomon R. Guggenheim Museum, 1071 Fifth Avenue, New York 10028. Tel. 860 1313. Wed-Sun 11-5, Tues 11-8.

LOS ANGELES
LAICA, Los Angeles Institute of Contemporary Art, 2020 S. Robertson Boulevard, LA, California 90034. Tel. 213 559 5033. Director Bob Smith. Large art centre with gallery space for performance, video, film, exhibitions.
Some Serious Business Inc., 73 Market Street, Venice, California 90291. Tel. 213 396 1312. Performance, video, photography etc.

SAN FRANCISCO
Site Cite Sight Inc., 585 Mission Street, San Francisco, Ca 94105. Tel. 415 543 6994. Director Jill Scott. Work chosen which would otherwise not be made available to the Bay area community. Performance, video exhibitions, documentation. Funded by NEA and California Arts Council.
Museum of Conceptual Art, 75 3rd Street, San Francisco. Tel. 495 3193. Director: Tom Marioni.
The Floating Museum, 3007 Jackson Street, California 94115. Tel. 415 563 8548. Arranges events on various sites in San Francisco area.
Video Free America, 442 Shotwell Street, San Francisco. Tel. 648 9040. Director Joanne Kelly. Open 12-4.

BOSTON
Boston Visual Artists Union Inc., 77 North Washington Street, Boston, Massachusetts 02114. Tel. 227 3076. Exhibition space, films, performances etc.

PHILADELPHIA
Foundation for Today's Art, Nexus, 2017 Chancellor Street, Philadelphia, Pennsylvania 19103. Tel. 215 567 3481. A non commercial artist run gallery in the centre of Philadelphia. 2500 square feet of space for exhibitions, performances, events and exchange shows with Canada and USA and video.

CHICAGO
NAME Gallery, 9 West Hubbard, Chicago, Illinois 60610. Tel. 312 467 6550. Artists run alternative space with exhibitions, performance and video events.

WASHINGTON
Washington Project for the Arts, 1227 G Street Northwest, Washington DC 2005. Tel. 202 347 8304. Promotes new and experimental art such as dance, theatre, music, visual arts.
Independent Curators Incorporated, 1740 N Street NW, Washington DC 20036. Tel. 202 872 8200. Offer exhibitions designed to appeal to non art specialists as well as those whose interest is mainly in the visual arts. Exhibitions, performances, video, educational programmes and art publications.
Museum of Temporary Art, 1206 G Street, Washington DC 2005. Tel. 202 638 9613. Exhibitions, performances, video, films, art publications. Non-profit art organisation.

USSR
IAA, Union of Artists of the USSR, Gogolevski Boulevard 10, 121019, Moscow G19.

YUGOSLAVIA
IAA, Savez Likovnih Umetnika Jugoslavije, Mrs Mirjana Kacarevic, Terazije 26/11, 1100 Beograd, Yugoslavia.

NEW ZEALAND
AUCKLAND
Elam School of Fine Art, Auckland University, Auckland. Tel. 31897.
Auckland City Art Gallery, Kitchener Street, Auckland. Tel. 792020. Open 10-4.30. Fridays 10-8.30.
New Vision Gallery, 8 His Majesty's Arcade, 171 Queen Street, Auckland. Tel. 375 440. Open Mon-Thurs 9-5, Sat 10-3. Contemporary New Zealand Work.
New Zealand Society of Sculptors and Painters, Elam Art School, Auckland University, Auckland. Tel. 31897. President P. Hanly (1980/81)
Barry Lett Galleries, 41 Victoria Street West, Auckland 1.
Peter Webb Galleries Ltd., T&G Building, Corner Elliott and Wellesley Street, Auckland. Tel. 373 090. Open Mon-Fri 9-5.30. Contemporary NZ work.

WELLINGTON
Queen Elizabeth II Arts Council of New Zealand, 110-116 Courtenay Place, Te Aro, Wellington. Tel. 851 176. Director Michael Volkerling. Visual Arts: James Mack.
National Art Gallery of New Zealand, Buckle Street, Wellington. Tel. 859 703.
PhotoForum Gallery, 26 Harris Street, Wellington.
Galerie Legard, 44 Upland Street, Wellington 5. Tel. 758 798. Open Tues-Fri 12-6, Sat 1-3.
Elva Bett Gallery, 147 Cuba Street, Wellington. Tel. 845511. Mon-Fri 10-5. Major contemporary NZ artists.

CHRISTCHURCH
Ilam School of Fine Art, Ilam University, 108 Ilam Road, Christchurch 4.
Robert McDougall Art Gallery, Botanic Gardens, Christchurch. Tel. 791 660 ext 484. Open 10-4.30 Sat and Sun 10-5.30. Large gallery showing contemporary work by New Zealand artists and other visiting exhibitions.
CSA Gallery (Canterbury Society of Artists 1770 members), 66 Gloucester Street, Christchurch. Tel. 67261. Open weekdays 10-4.30. Weekends 2-4.30. Large gallery spaces both upstairs and downstairs. Variety of exhibitions ranging from one man to group shows, performances, painting, craft etc.

ELSEWHERE
Govett Brewster Art Gallery, Queen Street, New Plymouth. Tel. 85149. Open 10-5. Permanent home of Len Lye films, painting and sculpture.
Gisborne Museum and Arts Centre, 18-22 Stout Street, Gisborne. Tel. 83832. Open Weekdays 10-4.30, Weekends 2-4.00.
Brooke Gifford Gallery, 112 Manchester Street, Christchurch. Tel. 65288. Open Mon-Fri 10.30-5. Contemporary work.
Dunedin Public Art Gallery, Dunedin. Tel. 778 770. Open Weekdays 10-4.30. Weekends 2-5.00. Major collection of contemporary NZ artists.
Manawatu Art Gallery, 398 Main Street, Palmerston North. Tel. 88188. Open 10-4.30, Sat and Sun 1-5.00, Thurs evening 6-9.00. Historical NZ artwork.
Rotorua Art Gallery, Tudor Towers, Rotorua. Tel. 85 594. Open 10-4, Weekends 1-4.30.
Kerikeri Arts Centre Inc., PO Box 127, Bay of Islands. Tel. 79 496.

USEFUL BOOKS

See Art Bookshops (Chapter 1) for your nearest bookshop.

FILM AND VIDEO

London Video Arts (catalogue). Price £1.50, plus postage. Available from London Video Arts, 79 Wardour Street, London W1. Tel. 01 734 7410.

Directory of Independent Film. Price £1.50, plus postage. Available from Independent Cinema West, 132A Queens Road, Bristol.

London Film Makers Catalogue. Price £1.50, plus postage. Available from London Film Makers Co-operative, 42 Gloucester Avenue, London NW1.

The Other Cinema Catalogue. Price £1, plus postage. Available from The Other Cinema, 12/13 Little Newport Street, London WC2.

Films on Offer. Price £2.25, plus postage. Available from BFI, 81 Dean Street, London W1.

South West Film Directory. Price 50p. Available from South West Arts, 23 Southernhay East, Exeter, Devon.

Video Distribution Handbook. Price £1.50. Fantasy Factory.

Perspectives on British Avant Garde Film. Price £1.50.

PRINTMAKING

Handbook of Printmaking Supplies. Price £2.00. Available from Printmakers Council of Great Britain, 31 Clerkenwell Close, London EC1. On sale at most art bookshops and some galleries.

Understanding Prints. A contemporary guide. Pat Gilmour. Price £2.95.

A Print Buyer's Handbook. A. Delgado. Wolfe Publications.

Prints and Printmaking. Anthony Griffiths. British Museum Publications. Price £5.95.

Prints and the Print Market. A Handbook for Buyers and Collectors. Theodore B. Danson 1977. Thomas T. Crawell and Co. (Expensive but comprehensive for major print collectors).

History of Engraving and Etching. Rosemary Simmons. Studio Vista. £7.95.

Collecting Original Prints.

PHOTOGRAPHY

See Photographic Workshops for addresses of photo galleries and workshops in Britain. Many of these sell photographic books. **The Photographers gallery** in London has a large selection of photographic books, magazines and postcards at 8 Great Newport Street, London WC2, also the **Arts Council Shop** at 8 Long Acre, London WC2 and Foyles and Zwemmers, Charing Cross Road, London WC2.

GENERAL

Writers and Artists Year Book. Price £3.50. Publishers Adam and Charles Black, 35 Bedford Row, London WC1. Available at most bookshops. Published annually. Excellent for writers but not so for artists, except perhaps commercial artists.

Arts Review Yearbook. Price £8.00. Publishers Arts Review, 16 St James Gardens, London W11. Tel. 01 603 7530/8533. Available at most bookshops and at The Royal Academy, Arts Council Shop.

London Art and Artists Guide. Price £2.95. Publishers Art Guide Publications, 89 Notting Hill Gate, London W11 3JZ. Tel. 01 229 4669. Available at Foyles, Arts Council Shop, Royal Academy, galleries etc.

Paris Art Guide. Price £2.50. Publishers Art Guide Publications, 89 Notting Hill Gate, London W11 3JZ. Tel. 01 229 4669. Available at most art bookshops and other galleries or direct from the publishers. Also **Australian Arts Guide** by Rooly Kean and **New York Art Guide** (£2.95). Future guide to cover Canada, California, Chicago, Amsterdam and other European cities.

Art Diary. Price $20.00. (£11.00). Publishers Giancarlo Politi, 36 Via Donatello, Milan 20131, Italy. Available from UK distributor Art Guide Publications, 89 Notting Hill Gate, London W11. Tel. 01 229 4669. An international art directory covering 38 countries. Names of artists, art galleries, art organisations etc. Published annually.

The Artists Studio Handbook, Artic Producers, 17 Shakespeare Road, Sunderland, Tyne and Wear. £2.00. £1.00 to Artists Newsletter subscribers.

Guide to Scottish Art Galleries. Paul Harris Publishing, Edinburgh. Tel. 031 556 9696. £1.95.

Visual Arts Handbook. Price $8.00 plus postage. Publishers Visual Arts Ontario, 417 Queens Quay West, Suite G100 Toronto Canada. Available direct from publisher or at Canadian art bookshops and galleries. Directory for Canadian artists with useful information and advice.

Anderson and Archer's Soho. Publishers Simon and Schuster Rockefeller Centre 1230 Avenue of the Americas, New York 10020, USA. A general guide to the galleries and buildings in Soho with useful information. Available in London at Stanfords, Long Acre, Covent Garden along with maps of New York and Michelin guide to New York.

West Midland Directory – Artists Craftsmen Photographers in the West Midlands. West Midland Arts, Lloyds Bank Chambers, Market Street, Stafford. Price £2.00. Glossy directory with photographs of work by professional artists in this area and details about the artist and his/her work.
Arts Centres. Every town should have one. John Lane. Price £6.75.
Handling and Packing Works of Art. Francis Pugh. Price £1.00.
Marketing the Arts. Keith Diggle. Price £2.50.
The Universities, the arts and the Public. Price 50p.
The Arts and Personal Growth. Pergamon Press. Price £5.50.
What is Abstract Art? Arts Council of Great Britain publications.
The Phaidon Companion to Art and Artists in the British Isles. Michael Jacobs and Malcolm Warren. £12.95.
Growing up with Art. Price £2.00.
Directory of Arts Centres (UK) Arts Council of Great Britain.
The Arts Council of Great Britain. Eric W. White. Price £1.00.
The Arts and the World of Business. Charlotte Georgi. Methuen 2nd edition. £4.90.
The Fine Art of Art Security. Donald Mason. Van Nostrand and Reinhold. Price £6.70.
Festivals in Great Britain. ACGB.
Contemporary British Art – with photographs. Walia and Perry Crooke. Price £9.95.
Thinking about Art. Edward Lucie Smith. Price £1.95.
The Art Galleries of Britain and Ireland. Joan Abse. Price £5.95.
Dictionary of Art and Artists. Peter and Linda Murray. Price £1.75.
British Art. Simon Silson. Tate gallery. Price £10.00.
Who's Who in Art. Art Trade Press. £10.00.
The Art and Antique Restorers Handbook. Barrie and Jenkins. Price £4.95.
Art Gallery Guide (Europe). Guide to specific paintings. Mitchell Beazley, £3.95.
Phaidon Companion to Art and Artists in the British Isles. £12.

Dutton Paperbacks New York
The New Art
Idea Art
New Ideas in Art Education.
Philosphy of Modern Art, Herbert Read. Faber.
The Hidden Order of Art. Anton Ehrenzweig. Paladin.
Pop as Art. Mario Amaya. Studio Vista.
Towards another Picture. Andrew Brighton and Lynda Morris. Midland Group Nottingham. Price £3.00. (artists' writings)
Art on the Edge. Harold Rosenberg. Secker and Warburg.
Art and Culture. Clement Greenburg. Thames and Hudson.
The Story of Art. E. H. Gombrich. Phaidon.
Women Artsits. Karen Petersen and J. J. Wilson Womens Press £4.95.
An Outline of English Painting. Faber 90p.
Success and Failure of Picasso. John Berger Writers and Readers Co-operative £2.95.
British Art Since 1900. Sir John Rothenstein Phaidon £5.95.
Performance Live Art 1909 to the Present Roselee Goldberg Thames and Hudson £5.95.
Progress in Art Suzi Gablik Thames and Hudson £8.50.
See Art bookshops Chapter 1.

ART PUBLISHERS

1. Thames and Hudson
2. Studio Vista
3. Academy Editions
4. Van Nostrand and Reinhold
5. Phaidon
6. British Museum
7. Faber and Faber
8. Tate Gallery
9. Victoria and Albert Museum
10. Secker and Warburg.
11. Arts Council of Great Britain
12. Art Guide Publications
13. Sotheby Parke Bernet
14. Audio Arts (Video)
15. Eaton House Publishers (Video)
16. Paul Harris Publishing (Scotland)
17. Petersburg Press
18. Artic Producers
19. Artlaw
20. Writers and Readers Co-operative

If you have any addresses or details to add to this guide book I would be grateful if you could send them on the sheet printed below.

Heather Waddell and Richard Layzell
Artists Directory
Art Guide Publications
28 Colville Road
London W11 2BS

Name of organisation/gallery/restaurant/bookshop/magazine, etc.

. .

. .

Address .

. .

. .

. .

Other information .

. .

. .

. .

. .

. .

. .

. .

Thank you.